D1571964

Suspended Animation

Suspended Animation

Pain, Pleasure and Punishment
in Medieval Culture

Robert Mills

REAKTION BOOKS

For Neil

Published by REAKTION BOOKS LTD
33 Great Sutton Street
London EC1V 0DX, UK

www.reaktionbooks.co.uk

First published 2005

Colour printed by Creative Print and Design Group, Harmondsworth, Middlesex

Printed and bound in Great Britain by CPI/Bath Press, Bath

British Library Cataloguing in Publication Data
Mills, Robert, 1973–
 Suspended animation : pain, pleasure and punishment in
 medieval culture
 1. Violence - Europe - History - To 1500 2. Violence in
 literature 3. Violence in popular culture 4. Violence -
 conditions - To 1492
 I. Title
 303.3'6

ISBN 1 86189 260 8

Contents

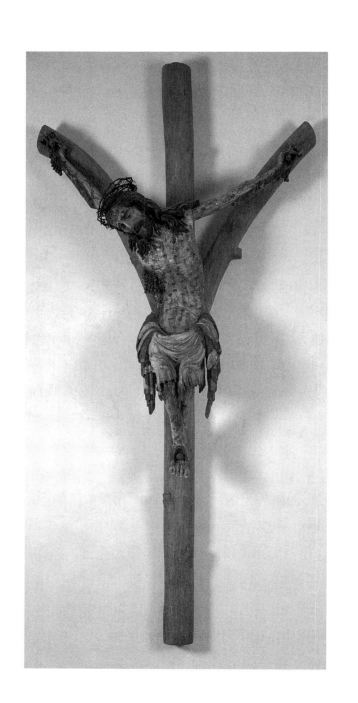

Introduction:
Speculum of the Other Middle Ages

'They used to hang you for stealing a loaf of bread, didn't they?', retorts the civilized western subject in the twenty-first century.[1] The sense of relief is palpable in the speaker's tone. We're comfortably distant from a part of our history that terrifies us, fascinates us, the statement implies. These days, thankfully, the western world is free of such apparent disjunctions between crime and punishment. Now, when criminals are chastised, at least the severity of the penalty matches more closely the perceived magnitude of the transgression. How could people have performed such acts of unwarranted barbarism on each other? What progress there has been in modern times!

The 'didn't they?' with which the sentence ends, however, signals an element of fragility in the speaker's declaration, the faintest recognition that self-definition is at stake. The expression is edged with the spectres of death and difference, but also with a voyeuristic sense of fascination, even shades of identification – the allure of the other. Psychic and social structures often produce what might be termed an 'exclusionary matrix', a dangerous, abject region that circumscribes the identities of ideas, institutions and selves. The word abjection (from the Latin *abicere*, to throw away, throw down, abandon, degrade) encapsulates this dynamic of foreclosure: a casting away, the production of a domain of disidentification against which entities and ideas stake out their claims to symbolic legitimacy.[2] Capital punishment functions as a metonym for the brutality of the past, establishing an uninhabitable space fantasized by the speaker as threatening to his or her integrity and consequently disavowed (even though that fantasy remains precisely *within* the subject herself as a founding repudiation, the horror within). Alterity performs its constitutive work . . .

The abject also confronts us in another meditation on the vicissitudes of penal horror: a late fourteenth-century carved *Crucifix* (illus. 1) from the Corpus Christi church, Wrocław (formerly Breslau, Germany; now a part of Poland).[3] It is a supremely provocative and emotive image. More

1 Anonymous Silesian master, *Crucifix*, c. 1370–80, painted wood carving from Corpus Christi church, Wrocław (Breslau). Naradowe Museum, Warsaw.

than any painting by Grünewald, more even than Holbein's *Dead Christ*, the carving demands an immediate response. Taking in the composition, first of all, the image seems to move incessantly downwards. Christ's veiny arms are stretched tensely, locked in a strained, bony curve. Leaning slightly to one side, the left arm is pulled taut by the weight of the body, its (literal) woodenness conveying the impression that at any moment something might snap. Cadaver, from the Latin *cadere*, to fall: the etymology of the word is reflected in the unnaturally elongated frame of the body on the Wrocław carving, drawn down along the length of the cross. Christ's legs bunch up pathetically, struggling against the weight of the upper body as it sinks downwards. The descending movement of the eyes' sealed lids – circled with a frame of bloody lashes – draws attention to the most captivating part of the image: the wound in Christ's side (illus. 66).

Moving closer now (if we can), we see that the wound emits rich, blobby globules of curdled blood. Unlike the lacerations in conventional crucifixion scenes, which are relatively bloodless in comparison (illus. 2), the gash is fashioned from droplets of blood arranged in neat lines, like strings of glossy pearls or eucharistic grapes, echoed in the bloody mass that exudes from the deep cuts that all but obliterate Christ's hands. The incessant flow is mirrored in the fall of the drapery that frames his sides, and the entire body is bespattered with miniature scourge wounds, interspersed rhythmically at intervals across his flesh. The rib cage is splayed in neat, concertina fashion, Christ's flesh sucked rigidly into his sides; the stomach is drawn in tight so that the creased lines of the belly echo the sharp, furrowed lines of the ribs. Even Christ's hair becomes a bloody, sticky, matted mess, confusingly assimilated with the surplus secretions of his wounded side.

How do we approach a culture that put such images at its very centre? How are we to comprehend such visions of excess?

ALTERITY AND THE MEDIEVAL PENAL IMAGINARY

Images of medieval punishment are commonly understood with reference to what Umberto Eco has dubbed 'shaggy medievalism', the idea of the Middle Ages as a barbaric epoch.[4] In a culture ravaged by violence, death, pain and disease, the story goes, it was entirely natural that those involved in the patronage, manufacture and viewing of artefacts like the Wrocław crucifix should exhibit a profound fascination with flowing blood, torn flesh and fragmented body parts. The classic portrait of the 'waning' Middle Ages painted by the Dutch historian Johan Huizinga in 1919 envisaged the fifteenth century as an epoch of 'barbaric'

judicial cruelty, deploying a rhetoric of extremes that has continued to surface intermittently in more recent surveys of premodern images of violence.[5] Lionello Puppi's *Torment in Art*, for example, elects as its subject the dialectic between martyrdom and passion iconography and the so-called 'realities' of temporal corporal punishment in the medieval and early modern city. The book opens with a dramatic evocation of life in the *ancien régime* city. The spectres of beggary and blood feuds, famine and prostitution are forever rearing their ugly heads; the streets are squalid and revolting, noisy and shit-filled; 'death and suffering', as he puts it, 'were part of the backdrop of daily life'.[6] Additionally, in a section entitled 'The City as Slaughterhouse', the author proceeds to relate in graphic fashion a lengthy catalogue of gruesome tortures and ghastly executions that were supposedly an everyday aspect of medieval life, and exclaims that the chronicle accounts of these horrors narrate 'the disturbing reality . . . in a manner revealing both the bleakness and convulsive fascination of the

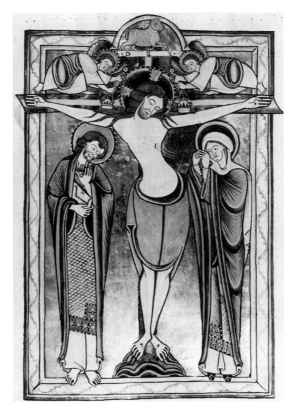

2 'Crucifixion', illuminated page from the Missal of St Bavon, Ghent, late 12th century. British Library, London.

material'. In Puppi's opinion, moreover, 'one can still feel that art will reveal the blood and tears that have been repressed: in the present case, the metaphor of violence used by the authority in the liturgy of public executions . . . re-emerges in the edifying sublimation of martyrdom'.[7]

In themselves, of course, such statements do not offer complete explanations; they suggest that the violence and turbulence of medieval representation simply 'reflect' the historical circumstances in which they were produced. While it may well be possible to posit such connections in particular times and places, in this book I work with the assumption that medieval art also possessed constitutive functions, shaping as well as reflecting social and psychic existences. In this respect, I follow the lead of medieval art historians such as Michael Camille and Mitchell Merback, who have suggested that paintings and manuscript illuminations provided opportunities for fashioning identities, for constructing multiple and contradictory interpretations of the real and for inflecting a range of social and political conflicts. Camille makes the case particularly convincingly in his study of illuminations in the fourteenth-century Luttrell Psalter; Merback argues similarly with reference to tortures represented in late medieval scenes depicting Calvary.[8] But even their work, on occasion, seems haunted by the idea of a causal connection between violent social realities and representational violence. 'Such images of death were produced in a culture ravaged by constant war and quite used to the public spectacle of corporal punishment meted out to miscreants in the public squares of towns', remarks Camille in response to a painting depicting a martyred saint.[9] 'Calvary came into its own amidst the turbulence of a century rocked by crises and catastrophes and violences of every sort: famines, plague, pogroms, peasant revolts, the schism of the Church', writes Merback of Calvary's blossoming as image and visionary spectacle.[10] I refer to their remarks on violence here not to chastise the particular contexts in which such statements originate, but to direct attention to the pervasiveness of evocations of alterity and historical difference in studies devoted to representational violence, even in the work of scholars who would in other ways wish to disrupt traditional assumptions about the relationship between history and representation.

An emphasis on medieval alterity also extends more generally to histories of the body (which is, after all, traditionally evoked as the most 'universal' of human attributes, and which is also often at issue in discussions of pain, punishment and violence). Feminist, queer and postcolonial studies, as well as disability and critical race theory, have drawn attention to the ways in which the corporeal ideals that emerge in particular historical contexts produce universalizing tendencies; recently, in medieval studies, approaches of this sort have provided important interpretative

frameworks for the study of monstrous bodies, identities and desires.[11] Against this backdrop, critics have been inclined to privilege bodies on the margins as a foil to dominant somatic structures; penal bodies in particular find themselves deployed as signifiers of a kind of temporal monstrosity, a notion of the Middle Ages as monstrously other. Listen, for example, to this invocation of the body of the mutilated criminal in the work of a distinguished cultural historian:

> In a society crawling with animals and parasites, where mud and sewage, rotting meat and decomposing corpses (of offenders who had been hung and quartered), increased the level of reeking exhalations, there was a high probability of seeing worms, caterpillars and flies appear from everywhere.[12]

Piero Camporesi, the author of these remarks, seizes on the punished body to communicate what he perceives as the stinking, creepy-crawly-filled dimensions of premodern experience. In such pronouncements, judicial violence and historical otherness appear to go hand in glove.

Alterity is not, of course, the only relationship to the past that medievalists recognize (though its particular relevance to the study of medieval penal regimes and bodies has often been asserted). The Middle Ages has also been erected customarily as possessing elements of continuity – or transhistorical connection – with the present, whether in historical studies emphasizing medieval culture as a point of origin for modern ideas and institutions, or in popular accounts describing the medievalness of contemporary customs, cultures and social practices. One recent example of this phenomenon demonstrates the continuing political stakes in appropriating the period as a marker of brutality and restraint: certain British newspaper reports produced in the aftermath of the aerial bombardment of Afghanistan in 2001 characterized the former Taliban regime as 'medieval'; a minister from the Northern Alliance, a high profile Taliban-opposition group, was quoted as expressing a desire 'to lead Afghanistan out of the Middle Ages'.[13] Statements of this kind unwittingly exemplify the contradictory dimensions that may be said to adhere to the term 'medieval' in modern usage: on the one hand, the medieval is *really modern*, serving to disparage a present-day institution; on the other hand, it is *really other*, bearing the traces of its status as a mark of primitivism and backwardness. Thus, a transhistorical Middle Ages occasionally finds itself in close alignment with a shaggy Middle Ages, signifying spatially with reference to, say, the 'medieval' practices of contemporary non-Western cultures, as well as temporally with reference to a repudiated past.

The topics of pain and punishment reveal a range of issues relevant to the critique of alterity in medieval studies; indeed they may be said to clarify the stakes of this critique, by foregrounding the extent to which discourses of familiarity and strangeness in historical writing are in some respects mutually constitutive.[14] At several points in this book, we shall encounter moments when 'alteritist' and 'transhistorical' versions of the past seem to lose their distinctness, as in iconography blurring the distinction between premodern acts and modern identities that has become a focus for sexuality historians, or depictions of pained bodies that provoke empathy as well as detachment. Multiple timelines seem to be at work in these contexts and it is important that we take a pliant view of history, rather than focusing our energies simply on the otherness of medieval specifics. Long histories do not necessarily entail no history, but draw attention to the temporal instability of identities, the way the past is *within* us too. The process of identifying with the past has the capacity to produce ahistorical, normalizing effects, in other words, but it can also draw attention to past's symbolic role as a resource for the formation of non-normative identities in the present. What signifies as difference for one individual may not feel that way to another, at least not in every respect.[15] Likewise, to insist too strongly on the otherness of medieval bodies, in narratives that identify modern bodies as 'the same', may have the effect of producing a spectacle of coherent modern selfhood that is restrictive rather than liberating. If we insist on distinguishing the present, all the time, from a world of medieval alterity, we may even be renouncing, or abjecting, parts of ourselves.

In this context, it is worth recalling that accounts emphasizing the otherness of medieval bodies derive some of their assumptions from a body of theoretical work designed to disrupt, rather than reify, particular historical and identificatory structures. The work of Michel Foucault, in particular, has impacted in deep-seated ways on studies of punishment and the body in both modern and premodern contexts; the alteritist agendas of this research may be said to derive, at least in part, from Foucaultian principles. *Discipline and Punish*, a book investigating the shifts in penal technology that have characterized Western society since the nineteenth century, opens with a shocking account of premodern brutality: the horrifying torture and execution of the regicide Damiens in 1757. Foucault contrasts the tale of Damiens with the regulations for a house of young prisoners in Paris, drawn up eighty years later and defining what, for him, represents an alternative penal style: an era of what he terms 'discipline', within which he locates the 'birth' of the prison.[16] Recent research on medieval crime has troubled the embedded chronology of such contrasts by suggesting that prison, in the sense of punitive confinement, finds its birthplace in the

Middle Ages, not in the eighteenth and nineteenth centuries as Foucault submits.[17] But the rhetorical force of Foucault's opening gambit nonetheless remains intact: it forces readers to recognize the otherness of another historical reality and thus to bear witness to the ruptures and technological shifts that characterize the history of Western penology. In this way, Foucault wishes to call into question understandings of that history as a liberal progress narrative, moving ever forward in the service of an increasingly humane social order. The shift to discipline, he suggests, cannot simply be attributed to humanization; it is associated with a fundamental transformation in the techniques and manifestations of power. Likewise, torture as it was practised from the Middle Ages until the eighteenth century was not simply an exercise in primitive barbarism, but subject to its own laws, techniques and symbolic codes. It too was an expression of a particular mode of power: the power associated with sovereignty.

My point, then, is not that evocations of historical otherness fail to produce oppositional effects. Foucault's nostalgia for premodern difference – especially in his work on sexuality – also potentially offers alternatives to the medieval as a space of abjection, to the extent that he imagines the Middle Ages as a *desirable* contrast to present, normative regimes.[18] Yet reminders of the ultimate otherness of medieval punishment, such as those encouraged by a reading of *Discipline and Punish*, simultaneously operate within contemporary historical practice precisely to stabilize modernity as a point of identification.[19] *This* sense of the Middle Ages – as an abject, excluded territory, positioned in antithetical relation to an eminently desirable modern – needs confronting in the context of analyses of medieval pain and punishment, since the deployment of alterity in such writings may well be related to the desire to identify with a particular version of modern selfhood, one that is ostensibly western, civilized and progressive. Foucault may well declare that what he terms the modern 'carceral city', with its imaginary 'geo-politics', takes us 'far away from the country of tortures, dotted with wheels, gibbets, gallows, pillories'.[20] But tell *that* to the people being tortured now, in the police cells, prisons, detention centres and execution chambers of – yes – the modern West. And tell that to the people watching violence on television and the silver screen. Bodily punishments may not possess the legal sanctions they enjoyed until recently in many parts of the world, but they continue to haunt our culture's imaginary and even, apparently, some of its social practices. Recent worldwide events have raised the possibility that certain Western democracies may actually be implicated in the proliferation of torture in the modern world, propping up regimes that routinely employ torture to enforce public order or creating circumstances in which they themselves become mixed up in allegations of abuse against, for example,

prisoners of war.[21] In this context, we should acknowledge the ways in which certain explanations and chronologies generated by historians – Foucault's included – may have contributed, albeit unknowingly, to the suppression of modernity's own, disavowed stake in torture as a representational or political act. The critical tendency to condemn, excuse or even celebrate images of torture with reference to notions of medieval alterity may ultimately derive less from an understanding of the Middle Ages 'on its own terms' than from false notions of our own moral superiority and ethical progression.[22]

It is important to meet this issue head-on. Few Westerners confront or participate in real acts of violence every day of their lives. But violence – and the threat of violence – nonetheless continues to structure those lives in the field of representation. This impacts upon the way we study violence historically. Judging images such as the Wrocław crucifix as comprehensible simply because 'it was more violent in those days', while at the same time suggesting that the violence of representation is consequently *in*comprehensible because we are not like that, enters into a critical vicious circle that is potentially disabling. Foucault's conception of the premodern period as an era of spectacular executions is deceptive, as is Huizinga's account of the all-pervasive cruelty of fifteenth-century justice. It goes without saying that capital punishment is abhorrent and indefensible, and medieval courtrooms were certainly not averse to proscribing horrifying and disturbing methods of chastisement on occasions when it was felt to be warranted. My point is not that medieval societies should be, as it were, 'let off the hook' with regard to their practices of cruelty. But the impression that daily life was, in the Middle Ages, peppered with elaborate execution rituals and bloodcurdling tortures, in contrast to more austere and less spectacular experiences of discipline and surveillance in modernity, is partly an effect of the ways in which the Middle Ages represented itself *to* itself.

This assertion is made on the basis of a comparative review of recent studies of crime and punishment in medieval Europe, many of which reveal the exceptional and infrequent nature of capital executions in the period. Notwithstanding the many regional variations, all the indications are that capital punishment was not as regular or as spectacular an occurrence in the Middle Ages as is commonly imagined.[23] In fifteenth-century East Anglia, for instance, it appears that more people accused of crimes escaped the death penalty than suffered it, that the majority of those tried were acquitted, that around one in ten of the arrested were executed, and that the rest pleaded clergy, escaped, abjured the realm, died in jail, were pardoned or delivered to other courts.[24] Investigations of crime and conflict in England in the previous century provide data that is similarly

suggestive: analysis of jail delivery records for the rural population of certain counties between 1300 and 1348 indicates that less than a quarter of suspected felons were convicted, a result of the fact that capital punishment was considered too severe to fit the popular attitudes to crime.[25] The same goes for areas of France: Provençal justice was based on a two-tiered approach to punishment, on the one hand a system of fines and on the other hand a regime of banishment, corporeal humiliation, bodily mutilation and spectacular execution. By allowing financial compensation for crimes as grave as homicide, this dual procedure enabled punishment to function variously, in both disciplinary and exemplary ways.[26] The patterns are occasionally shaped by factors such as gender: research into medieval legal and literary discourses on rape indicates that, despite harsh penalties for forced coitus in Roman Law, French courts for the most part exhibited incredible leniency with regard to male offenders.[27] But comparisons with broader trends across Europe suggest that these tendencies are in keeping with a more general pattern of mitigation too. In Italian urban centres such as Venice, fines and prison sentences increasingly replaced corporal punishment for the majority of crimes; the preferred goal of Venetian justice was 'brutality in discrete quantities'.[28] So it seems that in many regions of late medieval Europe, judicial violence was exercised selectively and acquittals and reduction of sentences were often the order of the day. In late medieval justice, spectacular executions weren't necessarily typical or routine.[29]

This begs the question 'If acts of capital punishment did not take place as regularly or as often as it sometimes believed, whence the overwhelming impression conveyed by medieval texts and images?' After all, it is hard not to be struck by the sensational descriptions of spectacular public executions in late medieval chronicles. The *Journal d'un Bourgeois de Paris* (1405–49), for example, is punctuated with accounts of lengthy judicial processions, spectacular penal pageantry and elaborate execution rituals. One entry describes the execution of Jehan de Montagu, Master of the King's household, for treachery in 1409. Having been 'put into a cart, wearing his own colours: an outer coat of red and white, hood the same, one stocking red and the other white, and gilt spurs', Jehan was subsequently escorted to Les Halles with two trumpeteers and beheaded, after which his torso was hung up high from the Paris gallows, still clad in its red and white finery.[30] Another passage records the execution of the 'false traitor' Colinet de Puiseux and six of his associates at the same spot in 1411:

He was on a plank higher up in the cart than the rest, with a wooden cross in his hands, dressed as he had been when captured, as a priest. He was taken on to the scaffold like this, stripped naked, and

beheaded, he and five of the others . . . this Colinet, the false traitor, was dismembered, his four limbs hung up one over each of the chief gates of Paris, his body on the gallows in a sack, and their heads stuck up on six spears in the Halles, like false traitors that they were.[31]

These accounts are memorable in their details, but it should be recalled that they are devoted to the exceptional torments meted out to traitors, not to the penalties administered to the vast majority of offenders. Moreover it is important to note that, despite the disciplinary emphasis of penal practice in the modern West, discourse on spectacular deaths features strongly in contemporary as well as medieval experience: historians of the next millennium might well look back on violence in the twenty-first century through the lens of the Hollywood video nasty, or news footage of horrendous acts of war, violent crime and murder, and declare that the age in which we ourselves live is detestably other. Or to cite an example more comparable to the chronicle form, photographic surveys of the twentieth century that emerged in the last years of the millennium seemed to possess an overwhelming emphasis on images of death, warfare, murder, famine and natural disaster.[32] Why the peculiar fascination with violence and suffering, shared by an audience with a taste for such volumes whose daily lives are not, in many instances, directly affected by violent acts? In turn, if the sight of death and capital punishment was not nearly so familiar or spectacular in the Middle Ages as is commonly believed, why were chroniclers, artists and storytellers so intent upon constructing such a subject in representation? Why were visions of punishment so symbolically central?

The historian Esther Cohen has provided a convincing explanation: that the bloody era of executions was a 'visual trick' designed to convey a spectacular language of punishment far out of proportion to the number of criminals actually ascending the gallows. As she perceptively remarks, what chronicles record is 'not how the law worked, but how people saw it working'.[33] I think Cohen is right in her assessment, but I'd like to suggest that the issue be framed in slightly different terms. What we need to understand is the perceived centrality of spectacular justice in medieval culture at the level of discourse and fantasy, or what I call, in the context of this study, the medieval penal imaginary.[34] It is perhaps stating the obvious to say that punishment is related to issues of power, but what were the modes of writing and speaking about punishment, of visualizing and imagining it, that made the exercising of power possible? One of the major premises of this book is that dominant power structures in medieval society were partly sustained through the deployment of representations of punishment and pain: these images possessed a strong ideological remit. Secular justice iconography created an arena for the construction of

institutional authority and bourgeois civility; the torments of the damned produced spaces for the projection of cultural prejudice, systems of incentive and social control; the punished bodies of Christ and the saints helped spawn powerful messages about the coherence of the Church and the 'body' of Christian faithful.

If these depictions were linked to the propagation of power in medieval society, however, they could also generate and legitimize various forms of pleasure. In the course of this book we'll see how pleasure, in its various guises, was central to the medieval penal imaginary and how this accounts, at least in part, for the *excessive* presence of violence. This visual excess frequently possessed a normative function, of course. In secular contexts, it operated to buttress state power and social distinction or to procure voyeuristic pleasure in the humiliation of others; in religious contexts, it effected the transfiguration – the making sublime – of death, suffering and self-sacrifice. But sometimes, just sometimes, it also provided spaces in which to work through more subversive possibilities: empathy with, and opposition to, the pain of the punished, fantasies of resistance and empowerment, even forms of eroticism that transgress accepted norms.

This required, in both religious and secular spheres, efforts to downplay the sentient reality of the punishment endured and the agony of bodies in pain. Medieval chronicles, which rarely mention the pain of the victims of the scaffold or describe the physiological details of their executions, clearly reproduce this dynamic of foreclosure: their descriptions are, for the most part, remarkably austere. This in turn may be connected to what I shall call, in chapter Two, a *burgerlijk* aesthetic, which directs attention away, squeamishly, from the pains of torture as visualized in painting. At the same time, by denying the embodied horror of penal ritual, certain chroniclers might also have been influenced by what could be termed a 'reparative' affective model: a paradigm of response designed to convey respect for the victim's dignity in response to their terrible plight, to rehumanize them in the face of their impending dehumanization.[35] The first half of the book considers responses to the late medieval iconography of justice in this light – depictions of hanging, secular justice paintings, Last Judgement scenes – and suggests that we reconnect with some of the punished bodies in question, bodies that until now have been sidelined or ignored. The second half turns to depictions of martyrdom and the sufferings of Christ, framing the analysis with reference to categories such as masochism, pornography and queerness. It is the book's contention that these categories, commonly perceived as being fundamentally alien to medieval modes of interpretation, bring into view the pleasures as well as pains associated with images of violence and death. Reparative responses potentially blur the lines commonly drawn

between affect – unpredictable, corporeal, contingent – and cognition – located in historically situated, culturally sanctioned processes. Moreover, it is only by opening ourselves out to the possibility of these oppositional modes of identification and response that we are able to appreciate how the art of pain might also have created spaces for the exploration of certain forms of desire, notably sexual desire, in response to the naked, tormented bodies of the martyrs and Christ. Understanding the ways in which pain and suffering are 'made good' has the potential to reveal ways in which they actually do harm. But we also need to imagine how images of pain might have been subverted, 'queered', in order to perform different sorts of cultural work from the work to which they were originally assigned.

THIS MIDDLE AGES WHICH IS NOT ONE

The complex transformations that punishment undergoes in the context of representation construct a set of interpretive paradigms in which we, as viewers, are thoroughly implicated. It is partly for this reason that the chapters that follow also cohere around the central concept of suspense, of life hanging in the balance. Suspense is a term more usually confined to discussions of literature, theatre and film, but this study suggests that close analysis of the temporal structures of medieval visual culture provides an occasion for fresh insights into its affective as well as ideological dimensions. A medieval aesthetic of suspense connects, among other things, German and Italian traditions of defamatory portraiture representing scenes of upside-down hanging, civic justice paintings displayed in Flemish town halls, afterlife iconography portraying the agonies of sodomites in hell, and the torture of Christian martyrs and Christ. The representation in these contexts of dramatic tension, and of what I term 'suspended animation', affords a perspective on the responses these art works engendered and the messages they expressed. Indeed, suspended animation is also a formulation that can be applied to the book's methodology, to the extent that my own relationship with the material, and with the historical circumstances that mediate my vision, have informed the discussion. If the conventional relationship to images of pain and punishment in historical writing is one of suspense and distanced speculation, my aim in what follows is to grate this against more shifting, fluid and animated modes of analysis.

This approach to medieval iconographic traditions has been shaped, in particular, by the insights of queer cultural history. I draw my inspiration here especially from Carolyn Dinshaw, who has, in her recent work,

attempted to develop relations with the past based on ideas of indeterm-
inacy, embodiment and 'queer touching'. The present book similarly
engages with the touch of the queer at several key points in the analysis.
In so doing, the aim is to provoke different kinds of relationship to histor-
ies of violence and its representation, based on a desire for what Dinshaw
has termed a 'partial, affective connection, for community' that may even
effect a 'touch across time'.[36] An epistemology of touch may seem like an
odd move in the context of a study which is focused, in various ways, on
manifestations of the visual, whether artistically, textually or theatrically.
Yet medieval theories of vision themselves expressed the idea that acts of
looking are also, in a sense, acts of sensory intercorporation – that vision
is carnal, and that sight carries the carnality of the viewer's body out into
the world.[37] The thirteenth-century thinker Roger Bacon, for instance,
attempted to integrate the insights of 'perspectivism' – a scientific dis-
course emphasizing the need to abstract vision from flesh – with an aware-
ness of the extent to which ocular experience fails to fully differentiate self
and other by virtue of its enduring fleshliness. Vision, he says, 'always expe-
riences a feeling that is a kind of pain'; we are moved, emotionally and
physically, by the things we look at.[38] Such theories trouble distinctions
between subject and object, and in turn problematize the identities around
which these distinctions turn. Modern notions of a gendered, and paradig-
matically masculine gaze, for instance, present a marked contrast to
medieval theories of fleshly, indeterminate and embodied modes of look-
ing. For medieval theorists such as Bacon, sight, by virtue of its corporeality,
is not straightforward in its gendered associations: it is fluid, ambiguous
and divided, so that the polarization of, say, seeing on the side of the
masculine and feeling on the side of the feminine doesn't work in any
simple fashion. Vision fails to articulate a clear division between subject
and object: in Bacon's words, 'it receives the species of the thing seen and
exerts its own force in the medium as far as the visible object'.[39]

Medieval concepts of vision as touch also resonate, in part, with the
concerns of queer history writing, which similarly attempts to complicate
the relationship between observer and observed by attending to the over-
laps and intersections of particular bodily senses in the production of
meaning. Tracing the relations of contingency and heterogeneity that may
be discovered in a bringing together of past and present, for example,
Dinshaw promotes certain paradigms of touching as an alternative to
conventional historicism. As I'm suggesting here, the touch of the queer
might also contain an optical dimension: a mode of ocularity that posits
no visual encounter as 'authentic', stable or predictable in its effects, even
in relation to a single viewing subject.[40] A sense of potentiality informs
my analysis throughout: the idea that the possibilities facilitated by

medieval iconography in the construction of selves and communities in the present and future might also have been feasible back then, and that reconnecting with the indeterminacy of the viewing process is a viable historical exercise. Indeed, suspended animation is a phrase that may be applied to the visual process itself, in the sense that works of art are zones of both temporal suspension and enlivened potential. The medieval images discussed in this book all purport to freeze moments in historical time: they depict bodies 'suspended' between different temporal zones, such as those of the hanged on the scaffold, dangling precariously between heaven and earth; bodies 'on the verge of' being dismembered, such as the ones depicted in secular justice paintings; souls eternally in torment in hell, always 'on the brink of' suffering more; bodies 'about to' suffer, for instance those of Christian martyrs; and bodies such as Christ's, which find themselves 'interposed' symbolically, in the gap between allegoric and literal interpretation. Precisely because images take on lives of their own in the minds of viewers and image-makers, they possess the capacity to touch, move and provoke; their petrified quality simultaneously fixes, or attempts to fix, particular meanings and associations, though this is a process that never entirely succeeds. A relationship with history that like-wise mediates between the suspensions that limited source materials impose and the fantasies that visual artefacts nonetheless set in motion may offer a means of blasting open the rock of periodization that historians customarily erect, to leave behind a Middle Ages of resonance as well as dissonance, *a Middle Ages which is not one.*[41]

One way of conceptualizing different Middle Ages would be through the metaphor of the speculum. One of the most widely copied manu-scripts in the late medieval period was a volume called the *Speculum humanæ salvationis* ('The mirror of human salvation'), which was devoted to interpreting the biblical life of Christ as a reflection, typologically, of stories in the Old Testament.[42] Typological mirroring does not provide an interpretative framework for the present book, though I do consider the ways in which past and present connect with one another incompletely, even fleetingly, by way of certain structural analogies and intersections. Taking a backward glance at history from the standpoint of the present describes one possible relationship with the past, but the medieval also has the capacity to look back at and disrupt modernity's own categories, troubling divisions between objects and viewing subjects. While there is certainly no continuum between the Middle Ages and today in its deploy-ments and depictions of pain, the past can potentially offer a critical per-spective from which to reflect on the present and on ourselves.[43] In this sense, the speculum that I have in mind may have more in common with the curved mirror of self-examination – a mirror folded back on itself –

than the flat, platonic mirror of 'disinterested' reflection. *This* speculum would not simply be a device of transhistorical identification or of distanced alterity, but a site of self-touching and implicated knowledge. In the present context, it would represent not *the* 'other Middle Ages', not the Middle Ages as the other of modernity, but *an*other Middle Ages – other Middle Ages – Middle Ages altogether different from modernity's other.[44]

It is not possible, within the context of this book, to discard 'medieval' or 'Middle Ages' as terms (institutional life and pedagogic practice continue to require them). But by declaring their strategic provisionality, they can at least be seen for what they are – sites of contest – and thus they can perhaps begin to take on new modes of signification untrammelled by accusations of anachronism. Working, like the curved speculum, in a mode of reparative 'self-touching' potentially enables the Middle Ages to *become* rather than simply to be, creating an understanding of the period as a product of vigorous and continued performance. It is by insisting on the indeterminate nature of our relationship with images and texts, discourses, people and places of the past, *by making a virtue of that very indeterminacy*, that we are able to feel the 'intensities' of the sources laid before us: experiences of resonance, contingency and touch. Of course this involves a degree of conjecture, posing the question 'How *might* medieval viewers have responded to these images?' The lived responses to specific works of art are lost to us; those that *might* have been documented in most cases went unrecorded. I do not wish to melancholically crave their return, by suggesting that their surviving traces delineate the *only* possible response patterns that we should admit (traces which in any case, for the period in question, generally recount the hegemonic, the theological, the proscribed). To implement alternative histories of response, we may need to make alternative sorts of connections, across time scales, genres, geographies, genders – not necessarily in order to prove outright that a particular response was possible, but to suggest, rather more tentatively, that such responses were not *im*possible.[45]

My analyses are informed ones, nonetheless, taking in a wide range of written as well as visual sources and evaluating the effectiveness of competing interpretations in particular situations. Whether or not they choose to acknowledge it, all histories involve a degree of speculation. At the same time, I have tried to be as thorough as possible in my evocation of a particular representation's cultural milieu. With this in mind, the book's argument is built around a series of case studies, often focusing in detail on a single image or genre but always moving outwards to discuss comparative material of various kinds. Sometimes, moreover, in an effort to map areas of resonance and partial connection, the juxtapositions are with modern representations or responses. The lyrics of a song depicting

lynching from the 1930s provides one of the contexts for a discussion of medieval depictions of hanging (chapter One); the different responses that circulate around a horrific image of flaying include 'ahistorical', empathetic reactions that, through a process of imaginary identification, potentially disrupt the polarity between medieval and modern (chapter Two); the pernicious figuration of sodomites in hell is compared with an equally pernicious piece of recent British legislation, now thankfully demised (chapter Three); images of holy martyrdom are viewed through the lens of modern pornography (chapter Four); postmedieval configurations of religious discipline are conceived in relation to their medieval precursors (chapter Five); I conclude with a consideration of devotional reflections on the tortured body of Christ (chapter Six), and how even this body might be appropriated for pleasurable and profoundly untheological ends. The book's main focus is representations of punishment in the fourteenth and fifteenth centuries, though it does look both forward and backward from this timeframe in several instances; while the majority of images discussed originate in northern Europe – especially France, Germany and Flanders – I sometimes refer, in order to present an illuminating case study or area of comparison, to Italian materials too. The choice of material is partly shaped by a desire for spatial and generic breadth, but it has also been determined by a commitment to what might be termed antidisciplinarity – a resistance to the tendency for disciplinary analysis to exclude certain objects and interpretations from view.[46] A focus on the queerness, as I see it, is precisely that discipline no longer works as it should – that things that are normally kept separable are made, instead, to touch, incompletely, partially, potentially. The chapters in this book always keep dominant expectations and norms in view, but decisions about the corpus of material have also been animated by an equally strong desire for relations with beings and ideas from the past that are plural, incomplete and suspended – not quite the 'same', but not quite 'different' either. If the book has a prevailing methodological premise in the construction of its temporal and spacial parameters, this is it.

CHAPTER 1

Betwixt Heaven and Earth

The overwhelming impression conveyed by a visit to some of Britain's most popular tourist attractions, such as the Tower of London and the London Dungeon, is that punishment in the Middle Ages was a heterogeneous affair: beheadings, mutilations, burnings, breaking on the wheel, being boiled alive in vats of oil. The tourists are not necessarily being misled in this impression: records suggest that such a varied and imaginative array of tortures was indeed stipulated – and carried out – at particular points in time in regions across late medieval Europe. In certain areas of fifteenth-century rural England, for example, it was prescribed that petty traitors be drawn and hanged; that high traitors be hanged, drawn and quartered; and that women traitors and relapsed heretics suffer burning. In Germany, breaking on the wheel was the most common form of aggravated execution after hanging. Turning to a more urban setting, in Paris criminals were occasionally dragged and beheaded, buried alive, burned at the stake or simply banished. In Florence, in the first half of the fifteenth century, beheading seems to have been a popular method of punishment (although from about 1460 hanging increased in relation to decapitation at a rate of nearly two to one). Images in medieval and early modern law books also testify to the sheer variety of penalties prescribed in parts of Europe: one of the miniatures in a fifteenth-century manuscript of the *Coutumier de Normandie* juxtaposes beheading, trial by combat and hanging (illus. 3), while Ulrich Tengler's *Layenspiegel* ('The Lay Mirror'), first printed in Germany in the early sixteenth century, includes towards the end a grisly woodcut depicting scenes of flagellation, beheading, burning, drowning and breaking on the wheel, as well as various forms of dismemberment; hanging itself is relegated to the background (illus. 4). Yet the existence of such depictions should not detract from the fact that the most common penal spectacle in late medieval Europe would have been the sight of a man being hanged. Surveys of court records in England, Germany, Italy and France from 1300 to 1600 suggest that

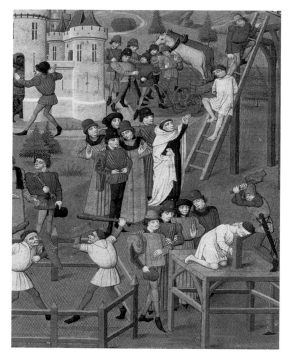

3 'Punishments for various crimes', a detail from an illuminated page in the *Coutumier de Normandie* (*'Belle-Isle Coutumier'*), c. 1470, Rouen. Pierpont Morgan Library, New York.

4 'Punishments for various crimes', woodcut in Ulrich Tengler, *Der neü Layenspiegel* (Augsburg: Hansen Othmar, 1511), fol. 205.

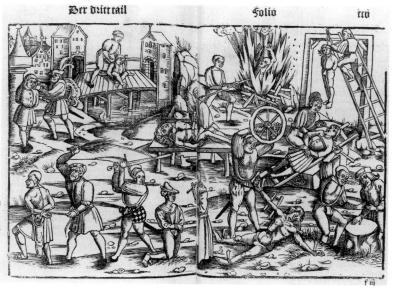

Der dritt tail Folio ccü

f iij

hanging by the neck was the preferred method of capital punishment, and that public hangings were events that most people would have had the opportunity to witness at least once in their lifetimes.[1]

But hanging before 1500 was not only an act of legal significance; it also had immense symbolic importance, and its representation in late medieval art and literature is as crucial an avenue of enquiry as hanging in fact. This chapter, which focuses mainly on fifteenth-century France, Italy and Germany, is concerned less with the technologies of hanging and its historical uses than with the cultural work representations of hanging performed. Depictions of hanging in this period, whether in visual or literary productions, not only depended on a common iconography, which conditioned their reception and symbolic value, but they also reveal a common interest in aestheticization: that is to say, certain aspects are modified or even beautified in order to perform ideological work that is unrelated to the judicial realities of hanging per se. It is not that this process – what might be termed a suspension of lived reality – inevitably lends itself to ignoring the plight of the hanged. Representations continually colour their referents, just as they condition even subjective experiences of the body-in-pain. But symbols are ambiguous and the very languages that beautify, smother over or disguise pain can also, in certain contexts, endow the punished subject with the capacity for utterance that corporal punishment supposedly takes away. In short, images of hanging do not always perform the cultural work of those who hang.

These claims are developed in response to the temporal dimensions of medieval hanging iconography. Hanging is a mode of punishment that relies literally upon techniques of suspension, and the messages disseminated in art and literature concerning it are likewise often related to notions of suspense. But the motif of suspension – of death postponed or deferred, of life hanging in the balance – also permits representations that depict punished beings who are not quite dead, who speak from the ropes on which they swing. This may, in turn, create situations in which empathy with the pained body of the hanged becomes a valid possibility. As the iconographic corpus assembled here reveals, victims of hanging are generally represented in medieval texts and images on the cusp between two different temporal states, in a threshold zone 'betwixt heaven and earth'. This imagery of betwixt and between, which I label, for the sake of convenience, an 'aesthetic of suspension', is crucial to an understanding of the general symbolic associations of hanging. But it also aids the interpretation of a range of historically specific ideological effects.

What might people have seen when they witnessed a medieval hanging? We are presented with an immediate problem here because detailed commentaries on the physiological facts of hanging are rare. Medieval chroniclers for the most part shied away from describing such details, concerned as they were with the spectacular pageantry associated with the deaths of traitors. As I suggested in the Introduction, this has contributed to a distorted picture of medieval penal practice: it suggests that pre-modern people were accustomed to witnessing extravagant, showy execution rituals with unremitting frequency. This may well have been the case in certain towns and cities in Europe at particular times, but the overall picture painted by court records is that the majority of criminals unfortunate enough to be sentenced to death met more ignominious ends at the end of a rope. Moreover, most of those hanged were of such obscurity, their misdemeanours so average, that their punishments failed to earn a place in chronicles or in popular consciousness. Reading, for example, the *Journal d'un Bourgeois de Paris* mentioned in the Introduction, the overwhelming impression is much the same as that offered to a visitor to the London Dungeon today: the chronicler's interest is in the executions of the high and mighty, the spectacular 'good deaths' of noble traitors, which represent the preservation of order in the city during a period of civil war. One of the most extended meditations on hanging in the Bourgeois' *Journal* concerns an execution that stands apart by virtue of the fact that it went spectacularly wrong. Captured by force and executed immediately without hearing his defence – 'they were very much afraid he would be rescued, for he was of very great lineage' – Sauvage de Framainville was escorted to the gallows in 1427 accompanied by the Provost of Paris and various others, including Pierre Baillé, the Grand Treasurer of Maine. Baillé, impatient to see justice being done, denied Sauvage the opportunity to make his confession. Hurrying him onto the scaffold, shouting at him, Baillé even went so far as to frogmarch the convict some of the way up the ladder. When the victim answered back, moreover,

> Pierre gave him a great blow with a stick and gave the hangman five or six too, because he was talking to him about his soul's salvation. The hangman, seeing Baillé's ill will, was afraid he might do something worse to him, and so, being frightened, hurried more than he ought to have done and hanged Le Sauvage; but because of his haste the rope broke or came undone and the condemned man fell and broke his back and one leg. Yet he had to climb again, suffering as he was, and was hanged and strangled [*pendu et estranglé*].[2]

Sauvage's execution occurred during an interval of English rule in Paris from 1420 to 1436, and its inclusion in the Bourgeois' *Journal* seems designed to convey the limited benefits of an English presence in the city after a period of civil disorder. The chronicler's point is that justice under the English produces a semblance of order, but without conforming adequately to established judicial conventions such as trial, confession and penal pageantry.[3] For this reason, the account pays more attention to the cruel Baillé and the blundering hangman than to the hanging itself. Be that as it may, the final words of the paragraph (that Sauvage was 'hanged and strangled') hint at one of the often forgotten aspects of the medieval scaffold: that it was a scene of intense pain and violence.

It is not readily apparent, from descriptions of this sort, that hanging was an excruciatingly painful way to die: medieval chroniclers rarely attend to such details. So it may be worth paying attention, in this context, to the historian V.A.C. Gatrell's account of deaths by hanging in eighteenth- and nineteenth-century Britain. People did not die on the scaffold neatly, he maintains: 'Watched by thousands, they urinated, defecated, screamed, kicked, fainted, and choked as they died.'[4] Gatrell's point is that, whatever the affront to our sense of politeness and academic decorum, we owe it to the victims to describe exactly what went on at the scaffold: we should at least *look* at how they died. Rather than treating the scaffold as if it was simply an abstraction, an idea – instead of blurring the memory of what the noose really did to people – we must, he suggests, 'move closer to the choking, pissing, and screaming than taboo, custom, or comfort usually allow'.[5]

Certainly, by all accounts, the condemned is conscious that he is hanging for some time after he has been given the fatal shove: the mouth emits a bloody froth; the body experiences convulsions and discharges urine and faeces.[6] In the Middle Ages, moreover, there was never any attempt to break the victim's neck by dropping him through a trap. The condemned was simply forced to mount a ladder backwards, his hands bound, sometimes tugged up by the executioner with a rope or leather noose around his neck; once the noose had been fixed underneath the horizontal beam of the gallows, the offender would be pushed free of the ladder and perish through slow strangulation.[7] Striking depictions of the process and its aftermath can be seen in the law books mentioned earlier: the miniature in the *Coutumier de Normandie* shows the offender being pulled up a ladder by a rope (illus. 3), while the woodcut from Tengler's *Layenspiegel* shows the use of a ladder and the winding of a rope around the crossbeam (illus. 4). Accounts describing the miraculous survival of hanged men also testify to the dreadful physiological processes that the bodies of executed criminals underwent. One miracle originating in twelfth-century Wales

concerns a certain William Cragh, who was hanged for treason. The legal proceedings initiated to establish the miraculous qualities of Cragh's revival (there would be no marvel in restoring the life of a living man) include the testimony of individuals who had seen the 'dead' corpse, such as the following horrifying reminiscence:

> His whole face was black and in parts bloody or stained with blood. His eyes had come out of their sockets and hung outside the eyelids and the sockets were filled with blood. His mouth, neck, and throat . . . were filled with blood . . . his tongue hung out of his mouth.[8]

These basic physiological and technological 'facts' are undoubtedly powerful; but they only go some of the way towards helping us to understand what people *felt* about the executions they watched and, perhaps as important, what the executed felt as they swung from the rope (which would, at any rate, be almost impossible to document). What we are left with are representations of hanging filtered through layer upon layer of rhetorical camouflage. I don't think Gatrell's suggestion that we move closer to the 'choking, pissing and screaming' of the condemned is especially viable in the case of medieval materials, but this does not mean, for all the camouflage, that the body-in-pain has inevitably and entirely disappeared from view. As we shall see, there were instances when medieval creators attempted to restore the capacity for discourse and language to the bodies of the hanged.

FRANÇOIS VILLON AND THE COMMUNITY OF THE THRESHOLD

The writings of the renegade fifteenth-century poet François Villon are a good example of the ways in which hanging, in the Middle Ages, was a focus for symbolic, as well as penal, work. Hanging crops up a number of times in Villon's oeuvre, as one might expect from a man who was often himself embroiled in criminal acts that risked punishment by hanging. Most significantly, the *Ballade des pendus*, Villon's most famous short poem, is explicitly concerned with hanging.[9]

Until recently criticism of Villon has tended to fall into one of two camps.[10] On the one hand, many commentators have implied that the poet's meditations on hanging are autobiographical. Indeed, according to one strand of criticism, the facts of which have not been verified conclusively, Villon wrote the *Ballade des pendus* in the hours immediately prior to his own execution by hanging (an event from which he was apparently

reprieved).[11] Such interpretations place emphasis on the identification between the poet and his internal narrators: commenting on the poet's use of the word *povre* to describe the hanged men in the opening stanza of this poem, paralleling the frequent description of himself as 'le povre Villon', David Fein concludes: 'How can we not read Villon's signature here?'[12] The first printed edition of Villon's poetry, published in 1489, calls the *Ballade* an 'Epitaphe dudit Villon' (illus. 5 and 6). On the other hand, critics have pointed to the dismal realism of the *Ballade des pendus* and its relationship with literature of the macabre; readings in this vein concentrate on the poem's 'death-facing' affects, its 'simple clarity and truths'.[13] But is either reading especially valid, the autobiographical or the realist?

Certainly the poem begins by pleading identification with the victims of the gallows (ll. 1–4):

Freres humains qui aprés nous vivez,	You human brothers, who after us still live,
N'ayez les cueurs contre nous endurciz,	Don't let your hearts be hardened toward us,
Car se pitié de nous povres avez,	For if you have pity for us poor men,
Dieu en avra plus tost de vous mercis.	The sooner will God have mercy upon you.

The five or six persons 'cy atachés' (l. 5; 'strung up here') request our association with their fraternity: they plead common humanity. They also beg for pity. In the next stanza, guessing that we might be offended by the suggestion that we are the brothers of those 'occis par Justice' (ll. 12–13; 'killed by Justice'), the speakers retort 'pas n'en devez avoir desdain' (ll. 11–12; 'you must not take offence at that'). The point of eliciting empathetic identification is not simply, however, to make us feel rage at the terrible fate of the executed on the gallows. The tone of the poem is also penitential, so that the final refrain of each stanza reads 'priez Dieu que tous nous vueille absouldre' (l. 10; 'pray to God He may absolve us all'). Like the trope of *memento mori* in the legend of the Three Living and the Three Dead (a popular genre of medieval macabre representation, which announces that 'you will be what we are; we are what you will be'), the poem functions as a grim warning to the living to amend their lives in order to save their souls.[14] You are not so different from us, the *pendus* declare, 'vous sçavez que tous hommes n'ont pas le sens rassis' (ll. 13–14; 'you know that not all men are truly sensible'). Their point is that hell is not just the fate of the condemned on the gallows but of everyone who

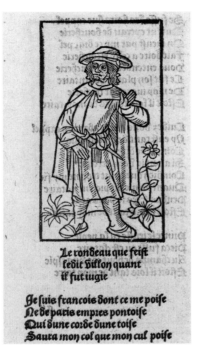

5 'Portrait of Villon', woodcut illustration to the first edition of Villon's *Le Grant Testament et le Petit, Son Codicille, Le Jargon et ses Balades* (Paris: Pierre Levet, 1489). Bibliothèque Nationale de France, Paris.

6 'Hanged criminals', woodcut illustration to the first edition of Villon's *Le Grant Testament et le Petit, Son Codicille, Le Jargon et ses Balades* (Paris: Pierre Levet, 1489). Bibliothèque Nationale de France, Paris.

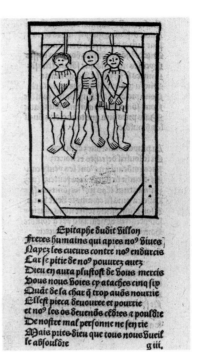

remains impenitent. So empathy is not simply evoked, like Gatrell, for the sake of the already-hanged. It is evoked for the sake of us – the readers – who are still alive but who are, at the same time, metaphorically dead to the world: those without 'sens'. As a result, there is a certain amount of pronominal confusion in the use of the word 'nous' in the poem. In the second stanza it is not exactly clear whether this refers to 'we' the hanged or 'we' collectively: 'Excusez nous . . . nous preservant de l'infernale fouldre' (ll. 15, 18; 'Make intercession . . . preserving us from the infernal fire'), the speaker declares. Whether or not we *ourselves* are meant to understand at this point that 'nous sommes mors' (l. 19; 'we are dead men'), our own preservation from hell seems to motivate the final stanza (ll. 31–3):

Prince *Jhesus, qui sur tous a maistrie,*	Prince Jesus, you who are the lord of all,
Gardez qu'enfer de nous n'ait seigneurie.	Keep Hell from having power over us.
A luy n'ayons que faire ne que souldre!	With it let's have no dealings and no debts!

The initial conceit is that we are to identify with the *pendus*, yet, in the third stanza, an alternative message hits home: 'Ne soiez donc de nostre confrairie' (l. 29; 'Do not, therefore, be of our brotherhood'). Identification with a hardened criminal is not, after all, what we should ultimately seek; rather it's our *own* salvation that's hanging in the balance.

Although in this way the poem shifts the emphasis from 'them' to 'us', the criminals swinging from the rope are closely connected to readers through the formation of a penitential community, over which Jesus holds dominion. The radical disjunction that Foucault perceives between ruler and criminal in *Discipline and Punish* is encapsulated in the image of Jesus, the 'Prince', having the capacity for mercy over the broad fellowship of sinners who find themselves in this ambiguous state. Readers and hanged are bonded together as beings on the cusp between life and death, heaven and hell. The suspension of the hanged is a motif that facilitates the construction of a new ideological message: that we should take care of our own souls rather than feeling sorry for the hanged. At the same time, our own potential status as victims in hell – our own predicament as 'about-to-be-punished' souls – reconnects us with the threshold status of the bodies in pain swinging from the rope. In this way, even as the poem is in one sense individualistic, warning us to save our own skins rather than worrying about the fates of others more unfortunate than ourselves, in another sense it promotes an image of community, a community of beings located within an atemporal, borderline space of betwixt and between. While manipulations of physical pain such as torture bring about a destruction of language, as Elaine Scarry has powerfully shown in *The Body in Pain*, products of the imagination are also capable of directing one's attention to the eradication of pain in social existence.[15] Likewise, Villon's poem is ethically committed to pain's overall cessation, even as it communicates its penitential warning for the sake of the living reader. By commanding identification between readers and the experiences of criminal bodies in pain, the *Ballade* solicits deliverance for all from the sufferings of hell.

The construction of this community of the threshold also provides an opportunity, potentially, for readers from times and places outside the immediate context in which the poem was written to bypass perceptions of historical alterity and feel the vibration or intensity of the imagery, 'touching', affectively, bodies supposedly located in the past. This perhaps explains the enduring fascination of the poem for European poets over the last 500 years, who have produced a whole crop of analogues, interpretations and translations.[16] Indeed, as I argue below, Villon's *Ballade* and its language of hanging may have exerted an influence, albeit indirectly, on the imagery contained in a popular twentieth-century song lyric.

There could be a link between this fascination and the imagery of suspension and bodily process around which the poem turns. Perhaps the most striking images in the poem are Villon's macabre depictions of decaying bodies. A fifteenth-century woodcut illustrates the first edition of the poem with a stark, almost ideographical representation of three bodies hanging from the gallows in various states of undress (illus. 6). Unlike the portrait of Villon on the opposite page (illus. 5), the image contains no shading or attempt to individualize. It is questionable whether, in its comic-book simplicity, the woodcut enables us to 'stare death in the face' or to identify with the pain of the hanged. Nonetheless, it is strangely disturbing too, perhaps by virtue of its emblematic, almost totemic status.[17] Likewise, the descriptions in the third stanza of the poem itself are unquestionably powerful (ll. 21–4):

La pluye nous a debuez et lavez	The rain has soaked us and has washed us clean
Et le soulail deceschez et noirciz.	And the sun dried us up and turned us black.
Pies, corbeaux nous ont les yeulx cavez	Magpies and crows have hollowed out our eyes
Et araché la barbe et les sourcilz.	And plucked away our beards and eyebrows too.

Descriptions of blackened corpses and hollowed-out eyes do not make for pleasant thoughts; undoubtedly they betray some of the horror of their imagined referents. Yet the imagery is also metaphorical in tone, relating to the penitential themes of the poem as a whole. The washing action of the rain, parallel to the stripping away of the flesh that reveals the bones in stanza one (ll. 6–8), evokes, like purgatorial fire, processes of cleansing and purification;[18] the phrase 'debuez et lavez' (l. 21) conjures up an image of the hanged men being laundered and hung out to dry.[19] The allusions to purgation are entirely appropriate in the context of hanging: the bodies suspended between heaven and earth mirror the souls caught between salvation and damnation. This imagery of suspension, at the same time, connects readers with experiences that all bodies confront. Caught themselves between life and death, pleasure and pain, human beings – as embodied beings – all have dealings with threshold states, which explains, I think, some of the poem's long-term appeal.

It is possible to put Villon's poem in an expressly medieval iconographic context, of course, and I am not suggesting that affective connections across the chasm of time somehow nullify a focus on specifics. The allusions to infernal torment, for instance, correspond with an illumination

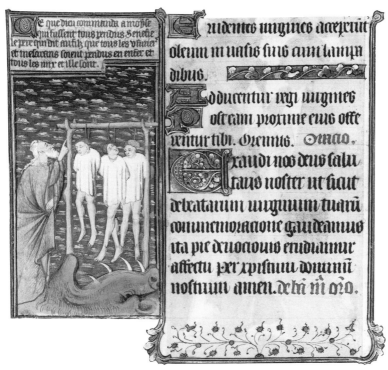

7 'Hanging of usurers, unbelievers and Jews in hell', miniature in the Rohan Hours, early 15th century, French. Bibliothèque Nationale de France, Paris.

in the Rohan Hours depicting the story of God the Father announcing to the Son (not included in the image) that usurers, unbelievers and Jews will be 'hanged in hell'. The three men, dressed only in white smocks, hang suspended from the gallows over the gaping jaws of Leviathan (illus. 7). The hollowing out of the eyes and the removal of beards and eyebrows in Villon's poem may also gesture toward the loss of self that was associated, in the Middle Ages, with acts of spiritual transcendence. Finally, the pecking of the birds recalls certain images of the suicide of Judas, such as a twelfth-century miniature from the 'Hildegard Codex' (illus. 8). Whereas Judas's body was traditionally represented dangling from a tree (illus. 9), in this depiction there is nothing to remind us of self-murder: the apostle's body hangs from a gallows rather than a tree, while a trio of fearsome ravens prey on his flesh; the corresponding scene above depicts Pilate examining Christ, thereby pointing up the judicial character of the scene below. Sanctioned by the arguments of certain medieval scholastics that Judas, in dying as he did, received his just deserts, motifs of this sort

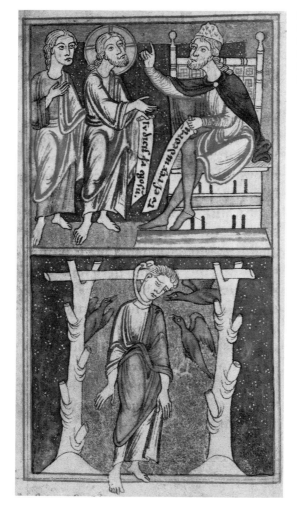

8 'Christ before Pilate; Suicide of Judas', miniature in the 'Hildegard Codex', 12th century, German. Bayerische Staatsbibliothek, Munich.

transform suicide into an act of punishment.[20] (This also makes sense in a culture in which self-murdering individuals were themselves subjected to post-mortem sanctions in certain times and places.)[21] In the *Ballade des pendus*, the affinity between the opprobrium of Judas and secular execution rituals is similarly clear. We've brought this upon ourselves, the *pendus* imply, 'Do not therefore be of our brotherhood' (l. 29). It would be spiritual suicide to ignore our words.

What I am suggesting, then, is that the poem might have had particular associations for medieval reading communities – the suicide of Judas,

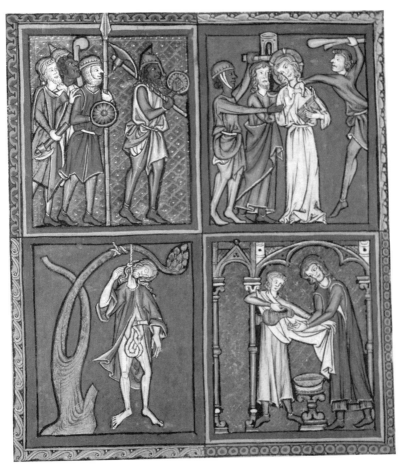

9 'Betrayal and Arrest of Christ; suicide of Judas; Pilate washing his hands', miniature in a combined Psalter and Book of Hours, late 13th century, northeast France (probably Arras). Pierpont Morgan Library, New York.

images of infernal punishment, Christian penitential themes – but that this does not preclude the existence of what might be understood as 'communal', if indeterminate and contingent, points of connection too, between the bodies of readers and the bodies represented in the text. Rather than simply seeking the 'truth' of the poem in medieval specificity, we should, I think, accommodate both dissonance and resonance in our analyses of the poem's mechanics. Accounting for the implicated and embodied nature of our encounters with represented bodies of the past is, I submit, an important historical project.

Elsewhere in Villon's poetry, images of hanging betray a message that, like the *Ballade des pendus*, shifts between forcing identification with the hanged and maintaining communities in the land of the living. While the *Ballades en jargon* clearly impart none of the spiritual tone of the *Ballade des pendus*, all are haunted by the spectres of hanging: beware of the 'haure du marieulx' ('breeze of the hangman') is the lesson of one poem, 'Eschec eschec pour le fardis' ('Watch out, watch out for the rope's end!') the refrain of another.[22] The first poem in the series opens with an image reminiscent of the *Ballade des pendus* (I, ll. 1–6):

A parouart la grant mathegaudie	At Paris, the great lookout point
Ou accollez sont duppez et noirciz	Where fools are strung up and blackened,
Et par les anges suivans la paillardie	And by the 'angels' on the track of crime
Sont greffiz et print cinq ou six	Are rounded up and taken, five or six –
La sont bleffleurs au plus hault bout assis	There are crooks installed in the highest seats
Pour le evaige et bien hault mis au vent.	Where they're exposed to rain and upper winds.

The message here is not that sinners repent, however, but that hardened criminals perfect their craft. 'Plantes aux hurmes voz picons' (I, l. 21; 'set your pick-locks to one side'), they are advised; 'babignes tousjours aux ys des sires pour les desbouses' (I, ll. 28–9; 'always befuddle them, the idiots, to relieve them of their cash').

The French critic Georges Bataille doubts whether we can ever really see death; practically speaking, it is beyond reach of human vision.[23] Likewise, Villon's narratives of hanging are not so much about death as about the spaces *between* life and death, where communities are constructed, temporarily, through shared experiences of between-ness. In both image and text, the realism of the rope's end is not expressed so much as a sense of suspended animation (entirely consistent with the countenance of the hanged: sus*pended*, 'pendus'). Death is arrested: the dead *speak*, after all. In the *Ballade des pendus*, the hanged lament 'Jamais nul temps nous ne sommes assis' (l. 25; 'Never at any time are we at rest'). The woodcut depicting Villon's poem (illus. 6) is similarly lively, the eyes of the hanged represented by two symmetrically placed dots seemingly staring out toward the viewer. Fantasies of the revenant dead pervaded the folklore of the gallows in the later Middle Ages: the custom of leaving the malefactor hanging for weeks or even months after execution testifies to

the belief that the dead body continued to suffer the humiliations exacted at the original penal spectacle.[24] Motifs of restlessness and suspension are also echoed in certain representations of the suicide of Judas: it is worth noting how imagery of the death of Judas, from the twelfth century, often focused on Judas's status as a figure of *desperatio* or despair, thereby betraying a preoccupation with the sinner's restless inner state.[25] Captured in the transitional moments between life and death, some images even show Judas as a hanging figure clutching the rope with his left hand, as if he is experiencing a last-minute change of heart. As a fifteenth-century canon of Passau Cathedral quipped in a sermon on the Passion, 'Perhaps Judas changed his mind and at this last minute tried to free himself from the rope?'[26]

Depictions conveying psychological states of 'betwixt and between' thus connect with images that attempt to convey, in narrative terms, the intervals where life and death may be said to meet. These intermediate zones possibly recall what Gatrell terms 'strategies of defence', attempts to offset the fear of death with anaesthetizing imagery and motifs of suspension.[27] At the same time, they also permit the communication of a recuperative message: one that attempts to restore the power of signification and existence to those to whom such power is denied. The hanged are described or describe themselves as weathered bodies, unable to escape their suspended fates, yet their symbolic value and capacity for speech allow them, within the fantasy of the poem, to escape the condition of silent oblivion. These are bodies depicted as lives within death, but they are also returned to a certain kind of political existence as subjects in the world (at least within the imaginary space of literature).

Another way in which Villon achieves this reparative message is through humour. In one short verse, described in the first printed edition as 'Le rondeau que feist ledit Villon quant il fut iugie' and illustrated by a portrait (illus. 5), he declares:

Je suis François, dont il me poise,
Né de Paris emprés Pontoise,
Et de la corde d'une toise
Savra mon col que mon cul poise.

I am François and I'm glum.
Born near Pontoise in the Paris
 slum.
Now, through a noose, my neck
 will come
To know the weight of my hang-
 ing bum.[28]

This isn't simply a joke on Villon's part, of course: his point is that only at the moment of death will he understand the true weight of his sinfulness. As such, like the *Ballade des pendus*, the verse possesses penitential

significance. At the same time, the humour of these lines helps to explain why the speakers in the *Ballade* plead with the reader 'De nostre mal personne ne s'en rie' (l. 9; 'Let no one make sport of our misery'); and why they later announce that 'Hommes, ycy n'a point de mocquerie' (l. 34; 'Humans, there's no cause here for mockery').[29] These lines recognize the fact that, confronted with the spectacle of rotting flesh and dismembered body parts, people sometimes laugh as part of their defence against fear; but that the predicament represented in the poem is actually deeply serious, because it implicates the readers in a community of penance.

THE GENTLE ART OF HANGING ENEMIES

Mockery is clearly at issue in another genre of penal iconography centred on images of hanging: the defamatory portrait. *Pitture infamanti*, rooted in the ancient doctrines of *fama* and *infamia* in Roman law, were commonly painted on the walls of principal centres of justice in north Italian cities from the thirteenth century to the sixteenth.[30] Their main function was to work a sort of performative insult aimed at humiliating traitors and debtors in contempt of court. The victim of a *pittura infamante* was rarely 'killed'; rather, he was shown in a variety of degrading poses, usually hanged upside down by the foot. Italian defamatory portraits are known only through descriptions and preparatory drawings; there are no surviving examples of commissions painted in public contexts. Nonetheless, they undoubtedly draw comparison with the iconography of the 'hanged man' in tarot cards. After all, the earliest tarot packs were produced in northern Italy about 1440, perhaps the most enduring monument to the prevalence of defaming images in this region (illus. 10).[31]

Class distinctions played a crucial role in the appreciation of *pitture infamanti*. Those pictured were usually males from the upper classes (women were never depicted), that is to say, men who would have something to lose by being shamed. The insult was thus effected, first and foremost, by associating men whose status would normally have permitted them the privilege of execution by decapitation with the humiliation of punishment by hanging. The only saintly associations with hanging involved miracle stories in which saints such as Jerome rescue men from the gallows who have been unjustly condemned (illus. 11), and it is very unusual indeed to find representations of saints themselves being hanged. A rare exception, depicting the hanging of Sts Gorgonius and Dorotheus, appears in the pages of the twelfth-century Stuttgart Passionary (illus. 12).[32] In religious contexts, hanging was reserved for the most shameful of deaths: the suicide of Judas. Thus, *pitture infamanti* worked by enacting

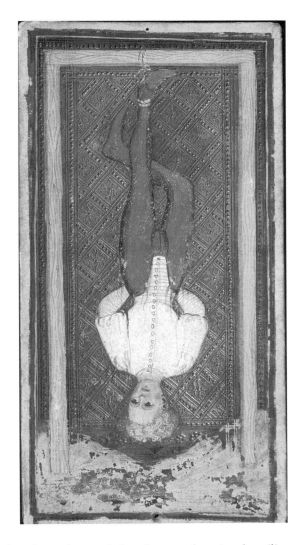

10 'The Hanged Man', Visconti–Sforza *tarocchi* (tarot) card, *c.* 1445. Pierpont Morgan Library, New York.

visually a number of ready-made associations between hanging, humility and social shame, in order to denigrate victims who were generally well heeled. But what was the particular meaning behind such images? What, especially, was the significance of the motif of being hanged upside down?

At the most basic level, the representation of upside-down hanging conveys the topos of *mundus inversus* (world upside down): motifs of symbolic inversion are one of the central principles of comedy. Anthropologists frequently understand inversion as a means of *Ventilsitten*, of 'letting off

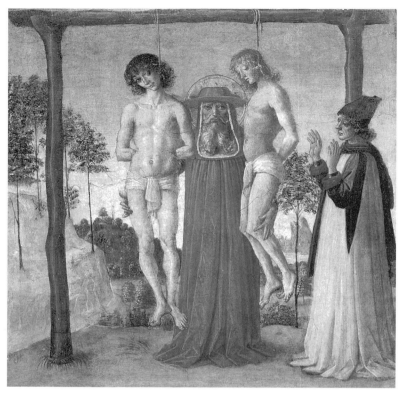

11 Pietro Perugino, *St Jerome Saves Two Hanged Men*, late 15th century, painted predella panel. Musée du Louvre, Paris.

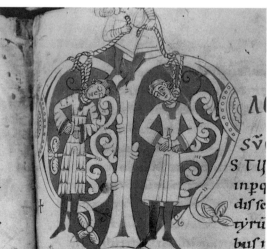

12 'Hanging of Gorgonius and Dorotheus', miniature in Stuttgart Passionary, *c.* 1110–20, German. Württembergische Landesbibliothek, Stuttgart.

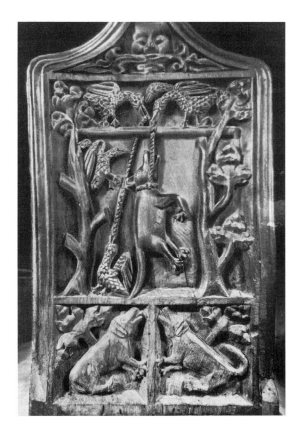

13 'Geese hang Reynard the Fox', 15th century, carved wooden bench-end. St Michael's church, Brent Knoll, Somerset.

steam'. They suggest that, by allowing us to engage in reversible operations, symbolic inversions induce a fundamental form of play: they create a space in which vicariously to try out new concepts, juggle new possibilities, test new roles.[33] Medieval depictions of Reynard the Fox hanged from the gallows by a collection of geese, such as that carved on the late fifteenth- or early sixteenth-century bench-end at Brent Knoll in Somerset (illus. 13), evince this playful, comedic aspect, based on the temporary disruption of the natural order. According to the legend, Reynard was called up for judgement by the king for crimes including rape and murder, and condemned to be hanged by the court: in the romance text the fox is eventually set free, on the condition that he sets out on a pilgrimage, whereas the bench end and analogous carvings show him being strung up by the neck.[34]

In other geographical contexts, metaphors of reversal could also take on more specific meanings. In late medieval Italy, for example, it is possible that *pitture infamanti* entered into a dialogue with another genre of

full-length portraiture popular in secular buildings at this time: murals depicting *uomini famosi* (famous men) or *uomini illustri* (illustrious men).[35] These paintings, representing a variety of illustrious personalities drawn from history, were typically portrayed on the walls of rooms in both private palaces and civic buildings. The characters depicted were generally drawn from the Old Testament and the early Christian empire, though, with the growth of humanism, Roman heroes, too, became popular subjects. In Renaissance Venice and Florence, moreover, portraits of this sort were increasingly employed as a form of visual genealogy emphasizing pride in the antiquity and eminence of one's lineage. Giorgio Vasari describes how, in Venice,

> in many gentlemen's houses one may see their fathers and grand-fathers, up to the fourth generation . . . a fashion which has ever been truly worthy of the greatest praise, and existed even among the ancients. Who does not feel infinite pleasure and contentment, to say nothing of the honour and adornment they confer, at seeing the images of his ancestors, particularly if they have been famous and illustrious [*chiari ed illustri*] for their part in governing their republics, for noble deeds performed in peace or in war, or for learning or any other notable and distinguished talent?[36]

It may be that the shame of being painted hanged upside down resulted in part from the wider frame of reference associated with having one's family members portrayed as *uomini illustri*. This is a tentative reading: a more exhaustive iconographic survey connecting the chronological and geographical dispersal of both genres would be required to make a convincing case for their discursive interaction.[37] Yet there are hints that a convergence of this sort was possible. After all, perhaps the most renowned painter of *pitture infamanti*, Andrea del Castagno, also painted one of the most significant surviving groups of fifteenth-century *uomini famosi* (illus. 14). This implies that, going beyond anthropological notions of play and subversion, an understanding of the particular circumstances in which motifs of reversal evolved would be helpful: the iconography of defamation may have worked, in part, by inverting expectations aroused by perceptions of imagery depicting 'famous men'.

A focus on specifics draws attention to the multiple realities and messages potentially conveyed by the various 'arts of hanging' described in this chapter. To concentrate on the particular contexts for the reception of hanging iconography is not simply to have recourse to notions of historical alterity; it may be possible to discover partial connections between different realities and different messages, for different people situated in

14 Andrea del Castagno, *Farinata degli Uberti*, fresco (transferred), *c.* 1450, from the Villa Carducci *uomini famosi* cycle. Galleria degli Uffizi, Florence.

different time frames. Because an image possesses a certain frame of reference for a modern individual, this does not necessarily invalidate claims that the image was able to signify in this way for medieval respondents as well. At the same time, uncovering a context for hanging iconography that has little resonance for most modern viewers, such as the discourse of *uomini famosi*, also helps to bring into focus the situated and shifting qualities of vision as an effect of discourse.

The Italian *pitture infamanti* are well documented. What is less well known is the popularity of the genre elsewhere in Europe, especially in the fifteenth century. The circulation of the motif of hanging as a communicator of shame and infamy in different regions of medieval Europe demonstrates that a focus on specifics yields further areas of symbolic complexity; at the same time there are crucial continuities between one manifestation and another, continuities that may even extend into modern times. In France, the Bourgeois of Paris describes

how, in the first week of May 1438, three pieces of cloth were hung at each of Paris's four gates:

> Very unpleasant pictures were very well painted on these pieces of cloth: each one showed a knight, one of the great English lords, hanging by his feet on a gallows, his spurs on, completely armed except for his head, at each side a devil binding him with chains and at the bottom of the picture two foul, ugly crows, made to look as if they were picking out his eyes.[38]

Here, again, we see the humiliating association with Villon's pecking crows; on each picture, moreover, was an inscription naming and shaming the malefactor: William de la Pole, Robert, Earl of Willoughby, and Thomas Blont. Similarly, a variation of the English chronicle known as *The Brut* records an incident that took place during the Duke of Burgundy's siege of English-controlled Calais in 1436:

> And they of Brigges [Bruges] made payntet clothes, howe the Flemmynges were att seege att Caleis, and howe thai wann the toune; and hanget out Englisshe men by the helis out at lopes [from branches] . . . all in dispite and hoker [scorn] of Englissh men.[39]

Nor was the Hundred Years War the only context in which the defamatory picture surfaced in France. In 1477 King Louis XI attempted to punish the traitor Jean de Chalon, Prince of Orange, by having him painted hanged on a gibbet by his left foot, his bowels protruding from his stomach (another association with Judas: Acts 1: 18 describes how the apostle, falling headlong, 'burst asunder in the midst, and all his bowels gushed out'). The prince's head was enveloped in flames, and a devil was depicted tearing out his tongue with an iron wrench; six versions of the portrait were distributed to various localities.[40] In the late fifteenth and early sixteenth centuries, the practice had been adopted in the British Isles. The chronicle of Edward Halle (printed in 1550) describes what the author terms the custom of 'baffling', before the Battle of Flodden in 1513:

> The Earle [of Surrey] bad the Heraulde for to saye to his maister, that yf he for his parte kept not hys appoyntmente, then he was content, that the Scottes should Baffull hym, which is a great reproche amonge the Scottes, and is used when a man is openly perjured, and then they make of hym an Image paynted reversed, with hys heles upwarde, with his name, wonderynge cryenge and blowing out of

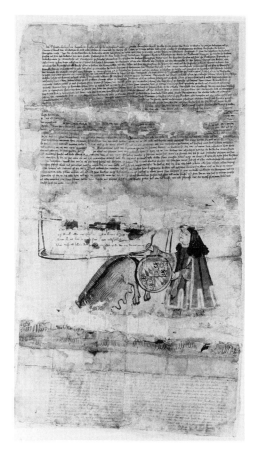

15 *Scheltbrief* ('Letter of Defamation'), Johann von Nassau against Johann von Baÿern-Holland, 1420, German. Hessisches Hauptstaatsarchiv, Wiesbaden.

hym with hornes, in the moost dispitefull maner they can. In toke that he is worthy to be exiled the compaignie of all good Creatures.[41]

Here, as with the Italian precursors, metaphors of inversion remain crucial. The Flodden example also bears witness to the dehumanizing intentions of the genre, the notion that the 'baffled' be expelled from the fellowship of 'good creatures', exiled to a space beyond normal political existence.[42]

Metaphors of topsy-turvydom are also crucial to the functioning of the German *Schandbilder*, the most obvious northern equivalent to the Italian defaming picture. These images, drawn on sheets of paper or parchment, were accompanied by insulting letters (known as *Scheltbriefe*) and posted on the door of the victim's house or in public places to the embarrassment of the person thus depicted. *Schandbilder* differ from

16 *Scheltbrief* ('Letter of Defamation'), Johann of Löwenstein against Ludwig of Hesse, 2 November 1438, German. Institut für Stadtgeschichte, Frankfurt am Main.

pitture infamanti in that they were disseminated by private individuals rather than state-sponsored institutions (privately instigated defamatory pictures in Italy were often banned by law).[43] Nevertheless, their mode of operation was much the same: they pictured the offending delinquent, usually a debtor, in shameful poses in order to effect a form of 'out-of-court' penalty with the hope of prompting him to make reparation.

Otto Hupp's exhaustive survey of the genre catalogues 39 surviving examples of *Schandbilder* and *Scheltbriefe* produced between 1379 and 1593 (fifteen before 1500); research more recently has uncovered up to 100 defamatory images in this period, mainly from north Germany.[44] The most common mode of defamation entailed representing the malefactor imprinting the anus of a female animal such as a sow or ass or bitch with his family seal, thereby smearing it with dung (illus. 15). (The anti-Semitic features of the motif are considered in what follows; its sodomitical valences are discussed in chapter Three.) The offender, however, was also commonly depicted hanged upside down, legs dangling from the rope. The *Scheltbrief* produced by Johann of Löwenstein against Earl Ludwig of Hesse in 1438 (illus. 16) depicts the debtor clothed in fashionable regalia, his heraldic arms suspended upside down beside him and his feet pecked by ravens. (This accentuates the symbolic reversal, since conventionally it was the eyes that were pecked out, as in Villon's *Ballade des pendus*.) The accompanying inscription relates how the picture was instigated as a result of an argument over a bowl of soup at the earl's castle. The letter also makes a scatological allusion to Judas, suggesting that the grievance might be a dispute over money. Johann declares: 'I submit that the wind that came from Judas when he hanged himself has hit him on the ears and eyes so that he doesn't see or hear his honour.' The practical purpose of the image is clear:

> This is why we should let his shameful picture hang here with his coat of arms, until he has given me compensation recognized by respectable people for those unwarranted things that he and his people did in the aforementioned manner, and ask all those who seek charity, who see him painted hanging, that they let him hang.[45]

The *Schandbild* applied by Saÿdro and Isaac Straubinger, two Regensburg Jews, against Hans Judmann in 1490 (illus. 17) likewise represents the miscreant hanged by the feet, dressed in knightly regalia, with a devil beating him round the head with a club.

It is important to stress that most of the aforementioned examples do not make allusions to conventional acts of capital punishment, akin to Villon's bodies on the scaffold. Certainly German *Schandbilder* occasionally

17 *Schandbild* ('defaming picture'), Saÿdro and Isaac Straubinger against Hans Judmann, 1490, German. A 17th-century copy in the Bayerisches Hauptstaatsarchiv, Munich.

depict the wrongdoers in question hanged in the traditional manner, broken on the wheel or even spiked on stakes (see illus. 18), but images of upside-down hanging were not designed to parallel the usual practices of the scaffold. Rather, they drew comparison with an analogous form of punishment that *was* occasionally employed in actuality: the so-called Jewish execution, in which a Jewish offender would be hanged alive by the feet (sometimes one foot alone) and a pair of angry dogs similarly strung up beside him.[46] The ritual was by no means confined to medieval Germany and there are instances documented as far away as Spain.[47] Nonetheless, the only extant legal formularies of the practice date to the end of the Middle Ages or later. The first definition of Jewish execution is provided in Ulrich Tengler's early sixteenth-century *Layenspiegel*, which interpreted it as an act of penance for someone who stubbornly upholds 'his Jewish heresy',[48] while one of the most detailed descriptions appears in a late seventeenth- or early eighteenth-century statute book from the Swiss canton of Glarus (which may correspond to earlier attitudes). The Swiss formulary reads as follows:

> He is to be hanged as a thief, by the feet with a rope or chains, on a specially erected gallows, between two raging or snarling dogs, betwixt heaven and earth, so high that grass and herb may grow

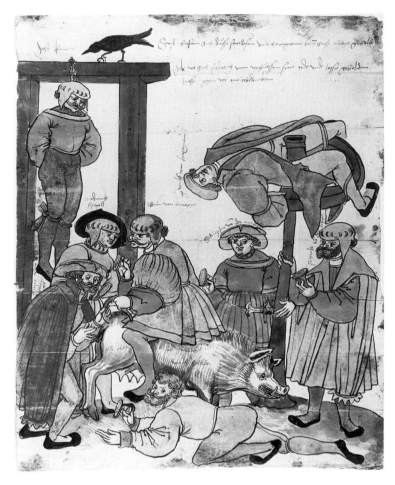

18 *Schmähbrief* ('defamatory letter'), Brüder Gladbeck against Friedrich von Niehausen and his guarantors, *c.* 1525–6, German. Hessisches Staatsarchiv, Marburg.

beneath him; thus he shall be committed to the dogs and the birds and the air, so that he be estranged from the earth; and you, judge, people and guards, assembled about the gallows, who watch over him, until he suffer death upon the gallows.[49]

This conveys an important aspect of hanging symbolism, the motif of suspense – of death delayed – already encountered in the discussion of Villon. The fate of the punished Jew quite literally hangs 'betwixt heaven and earth'.[50]

One of the earliest detailed records of the practice, in the diary of Andrea Gattaro of Padua, delegate from Venice to the Council of Basle, describes

how, in 1434, two German Jews were arrested as thieves, tortured and encouraged to turn Christian. Of the two, one converted and was beheaded; the other, 'condemned to be hanged by the feet with a dog beside him', was drawn up on the gallows by a rope, where he remained for a time until, realizing that 'his prophets had availed him nothing', he decided to call upon the Virgin Mary for help. At this point, the dogs' barking abated and at once he cried to the monk standing below: 'I wish to become a Christian!'[51] Like the iconography of defamation, the ritual described here participates in symbolic reversal: the upside-down hanging presents an affront to the Jew's honour.[52] At the same time, in common with other stories representing Jewish conversion, the narrative perpetuates anti-Semitic fantasies about the stubbornness of Jews: the malefactor is given time to contemplate the terrifying fate that awaits him should he not convert. (In the case just described, the hanged Jew was eventually spared.) Significantly, too, the inversion on the gallows assimilated the Jew with another form of symbolic reversal: the disjunction between man and beast. According to Esther Cohen, upside-down hanging was a penalty commonly reserved for murderous animals, especially pigs (with whom the Jews were associated, by virtue of the prohibitions against eating pork in Leviticus).[53] Thus, in the case just cited, the thieves were 'urged repeatedly to turn Christian, so as not to die like beasts'.[54] The implication is that the Jewish victim finds himself, like Judas, on a threshold, asked to choose between accepting a legitimate social death as a Christian and an ignoble, animalistic end.

A rare visual depiction of the Jewish execution appears in an anonymous broadsheet narrating the alleged desecration of an image of the Virgin by Jews in the Cistercian monastery of Cambron, in the province of Hainaut (now in Belgium), in the early fourteenth century. The pamphlet, printed in Strasbourg in the early sixteenth century, was illustrated with woodcuts depicting, among other things, the ordeal of the ringleader William: tortured in order to obtain confession and tried by combat, the offender is subsequently dragged to the gallows and punished by being hanged upside down, over a fire, next to two dogs (illus. 19); an earlier image in the sequence shows how the image of Mary stabbed by William miraculously bled.[55] The woodcuts bear a striking resemblance to a painting in a chapel near the city of Mons, similar in date, which again identifies the punished iconoclast as a Jew.[56] The motif of the fire (a reference to the flames of hell and the most severe mode of penance according to Church law) conveys the Jew's suspension between spiritual salvation and eternal damnation; like *Schandbilder*, the woodcut also uses the convention of the pecking raven in order to accentuate the victim's reversal. The motif of between-ness enshrined in later legal definitions of Jewish execution is also apparent in the text that accompanies

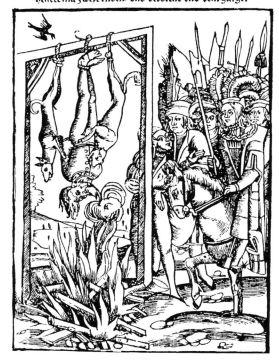

Wie der Graue den Juden ließ er,
Henckt mit zweyẽ rüden, vnd verbrent vnd dem galgẽ.

19 'Jewish execution', wood-
cut from *Enderung vnd
Schmach der Bildung Mariae
von den Juden* ('The
Desecration and Shame of
the Picture of Mary by the
Jews') (Strasbourg: Matthias
Hupfuff, *c.* 1512–15).

the image: the Jew, according to the poem, 'should be put to death, as well as
alienated from earth, by hanging upside-down with two enormous dogs
beside him'. The text continues by describing the punishment as a 'penance'
and an example of how 'all Jews are outlawed who commit such abominable
outrage and shame our religion day after day'.[57]

There are clear parallels between the *Schandbilder* in illus. 16, 17 and the
iconography of Jewish executions. Like the punishment of the suicide after
death, the aim of *Schandbilder* was to shame those against whom judge-
ment in a real court of law was frustratingly deferred; like the execution of
the Jewish malefactor, the penalty of upside-down hanging was designed
to punish those whose fate and social status were believed to be literally up
in the air. Of course, there is a crucial difference between *Schandbilder* and
Jewish executions: one penalty was inflicted virtually, through representa-
tion, whereas there is evidence that the other was carried out in actuality.
But both relied on a logic of suspension, of things hanging in the balance.
This raises the possibility that *Schandbilder* and anti-Semitic frameworks

interacted on some level. It could be the case, for example, that the makers of defaming pictures employed a vocabulary of anti-Semitism and animalization directly, in the service of representations aimed at denigrating non-Jews. This assumes, of course, that Jewish executions provided an iconographic 'source' for defamatory pictures: it is not possible to establish such a clear genealogy. At the same time, it is feasible that visualizations and actual performances of Jewish and animal executions provided a relevant *interpretative* framework for Germanic *Schandbilder*; a network of associations between denigrated Jewishness and upside-down hanging may have increased the humiliation of the person thus depicted. In this way, it is possible that the horizon of expectations provoked by images of upside-down hanging in medieval Germany differed in certain respects from that aroused by *pitture infamanti*. I would like to suggest that viewers of German *Schandbilder* derived some of their understanding of the image from constructions of the archetypal, punished Jew.[58]

The anti-Semitic backdrop for *Schandbilder* is also revealed by comparing *Scheltbriefe* depicting debtors stamping their seals on the rectum of a female animal (illus. 15 and 18) with pictures representing Jews sucking at the teats of a sow and eating its excrement. The latter, popular in German-speaking territories from the thirteenth century, constitute an iconographic genre known as the *Judensau* (illus. 20).[59] As in the Jewish execution, where the victim was aligned with a pair of barking dogs, the Jews in the *Judensau* image, depicted as suckling piglets, are characterized as being alien, not human 'like us'. We see, in this way, the deployment of an overall language of animalization and scatological obscenity, intended, on the one hand, to

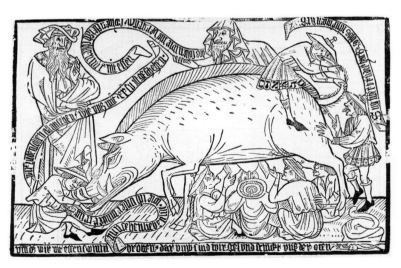

20 *Judensau*, woodcut, printed *c*. 1700 from a 15th-century German block. Historisches Museum, Frankfurt am Main.

ruin the reputation of an upstanding member of the non-Jewish community and, on the other, to associate Jews with the animal they supposedly most abhor (see illus. 20, where one of the captions to the *Judensau* image reads 'This is why we do not eat roast pork').[60]

What looks like a common iconography of defamation, then, has the capacity to communicate a variety of different messages: historical and regional peculiarities colour the narrative. The most obvious discrepancy between German and Italian defaming portraiture concerns its institutional status. In Italy, *pitture infamanti* were generally the tools of authorities; in all instances, the individuals depicted were wealthy men, frequently nobles, concerned with issues such as status and lineage. The 'victims' of German *Schandbilder* were similarly well off, but, unlike their Italian counterparts, they were involved in disputes with private individuals. But it seems likely that the social tensions that arose from monetary debt in areas of medieval Germany were regulated, in part, through an imagery of infamy with anti-Semitic undertones. These parallels between defaming portraits and images depicting Jewish executions (see illus. 19) would not necessarily have been a frame of reference available to Italian viewers of *pitture infamanti*.[61] In Italian contexts, the humiliation was potentially effected by alluding to the inversion of a particular genre of class-specific portraiture (pictures of *uomini famosi*); in the German-speaking world, the affront partly worked by perpetuating anti-Semitic, dehumanizing sentiments (the idea that the defamed individual become bestial, like a Jew). Of course, in at least one documented instance of Germanic defamation – the *Schandbild* depicting Hans Judmann (illus. 17) – the instigators were themselves Jewish. Presumably the offence here worked by channelling the humiliation normally inflicted by Christians on Jews against the Christians themselves. Such a reparative turning of the tables may indeed have subversive implications. But it is important not to ignore the wider contexts for such a manoeuvre. After all, as well as contributing to the symbolic language of Jewish executions, metaphors of reversal were an important component in host desecration narratives in the later Middle Ages: Jews were said to have mimicked and inverted the conventions of eucharistic ritual as they went about mutilating the holy wafers. Such stories, we should recall, had the ability to rouse communities into a frenzy of real anti-Semitic violence.[62] This suggests that, while medieval Europe possessed a common vocabulary of hanging, we should also draw attention to the particular messages that even a single 'art' of hanging might convey. In certain times and places, the interaction between anti-Semitism and vocabularies of shame may actually have helped to fuel the association between infamy, Jewish identity and animality, creating a vicious circle of prejudice that disadvantaged Jews in actuality.[63]

The discourse of 'high art' provides an additional framework for under-standing certain images of hanging produced at the end of the Middle Ages. I take my cue from the fact that in Italy, by the second half of the fifteenth century, *pitture infamanti* were associated explicitly with the pro-duction of aesthetic pleasure. Giorgio Vasari describes how in 1478 the Signoria of Florence commissioned a series of defaming portraits from the painter Andrea del Castagno in order to reap vengeance upon the members of the Pazzi family who that year had attacked Lorenzo de' Medici and his brother Giuliano during mass in the cathedral. In fact Vasari gets his dates wrong, since Andrea had died in 1457, 21 years before the Pazzi conspiracy; the *pitture infamanti* he actually painted (in 1440) depicted the treacherous Albizzi conspirators.[64] No matter: Vasari's description of the paintings is still extremely telling:

> In the year 1478, when Giuliano de' Medici was killed and his brother Lorenzo wounded in S. Maria del Fiore by the family of the Pazzi and their adherents and fellow-conspirators, it was ordained by the Signoria that all those who had shared in the plot should be painted as traitors on the wall of the palace of the Podestà. This work was offered to Andrea, and he, as a servant and debtor of the house of Medici, accepted it very willingly, and, taking it in hand, executed it so beautifully that it was a miracle. It would not be possible to express how much art and judgment [*arte e guidizio*] were to be seen in those figures, which were for the most part portraits from life [*ritratti per lo piú di naturale*], and which were hung up by the feet in strange attitudes, all varied and very beautiful [*tutte varie e bellissime*].[65]

The city was so pleased with the pictures, Vasari tells us, that the painter earned the nickname 'Andrea degl'Impiccati' ('Andrea of the Hanged Men'). Vasari was writing decades after the event, and it is possible that aesthetic attitudes had changed. Yet what this passage demonstrates above all is that *pitture infamanti* could be seen as things of beauty.

For all Vasari's claims that these pictures were, for the most part, 'portraits from life', the defaming portrait actually seems to have had little in common with the lived realities of the scaffold. Painted by the most renowned artists of the day (the Pazzi pictures were in fact painted by none other than Sandro Botticelli),[66] the only remaining visual records of the Italian genre are a series of drawings by Andrea del Sarto, made in preparation for another commis-sion of Florentine defaming portraits *circa* 1529–30 (illus. 22). In these, there is no element of terror, no abject frothing at the mouth or rot or defecation:

they are in many ways superbly attractive images. A similar element of aestheticization attends to the drawings by Pisanello (illus. 23), produced as preparatory studies for his fresco of *St George* commissioned originally in the 1430s for the Pellegrini chapel in Sant'Anastasia, Verona (illus. 21).[67] Although in this case the drawings were not designed with defamation in mind, they betray the same beautifying urge. It is only in the lower pair that we have anything approaching abject horror. Here the bodies of the condemned stretch the neck in an unnaturally elongated contour, their garments falling away to reveal naked flesh; the viewer is temporarily unsettled, death somehow trapped in the representation of bodily disintegration (it is telling that these horrible images did not make it into the finished fresco). But in the other drawings, aestheticism, not realism, is the order of the day: plump body forms, neatly positioned legs, elegantly swaying heads.[68]

Punishment is consequently beautified in ways that enable it to become not a site of abjection, that 'twisted braid of effects' from which we turn away gasping, but a locus of pleasure.[69] Once more, defaming portraits convey an aesthetic of suspension, of bodies on a threshold between life and death. Art historians sometimes play down the imaginary status of defaming portraiture. David Freedberg, for example, interprets *pitture infamanti* as exercises in artistic realism, made possible by the prospect of verisimilitude created by the Italian Renaissance. Realism, he suggests, was essential to the functioning of images of this sort: the quality of shame depends on the perception of the defamed as being materially present in the image, based on the universal human tendency to elide the resembling

21 Antonio Pisanello, *St George, the Princess and the Dragon*, c. 1436–8, fresco. S Anastasia, Verona (now in the sacristy, formerly in the Pellegrini chapel).

22 Andrea del Sarto, *Nude Youth Hanging Upside Down*, 1530, preparatory drawing, chalk on paper. Galleria degli Uffizi, Florence.

23 Antonio Pisanello. *Studies of Men Hanging and Two figures*, 1430s, pen and brown ink over black chalk. British Museum, London.

image with its physical prototype.[70] To a certain extent I agree with this assessment, but I also think we ought to account for the imaginary and symbolic dimensions of the genre. Defaming portraits do not necessarily convey the physical effects of hanging. Indeed, Samuel Edgerton has made a case for the idea that the genre's aesthetic qualities contributed eventually to its disappearance: the art of defaming portraiture finally died out in Italy in the sixteenth century, he says, 'because it pleased aesthetically too much and insulted too little'.[71] It is in this sense that the art of insulting and 'art-for-art's-sake' are implicated in the satisfactions of fantasy: each operates to rein in the real, making possible the licensed release of aesthetic pleasure. Certain genres of visual representation were becoming, to repeat the familiar cliché, Art with a capital 'A'. In such a climate, punishment iconography became divested of its power to punish.[72]

Of course, this is not to say that hanged bodies were ever completely purged of their defamatory status in the late Middle Ages to the extent that, say, images of the crucified Christ and saintly martyrdom were. The sheer popularity of hanging as a mode of punishment in Western history makes such a possibility highly unlikely. But visual images, like words, do not always mean what one wants them to say; an image, designed to enact shame and virtual violence, can also prove pleasing to the eye. In later chapters, we shall see how this process created a range of semantic possibilities largely unforeseen by their instigators and producers. But here we have also seen how the horrors of hanging were offset, in medieval representation, by aesthetic devices deliberately intended to have such pleasurable effects: Villon's humorous asides, for instance, or depictions of the 'body beautiful' in defaming portraiture. Given the tendency to downplay hanging as a topic worthy of concerted analysis in recent accounts of medieval penal iconography, the process seems to have worked. Aestheticization has resulted in another 'visual trick' designed, on the one hand, to mask the sheer agony of death by strangulation and, on the other, to enable images of hanging to take on other, more excessive associations: as penitential warnings or defamatory insults, or even as a mode of Art.

STRANGE FRUIT

Finally, by way of conclusion, I wish to refer to an evocation of hanging that presents something of a contrast to the medieval imagery discussed up to now (perhaps, that is to say, with the exception of Villon's attempts to construct a space of temporary communion between the bodies of readers and the pained bodies of the *pendus*). The description in question appears in the lyrics of a song written by a white Jewish schoolteacher and

political activist from New York in the 1930s and recorded in 1939 by Billie Holiday. The words of 'Strange Fruit' by Abel Meeropol (who wrote under the pen name 'Lewis Allan') are worth quoting in their entirety:

Southern trees bear a strange fruit,
Blood on the leaves and blood at the root,
Black body swinging in the Southern breeze,
Strange fruit hanging from the poplar trees.

Pastoral scene of the gallant South,
The bulging eyes and the twisted mouth,
Scent of magnolia sweet and fresh,
And the sudden smell of burning flesh!

Here is a fruit for the crows to pluck,
For the rain to gather, for the wind to suck,
For the sun to rot, for a tree to drop,
Here is a strange and bitter crop.[73]

The imagery should be familiar by now: pecking crows, swinging bodies, the ravages of rain, wind and sun. Yet the uses to which the motifs are put are somewhat different. The blackened bodies of Villon's *Ballade des pendus* have been transformed into the black body of a man who has been lynched.[74] Gone is the penitential tone of Villon's poem (although, as a frank depiction of racist violence in the American South following the Civil War and throughout the first half of the twentieth century, the song certainly provoked a secular reaction akin to penitential reflection when performed by Holiday: its greatest impact was among white liberals and leftists).[75] Gone too is the humour of the medieval precursors.[76] What we are left with is a powerful meditation on racist oppression that refuses to sidestep the pain of its subject matter. Meeropol's body does not speak from the dead, far from it – this is a body that bleeds and burns.

'Strange Fruit' has been dubbed 'a declaration of war . . . the beginning of the civil rights movement', 'the first unmuted cry against racism'.[77] As such, Meeropol's poem throws into relief one of the major themes in this chapter. Medieval representations of hanging were frequently about matters other than hanging. Defaming portraits were designed to effect the humiliation of men still very much alive; Villon's poems urge readers to self-correction and personal salvation (spiritual or otherwise), even as they also, by constructing a temporary 'community of the threshold', provoke a degree of sympathetic engagement with the bodies of the hanged; in Renaissance Italy, images of hanging could even be made to signify in the context of Art. In these examples, the immediate referent (the body-

in-pain) becomes lost amid a litany of allusions to living bodies, religious sentiments, aesthetic sensibilities and performative insults. It is difficult, in contexts such as these, to get close to the 'choking, pissing, and screaming' of the scaffold, as Gatrell suggests we might. Meeropol's lyrics, on the other hand, seem chilling by comparison. They, too, are aestheticized, noticeably in the jarring juxtaposition of lynching with fruit; they, too, refer beyond the body-in-pain to a subject distinct from hanging, in this instance the pressing issue of black civil rights. But the lyrics of 'Strange Fruit' were produced in a culture of actual violence directed against black people and other social pariahs in the period immediately prior to the song's recording: between 1889 and 1940, at a conservative estimate, almost 4,000 people were lynched in the United States, four-fifths of them black.[78] It is this historical situation and the serious political investment of 'Strange Fruit' in exposing that situation that makes Meeropol's lyrics potentially more troubling to the modern beholder than some of the medieval depictions of hanging discussed in this chapter. The medieval images surveyed here were also produced in a culture of violence, but that violence often acted as a stepping stone to the creation of unrelated messages, rather than being a subject of critique on its own terms. After all, the viewers of *Schandbilder* were hardly interested in the anguish of the Jews who occasionally suffered such a fate; Villon's readers are urged to avoid the fate of the hanged through religious penance (in the *Ballade des pendus*) or perfecting their crimes (in the *Ballades en jargon*). At the same time, Meeropol and Villon, though separated by almost 500 years, also 'touch' in certain ways and produce a range of comparable effects, for instance feelings of horror, social guilt and compassion. If 'Strange Fruit' gets medieval in its Villon-esque metaphors of hanging, it does so with a view to exposing the modernity of that supposedly medieval practice. Empathy with the pained body of the hanged, it suggests, goes hand in hand with the termination of pain and the cessation of oppression. In both medieval and modern contexts, then, artfulness and beautification do not inevitably distract beholders from the social realities of pain. They can also be used partially to restore the power of discourse to those in pain, even contributing to a vision of pain's future elimination.

Skin Show

Gerard David's *Judgement of Cambyses*, installed in the Judgement Chamber in Bruges Town Hall in 1498 (illus. 67 and 68), contains one of the most arresting, and yet probably least understood, depictions of punishment that survive from the late medieval period. The painting depicts, in two panels, an old Persian legend first recorded by Herodotus in his *Historiae*, which describes the flaying of a corrupt judge, Sisamnes, by King Cambyses.[1] A medieval version of the story was related in a compilation of oriental, legendary and classical fables called the *Gesta Romanorum*, translated into Flemish and published in the late fifteenth century in several editions.[2] Chapter 29 of the *Gesta* recounts how a certain judge, bribed by a large sum of money, makes a corrupt decision. An emperor, who does not take kindly to such partial administrations of justice, commands the judge to be skinned alive:

> The sentence was immediately executed, and the skin of the culprit nailed upon the seat of judgment, as an awful warning to others to avoid a similar offence. The emperor afterwards bestowed the same dignity upon the son of the deceased judge, and on presenting the appointment, said: Thou wilt sit, to administer justice, upon the skin of thy delinquent sire: should anyone incite thee to do evil, remember his fate; look down upon thy father's skin, lest his fate befall thee.[3]

David's diptych represents four episodes from the legend. The panel on the left depicts in the background the venal judge receiving a bribe (illus. 24), and in the foreground his dramatic arrest by Cambyses (illus. 67). On the right, we are confronted with Sisamnes' grisly public execution by flaying (illus. 68), and in the top-right corner we glimpse the moral of the tale – the judge's son, Otanes, dispensing justice from a seat draped with his father's skin (illus. 25).

24 Detail of illus. 67, showing Sisamnes receiving a bribe.

25 Detail of illus. 68, showing Sisamnes' son Otanes dispensing justice.

The Bruges diptych lays claim to being one of the earliest surviving depictions of this theme, which was rarely represented in justice paintings before the sixteenth century, when the legend increased in popularity. What is unique, indeed memorable, about David's treatment of the subject is the fact that, unlike almost all subsequent representations, which concentrate on the final episode (in which Otanes is seated on a chair covered with his father's skin), the Bruges panels devote most space to the arrest and punishment of Sisamnes himself. In contrast, other depictions of the Cambyses legend rarely represent the shocking execution scene at all; if they do, they consign it to the background, thereby tempering its violence (see illus. 29–31).[4] We should be careful not to attribute the peculiar qualities of late medieval Netherlandish painting simply to the development of a mimetic, reality-conferring aesthetic: as we shall see, the so-called realism of David's painting is by no means an objective embodiment of material reality.[5] Yet the effects that this work of art produces are undoubtedly powerful: when I have lectured about the diptych in public or shown reproductions of the second panel to

students, more than a few viewers have half-hidden their eyes in horror. This chapter attempts to account for some of these effects, engaging with the resonances and intensities that the painting appears to produce in the minds – or bodies – of myself and others, while at the same time attending to the historical circumstances that conditioned the painting's original reception, function and ideological message. If the previous chapter considered a facet of the medieval penal imaginary that relied heavily on imagery of suspense, by virtue of hanging's literal and metaphoric associations with betwixt and between states, in what follows we shall see that other genres of punishment iconography also traded in motifs of temporal postponement to convey their ideological messages, and that these motifs were similarly connected to experiences of the body as a potentially threshold entity, trapped in the interstices between life and death and always 'about to' suffer pain. The motif of flayed skin in particular provides a point of departure for exploring these issues: the second panel in David's diptych, which represents skin both as a sensory threshold (bestowing identity and subjectivity) and as a lifeless object (serving as a support for the didactic lesson), helps to bring into focus the intertwined relationships between pain, pleasure, suspension and ideology that are the subject of this book.

Before analysing the symbolic and aesthetic layers that converge in the representation of flayed skin, some historical background to David's painting would be helpful. What was the purpose of late medieval justice paintings more generally? Town halls in the later Middle Ages were a focus of civic pride, wealth, prestige and power, and one of their most important functions was to house the courtrooms in which the city's aldermen administered justice. It became common practice in the Netherlands and Germany to decorate the walls of the courts with scenes of justice, most commonly images of the *Last Judgement*, but also themes selected from moralistic texts or historical allegories representing *exempla iustitiae*.[6] Almost all such depictions of exemplary justice have been removed over time, but records show that commissions were procured from the most distinguished painters of the day: rare survivals include Dirk Bouts's *Justice of the Emperor Otto III* (illus. 26 and 27),[7] completed at the behest of the magistrates of Louvain in 1468, and the four panels by Rogier van der Weyden depicting the *Legend of Trajan and Herkinbald* for Brussels town hall (1439–61), known through a tapestry copy.[8] The exact purpose of these images is a matter of some debate, but it is generally accepted that, in their exemplary context, they were designed above all to convey a salutary message, functioning as a 'harsh warning' to jurors gathering for judgement in the court chamber to seek the truth.[9]

While justice paintings functioned to inspire jurors to mete out justice with propriety, they also helped to convince ordinary townsfolk, who

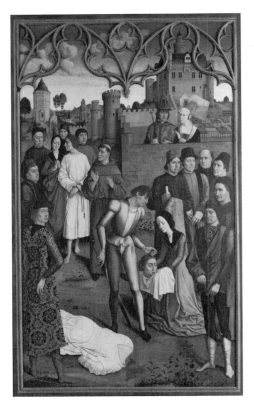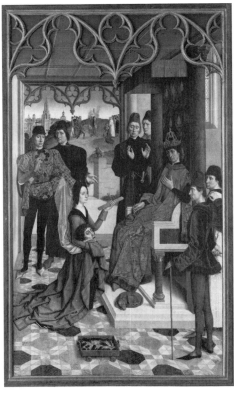

26 'Wrongful
Beheading of the
Count', Dirk Bouts,
*Justice of the
Emperor Otto III*,
c. 1470–75, oil on
oak. Musées des
Beaux-Arts de
Belgique, Brussels.

27 'Trial of the
Count's Wife', Dirk
Bouts, *Justice of the
Emperor Otto III*,
c. 1470–5, oil on oak.
Musées des Beaux-
Arts de Belgique,
Brussels.

might have the opportunity to see them, both to respect the law and to believe in the integrity of the judges. Justice paintings consequently possessed a strong ideological remit: scenes such as the *Judgement of Cambyses* were designed to convey the power and authority of the administrators of justice in the city, as well as making them reflect critically on their roles within that process. The painting served not only as a harsh warning, in other words, but also as a lavish, self-affirming embellishment designed to shore up the identities of the burghers of Bruges involved in administering justice in the city.[10] David's diptych, like that of Bouts, is reckoned to contain portraits of the actual magistrates responsible for dispensing justice in the city at the time of commission, the inclusion of which served to highlight the supposed analogy between the good conduct of the just heroes of the exemplum and the behaviour of the aldermen themselves.[11]

Indeed, it is possible that the painting was commissioned with a view to advancing a very specific ideological agenda: the art historian Hans J.

van Miegroet has proposed that it functioned as a political allegory that served to delineate aspects of Bruges' recent troubled past.[12] After the sudden death of Mary of Burgundy in 1482, the city refused to recognize her husband Maximilian as regent, in lieu of the couple's son, the future Philip the Handsome, who was only four years old at the time. (According to the marriage contract drawn up with Mary, Maximilian's own power in the Burgundian Netherlands expired in the event of her death.) In 1487, determined to gain the city's support, Maximilian entered Bruges by force. In the following year, though, he was taken hostage and imprisoned in a house on the market square. At this point certain pro-Burgundian magistrates, who had purportedly conspired with Maximilian, were arrested, questioned and tortured by the civic authorities in Bruges; some were even decapitated for their treachery. Later that year, however, there was another twist to the tale: Frederick III, the Habsburg emperor, sent a large force to free his son Maximilian, and Bruges responded by entering into hurried negotiations: the city agreed to release Maximilian if he would consent, among other things, to make his son Philip duke of the Burgundian Netherlands. Yet the city revolted against the Habsburgs again in January and July 1490; it was only in November 1490 that it finally capitulated. David's painting, van Miegroet argues, allegorizes this turn of events by reminding the city officials of their duty as judges, berating Bruges for its political misconduct, and warning magistrates against resisting the authority of the Habsburgs. According to van Miegroet, this explains the painting's unique stress on arrest and punishment, rather than the exemplary charge of the final episode (the skin-draped justice seat) that would become the focus of the story as the tradition developed: the flaying scene, he says, recalled the traditional punishment for the crime of *lèse-majesté*, and was thus designed to function as a terrifying warning to the magistrates of Bruges to show loyalty to the Habsburgs.[13] In this reading, then, the painting conveys the authority of the Burgundian court, above all, through a didactic logic of 'look and learn'.

Although I am not convinced that the painting was designed with such an explicit political allegory in mind (which would be highly unusual in the context of the late medieval iconography of justice at large), it does seem important to emphasize the painting's unusual focus on themes of crime and punishment over and above justice per se. Clearly, David's rendition of the subject has the capacity to instil a powerful response in the beholder, potentially with a view to social regulation.[14] But the representational strategies by which this ideological project was achieved have been all but glossed over in more conventional accounts of the painting. It is presumed without question that if the image was *intended* to provoke reactions of anxiety in the minds of viewers, then anxiety is what it produces.

Art historical discussions of the painting are full of such hidden assumptions. Critics simply place *Cambyses* in an iconographic context, stressing its textual precedents, historical background and corporate function, while ignoring what is most obvious and unique about this image: *the body of the condemned man himself, and possible reactions to that body.* By stressing the painting's allegorical or exemplary functions, and the painter's corresponding lack of control over the iconographic content of his work, critics also fail to account for the aesthetic factors that contribute to the painting's role as a peculiarly 'painful lesson'.[15] Exactly which elements of David's image have this terrifying effect on the viewer?

Put simply, David's *Cambyses* represents a zone of abjection alongside regions designed to elicit identification. This may seem obvious to those observers coming to the painting for the first time: the eyes of most modern viewers are simultaneously seduced and repelled by the condemned man's incised body in the right-hand panel. Standing in the gallery in Bruges where the painting is now exhibited, and watching the tourists file through and either stand transfixed with fascinated horror or shuffle past in a state of shock and embarrassment (they thought they'd be in for an afternoon of pretty pictures), it seems that, for modern beholders, the scene of flaying is usually the most compelling aspect of the painting. Art historical discussion of the painting betrays a comparable, albeit unacknowledged, response. Seldom reproduced in colour, art historians have tended to treat the image more often as an indicator of general stylistic and compositional developments in late fifteenth-century painting than as the embodiment of abject horror.[16] It has been assigned a historiographic role, as a firmly dated and easily assigned work in the oeuvre of a fledgling artist, whose later commissions at least exhibit the pious serenity more traditionally associated with early Netherlandish painting. When presented in an exhibition of Flemish 'primitives' in 1902, the writer of the official exhibition catalogue proclaimed, with more than a hint of disapproval, that 'the painter has produced with extraordinary calmness and serenity, the most realistic, bloodiest of all tortures, that has ever been painted'; like martyrdom iconography, moreover, such images 'reproduce with the same candour and superior dryness carnage, human sacrifices, and murder'.[17] A few years before, in the first monograph to be written on David's collected works, W. H. James Weale suggests similar misgivings, stressing that 'the flaying of a man is doubtless by no means a pleasant thing to look at, but it was not the painter who chose the subject'.[18] Be that as it may, it is not to the painter's intentions that we should turn but to the aesthetic properties of his art, if we are to understand the painting not simply as a political allegory or moral exemplum, emptied of all affective content, but as an image that relies on particular visual codes and embodied

responses to articulate its ideological message. The effects this painting generates are not simply by-products of the didactic agenda, in other words, but constitutive of its very meaning, so that emphasis needs to shift from *what* to *how* the image means.

All the same, it is hard to come to terms with this question of 'how?' when the bodies of viewers and the bodies of paintings are not allowed to connect, touch or mingle in scholarly writing – when one is not allowed to experience shock or horror or surprise in response to a historical artefact. Defensive manoeuvres of this sort permeate the history of the reception of David's *Judgement of Cambyses*: there seems to be a consistent refusal to *look* at the body of the condemned. My suggestion is that this is because that body, when wrested from its immediate context, is a profoundly horrifying image. Historical studies find it difficult to come to terms with artefacts that generate such powerful responses. These are not the sorts of sentiments that, to use Foucault's telling phrase, 'answer to the purpose of historians', since historical enquiries traditionally require more rational, empirically verifiable methods of analysis.[19] By directing attention specifically to the body of Sisamnes, then, I'd like to give consideration to the traumatic, unthinkable dimensions of the painting, even as its imaginary and symbolic resonances for medieval viewers necessarily form the backbone of my analysis.

First, I wish to highlight the cultural associations surrounding the removal of skin in the Middle Ages, specifically the place of flaying within what I call the medieval penal imaginary – the network of visual and textual significations that transform the violated bodies of executed criminals into discourse and fantasy. To what extent did David's painting draw on experiences shaped by medieval judicial spectacle? One assumption should be challenged in this context: the idea that paintings such as David's somehow directly reflect *actual* penal practice.[20] There are few grounds for such a contention, since there is little evidence that flaying was practised upon those who offended against the law in this region, or indeed any other, in the later Middle Ages. Flaying is occasionally mentioned in Anglo-Saxon law and rare historical instances of the practice have been recorded (mainly in English and French contexts), for instance the skinning of Hughes Gérard, Bishop of Cahors, indicted for an attempt to poison Pope John XXII of Avignon in 1317. What looks like a possible allusion to flaying also appears in the centre of the woodcut depicting punishments in Ulrich Tengler's sixteenth-century *Layenspiegel* (illus. 4). It should be stressed, though, that records of the penalty actually being carried out are exceptional.[21]

The significance of flaying for visual and literary expression, on the other hand, is all too apparent: like bodily executions more generally, skin

removal had an imaginary and symbolic potency out of all proportion to its frequency in lived experience.[22] In literature, for example, it was persistently associated with various forms of treason: in the thirteenth-century Middle English romance *The Lay of Havelok the Dane*, Havelok's peers condemn Earl Godard to be 'al quic flawen' and then dragged to the gallows.[23] Such depictions draw attention to the representational status of flaying in medieval culture, but it is virtually out of the question that David would have modelled his image on executions that he had witnessed himself. *Cambyses* was certainly not designed to exploit the fear of beholders to imagine themselves as victims of flaying in judicial practice: after all, when the treacherous judges of Bruges were called to account in the troubles of 1487–8, they were beheaded, not skinned alive. Instead it seems important that we contemplate the network of cultural assumptions held by David's audience, pertaining to skin and its removal.

THE SIGNIFICANCE OF SKIN

What is it in the symbolic content of the image that inspires horror? First and foremost, there is the nature of the punishment itself: the removal of skin. Skin is the limit of the body's spatial location, a visual surface cloaking the internal organs and protecting them from damage. It is at once both a surface for the inscription of signifying traces and a sensorial threshold mediating between the external world and internal sensation.[24] According to Guy de Chauliac, a surgeon and anatomist whose vast treatise of 1363 was translated into numerous vernacular languages in the fifteenth century, the skin is a covering of the body made for the 'defending' and 'giving' of feeling.[25] Chauliac goes on to distinguish two types of skin, one skin proper, which covers the 'the outer members', and the other more properly termed a 'pannicle', which covers the 'the inner members'; as such, the skin, properly defined, is a protective barrier, the visible, regulatory marker between inside and out.

In medieval devotional texts, skin was sometimes constructed through metaphors of clothing: poets imagine being 'clad' in Christ's skin, for example.[26] As such, skin was a surface with deep meditative possibilities; indeed it was quite literally so, to the extent that manuscripts, made from the skin of dead animals, functioned as the physical support for medieval texts and images. Writing in the Middle Ages involved intense physical labour, which may have contributed to the trope of *memoria* as an inscribed parchment, written with the 'pen' of our memory.[27] In keeping with this idea, the *Gesta Romanorum* version of the Cambyses myth ends by interpreting the skin nailed to the judgement seat as Christ's passion, 'a memorial to us of what our conduct should be'.[28] Late medieval poems

28 'The Charter of Christ, sealed with Christ's wound', drawing in a Carthusian miscellany, 15th century, English. British Library, London.

likening the crucified Christ to a piece of vellum, stretched out and 'penned' with the scourges and thorns of torture, in letters that are wounds, similarly drew attention to the memorial significance of bodily surfaces: sacred skin was simultaneously a record of suffering and a mnemonic tool reminding readers to turn from sin. A manuscript containing the fifteenth-century English poem 'The Charter of Christ' makes this association between skin, parchment, pain and meaning explicit: Christ's body, dotted from head to toe with tiny wounds, drips blood directly onto the charter, which is sealed, in turn, with the wound of his heart (illus. 28).[29]

Turning to literature produced in more secular contexts, skin could again be an object of intense devotion: descriptions of a woman's body in medieval love narratives conventionally include accounts of her skin's alluring complexion.[30] Conversely, when diseased or violated, skin could also be an object of disgust, loathing, repulsion and fear. Medieval lepers, whose skin disease was supposedly connected to their moral shortcomings, were required to undergo rites of separation analogous to the burial

29 'The Judgement
of Cambyses',
miniature in
an Apocalypse,
southern Germany,
c. 1425–40.
Wellcome Library,
London.

of the dead, so important was an uninterrupted body surface to the maintenance of worldly identity.[31] Medieval executions were themselves often accompanied by elaborate rituals of inversion, in which the divestiture of clothing symbolized the social death of the victim.[32] What could be more terrifying in this context than the removal of the skin itself, the body garment *ne plus ultra*? In keeping with medieval notions of skin *as* memory, to flay someone alive would be to tear away the bodily surface onto which transitory memories and identities could be inscribed – only to fashion an etched parchment in its place (the dead skin), from which 'timeless' moral lessons could be read.

David's painting thus exposes with brutal clarity the process by which a pained body becomes an ideological object. Responses to Sisamnes' execution are potentially forced to mediate between two poles: the act of flaying provokes feelings of abjection, while the lifeless material that is its consequence encodes didactic lessons. The French critic Julia Kristeva has defined the abject not simply as that which is filthy or amoral, or

lacking in cleanliness or health, but that which 'disturbs identity, system, order', a 'jettisoned object' that continues to manifest danger from its place of banishment.[33] Moreover, the abject's utmost embodiment is, for her, the corpse: it represents the place where the border, the line dividing self from other, has 'become an object'.[34] The concluding episode of the Cambyses myth, where Sisamnes' skin is deployed as material support for the administration of justice, produces a similar effect: here is a border that has quite literally become an object. Indeed, most extant Cambyses depictions represent this scene rather than the act of flaying: a fifteenth-century *Apocalypse* manuscript in the Wellcome Library in London depicts Otanes sitting on top of his father's skin, while Cambyses declares, in a banderole issuing from his mouth, *Super pellem patris tui sedebis iuste iudicabis* ('You shall administer justice seated on the skin of your father'); Otanes has an empty banderole (illus. 29). Other depictions show the skin dangling menacingly above Otanes, such as a panel from the workshop of Lucas Cranach the Elder of *circa* 1540, where the flaying takes place in the background (illus. 31), or hanging over the side of the judgement seat, as in a woodcut from a sixteenth-century German law book (illus. 30). In these depictions, Sisamnes' flayed remains frequently retain the marks of the body to which they were formerly attached – eye sockets, fingers, toes, hair, even earlobes – as if to externalize the identity that has been purportedly destroyed. Just as Sisamnes violated the boundaries of the body politic by accepting a bribe, so now he pays the price for his transgression by having his own corporeal boundaries undone; and the draping of his juridically marked surface over the seat of justice reminds his successor, his son no less, of the requirement to maintain integrity at all costs – or risk total dissolution.

30 'The Judgement of Cambyses', woodcut in Justinus Gobler, *Der Rechten Spiegel* (Frankfurt, 1550).

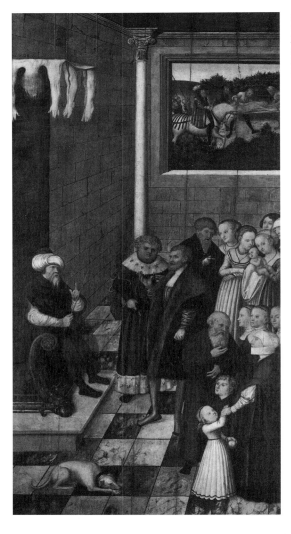

31 Workshop of Lucas
Cranach the Elder, *The
Judgement of Cambyses*,
c. 1540, oil on oak. Staatliche
Museen zu Berlin
(Gemäldegalerie).

But if the skin of Sisamnes communicates the horror of death in the
minds of viewers, it equally mediates something immaterial and abstract:
the intangible 'truth' of just judgement. Like the animal pelts used to
produce vellum, the judge's skin is transformed into a sheet of parchment
onto which the letter of the law can be inscribed: it becomes a mnemonic
of bad conduct, a sign that moral order has been restored and an oppor-
tunity for others to 'reflect' on what good conduct should be. In David's
rendition of the scene the skin is depicted as a plain surface, like the de-

haired, tidied-up pelt used to make parchment, with little detail to connect it to the human form. The status of skin in David's painting thus oscillates between abjection and abstraction. It is little wonder, given this element of equivocation, that the *Gesta Romanorum* ultimately reads Sisamnes' skin as a symbol of Christ's passion: this, too, is an event where abjection and sublimity have become powerfully intertwined. Christ's skin was a site of suffering, of course, but the *Gesta* moralist ultimately directs the reader's attention away from Christ's death to the opportunities it provides for salvation. Amend your ways, the moralist implies, and you will receive just judgement in heaven.

The appropriation of flaying as a motif suspended between two seemingly opposite poles – horror, on the one hand, and the restoration of order, on the other – may be related to ambivalent attitudes toward bodily division in late medieval culture more generally. The splitting of bodies into parts, whether in search of knowledge or as an expression of power, was subject to deeply rooted fears, and men of blood – whether executioners, butchers or surgeons – were considered to be dangerously polluted.[35] The attitudes of Pope Boniface VIII are symptomatic of such taboos. In 1299 he issued the bull *Detestande feritatis*, famously condemning the distributive burial practices of nobles and high-ranking dignitaries. This proclaimed that the custom of dismembering bodies after death, boiling their severed remains to separate flesh from bone and dispersing disconnected body parts across multiple burial sites, was not only abominable in the sight of God but also repugnant to human sensibility. Moreover, bodies breaching the injunction would be denied Christian burial. Boniface's pronouncement had an immediate effect: for years after, the number of separate burials of different body parts declined rapidly in countries such as England, and the bull and its glosses may even have deterred some surgeons from dissecting corpses for anatomical purposes. Yet the impulse toward division nevertheless continued during the fourteenth century and exemptions from the bull were increasingly granted, particularly in France. Like the body of the Christian martyr, the dismembered corpse paradoxically assumed a role as a marker of status and social distinction. The divided body, after all, extended the possibilities of salutary prayer (necessary to release one's soul from purgatory), and it also offered the prospect for those who died far from their families, whose rotting corpses could not withstand the journey home, that on judgement day their reassembled body parts would rise in the vicinity of friends and relatives.[36] These customs, and Boniface's pronouncements against them, suggest that medieval thinkers found themselves caught between acknowledging the abjection of bodily division and promoting its signifying possibilities. The idea that the body is a vital component of personhood attended

both to the horror that the corpse could be broken into parts *and* to the notion that it remained a source of identity and social power when geographically dispersed.[37] Likewise, the fate of Sisamnes plays upon deeply held fears regarding bodily disintegration in the Middle Ages, and simultaneously indicates the power of his divided body parts to become a signifying support for memory and didactic truths.

THE *BURGERLIJK* AESTHETIC

If this reasoning provides solutions to the *symbolic* content of the flaying motif, it does not explain the specific *aesthetic* qualities in David's painting that bestow it with such a capacity to horrify. What were the visual tactics used to illicit – and simultaneously foreclose – such responses? My suggestions at this point are necessarily subjective and affective. There are no detailed eyewitness accounts of the painting, or paintings like it, from the late Middle Ages, and most of the information we do have regarding medieval viewer-response relates to art drawn from devotional contexts. Religious accounts of image use can be used with care to denote certain general paradigms of visual engagement, but these do not resolve all the particular problems of interpretation that pertain to a specific work of art. Given that one of the aims of this study is to engage with the contingent, indeterminate and 'tactile' dimensions of the viewing process, a description of my own responses to the image may provide a helpful supplement to a more verifiably 'medieval' paradigm of response.

A close look at the rendition of Sisamnes' body reveals the painter's extraordinary, almost pedantic attention to detail. Every hair on the victim's body is minutely described – leg hair, pubic hair, even the wisps around his nipples and armpits. Sisamnes' arms have well-defined veins, and his skin bunches at the wrists under the strain of the taut ropes (illus. 32); his face is lined and the jugulars are clearly marked out (illus. 33). This is not to say that the image is 'realistic': the logic of the painting demands that it retains a strong element of aestheticization, or symbolic layering, to achieve its ideological effects. At the same time, as David Freedberg has argued, *all* image cognition relies to some extent on the elision of a resembling signifier with its imagined prototype. Identification with the sensate body – stemming from psychic identification with and imaginary mastery of our own bodies – generates the horror / fascination that attends to visions of an imaginatively enlivened image.[38] What shocks me most about the right-hand panel of David's *Cambyses* is not the naturalism of Sisamnes' body so much as the affront that the exactitude of the painting's composition presents to my own experiences of embodiment as something fluid and in process: it

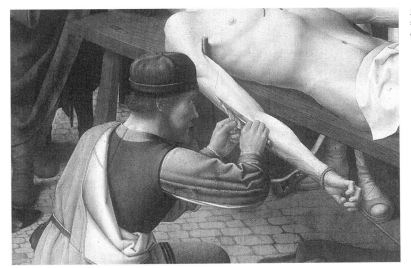

32 Detail of illus. 68, showing the flaying of Sisamnes' arm.

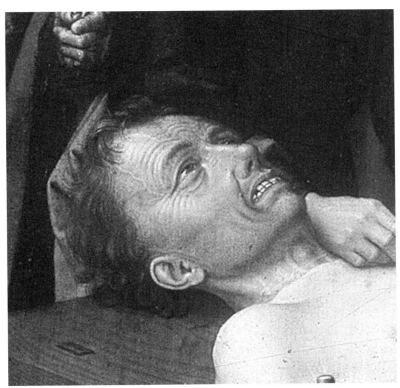

33 Detail of illus. 68, showing Sisamnes' frown.

34 Detail of illus. 68,
showing the flaying
of Sisamnes' leg.

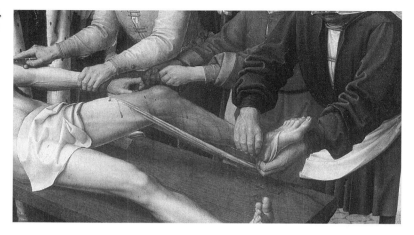

makes me confront the boundaries, the mortal limits, of bodily experience. The scribe-like precision with which the executioners go about their work demands such sensation. Looking at the way they slice into the judge's taut, canvas-like skin, I feel the beginnings of a nauseous sensation rising up from my stomach. Light catches the skin's sliced edge on Sisamnes' right leg, which is dragged in a perfectly straight line toward the heel – a technique that, in resisting the natural tendency of the body to curve, is profoundly disturbing. The skin being torn from the leg is pulled off to form three or four straight lines, bunched up like a fan (illus. 34).

Significantly, the composition is reminiscent of illustrations to fifteenth- and sixteenth-century surgical manuals, in which a surgical blade slices neatly through 'tunics of flesh', or a flayed subject strikes a pose with a knife in one hand and his peeled skin in the other (illus. 35 and 36) – such images provide a striking intertext for David's painting.[39] The panel also compares well with images depicting the dissection of Nero's mother Agrippina: a miniature devoted to the subject appears in a Netherlandish manuscript of the *Roman de la Rose* contemporary with the painting (illus. 37). Literary depictions are similarly disposed, as in the aforementioned *Lay of Havelok the Dane*, which recounts the execution of Earl Godard in minute fashion: Godard, roaring inordinately, is described as a 'fule file' (true wretch); in contrast, the execution has all the precision of an anatomy lesson, beginning at the victim's toe.[40] One of the most unsettling aspects of *Cambyses* is the deeply serious attitude of the executioners, which again parallels anatomical illustrations. In the *Agrippina* miniature, for instance, the chief dissector is shown going to work with rolled-up sleeves, while his assistant wields a knife purposefully. Likewise, in David's *Cambyses*, the executioners are represented in a range of

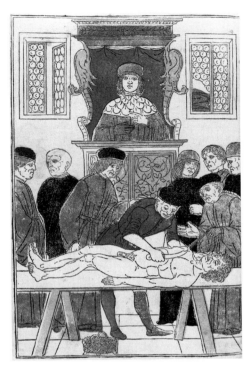

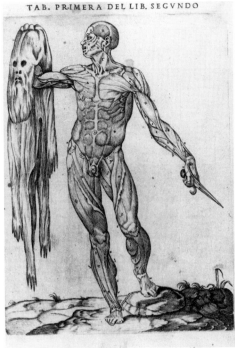

detached, businesslike attitudes. Gingerly tracing the surface of the body with their instruments, they look only to their assigned task – apart, that is, from one young man, to the right of the painting, who, as he holds Sisamnes' arm, distractedly looks out toward the beholder. This motif of catching the beholder's eye, which also sometimes appears in scenes of holy martyrdom (see chapter Five), is a technique that associates the painting with the imagery of temporal suspension discussed in chapter One. By incorporating the viewer within the scene, historical time is suspended, opening the image out to a range of 'trans-historical' responses that partially bypass the burdens of medieval alterity.[41] This simple but effective strategy has been deployed by David to enable medieval viewers to incorporate an ancient legend into their particular, historically situated understanding, but it also allows modern viewers to construct their own affective relationships with the painting, 'touching' the image with their eyes and experiencing it from within.

In the later Middle Ages, empathetic relationships with the body of Christ were formed partly through devotion to his blood, as the Wrocław crucifix discussed in the Introduction clearly demonstrates (illus. 1 and

35 'Dissection', woodcut in Johannes de Kethan, *Fasciculo de Medicina* (Venice: Zuane and Gregorio de Gregorii, 1493).

36 'Flayed figure', woodcut in Juan Valverde de Hamusco, *Historia de la composicion del cuerpo humano* (Rome: Antonio Salamanca and Antonio Lafresii, 1556).

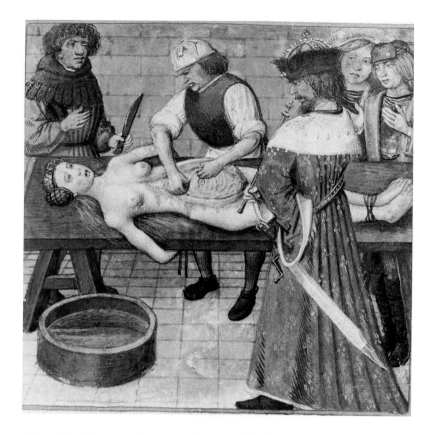

66). In David's execution panel, however, blood is striking by virtue of its almost complete absence. The only signs of blood we see on the body of the condemned are the few droplets running down his breastbone, from his upper leg, and perhaps a tiny globule just above one of his teeth (or else he has a tooth missing); small amounts of blood also drip from the fingers of one of the executioners onto the floor below. It is possible that the eucharistic connotations of blood in passion iconography made its visual association with the body of Sisamnes somewhat problematic. But the depiction's bloodlessness may also have been a strategy deployed by the artist to heighten dramatic suspense: at what point will the blood really start to flow . . . when will death ensue . . . what will the corpse look like when it has been fully laid open? The artist, by portraying the scene in suspended animation in this way, creates a kind of 'roller-coaster' aesthetic, a dramatic temporality that is both a source of pleasure (suspense is, after all, what we enjoy most about modern horror films) and a source of anxiety.[42]

Temporal disjunctions of a different kind are produced by marginal details included in the panel that distract viewers from the principal episode. To the left of the main execution scene, for instance, David has included an image of a small dog cocking its leg and urinating, or perhaps scratching itself for fleas (see illus. 68). The symbolic or allegorical significance of the motif is ambiguous, but the inclusion of an animal performing a mundane bodily function does work to convey Sisamnes' humiliation more deeply: it suggests that the rhythms of animal existence go on unobstructed in the face of such terrible violence.[43] Motifs of this sort embody precisely the contradictory paradigms of response that the painting sets up: a tension between detached moralizing, directed toward the *deferral* of gut reactions, and the abject horror that, on account of the corporeality of Sisamnes' ordeal, can never be effaced entirely.

The countenance of the spectators who crowd round the body of Sisamnes is also important in framing the viewer's response (illus. 38). Like the executioners, their stoical gestures displace all visceral reactions onto the viewers outside the frame, a technique that defends forcefully against an affective relation with the image. Unlike the Netherlandish dissection miniature discussed above, where Nero is represented gawping intently at the dissected flesh of his mother (illus. 37), most of the burghers witnessing the execution here stare through the victim's body, away from it, at each other; the executioners, likewise, look only to their individually allotted activity, an attitude that fragments the body into its constitutive parts (illus. 39). As already suggested, medieval attitudes to bodily division were ambivalent, variously expressing enthusiasm for the practice in the context of Christian burial and holy martyrdom, and exhibiting horror when confronted with partitioned bodies in other spheres. The attitudes of the spectators likewise hint at the dual poles of abjection and sublimation in David's painting. Their detached attitudes work to dehumanize the victim, stifling reactions to the body as still-

38 Detail of illus. 68, showing spectators at Sisamnes' execution.

living whole. Sisamnes' body is in the process of being stripped of political life, reduced to the bare fact of living by the removal of the surface onto which his identity was formerly inscribed; but all the onlookers can do is contemplate what it says about justice. Pondering the execution's moral message, in other words, the burghers turn away from the pained body on which that message is violently written. Like ideology, which refuses to acknowledge the scene of its genesis, something dead (or dying) drops out of the equation – and out of the field of vision.

Yet when we force ourselves to look, if we can, at the flayed body itself, we see that it still retains the capacity to signify. It requires only a subtle change in perspective to resist the viewpoint of the painted spectators and look at what they don't. Unlike the blank, emotionless expressions of the burghers, we can observe, in Sisamnes, a face lined with pain (illus. 33). His grimacing gob exposes clenched teeth and his neck is tensed and sinewy (his eyes also seem to be watering slightly, signalled by the speck of white added to the left of the cornea). Such gestures are reminiscent of the countenance of the damned in *Last Judgement* paintings, for instance Rogier van der Weyden's Beaune altarpiece (illus. 40). Like the first panel, in which he reacts to his removal from the throne of justice with obvious apprehension, Sisamnes himself, the *victim*, stipulates a response of horror in the bodies of those beholders who choose to look awry. Shifting our perspective slightly, then, it is possible to witness the terror of the condemned.

But David's painting was not designed to be victim-identified in its original context. Instead, the aim was to encourage viewers to align themselves with the burghers who frame the picture (who were, after all, its original

40 'Grimaces of the damned', detail of Rogier van der Weyden, *Last Judgement* altarpiece, *c.* 1445–8, oil on panel, partially transferred to canvas. Musée de l'Hôtel Dieu, Beaune.

audience). Technical investigations of the panels show that David replaced or reworked the heads of many of the bystanders, perhaps in order to represent the likenesses of the principal aldermen serving Bruges just prior to the painting's completion; further modifications included the addition of motifs such as swags, putti and classical medallions, which again suggests an attempt to make the painting fashionably up-to-date.[44] Alterations of this sort demonstrate that identification with the bystanders, even to the point of incorporating portraits of their present-day counterparts, was valued over and above identification with the victim.

Given the painter's investment in aligning the viewer with spectators within the painting, it would be worth accounting for the class-inflected nature of response.[45] After all, the painting was commissioned with a very specific social group in mind, the burghers of late fifteenth-century Bruges. Like traditional art criticism, which views the painting through the lens of detachment and moral superiority, the painting embodies what might be called a '*burgerlijk* aesthetic', that is to say a mode of representation that, by means of motifs of exactitude and emotionless expression, militates against an instinctual, corporeal reaction. The Dutch word *burgerlijk* is employed here both to account for the class-inflected nature of response – the fact that the painting was commissioned with the burghers of

Bruges in mind – and because, like its German counterpart, the term conveys a stronger sense of civility and decorum than the English equivalent 'bourgeois'. Analogous with the aesthetic of suspension sketched out in the previous chapter in relation to medieval arts of hanging, the *burgerlijk* aesthetic is reliant on a dynamic of foreclosure, but also, as we have seen, on the representation and simultaneous effacement of a threshold bodily state, a body that is neither quite alive nor fully dead. Death itself cannot be captured in discourse, and the affective foreclosure that a medieval burgher might have experienced or attempted to experience in response to the painting was a way of turning attention from the body-in-pain – the body in the process of dying – to the didactic messages that this death was supposed to convey. The *burgerlijk* aesthetic also entails what Gatrell calls squeamishness. Squeamishness, in Gatrell's definition, is not to be confused with sympathy or empathy; it is, by contrast, an emotion that 'refuses to accept the pain which sympathetic engagement threatens . . . It denies material reality or others' emotions and blocks the echoes of these within the self. It is a colder, more distanced, more aesthetic emotion, defensively fastidious in the face of the rude and the unsightly'.[46] Fastidiousness may also be at issue in the *Judgement of Cambyses*. The painting was *intended* to install an ideological message, provoking meditation on moral truths ('look and learn') rather than engagement with abject bodies.

At the same time, this does not rule out the possibility that some viewers – medieval burghers even – looked differently too, resisting the requirement for civilized, detached, decorous modes of spectatorship by focusing directly on the body-in-pain that has been so consistently ignored by modern critics. Many medieval viewers would have been open to the idea that bodies continue to signify beyond their limits – beyond death and beyond the boundaries symbolized by one's skin and bones. As later chapters demonstrate, religious writings taught that images of the body-in-pain could communicate the experience of pain to their viewers, and that emotional identification with the victim's posture could be actively pursued in such contexts.[47] Although perspectives of this sort were not necessarily sanctioned in the context of medieval secular justice, responses that attempted to read David's *Cambyses* 'against the grain', identifying with the condemned man (with whom we are presumably *not* supposed to identify), were nonetheless eminently possible in the context of religious devotion. For instance, there was a venerable tradition of representing the skinning of St Bartholomew in devotional manuscripts and panel paintings from at least the thirteenth century. The most striking example occurs in a stunning panel from Stefan Lochner's fifteenth-century *Martyrdom of the Apostles* altarpiece: here, Bartholomew is depicted completely naked as a flap of flesh is pulled away from his arm; drops of blood, exquisitely painted, drizzle down

41 Anonymous
artist, *Martyrdom
of St Bartholomew*,
16th century,
oil on wood,
Netherlandish.
Renaissancezaal
't Brugse Vrije,
Bruges.

his spine (see illus. 69). But what is more remarkable in this context is a sixteenth-century painting directly based on David's right panel by an unknown Netherlandish master (now hanging in the Renaissancezaal 't Brugse Vrije in Bruges), which transforms the scene into an image of saintly martyrdom: you can still see traces of a golden halo encircling Bartholomew's head, and the saint's face no longer emits a terrified grimace, like that of Sisamnes, but instead expresses an attitude of dignified detachment (illus. 41). The painting is, indeed, a much less horrible image. The saint's face is less veiny, the flesh under the skin of the leg less detailed, the lines much less taut; significantly, the whole scene has been transferred into a serene pastoral setting. That a Christian image could be fashioned so easily out of entirely secular subject matter demonstrates that the subtle change in perspective I've been proposing in relation to David's panels may also have been a valid alternative for medieval viewers. The Bartholomew image, with its moral bias toward alignment with the saint, would presum-

ably have been understood as predominantly 'victim-identified'. (In the Lochner panel, too, Bartholomew's expression is stern but hardly beset with agony.) Religious writers engaged in radical practices of *imitatio Christi* – the imitation of Christ – to the extent that they wanted to *become* the tortured bodies in pain to which they were devoted. So by the time of David's commission, there was a long and respected tradition of looking at and identifying with the body-in-pain in the context of Christian devotion.

But martyrdom iconography and David's painting are ultimately designed to convey different moral messages, through the medium of the pained body. The Netherlandish Bartholomew panel is not designed to provoke horror, but meditation on the victim's sufferings as a route to sacred sublimation; the *Judgement of Cambyses* promotes lines of identification that converge on the spectators and the didactic lessons they uphold. Of course, it is entirely plausible that medieval viewers *might* have entertained horrified reactions when confronted with the *Judgement of Cambyses* or the *Martyrdom of Bartholomew*. Just as devotional imagery plays on the capacity of the viewer to reconstruct the body in the image empathetically, David's painting operates by opening up the viewer's own surface – like the body of the condemned – to the possibilities of imagined corporeal destruction. It is only chance that, within the context of these fantasies, prevents the pained body of Sisamnes from being our own – and we imagine that we ourselves might be next in line. The narrative and historical frameworks that condition the painting's reception are consequently deferred: the sight of and empathetic engagement with the body-in-pain work to resist that body's transformation into the mediator of a particular ideology. Viewers who respond to images of the pained body accordingly resist the demands of history, since by partially obscuring the body's qualities of specificity and difference – by bypassing the specific languages and codes within which the body is historically understood – they appropriate the bodies represented as sites of imaginary identification. At the same time, a gap also remains in place between the physical sufferings of Sisamnes and the viewer's body, not only by virtue of the fact that the victim's tormented body is *not* actually ours, but also because the painter has exploited visual strategies that attempt to direct attention away from that body and towards an exemplary message about citizenship and the practice of law (which returns viewers to a particular medieval present). The painting works hard to displace empathetic, 'ahistorical' reactions, much as it simultaneously attempts to draw viewers in. It is only if we choose to look in certain ways, to engage with the abject body at the painting's heart, that we feel anything approaching a bristling sensation of horror. What I think the painting ultimately attempts to establish is a response that is squeamish, disembodied, self-distancing and detached. *Burgerlijk*, in a word.

CHAPTER 3

Eliminating Sodom

In April 1424 Bernardino of Siena, a Franciscan friar and one of the most celebrated preachers of fifteenth-century Italy, delivered a series of consecutive sermons in the city of Florence attacking the vice of sodomy. Every human calamity, he said, could be ascribed to this terrible sin, from flooding and warfare to disease and death – and God would take his revenge by raining down fire on the city as on Sodom and Gomorrah.[1] In the conclusion to one of his sermons, Bernardino told the congregation to deride sodomites by spitting whenever sodomy was spoken of: 'Whenever you hear sodomy mentioned', he exclaimed, 'each and every one of you spit on the ground and clean your mouth out well. If they won't change their ways otherwise, maybe they'll change when they're ridiculed. Spit hard! Maybe the water of your spit will extinguish their fire. Like this, everyone spit hard!' The scribe reporting the incident remarked that the saliva hitting the stone pavement of the church where Bernardino preached 'seemed like thunder'.[2]

In Bernardino's venomous words, we are not just hearing the hyperbolic outpourings of Christian penitential invective, but the manifestations of a discourse on sodomy that was to emerge with particular vigour in certain regions of Italy in the fourteenth and fifteenth centuries. In northern Europe, with rare exceptions, sodomy was a sin that was largely the concern of theologians and ecclesiastical disciplinarians rather than a crime to be pursued by secular ruling bodies: the first civil regulation of 'buggery' or 'sodomy' in England, for example, was not passed until 1533; cases of sodomy in France were comparatively rare; and the only city in the Low Countries where sodomitical vice was pursued with any consistency in the later Middle Ages was Bruges.[3] In Swiss and German cities, sodomy cases were increasingly recorded during the course of the fifteenth century, but the level of persecution remained comparatively low in comparison with other offences, such as murder or theft.[4] In late medieval Italian urban centres, however, sodomy became one of the most prominent

and aggressively policed sex crimes ever known in any pre-modern context; it was an offence for which even capital penalties were regularly implemented in certain locations. In Florence, the republic's governing body identified sodomy as one of the city's most serious moral and social problems and in 1432 created a magistracy called the Office of the Night devoted solely to the pursuit and prosecution of the crime. During the 70 years in which the Office of the Night carried out its prosecutions, as many as 17,000 individuals were denounced at least once for sodomy, an average of around 240 per year in a population of 40,000; up to 3,000 were convicted and punished.[5] A similar council was set up in Venice in the fifteenth century, where the normal penalty for sodomitical 'sins against nature' was death, usually by burning, a penalty that seemed designed to hark back deliberately to the burning of the biblical Sodom and Gomorrah.[6] Sodomy was also pursued with vigour in mid-fifteenth-century Bologna, where special commissions were set up by members of the ruling council to discover those holding 'schools of sodomy' (although here the death penalty tended to be commuted to exile or whipping).[7]

The prosecution of sodomy in these regions provides the historical backdrop for one of the most memorable depictions of sodomy in late medieval literature: cantos 15 and 16 of Dante's *Inferno*.[8] But rather than attempting to create a fit between an early fourteenth-century poem and documentary material produced subsequent to Dante's death (in 1321), what I wish to consider here is a constellation of representations that emerged in wall paintings at precisely the time that 'sodomophobia' was at its most virulent in Italian culture: images depicting the punishment of sodomites in hell. These pictures, which are largely unrelated to Dante, are unique in the history of medieval sexuality, but they have never been considered together in any depth. Perhaps because of the phobic framework in which they appear, they are not mentioned in surveys of 'homosexuality in art' in the Middle Ages; nor, given their geographical specificity, are they afforded much attention in general accounts of infernal iconography in the medieval period.[9] The case study presented in this chapter will attempt to redress the balance by considering three things: first, the immediate symbolic messages of the images in question; second, their historical significance in the context of late medieval Italian judicial practice and religious proscription; and third, their participation in the wider structures informing late medieval afterlife imagery, by which individual subjects, ethnic, religious and social groups, corporations, governments and nations legitimized their claims to social, political and moral superiority.

42 'Hell', detail of Buonamico Buffalmacco, *Last Judgement*, *c.* 1332–42, fresco on the south wall of the Camposanto, Pisa.

DYING FOR ALL ETERNITY

Before turning to the deployment of sodomites as ideological objects in medieval and modern discourse, let us look closely at the images themselves. The earliest representation making explicit reference to the infernal punishment of sodomites is Buonamico Buffalmacco's depiction of hell on the south wall of the Camposanto in Pisa (*c.* 1332–42), which represents the torments imposed for each of the seven deadly sins (illus. 42). The fresco was badly damaged by exposure to the elements, as well as by a bomb in the Second World War, but comparisons with early nineteenth-century engravings made by the Italian printmaker Carlo Lasinio and his son Giovanni Paolo Lasinio help with the comprehension of particular scenes (illus 43).[10] Buffalmacco's fresco is noteworthy as a whole, in that it transforms hell from being a relatively abstract zone of terrifying torment to a highly structured judicial theatre. There are earlier instances of such an arrangement: the twelfth-century *Last Judgement* mosaic at the Basilica on Torcello is similarly divided up according to the deadly sins. But the taxonomy of sinners at Pisa is without precedent in its ability to make explicit connections between the malefactors and their sinful acts. The painting divides hell into various zones, each infernal place corresponding to the punishment of a particular fault. The six lower zones punish one of the seven deadly sins; the top zone, representing those opposed to the religion of Christ and the unity

of the Church (heretics, soothsayers, simoniacs, Muhammad, the Antichrist, an excommunicate), seems related to Pride, the only one of the seven sins not represented in the lower zone. Overall, the fresco demonstrates a desire for civic and religious cohesion, expressed through the condemnation and classification of enemies and social outcasts. Significantly, several of the sinners are labelled, a sign of the artist's attempt to transform a gruesome spectacle into a moral lesson. Sometimes the punishments are also designed to establish a visual or metaphorical 'fit' with the punished fault: the avaricious are force fed money; the gluttons are placed at a laid table, their gluttonous desires frustrated by the tormenting devils; the Antichrist is flayed, a symbol that, like the *Judgement of Cambyses* discussed in the previous chapter, articulates a disruption of the borders of the body, akin to the Antichrist's treacherous attempts to destroy Christian unity.

The sodomites themselves find their place in Buffalmacco's schema among the lustful and are represented as a pair: one is skewered from his anus to his mouth and twisted on a spit above the infernal flames by a devil, his hands tied behind his back and coiled with a serpent; the other, similarly beset by a serpent, sits in front of his accomplice and receives one end of the skewer in his mouth (illus 43). Like other sinners in the fresco, the figures have been rendered almost life-size by the artist; both look at each other with open eyes, wearing labelled mitres on their heads. (The mitre was a common method of identifying the faults of criminals in acts of temporal justice in medieval Italy.)[11] There are earlier precedents for the iconography of the sinner being turned on a spit by a devil, for instance the *Last Judgement* mosaic in the Baptistery in Florence (illus. 44 and 45) and Giotto's frescos of the same subject in the Scrovegni chapel in Padua (illus. 47 and 48). The impalement of a male body on a spit also features in an illustration in Matthew Paris's *Chronica majora*, which depicts the depravities allegedly committed by Mongols during their incursion into Silesia in 1241: here the motif is designed to associate this 'monstrous

tribe of inhuman men' with cannibalism, rather than with sexual vice per se (illus. 46).[12] Nonetheless, the Camposanto representation is the first that clearly links this mode of torment with sodomites in hell. An identical arrangement is used in the fifteenth-century frescos in the Bolognini chapel in San Petronio, Bologna, by Giovanni da Modena (illus. 49 and 70), although this time there are no mitres or labelling: the two figures are bald-headed. Here, also, the figure of the devil, who seems to point toward the skewered anus of the roasted sinner, is more prominent than at Pisa, as are the wispy flames that lick the sinner's genital region.[13] Finally, the iconography is redeployed, with some variation, in the early fifteenth-century paintings in the nave of the Collegiata in San Gimignano (illus. 71 and 72), where the artist Taddeo di Bartolo turns the arrangement round, places the skewered sodomite on his back, and, rather than roasting on a

44 'Hell', detail of Coppo di Marcovaldo, *Last Judgement* mosaic in the Baptistery, Florence, 13th century.

45 Detail of illus. 44, showing a sinner turned on a spit.

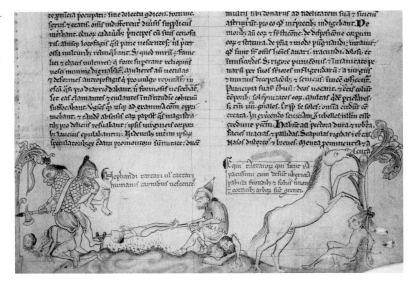

46 'Mongol depravities', miniature in Matthew Paris, *Chronica majora*, before 1259. Corpus Christi College, Cambridge.

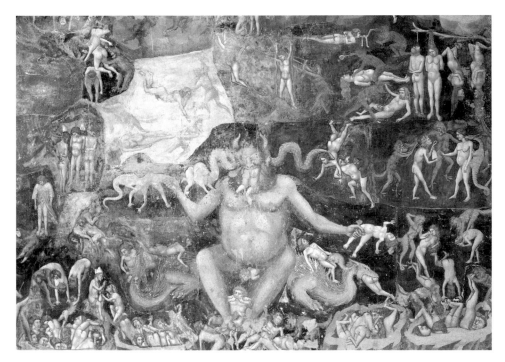

47 'Hell', detail of Giotto, *Last Judgement*, c. 1303–5, fresco in the Scrovegni chapel, Padua.

48 Detail of illus. 47, showing (top left) a sinner turned on a spit.

49 'Hell', detail of Giovanni da Modena, *Last Judgement*, c. 1410–12, fresco in the Bolognini Chapel, S Petronio, Bologna.

spit as such, simply shows him being penetrated from his arse to his mouth by a devil; here, the labelled mitre, bearing the vernacular inscription SOTOMITTO, is still clearly visible.[14]

What is the symbolic significance of depicting sodomites in this fashion? First, there is the rather obvious analogy with anal and oral sex imaged in the phallic skewer penetrating from the anus to the mouth, and then on into the mouth of another. Contrary to popular belief, sodomy has not always and self-evidently been associated with either anal sex or male homosexuality: it is what Foucault calls 'that utterly confused category', an untranslatable term that has basically been used to mean whatever anyone wanted it to mean.[15] In the writings of Thomas Aquinas, the definition of sodomy is substantially narrowed: the term *sodomia* explicitly designates sexual relations of any kind between members of the same sex.[16] Generally speaking, though, theological writings invest sodomy with notions of sin and retribution, responsibility and guilt; *sodomia* cannot be translated unproblematically as

homosexuality.[17] Sodomy might cover sexual relations between Christians and heretics, for example, or Christians and Saracens; it could encompass intercourse with animals or other 'unnatural' liaisons. Be that as it may, the images under consideration here, depicting sodomites in hell, seem to incorporate a far more restricted definition: Italian infernal iconography represents sodomy as an overtly sexualized category linked primarily to same-sex intercourse (as in Aquinas); more specifically, it associates the vice with relations between men that pivot around the penetration of orifices. Sodomy no longer appears, in these contexts, 'utterly confused'.[18]

The visual association of sodomy with penetrative acts performed between men corresponds to the particular judicial contexts within which these images arose. Prosecution records from cities such as Florence and Venice in the late fourteenth and fifteenth centuries suggest that the aspect of sodomy that seems to have proved most hateful to prosecutors was male anal intercourse and its external simulation between the thighs of a so-called passive partner.[19] In Venice, in 1467, legislation was even passed in council requiring surgeons and barbers to report anyone treated for injuries resulting from anal sex.[20] Oral sex between males was also a particular concern of prosecutors in regions such as Florence, where judicial records describe boys being 'sodomized' by receiving fellatio from older adolescents and young men.[21] So although sodomy traditionally concerned a fairly wide range of activity not necessarily linked to same-sex relations (including masturbation, any form of vaginal or non-vaginal sex that did not conform to the missionary position, and even bestiality), in Italian religious painting and judicial records it possesses some of the characteristics with which it is still associated today in both popular and legal contexts.[22]

In this way, modern notions of homosexuality may be partially connected, by an invisible but expansive thread, to the category of the medieval sodomite – a relationship that works to complicate the rupture sometimes perceived by sexuality historians between pre-modern sodomitical acts and modern homosexual personages.[23] An acts-based discourse such as medieval confession, which Foucault cites in support of the view that pre-modern selves were constructed with reference to an indefinite archive of forbidden pleasures, inevitably produces a view of sexuality as act-specific: the whole point of confession is to prevent acts of sin from becoming so habitual that they solidify into identities. But other genres (romance, for instance) sometimes betray a sense of the sodomite as a sexual identity. In these contexts, the category defines not only what one does from time to time, but also, apparently, what one is. Unlike the self-affirmative vocalizations of modern gay liberation, of course, these medieval articulations of sexual identity are rarely benign: sodomites are typically called into being in order to effect their regulation, exclusion or eradication. Yet works produced

in certain milieus apparently promoted a link between sexuality and self-hood of some sort, long before the inception of nineteenth-century forensic medicine.[24] I don't wish to suggest that the term 'sodomy' was unambiguously related to sexual identity in the medieval period, or that the sodomites of the Middle Ages were 'really early modern'. The modern terms used to describe same-sex desire, including 'sodomy' and 'buggery' (which endured, until recently, in legal contexts), are themselves vexed categories, as will be demonstrated in what follows. Rather, overly schematic applications of the opposition between pre-modern acts and modern identities are potentially disabling, for they fail to explore the multiple discursive contexts in which medieval sexuality was imagined.[25]

One genre where I think medieval thinkers *were* working with a sense of sexual identity – at least partially – is iconography depicting the after-life. This may seem odd for a genre that is clearly related to an acts-based discourse such as confession. But images of punishments in hell differ in one crucial respect from medieval confession manuals prescribing penance for the sins of living individuals: infernal sinners are labelled, essentialized even, as purveyors of certain sexual acts *for all eternity*.[26] Their bodies are simultaneously made to speak the truth of their sinful souls, in other words, and punished by an endless performance of repetitive acts that create the illusion of inner sinful depth.

Medieval afterlife imagery produces sinful essence by depicting the aberrant activity in a moment of suspended animation: the identity of the medieval sinner is constructed, in infernal contexts, by the continual exaction of punishments for all time. This space of suspension, in which identities are fashioned in the process of being paradoxically destroyed, is reminiscent of Augustine's conception of hell in the *City of God* as a place of perpetual second death:

> For that death, which means not the separation of soul from body but the union of both for eternal punishment, is the more grievous death; it is the worst of all evils. There, by contrast, men will not be in the situations of 'before death' and 'after death', but always 'in death', and for this reason they will never be living, never dead, but dying for all eternity.

This chilling passage imagines hell as a definitive space of betwixt and between. The damned, suspended *in* death with no hope of release from torment through an act of final obliteration, suffer the throes of a continually deferred death – a state where, in Augustine's words, 'death itself will be deathless'.[27] In keeping with this framework, sodomites in Italian *Last*

Judgement scenes are likewise represented undergoing what might be interpreted as a continuous process of dying, which extends for all eternity the spiritual death that their sinful sexual acts precipitated in life. In hell, in other words, one is not simply a person who engages in occasional acts of sodomy; through a process of temporal suspension, one assumes a lasting identity of sorts. The infernal sodomite, like all his fellow sinners in fact, is depicted fixed in a state that simultaneously conveys the outward traits of a sinful encounter and the chastisement of the corresponding transgression. He is 'caught in the act', as it were.

Freezing the action, in this fashion, to a moment when death's limits have been held at bay, endows the scene with ahistorical, identity-bestowing characteristics. Like the hanged in Villon's *Ballade des pendus* (discussed in chapter One), the sodomites are depicted as eternal wanderers, imprisoned in their bodies and violently inscribed as sinful subjects. But the proceedings are also confined to the moment when they are most powerfully concerned with the transgression of bodily boundaries. Just as Bernardino of Siena saw sodomy wherever he went, these images depict it always on the horizon and in our midst. The sodomites might have been represented in the instant before or after the 'crime' itself, say in the process of soliciting each other's affections, as in certain north European images depicting two young men, one of whom bears a falcon as a signifier of same-sex love.[28] Or they might have been shown with the open mouths and tiny effeminate pricks that, as Michael Camille has suggested, demarcate the sodomites in illuminations accompanying manuscripts depicting Dante's *Inferno*; or even with the hand-on-hip gesture that marks out Brunetto Latini, Dante's infamous sodomitical role model, as medieval art's first 'flaming queen' in a fourteenth-century manuscript in the Musée Condé, Chantilly.[29] But the makers of the *Last Judgement* scenes under consideration here have chosen to combine allusions to a sinful act and its punishment in a single temporal sequence. The motif thus communicates the disciplinary implications that attend to the performance of sodomitical acts, while at the same time conveying the sexual roles that sodomites were perceived to inhabit. Represented 'in sodomy' at the same time as they are eternally dying from it, the sinners neatly exemplify Augustine's concept of hell as a suspension in death.

The construction of a visual analogy between punishment and sinful act was also influenced by secular notions of *contrapasso* ('against the way', 'counter-move'), a form of natural law in which penalties echoed the crimes they punished.[30] In this respect, the medieval iconography of hell had much in common with the modes of punishment dreamed up by eighteenth-century penal reformers. One of the crucial questions that Foucault poses in *Discipline and Punish* with regard to nineteenth-century

penal regimes is why, when thinkers such as Cesare Beccaria and the *Idéologues* envisaged a kind of analogical penal 'theatre', what in fact developed was the regime of the prison. The ideals of reform and the development of the penitentiary, although they both aimed at correcting the individual, relied on quite different technologies to achieve this end: reformers proposed signs, lessons and representations as forms of persuasion, whereas prison seized the inmate's body in order to exercise, train and transform it. The reformers also insisted that these punishments be publicly displayed as exempla. 'At the cross-roads,' writes Foucault, 'in the gardens, at the sides of roads being repaired . . . will be hundreds of tiny theatres of punishment. It will be a visible punishment, a punishment that tells all, that explains, justifies itself, convicts: placards, posters, symbols . . . each punishment should be a fable.'[31] While this observation obviously makes reference to eighteenth-century writings, the medieval penal imaginary betrays a strikingly similar logic: a painting such as Buffalmacco's hell fresco is a supreme visualization of the idea that the punishment should fit the crime. Punishments act as signs, linking specific torments to specific crimes. And the depiction, specifically, of sodomitical vice in such contexts reveals how images of exemplary justice, with their fable-like iconography, worked by partially blurring the distinctions between identities and acts.

Significant in this respect is the way in which the sodomites in hell are subjected to a sort of poetic justice based on their perceived roles in the respective sexual acts they perform. Judicial records from fifteenth-century Italy suggest that the term 'sodomite' rarely included the so-called passive partners of either sex (that is to say, those penetrated phallically in the anus or between the thighs, or those who 'received' fellatio); often only those who took the active role as anal penetrators and fellators were considered sodomites, and as such received the harsher penalties.[32] In afterlife imagery, however, the sexual roles seem to have been reversed. In Taddeo di Bartolo's hell, the man labelled SOTOMITTO, rather than being the active inserter as he is supposedly accustomed, is forced into what was perceived to be the more humiliating passive role. The spelling of SOTOMITTO, indeed, appears to pun on *sodomito* (sodomite) and *sottometto* (I submit), suggesting a literal conflation of the sodomite with he-who-submits. The partner, who is possibly the 'passive' counterpart, is subjected to the seemingly less painful torment of sucking on the end of the polluted, penetrating skewer. As such, he appears to take on an ostensibly more 'active' role in the performance of fellatio. Blond-haired and youthful, the lad's genitalia are clearly visible amid the flames. Moreover, there is an inscription beside his head, hard to see now with the naked eye, the first line of which reads CATIVO: the equivalent word in modern Italian is the adjective *cattivo*

(bad / naughty). (The second and third lines of this inscription are too badly damaged to decipher properly).[33] The phrase seems designed to draw attention to the sinfulness of oral sex and perhaps, also, to the figure's distinctive 'role' in the sodomitical scenario. Given these factors, it seems likely that the two sinners are identified by the visualization, through inversion, of their perceived positions in the sexual act. Sodomy is depicted as a melding together of two separate positions of identification, active and passive, which are brought together in the performance of the vice. This produces, in turn, a coherent picture of what sodomites are believed to do with each other and how they receive their just deserts.

The conception of sodomy as a blend of acts, identities and 'roles' becomes more complex still when we consider the rare instances in which analogous penalties were applied to men accused of sex crimes in actuality. There is, of course, no direct parallel to the roasting on the spit in Italian judicial practice: the punishment for 'active' partners generally ranged from heavy fines and banishment to death by burning, depending on the age and status of the convicted individual and the number of times he had offended in the past.[34] Nevertheless, it appears that the concept of *contrapasso* conveyed by visual and literary depictions also extended to judicial practice in certain instances, as an incident in Florence in the fourteenth century bears witness. In 1365 the Florentine authorities heard that a fifteen-year-old, Giovanni di Giovanni, voluntarily allowed himself to be sodomized by numerous men. Giovanni's sentence labelled him a 'public and notorious passive sodomite' and he was subjected to an exemplary punishment. Having been dragged on an ass to the 'place of justice' outside the walls of the city, he was publicly castrated and then punished, so the sentence reads, 'in that part of his body where he allowed himself to be known in sodomitical practice'. That is to say, he was branded between his thighs with a red-hot iron.[35]

Incidents such as this suggest that, in both temporal and divine judicial spheres, sexuality was regulated according to a clear symbolic framework. Sodomy was simultaneously identified with certain positions and possibilities (perceived as inner depth) and marked out through the external re-enactment of those roles in the form of excruciating corporal penalties. The punishment in Florence of Giovanni di Giovanni articulates this movement from depth to surface on the body of the condemned; the penalty of phallic penetration also conveys a purgative logic, aimed at addressing the specific parts of the body with which the sin in question was performed.[36]

So far, the discussion has begun to unravel some of the symbolic messages conveyed by the infernal sodomitical scene. It does not, however, account for one of the most salient features of the penalty prescribed both in the earlier depictions at Padua and Florence (which, although unlabelled, *could* have been intended to make allusions to sodomitical vice), the images at Pisa, Bologna and San Gimignano, and analogous images in manuscript illuminations (illus. 50 and 51): the fact that the anally pene-trated figure is depicted as a piece of meat cooking on a spit. An anecdote from an Italian dramatic *lauda*, contemporaneous with the Pisa frescos, helps to unlock aspects of the iconography's significance.

The drama in question was written in Perugia in the second quarter of the fourteenth century and is split into two halves, one describing the Antichrist and the second the Last Judgement.[37] In the latter section, Christ addresses the damned by announcing specific penalties for the seven deadly sins and, when he comes to the sodomite, he exclaims:

Tu, sodomito puzolente	You, stinking sodomite
m'haie crocifiso notte e giorno;	have crucified me night and day;
va a lo'nferno tostamente	go quickly to hell,
en quille pene a far sogiorno.	to stay a while amid those
Mettel tosto en gran calura	punishments.
ché peccò contra natura.[38]	Put him quickly in that great heat,
	since he sinned against nature.

Christ goes on to stress the futility of repentance, and the final stanzas of the drama are devoted to depicting Satan and the devils carrying out the tortures of different sinners. The very last verse is devoted to the sodomites themselves:

Sodemite maledette	You cursed sodomites
che pecchevate contra natura	who have sinned against nature
rostite a guisa de porchette!	roast like little piggies!
Zabrin, si aggie quista cura,	Zabrin, let this remedy be followed,
fa encender bien lo forno	fire up the furnace well
e volta bien l'arosto atorno.[39]	and give the roast a good turning.

The sodomite in this description is likened to a slab of cooked meat, and more specifically to a pig.

As we have already seen in chapter One, in relation to anti-Semitic *Judensau* depictions (illus. 20), pigs in the Middle Ages were rich with

50 'Hell', miniature in Augustine's *City of God*, book 21, Boucicaut Master, Paris, *c.* 1418. Walters Art Gallery, Baltimore.

51 'Hell', detail from illuminated page in a Book of Hours, Master of Brussels Initials, Bologna, *c.* 1406–7. British Library, London.

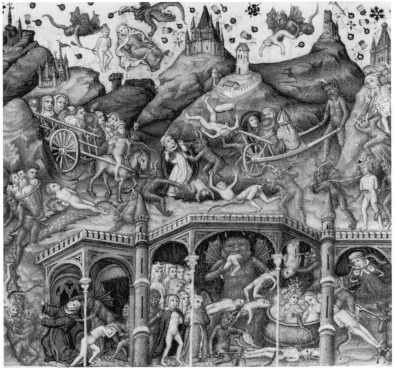

symbolic associations. Medieval Christians perceived them as 'creatures of the threshold', kept in close proximity to the home and fed the household's left-overs; they were objects of both fear and fascination. A Latin bestiary, produced in England in the late twelfth century, figures pigs as stand-ins for the sinful social outcast: 'Swine signify sinners and unclean persons or heretics.'[40] In medieval sermons, pigs were employed as emblems of greed, drunkenness and lechery; visually, their pink colouring and apparent nakedness also disturbingly resembled the flesh of babies, and in this way pigs were perceived as transgressing the binary traditionally held up between man and beast.[41] As such, pigs were a highly appropriate way of figuring sodomites, whose sexual crimes were often aligned with bestiality and sensuous indulgence; the resulting animalization also conveyed at a glance the perceived status of sodomy as the ultimate 'sin against nature'.[42] Here, like the examples discussed in previous chapters, we become witness to the dehumanizing effects of corporal punishment but also to the liminal positions in which punished bodies might be placed. Striking in this context are German *Schandbilder* depicting debtors stamping their phallic seal (often held at groin height) on the defecating anus of a female animal, commonly a sow (illus. 15 and 18).[43] The arrangement deploys the sodomitical script as a means of destroying noble identity; it aggravates the shame by equating sodomy with animalistic shit.[44] Suggestive also is the analogy that Bernardino of Siena strikes up in one of his sermons between three varieties of swine – wild boars, domestic pigs and porcupines – and a taxonomic description of what he sees as the three varieties of sodomites.[45] Pigs, it seems, were ripe for a range of symbolic interactions with defamatory rhetoric about sodomy. In keeping with these associations between sodomy and animal allusions, sodomites in Italian *Last Judgement* scenes likewise become transformed into animalistic pigs turning on spits and penetrated up the arse; manoeuvred into an alignment with cooked meat, they are represented as inhabiting the threshold states that denote, in the border zones between man and beast, a form of life without symbolic legitimacy.

IDENTITY, ANAL RHETORIC AND ABJECTION

Medieval hell iconography also displayed an interest more generally in metaphors of corporeal ingestion and anal expurgation. Christian eschatology has always reflected a peculiar fascination with images of mastication and regurgitation, both in the context of hell and of the resurrection of the dead.[46] Demonic chefs are depicted in infernal settings, cooking sinners in giant cauldrons; souls are shown roasted on grills; sinful women

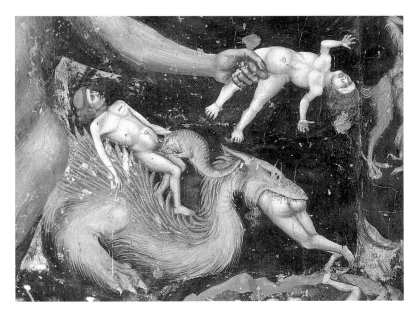

52 Detail of illus. 47,
showing a sinner's
genitals being
devoured.

have their breasts bitten by serpents; the genitals of their male counter-
parts are devoured by dragons (illus. 50–52). Taddeo di Bartolo's hell at
San Gimignano is especially striking for its representations of immod-
erate consumption: five portly gluttons are tempted with a table of culi-
nary delights but prevented by the devils from actually eating or drinking,
while a sixth in the foreground simultaneously stuffs / shits himself; in the
adjacent scene a devil excretes coins into the mouth of a usurer, one of
the representatives of avarice (illus. 53). The mouth of hell, which emerged
in the eleventh century in England and France, assimilates damnation itself
with the terrors of bodily consumption: the jaws of Leviathan are repre-
sented in the top register of the Pisa fresco, to the right, swallowing
Muhammad and the excommunicate (illus. 42).[47] From the fourteenth
century onwards, moreover, Italian *Last Judgement* scenes show hell dom-
inated by the image of Satan, stuffing sinners into his greedy gob before
expelling them from his backside (illus. 42, 47, 49 and 71).[48]

The scatological preoccupations exhibited in these scenes demonstrate
a peculiar interest in bodily processes and the transgression of corporeal
boundaries. Similar concerns are registered in medieval responses to
sodomy in cities such as Florence, Venice and Bologna. As I have already
suggested, attempts to regulate sodomy in these locations focused above
all on policing the 'unnatural' anal and oral dispositions of those tending
toward sodomitical vice. Thus, the invention of graphic, anally fixated

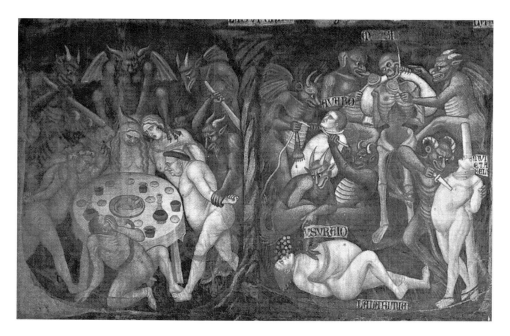

penalties for *all* sinners in visions of the afterlife may be related, albeit indirectly, to heightened fears of anal sexuality and sodomitical vice in late medieval Italian prosecution records. Furthermore, depictions of the sinner in hell as masticated, regurgitated shit and images of sodomy as anal penetration and roasting both participate in a process of identity formation that was to become the great labour of bourgeois cultural production in centuries to come: the creation of an invincible, guiltless self through the expulsion, or negative introjection, of elements that surround and threaten it.[49]

Charting the emergence of a class-inflected 'civilizing process' in late medieval Italy goes beyond the scope of the present study: independent evidence supporting the convergence of medieval concepts of class with modern notions of bourgeois sensibility would be required to make such an argument convincing. But just as dissociation from the abject was an important element in certain strands of late medieval Netherlandish panel painting (constituting what I termed, in the previous chapter, a '*burgerlijk* aesthetic'), I would like to suggest that, in Italian civic contexts, the depiction of punishments in the afterlife was one of the mechanisms by which a group or class or institution made a bid for political and ideological supremacy.[50] After all, the patrons of Italian *Last Judgement* paintings were typically well heeled, often merchants and bankers, members of the middle

classes: like the *Judgement of Cambyses* in Bruges, these were class-specific commissions, produced in a climate of moral anxiety surrounding money.[51] Bartolomeo Bolognini, one of the wealthiest citizens in early fifteenth-century Bologna, left precise instructions concerning the iconography of the Bolognini chapel frescos in his will, including the depiction of 'terrifying infernal pains' above his tomb.[52] Hell was also an important element in the frescos commissioned by Enrico Scrovegni for his chapel in Padua (illus. 47). The Scrovegni were, by the late thirteenth century, one of the city's leading banking families; Reginaldo, Enrico's father, even earned a place in Dante's *Inferno* thanks to his usurious practices.[53] It is little wonder that Giotto depicted Enrico kneeling in the pose of a donor at the bottom of the *Last Judgement* fresco, just to the left of hell, presenting a model of the chapel to three haloed figures.[54] Significantly Judas, the archetypal proprietor of ill-gotten gains, was also painted, to the right of the donor figure, hanging from a tree in hell. Commissions of this sort were clearly motivated by concerns to atone for sins related to the acquisition of wealth. To represent hell in this way meant, paradoxically, to avoid it.

Within a climate aimed at penitential reflection, we can thus locate attempts to dissuade viewers from sins of which the patrons were themselves guilty: the evils of avarice and usury. But is it possible that patrons had a personal investment in representing other sins as well, vices such as sodomy? In late medieval Italy, after all, sodomy was conventionally believed to be a vice of the rich and powerful. When Bernardino of Siena preached against the Florentine practices that he presumed led to sodomy, he specifically addressed the privileged classes: 'You don't make your sons work in a shop, nor do they go to school to learn any virtues . . . they're good for nothing but lusting with sodomites'; the sodomites of Dante's *Inferno* are described as 'clerks and great men of letters, of great fame, all fouled with the same sin in the world'.[55] This is not to say that the *actual* social make-up of those accused of sodomy was, in fact, clerical, aristocratic or mercantile: in Florence, sodomy seems to have been practised across the social spectrum.[56] Nonetheless, given the moral climate affecting afterlife commissions, it is feasible that affluent individuals such as Bartolomeo Bolognini had a stake in asserting their purported 'normality' by visually excluding elements deemed stereotypically part of their social make-up. In other words, images of hell may have been deployed, in part, as a space in which individuals or social groups could vicariously discover their 'own' transgressive pleasures – be they greed or usury or even sodomy – under the sign of abject 'others'. It has been suggested by more than one commentator, indeed, that Bernardino himself came into direct contact with sodomy in his own boyhood, even that he was himself a 'repressed homosexual': he recounts in his writings how he was propositioned by

older sodomites as a lad, encounters that have been used to explain the zealousness with which he attacked the vice in adult life.[57]

Just as the didactic logic of Italian hell iconography warranted the viewer's disassociation from certain sinners – that fact that we are, or should be, not that or *that* – medieval Italian sodomy discourse similarly deployed rhetoric whose aim was to shore up normative social categories. In his sermons, Bernardino frequently laments the danger to the family unit posed by sodomy and the corruption of young boys; he complains about the dangers of population decline, the threat to civic identity resulting from the wrath of God and the sheer embarrassment of being associated with such unnatural vice. Sodomy is, he suggests, a limb that must be amputated from the body politic, an infection and a cancer.[58] 'You don't understand', he announces, 'that this is the reason you have lost half your population over the last twenty-five years. Tuscany has the fewest people of any country in the world, solely on account of this vice.'[59] Venetian laws adopt similar rhetoric: everything must be done, a statute of 1496 states, 'in order to extinguish and efface the exceptionally common and horrible sin and crime of sodomy in your city, which is against the propagation of the human race and a provocation of God's anger on earth'.[60] We hear echoes in these laws of the demographic catastrophes caused by plague in the fifteenth century and related anxieties about marriage, children and family life nourishing perceptions that sins 'against nature' threatened to rock the very foundations of human society.[61] There are also indications suggesting the conflation of sodomophobia with xenophobic prejudice. A Florentine statute of 1325 attributes the 'contagion' of sodomy to foreign vagabonds; those prosecuted for sodomy in fifteenth-century Bologna often came from outside the city.[62] These examples demonstrate how, in its strategic deployment as a perceived threat to the civic body politic, sodomy was transferred from the sexual to the social and endowed with a pernicious rhetorical function.

The state itself had an important stake in expelling sodomy under the sign of the sinful 'other' in order to shore up its own metaphoric boundaries. In fifteenth-century Florence, for example, sodomy became a crucial term in the political wrangling that ensued in the transfer of power from one regime to the next. At the end of 1494, after the fall of the Medici, the restored Republic of Florence passed the harshest sodomy legislation in the city for decades, overtly reproaching the former regime for its indifference to the vice in the past:

> Considering . . . how abominable and disgraceful before both God and men is the most wicked vice of sodomy, and how much injustice and little fear of God there has been for some time concerning the repression and extinction of this vice because of the evil

government of the past regime, [the priors wish] to reform the law as is necessary in a Christian and religious Republic.[63]

As we have seen, the fantasy of the sodomite in late medieval Italian wall painting generates a nexus of identifications between degenerate bodies, unnatural acts and sinful sexuality that is comparable in brutality. The abject is appropriated in both legal and iconographic contexts as an unliveable, uninhabitable zone that produces the defining limit, the 'constitutive outside', of a particular identity, institution or abstraction; the visual and legal denigration of sodomy represents but one manifestation of the phenomenon by which individual subjects, cities, corporations, governments and even nations produced themselves in the Middle Ages, as today, through processes of exclusion and abjection.[64]

An analogy with modern appropriations of sodomy discourse may prove instructive in this context. Recent debates in contemporary Britain over the retention of Section 28 – a piece of local government legislation repealed in 2003, which sought to prevent schools and local authorities from 'promoting homosexuality' and, more specifically, from promoting homosexuality as what it termed a 'pretended family relationship' – suggest that sodomy in modern history, no less than in medieval Italy, retains its status as the negative term in the construction of everything from individual subject status to party political identity and statehood.[65] In a House of Lords debate in 2000, for example, the Tory peer Lord Waddington declared:

It is quite wrong that [children] should be taught . . . that a homosexual relationship is equally as valid and normal as a heterosexual one and that sodomy is perfectly acceptable behaviour. There are two obvious reasons why that is wrong, which have already been mentioned . . . First, such teaching runs entirely counter to the teaching of all the main religions in the world and contradicts the belief of the great majority of people who can see from their own knowledge of anatomy and biology that sodomy is an unnatural act. Secondly, to teach young people that a homosexual relationship is as normal and valid as a heterosexual one is to conceal from them the appalling health risks involved in homosexual behaviour in general and sodomy in particular.[66]

Sodomy, despite being what Foucault calls an 'utterly confused' category, has been resurrected in a modern parliamentary debate without question and made to perform its unashamedly homophobic work; once again sodomy becomes an unnatural act that inspires the wrath of God, threatens the family, puts the young in danger and carries with it the spectres of

disease and death. If the sodomites in medieval representation are figured as pigs roasted on spits and animalistic plague-spreaders, in House of Lords debates they become performers of 'unnatural acts' with 'appalling health risks'. The association of sodomy with repetitive enactment ('sodomy is an unnatural act') in Waddington's speech confounds the easy distribution of sexuality into a periodization of pre-modern acts and modern identities. Indeed, as I am implying here, the peer's veiled reference to AIDS is just one manifestation of an ideological rearguard action aimed at policing what constitutes society and the 'family': like the sodomites in hell on their spits and the anally purged 'passive sodomite' Giovanni di Giovanni, or as in Florentine statutes conflating sodomy with plague and demographic decline, the sinful body is figured in state-sponsored representation as the outer locus of (imagined) inner psychical depth, manifested as disease or perverse sexual act.[67] Here is a space in which medieval and modern touch in telling, if unsurprising, ways.

There is, nonetheless, another way in which these medieval sodomitical tableaux may partially chime with modern concerns. One example of pre-modern penal technologies being seized upon by communities as a means of oppositional self-definition is found in modern gay liberation discourse in the USA and Britain, which went through a phase of naming gay sexual spaces as 'dungeons' and 'infernos'. Conversely, recent journalistic reports of the advent of a 'post-AIDS' world of fully assimilated gayness have arguably imposed a medieval-style penal imaginary on modern experience, by effectively separating the post-AIDS 'saved' from the pre-AIDS 'damned'.[68] As we have seen, the deployment of medieval vocabulary such as 'sodomy' and the associations that certain sexual practices are forced to endure with death, disease, bestiality and the preparation of food produced similarly normative effects. Nonetheless, these discourses also presumably had the capacity to sustain a limited amount of oppositional force when read against the grain. Comparable to the iconography of infernal sodomites, after all, is the appropriation of the phrase 'spit-roasting' in recent British gay sexual fantasy and practice. For some years now the expression has been used by gay men to describe the practice of 'taking it both ways'; being on the receiving end of a spit-roasting is seen as an eminently attractive possibility, with those who wish to be the objects of the spit apparently outnumbering those who would like, as it were, to 'perform the roast'. In recent years, a London nightclub has even advertised a weekly event on its premises bearing the title 'Spit Roast', presumably to communicate the fact that the prospect of a menu of uninhibited sex awaits those who attend.[69]

I suspect that the coining of the phrase 'spit-roasting' has parallels with straight pornographic depiction, where it is potentially inflected with

misogynistic overtones (transforming the female 'victim', like the medieval sodomite, into meat).[70] The wording possibly even originates in these heterosexual contexts and I am not suggesting that in modern usage it is always subversive. But despite having no direct or perceptible ties with the medieval iconography of spit-roasted sodomites in hell, the deployment of fantasies of animalization in modern queer lives draws attention to the possibility that medieval iconography might itself have held out the prospect of queer, unstable, non-normative and identity-conferring effects for certain pre-modern beholders. Rarely, in medieval religious instruction, are sodomitical acts visualized or explicitly described; sodomy is traditionally the 'unmentionable vice', what Chaucer's Parson dubs an 'abhomynable synne' that nobody 'oghte speke ne write'.[71] Yet, in the Italian *Last Judgement* scenes discussed in this chapter, sodomy is given much more than a mention: it is depicted visibly, in the guise of punishment, as an act taking place between two men and involving what looks like oral and anal penetration. Thus, if the lesson for medieval beholders was that sodomitical acts would be punished in eternity, the didactic aims also had the potential to backfire, fuelling the imaginations of a cluster of medieval sodomites and queers. This is speculative thinking, of course, but in the context of the sodomitical networks that historians have uncovered in late medieval Italian urban centres, it may, just may, have produced such an eventuality for a favoured few.

CHAPTER 4

Invincible Virgins

Generally speaking, the representations encountered so far were designed to foreclose identification with the punished body-in-pain. Looked at the right way, of course, these images do have the capacity to elicit empathy with the sufferings of the hanged or with the victim of judicial flaying, or even to provoke meditation on the roles, identities and sexual proclivities of sodomites. But, in the Middle Ages, the institutional contexts and cultural affiliations of depictions of this sort militated against their reception as habitually 'victim-identified' productions. Conversely, the second half of this book explores representations that make efforts to persuade viewers to adopt the point of view of the suffering body, touching it with their eyes and incorporating it affectively into their field of vision. The images in question are religious and portray the torments inflicted on martyred saints and Christ. These depictions, too, have the ability to give rise to 'resistant' responses, responses that go against the institutional, cultural or historical grain. Spectators might look with the torturers rather than the saints, for instance, or focus on modes of suffering that get occluded in the medieval Christian imaginary. But the most striking feature of passion and martyrdom iconography from this period is that, on a regular basis, the viewers are deliberately brought into alignment with the perspective of a tormented sacred object and invited to regard that pained entity as a focal point for desire and spiritual transcendence.

At first sight, this is not always immediately apparent. After all, the painting at the centre of the present chapter's investigations, though clearly devoted to the body of a martyred saint, has also been viewed – controversially – as a manifestation of pious pornography and as an embodiment of the objectifying logic by which men enjoy looking *at* (rather than identifying with) a suffering female body. Attributed to Master Francke, a Dominican friar working in Hamburg in the fifteenth century, the painting (which is part of a larger altarpiece now in the National Museum of Finland, Helsinki) depicts the *Martyrdom of St Barbara* in a sequence

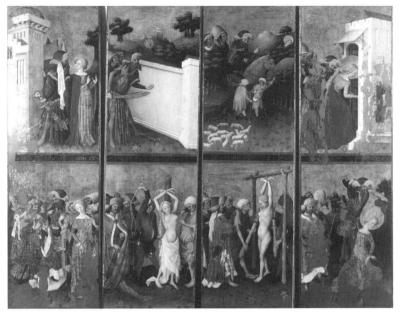

54 Master Francke, *Martyrdom of St Barbara*, c. 1410–15, tempera on oak. National Museum of Finland, Helsinki.

of eight interconnected panels (illus. 54 and 55). The scene that has pro-voked the strongest sentiments in modern criticism depicts Barbara's agonizing torments, following her declaration of Christian faith (illus. 73). The image shows the saint tethered to a stake, her arms raised tortuously above her head. The martyr's long, golden hair falls in tresses down her back and her only clothing is a loose cloth wound seductively around her waist. To her right, in the foreground, is the pagan prefect Marcien. His hands are clasped firmly around the handle of a long, menacing weapon, as if ready to draw, and his eyes stare fixedly at his victim's denuded upper

55 The *St Barbara* altarpiece, with wings folded out to reveal scenes from the *Life of the Virgin*.

body. Beside him is Barbara's father, Dioscurus, who lays a hand on the prefect's shoulder. The gesture is not one of deterrence by a pained father: it implies that he views Barbara's torture as a necessary evil from which he will not interrupt the prefect. (After all, it was the father who turned his daughter over to the prefect for trial and who will go on to behead her with his own hands in a subsequent scene.) What the torture consists of is a horrific battering of Barbara's naked body by two swarthy and repulsive tormentors. To her right, a pot-bellied, whip-wielding brute tugs her hair; to her left, his shabbily dressed accomplice fingers her lower breast and prepares to slice it off. Barbara, meanwhile, seems quite unmoved by the whole experience. Her cheeks retain their rosy tint; her eyes are raised heavenwards; and her lips even wear the hint of a smile.

Francke's painting is uncannily reminiscent of a passage by the feminist critic Andrea Dworkin in her book of 1981, *Pornography: Men Possessing Women*. Dworkin, describing a pornographic feature entitled the 'Art of Dominating Women', comments:

> The third photograph . . . shows the woman tied at her wrists and above her elbows by white rope, arms raised over her head, gagged. The workman in overalls is grabbing her breast. He is approaching the breast with pliers. The fourth photograph . . . shows the gagged woman to just below her breasts. The hand with the pliers is also in the picture. The pliers appear to be cutting her breast.[1]

The photographs are followed by a case history detailing the sexual adventures of the victim. Dworkin continues:

> The conceit is that this is a woman's story told in a woman's voice, a woman's celebration of the force she seeks out so that she can submit to it, be hurt by it, and experience her transcendent femininity . . . The white woman, the totally submissive woman, demands total force, total pain, total humiliation, at the hands of a male racially stereotyped as a sexual brute . . . she is the unquenchable submissive whose femininity is fulfilled in the most abject degradation.[2]

The two images – Francke's and the contemporary pornographer's – seem so structurally alike that Dworkin's words, taken out of context, might easily be used to describe the ordeal of St Barbara. Dworkin's argument about representations of this kind is that they reflect a male supremacist ideology, but she also maintains that they underpin abusive practices in the real world – practices that include rape. For anti-pornography com-

mentators such as Dworkin, writing in the 1980s, heterosexual relations between men and women are characterized by the inherent violence of the male role; this violence, they suggest, is both expressed in and inspired by pornographic fantasy, which, with its reliance on a phallic economy of objectification, fetishization and male power, ultimately underwrites a theory and practice of rape.[3]

Similarly, in recent years medievalists have suggested that written lives and paintings depicting the tortures of female virgin martyrs are infused with pornographic content and that this is intimately connected to matters of rape. The art historian Margaret Miles coined the phrase 'religious pornography' to describe paintings such as Francke's; more recently Madeline Caviness has suggested that Francke's altarpiece risks aligning the viewer's line of sight with those of the torturers and 'phallocrats', in order to produce affects comparable to contemporary pornography. 'Viewing these spectacles ahistorically', Caviness writes, 'we are confronted by a blonde who has been tied up, partially stripped, with her garments now slipping below her pubis, being subjected to sadistic threats and vulnerable to gang rape.'[4] Literary critics have been similarly disposed: with the publication of Kathryn Gravdal's groundbreaking study of rape in medieval French literature in 1991, many of the issues raised in feminist debates on rape and pornography in the previous decade were brought to bear on medieval literature from a variety of genres. Commenting on saints' lives in Old French and Latin, Gravdal makes the point that female virgin martyr legends commonly betray an interest in motifs representing the prospect of sexual coercion: forced prostitution, harassment by a pagan seducer, imposed marriage, and even, on occasion, rape itself. Although these attempts at sexual violence are never in fact successful and the virgin's virtue always remains miraculously untarnished, Gravdal suggests that they nonetheless afford a space in which audiences can contemplate images of female nakedness; the act of rape, moreover, is displaced metaphorically onto scenes of torture, which fetishize the saint's upper body as a snare for visual attention (for instance, in scenes of breast removal) and penetrate it with an assortment of phallic objects.[5]

Subsequent to the publication of Gravdal's book, much attention has been lavished on the 'rape plot' of female virgin martyr legends, an interest that resonates with the topics dominating certain strands of mainstream feminist criticism in the decade before. Although displaying important differences of opinion as to the significance of saintly sexuality, these studies have done much to highlight the status of rape motifs and pornographic content in English and French hagiography.[6] The purpose of this chapter, however, is not to conflate the political agendas of the feminist anti-pornography movement with the concerns of medieval literary

scholars and art historians about hagiographic violence, nor to lump thinkers in either category together, as if they represent some sort of ideological monolith. Even as I explore the ways in which the two fields might be partially connected, it is important to be aware of the distinctions within and between them. It is not clear, for instance, that modern readers of saints' lives advocate the suppression or destruction of images and texts deemed pornographic. The anti-pornography positions advocated in the 1980s and '90s frequently favoured censorship, construing pornographic depictions as injurious acts that have 'real' effects on those who view them, acts producing fantasies that are both liable to reproduction in the real world (by men) and experienced as degrading (by women). Medievalists have an interest in treating such depictions as symptomatic of particular ideological structures in the past, but they would presumably not go so far as to advocate the iconoclastic battle cries of certain anti-pornography critics that 'Art will have to go'.[7] In this respect, studies of medieval hagiography may have more in common with the 'anti-censorship' wing of pornography criticism, which argues that pornography is a meaningful text about the sexual acts it represents.[8] On this basis, arguments have been made that hagiographic representation does not simply signify as a function of normative patriarchal power, but may also incorporate recuperative or empowering models.

At the outset, then, it is worth pointing out that the modern pornography debate produces no easy fit with critical responses to medieval saints' lives, even if it has provided the circumstances for some of its most powerful feminist interventions. Several scholars have written eloquently of the ways in which the 'pornography of representation' delineated by certain modern critics does not, in fact, always provide the most productive interpretive framework for exploring female saintly imagery produced in late medieval England, since a focus on the historical specifics of hagiographic representation draws attention to the fact that scenes of female victimhood and sexualized torture are not the norm in this particular context.[9] It should be recalled that what we now label as pornography is a predominantly post-medieval invention, tied to the creation of bourgeois standards of privacy and the emergence of print culture, which allowed for the mechanical reproduction of transgressive imagery within the context of a market economy.[10] To ignore this material context for modern pornography would be to collapse the distinctions between images produced by different technological processes and distributed by alternative means to particular social groups.

At the same time, in the course of historicizing our terms, we are not necessarily obliged to throw the baby out with the bathwater. An alignment between hagiography and pornography may prove helpful to the

extent that it draws attention to points of partial connection, identification and analogy with modern processes of viewing, imagining and identifying. Pornography and hagiography are complex, ideologically resonant genres, which signify in very different ways according to temporal and spatial circumstance; but this does not mean that structural parallels between the two should be ignored completely. When medievalists have deployed the term 'pornography' or alluded to voyeuristic practices in their writings, the tendency has been to exploit the senses in which these words are customarily marshalled by anti-pornography critics; it is as though the deployment of words such as 'pornography' enters into an accusatory mode of address, in which the position scorned is that of an (implicitly male) beholder who adopts the position of a prospective rapist in the hagiographic plot. When the concept is restricted in this fashion, the unpredictable, animated and *embodied* dimensions of response risk being downplayed (facets of the medieval penal imaginary that have been at issue throughout this book). A more capacious definition of pornography, on the other hand, which views pornographic depiction as a site of fragmentation that produces a splitting or multiplication of identifications, may help to draw attention to the ways in which hagiography, likewise, exploits a viewer's capacity for cross-identification across bodies, subject positions and genders.

The pornographic is not a self-evident category in modern criticism but a site of intense debate and disagreement.[11] The assumption that it can be applied only to medieval texts and images in a singular, ahistorical fashion seems to me, in this respect, misguided. The cultural significance of pornographic depiction is not all-encompassing or restricted to a single point of view. Certainly, it has the power to cause deep offence to certain viewers, even as it simultaneously stimulates and arouses others; it may even give rise to the continuing production of fantasies in certain situations, reproducing and inadvertently proliferating meanings in ways that contradict the intended purpose of the representation itself. Defining pornography as a space of fantasy and multiplicity, in other words, we may be in a position to interrogate some of the more 'offensive' or objectionable responses to medieval hagiography that remain unaccounted for in readings that simply emphasize a gender-inflected rape plot or, conversely, saintly empowerment. Hagiography, like pornography, is a field of suspended action: action that takes place in the imaginations of viewers and readers, rather than simply in the visions of artists and writers.[12] This means that the action represented *in* the image does not necessarily correspond to the action *of* the image. Moreover, what looks on the surface to be a set of texts and images encoding narratives about rape or gendered resistance can function, all the same, to denigrate the figures of the

tormentors on the basis of religion, ethnicity and social class (among other things), so that the 'victim' of hagiography – its scapegoat – is not necessarily coextensive with the saint.

SUBLIME OBJECTS

Returning to the panels that are the focal point of this chapter, domination and submission are both at issue within the space of suspended action generated by the scenes of Barbara's martyrdom. My argument in what follows concerns first of all the distribution of these roles in the texts and images, and then ultimately in the minds of viewing subjects.

Barbara's story was enormously popular in the later Middle Ages, particularly in Belgium and France, where it was narrated in poetry, prayers, hymns, prose and above all drama.[13] The exact source of Master Francke's iconography is unclear and I draw here on a late fifteenth-century French prose rendition.[14] The story in the *Vie de Sainte Barbe* runs as follows: Barbara is the exceptionally beautiful daughter of Dioscurus, a rich pagan king from Nicomedia. She is also incredibly well versed in arts and science and her philosophical enquiries lead her to question pagan practices such as idolatry. News reaches Barbara from Alexandria that a priest called Origen has grasped the existence of 'the true God', and she writes to him and receives knowledge of the Christian faith. After the didactic prologue, the prose text focuses more specifically on the passion sequence that is the subject of Francke's painting. This section begins with a scene in which Dioscurus, admiring his daughter's great beauty, decides that he doesn't want other men to fall in love with her. This seems designed to crystallize the patriarchal structures of looking by which women are transformed into chattel (even if, in his jealousy, Dioscurus ultimately refuses to allow her to become an actual object of exchange between men). The king decides to build a large tower in which to lock up his daughter 'like a very noble and excellent treasure';[15] when suitors approach with a view to marrying her they are firmly refused. Barbara announces that she wishes to take a vow of chastity, which makes the covetous and unsuspecting king overjoyed. He decides to build a sumptuous bathhouse in celebration, but is called away on imperial business, at which point Barbara descends from her tower. Entering the newly built bathhouse, she has a vision in which the mysteries of the Christian faith are revealed, including the symbolism of the Holy Trinity. Seeing only two windows in her tower, the saint orders the workmen who were building the bathhouse to add a third in honour of the Trinity, after which she receives baptism miraculously at the hands of St John the Baptist; this is an act that seals her conversion to Christianity.

On Dioscurus' return, Barbara renders an account of the Trinitarian significance of the three windows and declares that she has promised her virginity to the member of the Trinity that has assumed 'char humainne' (human flesh), which, provoking her father's outrage, causes him to raise his sword to kill her. This moment is the subject of the first panel in Francke's painting: Dioscurus has his hand on his sword hilt, while Barbara is depicted counting on her fingers (illus. 56). In the next panel (illus. 57), we see Barbara's miraculous escape to a mountain outside the city walls. In Francke's rendition, Dioscurus clenches his fist and brandishes his unsheathed weapon at groin height, accompanied by a band of staring onlookers who peer through cracks in the wall, in an arrangement with voyeuristic overtones. Panel three depicts Dioscurus setting off on horseback in pursuit of his daughter, whose whereabouts is betrayed by a deceitful shepherd (the painting shows how the betrayer's sheep, as punishment, are turned into locusts). Next, Barbara is dragged from the mountain by the hair to be shut up once more behind bars (illus. 58), before being handed over to the pagan prefect, Marcien, for trial (illus. 59). In the latter episode, the objectifying logic of masculine vision is again personified in the painting by the presence of three jailers, two of whom also featured in the earlier episode at the wall. The men, wearing the caricatured expressions typically imputed to late medieval fops and executioners, press themselves against Barbara's sides, running their hands along her upper body and ogling at her face with lustful eyes.[16] The panel bears comparison with passion iconography depicting *Christ before Pilate* or the *Mocking of Christ*, where the soldiers circle their prisoner in a claustrophobic manner (illus. 60). But the wide stares of Barbara's tormentors, contrasting wildly with the martyr's half-closed lids, also appear to accentuate visually the logic of the 'male gaze': a world in which voyeuristic and fetishistic pleasure transforms the female subject into an erotic object.[17]

The scenes that follow the trial render these structures of looking even more apparent. These depict, after Barbara refuses to sacrifice to idols, the saint's disrobing, dismemberment and torture. The first (illus. 73) illustrates the episode in the prose account when the maiden is stripped naked and her breasts sliced off with an old sword, 'in order that the incision should be made much more prolonged and painful'.[18] Surviving her first bout of torments, in the text version Barbara is thrown back into jail, where her wounds are healed by a visit from Christ, who declares 'Barbara, comfort yourself because great joy awaits you in heaven . . . I am with you and will deliver you from all the wounds which have been inflicted upon you'.[19] Although Francke does not portray this event specifically, in the seventh panel (illus. 74) Barbara's intact body conveys the substance

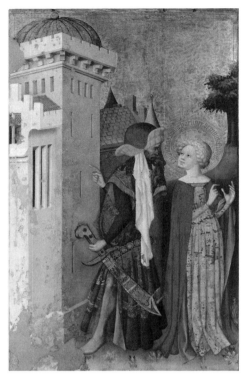

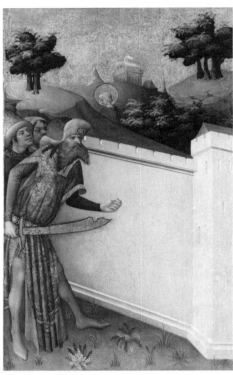

56 'Barbara explains
the Trinity to
Dioscurus', a panel
from Master
Francke's *Martyrdom
of St Barbara*.

57 'Barbara escapes',
a panel from Master
Francke's *Martyrdom
of St Barbara*.

of her miraculous recovery by implication; like a character in a *Tom and Jerry* cartoon, she bounces back from her ordeal unharmed.[20] This time, the saint's flesh is burned with fiery torches – again addressed to her upper body – and her garments are more revealing still; once again, Marcien clasps his sword and leers at her exposed chest. In the text version, the martyr undergoes further ordeals, such as being dragged around the town naked in a dramatic ritual of public exposure (a humiliation from which she miraculously escapes thanks to a rescuing angel who delivers a white stole to protect her from wanton looks). Then, in the final panel, Dioscurus prepares to decapitate his own daughter, who kneels timidly at his feet. The former does, of course, get his just deserts in the written account: as he descends the hill on which Barbara was executed, he is struck by lightning and his body disappears without trace.

As I have implied in my description so far, Francke's painting seems replete with references to gratuitous violence, objectification and female passivity. Thus it may afford, as Gravdal puts it, 'a sanctioned space in which eroticism can flourish and in which male voyeurism becomes licit,

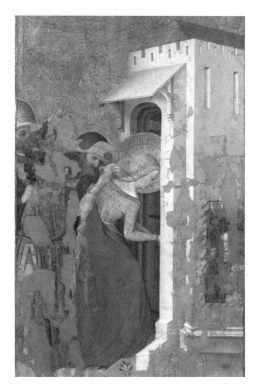

if not advocated'.[21] But does this mean that, for certain respondents, it functioned as figurative rape? And if so, to what end? For proponents of the anti-pornography movement the voyeuristic structures of pornography ultimately construct an ideological 'blueprint' for rape.[22] Certain pre-modern commentators likewise presumed a causal connection between spectacle, representation and action. For instance, the early Church father and iconoclast Tertullian famously declared: 'every public exposure of an honourable virgin is [to her] a suffering of rape'.[23] This is an argument that, like those of anti-pornographers, equates representation and corporeal revelation with actual sexual violence. But would some medieval viewers have responded to Francke's painting in this manner, effectively 'raping' Barbara with their eyes?

In addressing this issue, it may be helpful to focus on the narrative frameworks in which rape is imagined in medieval saints' lives. The most important thing to note is that, while rape is always clearly at issue in virgin martyr legends, actual forced sex nonetheless remains *unrepresentable* within the Christian symbolic order, a theoretical possibility that is not

58 'Barbara goes to prison', a panel from Master Francke's *Martyrdom of St Barbara*.

59 'Barbara's trial', panel from Master Francke's *Martyrdom of St Barbara*.

realizable as such. Most virgin martyr legends – Barbara's included – originally date to the late antique period, a time when Christian communities experienced physical and ideological assaults from various quarters. Be that as it may, early Christian representations describing persons as bodies experiencing pain may not simply be realistic reflections of a historical 'reality'; they also potentially operated as part of a far-reaching formulation in the culture of the period depicting the human self as a suffering body. Within Christian texts, moreover, this understanding of selfhood was presented as empowering: pain could be redemptive, death a victory. Indeed, according to Judith Perkins, representations of suffering selfhood produced in this vein fuelled Christianity's growth as an institution.[24] In this context, the figure of the virgin martyr, resistant to violation, would have been an especially valuable representational trope, an icon of

impregnability and a symbolic stand-in for the beleaguered but ultimately invincible Church.

This is a function that remained important in later periods, when Christian communities apparently had a continuing stake in representing themselves as both victorious and constantly under threat. Although audiences in the later Middle Ages were temporally distant from the period of early Christian persecution, the vigorous production of vernacular texts about martyrdom between the twelfth century and the fifteenth attests to the long-term appeal and symbolic value of martyrdom as a cultural phenomenon.[25] The virgin body, in particular, possessed a strong representational significance in medieval Christian ideology, since it was an ideal metaphor for order and invincibility. In a period of crusading zeal, when anti-Semitic narratives about host-desecrating Jews competed for attention with stories about Saracen aggression, the contained but endangered body of a virgin allowed hagiographers and artists to imagine and symbolically inscribe the perceived coherence of, and threats to, the *corpus verum*, or true body, of the Church.[26] The miniature from Matthew Paris's *Chronica majora*, depicting Mongol atrocities committed against, among other figures, a naked woman tied to a tree by her hair (who is presumably meant to represent a raped or about-to-be-raped virgin), neatly reproduces the logic by which, in the space of representation, individual threatened bodies become metaphoric stand-ins for a communal body politic that perceives itself to be in danger (illus. 46). The text that accompanies Paris's miniature describes how 'virgins were raped until they died of exhaustion; then their breasts were cut off to be kept as dainties for their chiefs'; these remarks are prefaced by a statement that the Mongol terror is punishment for heresy and other sins then being committed by Christians. The implication is that the violence committed against individual Christians from outside mirrors the disintegration of the Christian body politic from within.[27] The motif of circumvented rape in the *Vie de Sainte Barbe* likewise encodes this principle of appropriating violated bodies metonymically, to conceptualize and circumscribe the boundaries of Christianity. The saint's body is imagined in the throes of extreme sexualized violence – her breasts, too, are removed – while she simultaneously remains inviolate and sexually pure. This conveys an essential and ubiquitous hagiographic paradox: the juxtaposition of violence and virginal impermeability.

In visual images of martyrdom, motifs of suspension are deployed to communicate this paradoxical situation to the viewer. In the two panels where Barbara's naked body is subjected to torture (illus. 73 and 74), the artist has frozen both scenes to moments just seconds before blood is shed, creating an instant of narrative tension that accentuates the erotic

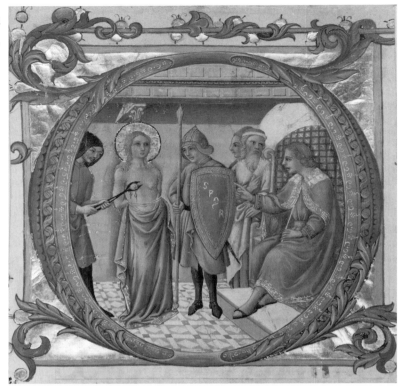

draw of Barbara's about-to-be-attacked body by guiding the eye toward
the saint's tender, unbroken flesh.[28] This presents a contrast to images
depicting the martyrdom of St Agatha, which often show blood flowing
from the virgin's right breast in order to make a typological connection
with the wound in Christ's side; at the same time, in Agatha images too,
the saint is rarely depicted with her breasts actually removed from her
body (illus. 61). Suspense creates a situation in which the Francke panels
can function pornographically, literally playing 'peek-a-boo' with the
body represented. The virgin body is visualized at the very moment when
it is most vulnerable to the looks of viewers who are characterized in the
painting as male. At the same time, however, aesthetic suspension directs
attention to the figurative level of the message, as well as – and possibly at
the expense of – the literal level. The virgin is represented as 'menaced', a
metonym for the institution of the Church constantly under threat; at the
same time, she remains unbreakable, in order to convey to the viewer the
Church's victorious and indestructible status.[29] By being placed outside

the narrative flow of action, the saint's body is transformed into a figure-head possessing qualities of stasis and iconicity. Understanding power simply as a function of action, from which anti-pornography critics assume women have been excluded, detracts from the ways in which inactivity – passivity even – can communicate power in the space of medieval religious representation.[30] The vision of the virgin's inviolate status is circumscribed by the viewer's recognition that the body thus represented would not, in actuality, remain impervious to these sorts of torments. Yet by constructing the virgin subjected to torture along the same lines as the virgin threatened with rape – that is to say, by not allowing the ultimate effects of violence / rape to be visualized as such – the artist plays on the ability of viewers to hold death and bodily destruction at bay, imaginatively, in the interests of reinforcing Christian hegemony.

In this context, it may be helpful to invoke what Elaine Scarry has termed the 'substantiating' functions of pain in representational contexts. Her argument concerns the process by which the incontestable reality of the physical body becomes an attribute of something that does not in itself appear to be real, incontestable or certain, for instance an institution, ideology or cultural construct. What becomes visible in this manoeuvre, she says, is the process by which invented ideas, beliefs and made objects will be accepted as though they have the same 'true' status as the natural world; the materiality of the body-in-pain, in particular, lends these disembodied constructs an aura of 'realness' and 'certainty'. This phenomenon works, moreover, by means of analogy: a process of seeing and touching the hurt body of another and believing that one has experienced its reality (when in fact one has only sensorially experienced the hurt of one's own body). Responses to pained bodies thus have an analogical component, a component that potentially produces what Scarry calls a 'twisting of terms', a translation of the material fact of the body into a disembodied cultural fiction signifying, for example, impregnability:

> The attribute of the body before the translation is the opposite of what the attribute is called after the translation: thus pain is relied on to project power, mortality to project immortality, vulnerability to project impregnability ... The extreme fact of the body ... is laid edge to edge with an extreme of sublimation, not a partially materialized and thus self-substantiating construction but a wholly verbal and disembodied assertion of impregnability.[31]

This point makes particular sense in the context of Christian martyrdom: the conceit is that the saint exists in a threshold space where the sensorial limits of human embodment are tested but to apparently little effect. It is

no surprise that Barbara is referred to regularly in the *Vie de Sainte Barbe* as the *insuperable vierge*, that is to say, the 'invincible virgin'. Insofar as the martyr and the Church are analogous to one another with regard to insentience and corporeal wholeness, they possess parallel qualities of insuperability; to the extent that both are represented undergoing ordeals that open them up to the threat of extreme violence, they are each connected, by a process of imaginative displacement, with the 'realness' of pain.

Abjection and sublimation thus come together in the body of the martyr and produce the circumstances for a powerful ideological operation: the substantiation of belief and of the institutions that control it. Another way of putting this would be to say that the tortured body of the saint is the point at which doctrine, violence and imagination coalesce. In chapter Three I identified hell, after Augustine, as a space of suspension in death, a place where sinners experience perpetual second deaths. The sufferings of martyrs likewise take place in a suspended, threshold zone, except that now the sufferings do not represent death, as such, in all its meaningless horror, but a space *between* two deaths: the natural death that allows the saint to escape her earthly shackles and the ultimate annihilation that should follow as a result. This second, definitive death never comes in hagiography. In the *St Barbara* altarpiece, the saint is not represented as a dead body, as such, and even her decapitation is depicted in the moment before her head falls from her body. Moreover, in written saints' lives, the martyr dies only in the literal sense: she continues to live on through her cult and through the dissemination of her sacred relics. The conceit is that Barbara is alive, in heaven, and that she has the power to intercede on our behalf; her posthumous miracles, numbering thirteen in the prose *Vie de Sainte Barbe*, reveal Barbara as a regular participant in earthly existence beyond her natural death. She has undergone the first, natural death that releases her from worldly desire (and the obligation to protect her virginity), but thereafter remains in an endless zone *between* deaths, a space where death's limits are disavowed and where destructive violence can be unleashed indefinitely against the saint's eternal, undying self. The saint's location in this threshold place (through undergoing tortures and, equally, through continuing to manifest herself in relics) is what facilitates the transmutation of an abject, corporeal and ostensibly dead entity into something radiant, immortal and sublime. Located in this fashion, moreover, the saint's body is potentially drawn away from its anchoring in a gendered optics and toward a positioning with more 'universal', or ideological, value.[32]

Up to now, my argument has focused predominantly on the most persistent ideological agenda in representations of the martyred female saint: the embodiment and symbolic reinforcement of belief. What remains to be seen is how this apparently 'universal' message intersects with more 'local', historically specific concerns. One of the ways in which martyrdom iconography potentially exhibits a degree of historical particularity, according to certain commentators, is in its interaction with medieval judicial spectacle. As I have implied elsewhere in this book, art historians have often been tempted to interpret images of this period in terms of their artistic 'realism'. The responses elicited are assumed to derive from the fact that medieval viewers may have witnessed comparable scenes in real life, or that the bodies represented depict sufferings graphically and realistically.[33] Comments of this sort, which, like anti-pornography critics, assume a causal relationship between art and life, fail to appreciate fully the imaginary dimensions of what is depicted. It is not clear, after all, that the real pains of legal punishment are conveyed in Francke's altarpiece: the physical suffering is aestheticized, displaced imaginatively to a space beyond the image, in order to facilitate an identification between the virgin and the Church.

If there *is* a way in which the *St Barbara* altarpiece could have entered into a dialogue with fifteenth-century judicial spectacle, it is not an especially direct or 'realistic' one. The motif of suspension that visually underscores the universalizing message of the 'menaced virgin' in the near-rape narrative also creates a visual alignment with one of the techniques of legal punishment that we have already encountered in this book: judicial hanging. The torments of St Barbara were unreal and unthinkable in penal practice (there is little evidence that mastectomy or burning with brands were penalties regularly imposed on women in late medieval Europe). But there may be parallels with a judicial reality of a different sort. One element that resonates with secular hanging iconography, as we have seen, is the sense of expectation and suspense that conditions this and other martyrdom depictions. But the motif of life hanging in the balance is also literalized in the two panels representing Barbara's nakedness, where, in both scenes, the saint's hands have been raised up high; in the scene depicting her burning with brands, the saint's hands have been attached to a gallows-like structure. In this way, by drawing visual comparisons with judicial hanging and by provoking empathy with the body of the saint, these images potentially create the circumstances for sympathetic engagement with the bodies of those judicially condemned to death by hanging, even as they also signify metonymically as the exposed, but inviolate Church. Francke's altarpiece is thus endowed with the capacity

to communicate both local and universal messages. It relies on associations with historically particular practices such as hanging in the depiction of certain torments, while at the same time utilizing the about-to-be-tortured body of the virgin, which always remains corporeally intact, to convey what appears to be a global point about the Church's status as an inviolate / threatened institution.

Another way to engage with the historical particularities of response to martyrdom depictions would be to focus on the social and gendered make-up of the audiences who commissioned and observed them. If, as modern commentators imply, the *St Barbara* altarpiece functioned as religious pornography – and, implicitly, as a didactic text for sexual assault – it cannot have done so for all its viewers, and certainly not for some of the women who may have had the opportunity to worship in its presence. Recent studies by film critics of genres such as horror and hardcore pornography have placed emphasis on issues of female spectatorship and demonstrated how these genres do not operate definitively as platforms for patriarchal power; medieval hagiography critics have likewise turned a spotlight onto the women patrons and readers of saints' lives and argued that these texts open up readings that, in particular contexts, 'may constitute relative empowerment or recuperation'.[34] It therefore seems important to consider the possibility that women may have viewed and sought meaning in Francke's altarpiece, a prospect that the conventional rape–pornography reading potentially precludes.

There are textual indications in vernacular saints' lives from certain regions of late medieval Europe, particularly lives produced in England, that female readers actively demanded tales of martyrdom such as Barbara's. For instance, the manuscript containing the prose *Vie de Sainte Barbe* bears an inscription suggesting that it belonged to Jeanne de France (*d.* 1482), duchess of Bourbon and Auvergne.[35] If women such as this were reading, hearing and commissioning texts of this sort in the later Middle Ages, it would be reductive to suggest that they simply encode male sexual fantasies or inscribe patriarchal conceptions of women as passive victims. By the same token it would make no sense to argue that saints' lives, at all periods and in all places, offered liberating spaces for female empowerment and subject formation. Both of these positions – which would claim that women are either absolutely disempowered by such representations or unconditionally liberated by them – are unsatisfactory. My point is not that we shuttle Francke's altarpiece around violently between readings that emphasize, on the one hand, positions of victimization, and, on the other, those of subject formation. Rather, saints functioned in the Middle Ages as heterogeneous figures, incorporating a body of contradictory discourses in which the lines between object-hood and subject-hood were often blurred.

One way of understanding a female audience's stake in representations of objectifying violence would be to reformulate the rape–pornography reading in less victimological terms. Under certain circumstances, for example, it is possible to read the rape plot in hagiographic romance as an exemplary text championing the strategies of verbal and physical resistance by which rape might be countered.[36] A case for such a reading can be made with regard to written hagiography. If, according to certain interpretations, saintly heroines 'function as objects and never as speaking subjects', this argument meets a challenge in those legends where the martyr's speech plays an important role.[37] As well as being a highly articulate expositor of Christian doctrine and a skilled rebutter of pagan mythology, for instance, Barbara frequently employs direct speech to disrupt the power of the male aggressor in order to prevent actual sexual coercion from occurring (in her case, forced marriage). In the prose *Vie de Sainte Barbe*, when her father requests her views on marriage, the martyr replies, 'in anger and disturbed by what he had said', that she wishes to take a vow of chastity.[38]

The power of the saint's speech to disrupt the rape script becomes especially apparent in scenes of torture. According to Scarry, physical torture operates to disable language in the victim, yet here Barbara remains authoritative *through* speech, interrupting her experiences of suffering with words addressed to her spectators, her tormentors and God.[39] For instance, while she is battered with hammers in a stock, the saint speaks to Christ of her voluntary sacrifice; after being dragged around the town naked, she shouts at the top of her voice that 'all those who adore idols should be damned'.[40] Significantly, Barbara's seditious talk is explicitly commented on in the trial scene before the tortures take place. Before Marcien has even begun the interrogation, Barbara speaks to him *hardiement*, or daringly, exclaiming:

'Do you wish to understand and know my Christian religion? I worship the true God'. To which the prefect replied: 'You are totally intoxicated with serpent venom and deception'. 'What!' he said, 'Are you not ashamed to respond before you are questioned?'[41]

Such instances of debate, dissidence and verbal eloquence challenge the assumption that hagiography simply equates women with flesh.[42] The verbal dissidence of female virgin martyrs might even have provided the circumstances for exemplary or 'empowering' messages in certain contexts.

Indeed in some saints' lives, resistance is even physically violent, challenging commonly held stereotypes of passive femininity. For instance, St Margaret, cast into prison between her tortures, is swallowed by a dragon.

Bursting triumphantly from the dragon's belly, Margaret is presented in iconography depicting the scene in a quasi-militaristic stance, treading on her opponent (illus. 62), thus demonstrating her ability to disrupt social constructions of femininity by doing a sort of gender-troubling 'drag'.[43] The saint subsequently proceeds to have discourse with a second devil, commanding him to return to his kin. Visual representations of this scene (illus. 63 and 64) occasionally show Margaret grasping the demon by the hair, raising an arm above her head and preparing to strike him with a hefty mallet.[44]

Is it possible that a female audience might have read in Margaret's violent antics and Barbara's insurrectionary speech a methodology for resisting, even preventing rape? This is a hypothesis that several critics have posited for particular saints, periods and locations, and there are accounts of female hagiographic readers occasionally putting these strategies into practice: the *vita* of Christina of Markyate, written soon after her death (*c.* 1160) by a twelfth-century monk of St Albans, describes one such episode. We know that Christina owned a large collection of virgins' lives, including martyr legends, and her engagements with hagiography may have shaped the experiences recorded in her own *vita*. Christina's biography

62 'Margaret emerges from the dragon', miniature in a Book of Hours, 14th century, French. Bibliothèque de l'Arsenal, Paris.

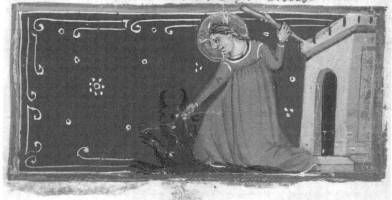

63 'Margaret the demon-slayer', a miniature in *Passion of St Margaret*, 14th century, Italian. British Library, London.

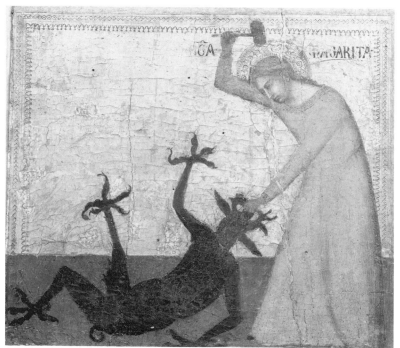

64 'Margaret strikes a demon', left scene from predella of Barna da Siena, *Mystic Marriage of St Catherine of Alexandria*, c. 1340, tempera on panel. Museum of Fine Arts, Boston.

tells of how her parents force her to marry (sexual coercion), how her mother beats her and tears out her hair (torture), and how she finally manages to get the betrothal annulled before embarking on a religious career (giving her soul to God); these elements all suggest obvious structural similarities with virgin martyr legends such as those of Margaret and Barbara. There is even a parallel to the lustful pagan tormentor, in Christina's encounter with a visiting bishop, Ranulf Flambard, who threatens to rape her.[45] Frequently, Christina uses her speech and cunning to escape the situations in which she finds herself. For example, when her spouse attempts to consummate the marriage, she diverts him from his task by divulging the Life of St Cecilia, who converted her groom, St Valerian, to chastity on their wedding night.[46] When Flambard tries to rape her, she suggests locking the door so that 'no man should catch us in this act', before making off through the door herself.[47] Here is a woman who appears to be refusing to give in to the social norms that script her as raped.

Thus, it seems that certain virgin martyr legends might have been understood by certain women as a call to contest their gender assignments as inert objects, whether in the marriage market (and thus victims of an insidious form of sexual coercion) or in situations of attempted rape.[48] Can the same, in turn, be argued for Francke's painting? We should remember that in the visual image Barbara is mute, and, because her nakedness must be portrayed in literal rather than figurative terms, her sexual identity is vividly exposed. This demonstrates that visual and textual representations of virgin martyrs work in distinctive ways, even as they are closely related to one another in terms of narrative content. Rape prevention does not necessarily function as the interpretative key for visualizations of female martyrdom, much as it might, under certain circumstances, have provided a basis for reading the written lives.

One horizon of expectations that *may* be relevant to both text and image has to do with the positive value attributed to corporeality in certain strands of late medieval devotion, particularly in the writings of female mystics. Mystical writers in the late Middle Ages, from Hadewijch to Margery Kempe, promoted their own bodies as a resource for approaching and identifying empathetically with the suffering bodies of Christ and the saints: they perceived what might be called the 'opportunity of physicality' in their engagements with sacred suffering.[49] Evidence for the provenance of Francke's altarpiece is scant, but there is a strong chance that it was originally commissioned for an altar dedicated to the virgin martyr and erected in 1412 in the St Catherine chapel in Turku Cathedral, Finland, by the incoming bishop, Magnus II.[50] The inner wings of the altarpiece are carved with scenes from the *Life of the Virgin* (illus. 55), and it is likely, given its subject matter and the presumed location in

the chapel of another female martyr, that the image attracted female as well as male beholders. What might have caught some viewers' eyes, as the writings of female mystics imply, was the profound corporeality of Barbara's ordeal. The body on which mystics commonly meditate is Christ's. As we shall see in chapter Six, this body could itself be the stage for a variety of cross-gendered exchanges, identifications and responses in late medieval culture. Francke's altarpiece also draws attention to a Christological interpretative framework, by visually aligning the bodies of Barbara and Christ in their sufferings. When the altarpiece is opened to reveal the carved *Life of the Virgin* scenes, we see that the painted panels representing Barbara's burning and mastectomy are juxtaposed with carved scenes representing, to the bottom left and right, the circumcision of Christ (illus. 65). Barbara's physical presence in these two panels is further emphasized by the fact that, in the two scenes directly above (representing the saint's escape from the tower and her betrayal by the shepherds), her body is singularly missing. This symbolic interplay between absence and presence is a way of drawing attention to the saint's – and Christ's – paradoxical status as simultaneously human and divine, visible and invisible. Moreover, a further level of identification exists across the two narratives represented in the altarpiece, between the virgin martyr and the Virgin Mary: the large, central carving depicting the Virgin's death

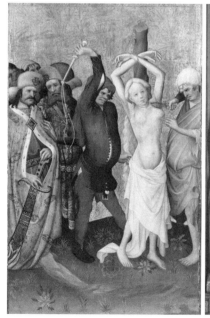

65 Detail of illus. 55, showing Barbara's mastectomy juxtaposed with the carved scene of Christ's circumcision.

and assumption can be read as a figurative counterpart to Barbara's own entry into heaven; the Virgin who looks after the baby Jesus in scenes of circumcision parallels the martyr who intercedes, like the Virgin, for the souls of medieval viewers.[51]

The *St Barbara* altarpiece thus relies on constructing a complex web of identifications, both internally, between the bodies of the saint, the Virgin and Christ, and externally, with reference to the bodies of viewers. The work constructs these networks of bodily interaction and identification to create the impression of a suffering Christian community: a community woven together, from the fleshly fibres of saints, Christ, the Virgin and Christian beholders, into a single symbolic *corpus*. This *corpus Christianum* is potentially empowering for certain viewers who identify themselves as part of its make-up, because it underscores the notion that fleshly suffering can be transmuted into sacred truth through the medium of martyrdom. The ideological purpose is to ground the Christian community, to enforce adherence to doctrine and to substantiate belief. But from the point of view of social existence, there is an important side effect: certain female readers and viewers may have discovered, in martyrdom depiction, a more 'positive' valuation of the fleshliness with which they were customarily associated as women in medieval culture.

DISCRIMINATING VICTIMS

This is not to say that virgin martyr depiction is devoid of erotic significance, or that martyrdom iconography precludes identification with sadistic aggression. It is perfectly feasible, given the voyeuristic overtones and aesthetic strategies of the *St Barbara* altarpiece, that male viewers sometimes responded to martyrdom depiction sexually, in the mind's eye or otherwise, in ways partially comparable with modern pornographic depiction. Although no record survives to prove that male viewers of Francke's painting found it erotically stimulating, the writings of Protestant reformers in sixteenth-century Germany indicate that it was possible to be aroused physically by certain representations of saints. Iconoclasts frequently criticized images for inciting carnal urges, so that a Lutheran Protestant from Strasbourg remarked *circa* 1520:

> Truly when I was young and they piped away on the organ in church, I longed to dance, and when I heard the singing there I was moved in the flesh but not in the spirit. Also I often had base thoughts when I looked at the female saints on the altars. For no courtesan can dress or adorn herself more sumptuously and

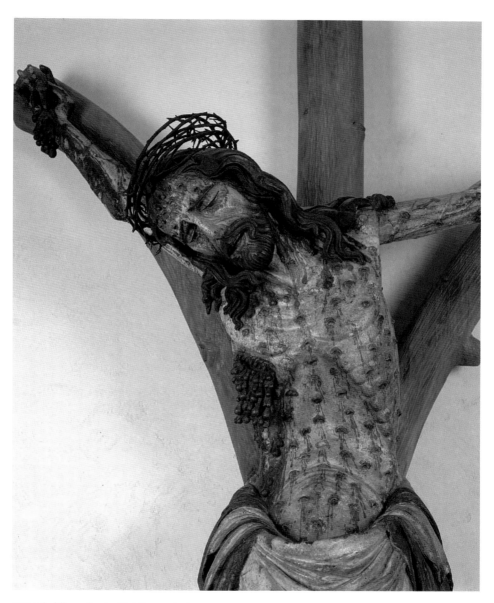

66 Detail of illus. 1, showing Christ's upper body.

67 'Arrest of Sisamnes', left panel of Gerard David, *Judgement of Cambyses*, 1498, oil on oak. Groeningemuseum, Bruges.

68 'Flaying of Sisamnes', right panel of Gerard David, *Judgement of Cambyses*, 1498.

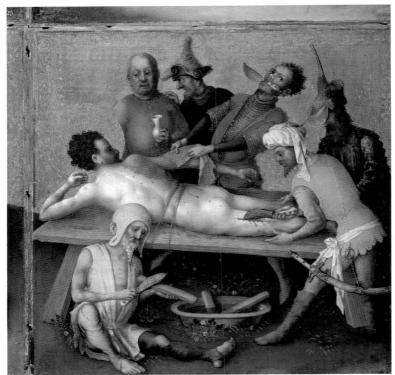

69 'Martyrdom of St Bartholomew', panel from Stefan Lochner, *Martyrdom of the Apostles*, c. 1435, mixed technique on wood. Städelsches Kunstinstitut, Frankfurt.

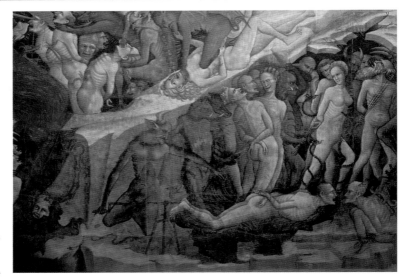

70 'Punishments of the lustful', detail from Giovanni da Modena, *Last Judgement*, c. 1410–12, fresco in the Bolognini chapel, S. Petronio, Bologna.

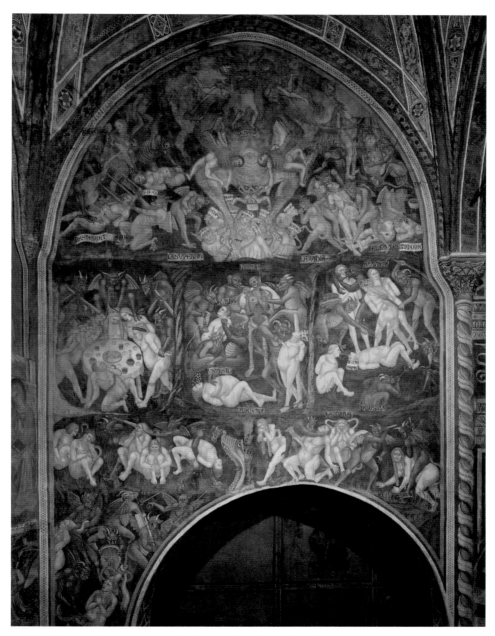

71 Taddeo di Bartolo, *Hell*, c. 1393–1413, fresco in the nave of the Collegiata di San Gimignano.

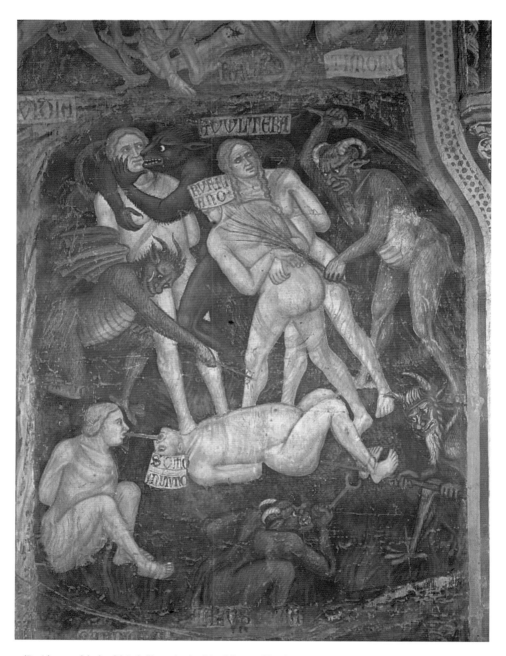

72 'Punishment of the lustful, including sodomites,' detail from Taddeo di Bartolo's *Hell*.

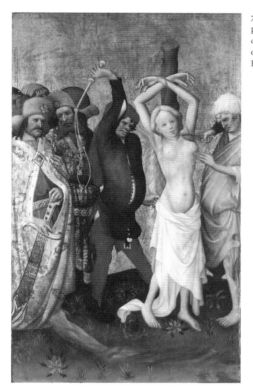

73 'Barbara's mastectomy and whipping', panel from Master Francke, *Martyrdom of St Barbara*, c. 1410–15, tempera on oak. National Museum of Finland, Helsinki.

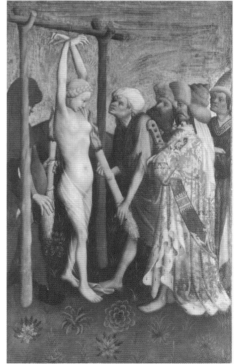

74 'Barbara burned with fiery brands', panel from Master Francke, *Martyrdom of St Barbara*.

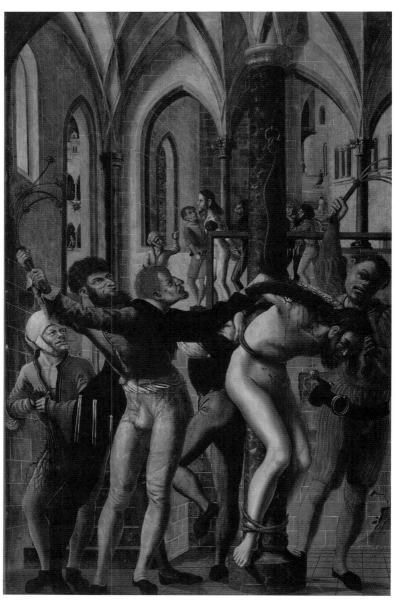

75 Marx Reichlich, *Flagellation of Christ*, c. 1506, oil on wood. Alte Pinakothek, Munich.

shamelessly than they nowadays fashion the Mother of God, Saint Barbara, Katherine and other saints.[52]

The reformer's comments are not directed at images of martyrdom as such, but at carved statues depicting Barbara and other saints in a sublime, heavenly pose (illus. 76). Also, the commentator makes a comparison between the erotic draw of these depictions and the 'sumptuous' fashions worn by prostitutes, a reproach that ultimately concerns the commercialization of sacred imagery in fifteenth- and sixteenth-century Germany. But the statement does hint at the possibility that some beholders responded carnally to visual depictions of saints in certain media, transforming them into erotic icons.

76 Tilman Riemenschneider, *St Barbara*, 1510, carved wood, Würzburg. Bayerisches Nationalmuseum, Munich.

At the same time, we should not assume that sexualized interpretations are simply the products of a predominantly male audience. It is important to recognize that the female saint's tortured flesh might have aroused some *women* beholders: queer erotic desires for the body of the saint potentially circulate in depictions of both male and female martyrdom. Moreover, it seems vital that we unpack the various trajectories of sadism in hagiographic depictions. Explicit sadistic identification is generally speaking less desirable for the medieval Christian viewer than an alignment with emphatically powerful forms of victimization.[53] Martyrdom iconography's major investment (within the context of Christian hegemony) is in aligning the viewer with the exemplary victim-as-hero. But this does not mean that late medieval devotion fails to incorporate *implicit* modes of sadism. The aim in this penultimate section of the chapter is to show how desire for and identification with saintly sublimity produced a mode of victim identification that was paradoxically sadistic when viewed from a certain angle.

My argument is that audiences, male and female, may have found reasons to identify with the saint as an icon of invincibility. If the *St Barbara* altarpiece shares certain characteristics with pornography, the virgin martyr's sublimated flesh was appropriated, at the end of the day, to reinforce Christian hegemony. But it is worth pointing out that the alignment of viewers, male or female, with the saint also includes a number of other ideological possibilities, which may complicate the assumption that victimization in martyrdom scenes is chiefly on the side of the saint. For if narratives of violence function as sites for an exploration of victimhood and empowerment (in which gender is certainly at issue), then they also provide a forum in which to engage with other marks of identity such as religion, race and class, in which men and women equally have a stake. Class is an important structuring device in medieval hagiography. St Barbara is noble-born, after all, her beauty as much a mark of social status as femininity; her tormentors, in contrast, are characterized as distinctly lower class and even, perhaps, ethnically distinct. Francke's torture scenes present the status divisions in starkly visual terms. While Barbara is presented as blond and unblemished, and her father serious and richly attired, the executioners are a motley crew: all shabby clothes, distorted features and brutish gestures – one even exposes his buttocks to view (illus. 73 and 74). As with modern fantasies of the archetypal pornographic consumer, the sexually voracious, animalistic look is displaced onto the uncivilized, uneducated, economically dispossessed outcast; in comparable paintings of martyrdom and Christ's passion, the 'other' may be depicted sporting 'foreign', Islamic-looking headgear (illus. 77) or dark skin (illus. 78).[54] Perhaps the biggest problem with interpretations that

77 'St George
scourged and
scraped', panel
from Andrés Marçal
de Sax, *St George*
retable, *c.* 1400,
tempera on wood,
German,
commissioned
for a confraternity
of St George in
Valencia. Victoria
and Albert
Museum, London.

shuttle the virgin martyr's body between positions of empowerment and victimization is that commentators risk aligning themselves, unwittingly, *with* such positions of prejudice. Women can and do exercise class privilege, racial and religious intolerance, not to mention oppressive political power, and an uncritical search for the 'empowered' female subject could end up losing sight of these more disturbing aspects of identification. Female recipients of hagiography were potentially victors as well as victims when it came to identifying with the suffering saint.[55]

78 'Flagellation of Christ', illuminated page in the Chichester Psalter, *c.* 1250, English. John Rylands Library, Manchester.

We should be alert, in this context, to the particular historical messages that passion narratives communicated to their medieval audiences in different times and places. The binary structures of hagiography ultimately helped medieval audiences to differentiate Christians from pagans. But this drama of polarities took on more specific inflections, according to geographical or historical circumstance. Vernacular saints' lives, for instance, were potentially useful as didactic tools in the war against heresy.[56] In addition, martyrdom depiction might relate the struggle between Christians and pagans by assimilating current constructions of Jews, Muslims and the lower classes with the fictional tormentors. In certain contexts, even sodomy could be appropriated to accentuate religious difference. For instance, Hrotsvitha of Gandersheim, a tenth-century German nun, describes how St Pelagius, a fearless young martyr of Christ, was put to death by a lusty pagan king 'corrupted by Sodomitic vices', after he had rejected the king's attempts to kiss him.[57] We see here how empathetic identification with the victim masks the complicity of audiences with modes of scapegoating that reverberated socially in particular contexts.[58] These examples suggest that to identify with the victim *in* the text (the martyred saint) is not necessarily to show sympathy for the victims *of* the text (the denigrated social outcasts).[59]

The Pelagius legend points to another route by which victims are fashioned in hagiography: allusions to paedophilic and incestuous desire. Pelagius is described by Hrotsvitha as having recently attained 'the first flowers of the age of youth';[60] the St Barbara story likewise centres on the relationship between a father and his chaste young daughter. Motifs of abused children form part of the symbolic fabric of virgin martyr hagiography, motifs consistent with the virulently anti-Semitic fantasies then being propagated, among which accusations of ritual child murder numbered strongly.[61] The *Vie de Sainte Barbe* makes allusions to incest indirectly, through a discussion of idolatry. We are told that Dioscurus, regarding his daughter's 'excellent beauty', 'began thus to contemplate how he could hide this image / statue so bright, so sweet and full of such great beauty, in order that no man might love her'.[62] Placing Barbara on a pedestal, Dioscurus covets his daughter as a cult-object – an *ymage* – sealing her up in a tower like a relic; his actions here simultaneously mimic the precepts of courtly love and highlight its idolatrous implications.[63]

The conclusion to be drawn from this is that medieval penal practice, and its representation and transformation in art, was discriminatory in its constructions of 'victim' and 'tormentor': each potentially functioned as a mechanism for transforming an assortment of religious, ethnic, social, psychic and gendered identities into abject 'anti-bodies', with a view to reinforcing the identity and symbolic wholeness of the Church. The pagan

tormentors might operate as screens for the projection of illicit desire (the pornographer, the sodomite, the paedophile, the incestuous father); they might figure forth stereotypes of the lower-class brute or the foreigner; specifically in relation to the female audience, they might also stand in, figuratively speaking, for unwanted husbands and rapists.[64] At the same time, the virgin martyr could recall the body of Christ or the attitudes of the 'morally superior' upper classes, while signifying in addition as a victim of incestuous or lustful desire, or even of judicial hanging; and she also functions as a metonym for the *corpus Christianum*. Thus, looking *with* the martyred body in question entails not only critiquing the processes of objectification and heterosexual desire by which the martyrs are coerced and the routes of power and subversive speech by which they achieve transcendence, but also a number of more unsavoury responses not accounted for in readings that simply focus on a gender-inflected rape script or narratives of saintly empowerment. We should certainly consider the objectifying logic of male gazing and female passivity in virgin martyr hagiography, and the possibility that this logic was subverted and reworked into a more enabling dynamic of victim identification; but we must also be aware of the ways in which such modes of analysis fail to grasp the layered and shifting qualities of victimhood in medieval hagiography.

TEARS FOR QUEERS

Medieval martyrdom representation articulates a unifying rhetoric, which bodies forth the semblance of a Christian *corpus*; but it also gives rise to elements of dissimulation and fragmentation, places where identities and identifications potentially proliferate. The line separating victors from victims is blurred, when looked at from a certain perspective, while the martyr's tormented body enters into a process of analogical substitution by which it paradoxically communicates the sublime. Suspended, in this way, in a zone of indefinite suffering and sublimation, that body becomes especially valuable as an ideological object. But responses did not *always* organize themselves coherently in support of the ideology in question. Reception of images is, and presumably always has been, precarious; the messages transmitted by passion narratives were contingent on the individuals who received them and the modes in which they were told, transmitted and exchanged. The next chapter considers how images of torture may have provided opportunities for proliferating meanings, by unravelling the queer possibilities in certain representations of sacred beating. But a final example here brings these issues into focus, and

emphasizes the extent to which a queer optic might also have provided an interpretative lens for virgin martyr legends such as Barbara's. Perhaps more importantly, this example also suggests how queer responses might emerge from the structures of response examined in this chapter, demonstrating the degree to which hagiographic subject positions and identifications might be fluid, multiple and sexually ambiguous.

In 1485 a production of the Life of St Barbara was staged in Metz in a spectacular three-day cycle. According to the chronicler Philippe de Vigneulles, Barbara was played, appropriately enough, by a young barber's apprentice called Lyonard from Notre Dame d'Aix in Germany: the saint's name is Barbe, which is also the French word for beard. The actor is described in the chronicle as 'ung tres beaul filz' ('a very beautiful lad') who 'ressembloit une belle jonne fille' ('looked like a pretty maiden'), and the chronicler recounts how the boy played his part so convincingly that several members of the audience shed tears of compassion. Moreover, in playing the part of Barbara, he held 'si bonne faconde et maniere avec si bonne mine et gestes' ('such good behaviour and manners, with such good [facial] expression and gestures'), that there wasn't a noble, cleric or layperson 'qui ne desirast à avoir ledit gairson pour le nourir et gouverner' ('who didn't desire to have this boy to nourish and raise him'). While a rich widow wished to make the boy her heir, she could not better the offer of a cathedral canon named Jehan Chardelly, who 'le print en si grant anmour qu'il luy fut delivré' ('held him in such great love that he was delivered to him'). Chardelly subsequently sent Lyonard to school, then to university, after which he ended up as a canon like his guardian.[65]

I refer to this short anecdote in conclusion because it signals the importance of opening up interpretations of hagiography to alternative desires than the straightforwardly heterosexual. Barbara is an incredibly beautiful girl who is played by an incredibly beautiful boy; counting among the audience who weep at the actor's performance is a widow who desires a boy who is dressed as a girl, and a canon who craves a girl whom he knows is also a boy. The dynamic is not exactly overtly erotic, but desirous longing is there nonetheless and the possibilities of same-sex union are never entirely effaced, even if they are ultimately displaced onto the homo-social world of paternal beneficence.[66] Returning to Francke's image once more in this context, we can perhaps now view the panel a little differently. For, when we look at Barbara's naked tormented flesh, it is not just dichotomous gender that we see before us but also a more ambiguous world in which victimization becomes a source of agency and corporeal investment and a medium for class-ridden prejudice, generational conflict and incestuous desire; where the resistant female protagonist looks just a little 'male' and the male viewer vicariously throws in his

lot with the tortured female saints; where the female viewer may herself enjoy the prospect of both eroticizing and identifying with the spectacular, tormented bodies of Barbara and her fellow martyrs. As such, the sacred body is the focal point for an exploration of positions of strength and weakness, pain and pleasure, identity and otherness; and the martyr, like the cross-dressing actor, provokes a crisis of categorization that undermines any attempts at constructing a binary typology based on sexual difference alone. Much as the *St Barbara* altarpiece is certainly *not* devoid of the capacity to offend, objectify and even wound in certain contexts, along dichotomously gendered lines, it should be remembered that, in paintings such as these, lines of identification were multiple and capable of generating a dynamic signifying field.

Of Martyrs and Men

Every year, on Holy Thursday, the inhabitants of San Vicente de la Sonsierra in the Rioja region of Spain assemble to bear witness to a spectacular act of religious devotion. As night falls, a procession descends from the church overlooking the town. Dressed in white robes and hoods, with their backs uncovered, members of the Cofradía de la Santa Vera Cruz, a long-established religious brotherhood, make their way through the narrow streets of San Vicente and scourge themselves with a *madeja* (hank or skein) made of flax, in memory of Christ's passion (illus. 79). A companion supervises each penitent, making sure he administers the appropriate level of discipline: not too harsh, not too soft. Then a village elder applies to the penitent's swollen back, six times over, a wax ball furnished with two glass spikes (illus. 80). The ruptures that result – twelve in total, recalling the number of apostles – cause blood accumulated in the bruises to stream forth. The penitents who whip themselves are labelled *los picaos*, literally the 'pickers': the ones who are pierced.[1]

Tourist brochures suggest that the procession of the *picaos* recalls the religious practices of the Middle Ages, although in fact the first formal written notice of the practice in the confraternity archives dates from 1551. At the end of the nineteenth century, however, the Flemish poet Emile Verhaeren, accompanied by the Spanish painter Darío de Regoyos, recorded his impressions of the ritual for inclusion in an account of the customs and festivals of Spain, and remarked: 'If someone wants to see a Spain of the Middle Ages, he should go one Good Friday to San Vicente de la Sonsierra, and if he wishes to allow himself be pricked he should enter into the black brotherhood.'[2]

The woodcut illustrating Verhaeren's remarks, engraved by de Regoyos, encapsulates perfectly the Gothic connotations of the scene: in the foreground a ghoulish penitent wields a scourge menacingly above his head, accompanied by a sombre-looking colleague; emerging from the church in the background is an assembly of shady, faceless figures, barely visible against the darkness of night (illus. 81).

The medieval is also invoked in a discussion of penitential ritual in Karen Armstrong's *Through the Narrow Gate*, the bestselling memoir of life inside a Catholic convent in England in the 1960s. Armstrong, who eventually abandoned her vocation as a nun, recalls how once, prior to taking her vows, she went into a disused dormitory to administer 'discipline' on her body, at the behest of the mother superior. 'Never had I expected here the excesses that I associated with the more frenzied Christianity of the medieval period', she observes, before recounting how she scourged herself over the back of the neck with a small whip made of knotted cords. In contrast to the *picaos* of San Vicente, however, Armstrong acted in private and alone; unlike them, the sensations she encountered were apparently anything but penitential in their associations:

> The cords bit into my flesh, smarted and stung. I felt sweat standing out on my brow and felt myself trembling all over . . . I looked up at the crucifix on the wall as my numbed neck began to prickle painfully into life, bewildered by the excitement that had possessed me. Where had it come from? Instead of beating my body into

subjection the discipline seemed to have roused it to a new life, touching something in me that left me frightened, tingling, and alert.[3]

Concerned by the 'peculiar pleasure' that the practice engendered, Armstrong sought advice from the mother superior, who, after getting over her initial shock, simply recommended: 'Beat yourself harder. Make it unpleasant and painful.'[4]

To what extent do representations of holy beating produced in the late Middle Ages reverberate with these post-medieval productions of sacred self-harm? How might the potential pleasure-inducing effects of penance, noted by Armstrong, resonate with responses to medieval iconography

81 'La procesión de San Vicente', woodcut by Darío de Regoyos, in Emile Verhaeren and Darío de Regoyos, *España Negra* (Barcelona: Pedro Ortega, 1899).

La procesión de San Vicente (boj).

depicting the passion of Christ and the saints? What stands out in medieval devotional writings is the notion that pain is *transferable* from one body to another: from the body in an image to the body of a devotee. In what follows, however, we shall see that the techniques employed to mediate this process of transference produce a fantasy of affective transformation, a fantasy in which the boundaries between pain and pleasure become manifestly blurred. This process is also at issue in the mortifications of the *picaos*, where bodies past and present weave together in a communion of suffering that enables participants to experience feelings of spiritual rapture and transcendence. While rituals such as this are documented in Spain only from the very end of the Middle Ages,[5] medieval images and texts representing the beaten bodies of martyrs and Christ suggest areas of both continuity and difference between medieval and modern. Projecting self-flagellation into the past as a quintessentially 'medieval' phenomenon risks obscuring some of the more remarkable affective and symbolic possibilities that the rite holds out, past and present, for its observers and practitioners.

Scenes of beating, it should be recalled, are foundational to certain works of modern theory, notably the writings of psychoanalysts and sexologists who, in the nineteenth and twentieth centuries, developed the concept of masochism. Since the expression was first coined by the nineteenth-century sexologist Richard von Krafft-Ebing to describe what he termed a 'perversion' – a sickness – concerned with eliciting sexual arousal from experiences of pain and humiliation, masochism has received a great deal of bad press. Popularly understood as a byword for all things negative, most people would hesitate to describe themselves as masochistic in the twenty-first century, except as an act of self-depreciation. To call someone else masochistic is to suggest that their perspective on life is twisted, that they tend toward destruction rather than empowerment.[6] Being labelled a masochist in sexual contexts, more than a century after Krafft-Ebing, still conveys pathological associations: so enamoured is the British legal system with the idea that sexual masochism is 'bad for the health' that in December 1990 sixteen men involved in consensual masochistic sex in Sheffield (the so-called Operation Spanner case) were convicted under the Offences Against the Person Act and in several cases given lengthy custodial sentences.[7]

Similar attitudes surface in the work of medieval historians. According to Caroline Walker Bynum, the bizarre ascetic practices attributed to certain medieval religious women in the late Middle Ages were conducive to 'empowerment', since, in her view, 'the extreme asceticism and literalism of women's spirituality were not, at the deepest level, masochism or dualism but, rather, efforts to gain power and to give meaning'.[8] This chapter

contests the simple conflation of masochism, dualism and victimhood in accounts of this sort, since, rightly defined, masochism is no such thing; the material presented challenges the opposition frequently assumed between masochism and empowerment. Despite its etymological links with nineteenth-century sexual pathology, I would also like to suggest that masochism provides a useful framework for interpreting certain medieval modes of representation. Again, the writings of medieval historians would suggest otherwise. Esther Cohen, who describes what she terms a 'philopassian' approach to pain – defined as the projection of positive value onto physical sensations that in our own day are more likely to elicit rejection – opposes the use of the term 'masochism' as a way of describing medieval modes of experience. 'Philopassianism is emphatically distinct from modern masochism', she states. 'One did not seek pain in order to derive sensual pleasure from it. The physical sensation was invoked because it was considered useful, not pleasurable.'[9] As such, in Cohen's view, pain in the late Middle Ages was embraced, above all, for its profound 'usefulness'. 'Pain', she writes, 'was seen as an avenue to knowledge. Knowledge of the body, of the soul, of truth, of reality, and of God. Whether self-inflicted or caused by others, physical pain was a way of affirming the boundaries of identity.'[10]

By contrast, I wish to dispute the idea that the Middle Ages, as an epoch of unbearable, if eminently useful, sensations, had little sense of the relationship between pleasure and pain. Focusing on fifteenth-century saints' plays and paintings depicting scenes of martyrdom and holy flagellation, my aim is to show how medieval pain, when imaged, could be transformed into a signifier of mystical or even erotic pleasure. I also think that the rejection of the term 'masochism' by historians is over-hasty, since masochism, too, is frequently about *affirming* rather than denying selfhood. The problem is partly one of definition (do we retain the negative, pathologizing tendencies of the term masochism?) and partly one of history (did pleasure and pain coalesce in the Middle Ages in line with modern conceptions of what masochism entails?). On both counts, martyrdom representation offers crucial insights. If we compare medieval scenes of holy beating with recent studies of masochism (notably work by Gilles Deleuze, Anita Phillips and Theodor Reik), its resonance with masochistic scenarios is all too apparent.

RITUAL, MEMORY AND SELF-SACRIFICE

Before focusing specifically on martyrdom it is important to situate scenes of holy beating in a wider signifying field. Broadly speaking, certain acts

of self-flagellation, such as those performed by the *picaos* in modern Spain, might be understood as rites of passage.[11] Anthropologists have long understood acts of radical self-mutilation as having a symbolic value in mediating the transition from one state of being to another. Martyrdom itself resembles a rite of passage, embodying, in Arnold van Gennep's classic formulation, rituals of separation (preliminal), transition (liminal) and incorporation (postliminal).[12] In this sense, it also has elements in common with initiation rites: the martyr is separated from the normal human community, undergoes a transitional stage of corporeally transformative mutilation, before being incorporated into the heavenly community.[13] Like scarification, mutilation is a means of permanent bodily differentiation that separates mutilated individuals from the common mass of humanity – symbolized in the act of cutting – and simultaneously incorporates them into a closely defined group – symbolized by their shared experience of disfigurement.[14] Of course, in one sense, the mutilations of the saints are not permanent: saints such as Agatha are represented in art with their body parts removed in one scene, and in the next reassembled; Sebastian is nursed back to health after his ordeal by Irene.[15] Nevertheless, the removed body parts of the saints also functioned as *permanent* markers of special status and intercessory power. Medieval artists, for instance, sometimes represented Agatha carrying her breasts on a platter, Denis carrying his head under his arms, their divided relics symbols of their post-liminal incorporation into the heavenly symbolic order. The counterparts to such rites of initiation are, of course, rites of banishment, expulsion and excommunication – essentially rites of separation and *de*-sanctification.[16] In the previous chapter, we saw how martyrs could be made to stand in for a beleaguered, yet invincible Church, and their tormentors could take on the trappings of a variety of excluded groups, from lower classes and incestuous fathers to Jews, Muslims and even sodomites. This scapegoating mechanism highlights how martyrdom representation encompasses rites of separation as well as incorporation.

The annual processions of the *picaos* in modern Spain possess analogous ritual functions. Most obviously, the acts of flagellation take place in public, defining membership of the confraternity and, for spectators, of the community of San Vicente de la Sonsierra. In addition, certain participants may experience the process as one of initiation, into adulthood and into the life of confraternity. Children are excluded from the processions and women are assigned a different role from men. Since 1998 female members have been admitted to the confraternity, but if they join the penitents it is in the guise of *Marías*, that is to say, figures associated with the Virgin Mary. This suggests a clear gendered dimension to the San Vicente ritual. When women participate in the processions they inhabit a

role analogous to the archetypal observer of the sufferings of Christ; it is no coincidence that the only statue brought forth in the procession is a *Mater dolorosa*, a Virgin in tears, and that the procession begins at a church dedicated to Mary.[17] By contrast, it is deemed appropriate for male devotees to mimic Christ's sufferings directly – to fuse, imaginatively, *with* those sufferings – by drawing blood. Beating out the rhythms of scourging on their backs, in other words, they simultaneously beat in their identities as pious men.

It is important, when considering rites of passage and initiation rituals, to take into account the specific place of *pain* in the ritual process. One of the most important ritual functions of pain is to act as an aid to memory. Pain is an intense and fundamentally unforgettable experience: it imprints a symbolic message of change and transformation in the bodily consciousness of both the initiate and the community at large, and, being a temporal experience, also fixes the change in time in order to create the appearance of metamorphic transformation.[18] Medieval writers who advocated the practice of self-flagellation in religious settings evidently viewed it as a means of perpetuating an act of violence that occurred centuries before (the flagellation of Christ) in order to effect penitence in the present. The eleventh-century theologian Peter Damian, author of *De laude flagellorum* (In praise of flagellation), wrote several letters rebutting critics of the practice in which he compares monastic discipline to the beatings enacted on the bodies of the saints and Christ. In one, for instance, he describes the mnemonic dimensions of self-flagellation in the following terms:

> When the faithful, in reverent devotion recall their sins and punish themselves with strokes of the discipline, they believe that they are partaking in the passion of our Redeemer. For, on the testimony of the Gospels, our Savior himself was scourged . . . Whoever will read their lives, can hardly be unaware that numberless martyrs also had to undergo severe scourging.[19]

Analogies between the pains of Christ and the martyrs, and productions of pain in the bodies of the medieval faithful, were also advanced as a means of authorizing the flagellant movements that surfaced, intermittently, in Europe in the later Middle Ages. Flagellants were groups of people drawn from the laity, by and large, who went from town to town flogging themselves publicly in satisfaction for their sins. The first such group was launched by a hermit of Perugia in 1260, amid the misery of the wars then being waged in Italy between the Guelfs and the Ghibellines, millenarian prophecies about the dawning of the Apocalypse and a disastrous plague

in 1259. Although comparable movements are also reported in areas of
south Germany and the Rhine in 1261–2, these initial occurrences were
relatively short-lived. Less than a century later, however, in 1348–9, a large
and seemingly organized flagellant movement made its way through
many parts of Europe, precipitated, it seems, by the Black Death; a strik-
ing depiction of one such group appears in a miniature from *circa* 1360
illustrating the *Chronik* of Gilles li Muisis (illus. 82). After their initial
appearance in Hungary late in 1348, flagellant groups subsequently sur-
faced in central and southern Germany, the Rhine valley and France (until
suppressed by secular authorities); although a boat carrying a contingent
of flagellants left the Low Countries for London in 1349, enthusiasm for
the movement in England was slight. Many of these groups, like their
thirteenth-century precursors, operated in a climate of millenarian expecta-
tion, but they seem also to have been fuelled by anti-clerical and anti-
Semitic sentiment: flagellants were apparently implicated in the massacres
of Jews that accompanied the Black Death in certain towns containing
prominent Jewish communities. What flagellant groups have in common
with the monastic 'disciplines' promoted by Damian is their adoption of
self-punishment as an act with powerful mnemonic associations. Viewing
penance as a mode of collective *imitatio Christi* – the imitation of Christ's
sufferings, by which all Christians could claim a share in the redemption
these sufferings had earned – individuals became members of the proces-
sions for a period of 33½ days, in memory of the life of Christ on earth.[20]

It is perhaps not coincidental that flagellant movements are documented in mid-fourteenth-century Breslau (Wrocław), the town where the carved *Crucifix* discussed in the opening pages of this book was commissioned (illus. 1 and 66).[21] An image such as this, which depicts Christ's body covered in a series of regularly interspersed welts, constructs a powerful record of the rhythmic scourging produced by flagellation; it might also have brought to mind, for some viewers at least, the bodies of living people similarly broken and tormented in the context of flagellant processions.

Pain, violence and memory likewise coalesced in the Middle Ages in the context of beatings carried out on young people and others in the course of their education. Law books such as Ulrich Tengler's *Layenspiegel* depict flagellation as a punishment carried out on adults (illus. 4), but medieval society also deemed it a peculiarly appropriate penalty for children. There is a wealth of evidence supporting the fact that English educators, in particular, wielded the whip enthusiastically in the classroom as a way of drumming lessons into their pupils.[22] Christian moralists took the view that children who were not subject to physical chastisement would be spoiled: 'He that sparyth the yerde [rod], he hatyth his sone; & he that lovyth his sone, he techith hym and chastisyth hym byselyche [constantly]', alleges *Dives and Pauper*, an early fifteenth-century prose treatise exposing the practical meaning of the Ten Commandments, in a direct quotation from the biblical book of Proverbs.[23] Medieval artworks similarly ventured a close correspondence between pain and pedagogy in the depiction of teachers. Woodcuts representing schoolrooms often showed masters clutching a bundle of birch twigs, as in a late fifteenth-century image illustrating a supplement to the *Sarum Hymnal* (illus. 83), and the standard iconography of Grammar showed her with a switch in her hand for beating pupils (illus. 84). Images of this sort were balanced by writers urging moderation in the distribution of pedagogic beatings, and there is evidence that schoolteachers in late medieval England were occasionally fined or even imprisoned for beating their students too harshly: 'controlled' beating was the order of the day.[24] Be that as it may, pedagogic violence would have been a phenomenon familiar to many young boys in the period, as evidenced by several poems, surviving in fifteenth- and early sixteenth-century manuscripts, that adopt the narrative voice of a beaten pupil and dream up strategies to manage, imaginatively resist or even escape painful beatings. One example opens with the observation of a would-be 'clarke' that his work is 'strange' because 'the byrchyn twygges be so sharpe'; the narrator recalls how, arriving late one morning, the master asked where he had been, the boy delivered the cheeky response 'Milked dukkes, my moder bad', upon which the master 'pepered' his 'ars' till it bled.[25]

C Expositio hymnorum
secundum usum Saru

83 'Early Tudor school scene',
woodcut in supplement to
Sarum Hymnal (London:
R. Pynson, 1496).

What is especially significant is that acts of beating were not simply a means of imposing discipline in the classroom but also a symbolic resource for imaginatively imparting knowledge. Fifteenth-century grammar books relating to the study and teaching of Latin, for instance, often made references to the necessity and justness of pedagogic violence in collections of *vulgaria*, or translation exercises, appended to the manuscripts. One such book, in a non-too-subtle ideological manoeuvre, features among its *vulgaria* the observation that if 'Jon my felow were y-bete as ofte as he doth deservy hit, with-out dowte he wold be come a gode chyld and an hesy [a good and well-behaved child] wyth-yn a fewe days', followed by a corresponding passage in Latin.[26] The statement promotes the idea that punishment is deserved and eminently useful: it works to produce a better child. Violence is translated here into a veritable mnemonic principle. Beating is not only a means of disciplining children physically

but also of marking them virtually, in the mind. The translation exercise draws on experiences of actual pain in the bodies of students to impress grammatical constructions violently on the pupil's memory. The 'rule of the rod', in these contexts, produces a virtual equivalence between the hammering home of knowledge in the mind and the production of painful impressions in the body.[27]

While the mnemonic techniques of medieval pedagogy resonate strongly, in this way, with the rituals of flagellants and self-disciplining monks – the sufferings of the past are invoked in each instance as a way of inscribing memory in the present – it is important not to lose sight of the fact that beatings enacted in the medieval classroom were not usually self-imposed. When Peter Damian writes in defence of monastic self-flagellation, one of the objections to which he responds is that the saints 'were flogged by others and did not flog themselves'. His answer is that even Christ, the king of martyrs, 'was handed over not only by Judas, but also by his Father and by himself'.

84 'Grammar and students', voussoir carving on west front, south doorway, south side, Chartres Cathedral, c. 1140–45.

If I should wish to suffer martyrdom for Christ and do not have the opportunity because the time of the battle is over, by afflicting myself with blows, I at least show my heart's fervent desire . . . if I punish myself with my own hands, or if the executioner applies the blows, I become the actual author of this ordeal if I voluntarily present myself to be tested.[28]

Damian's argument here centres on a principle of sacrifice that fuses the roles of victim and agent into a single entity. Whereas power in the pedagogic scenario is distributed inequitably between teacher and pupil, by virtue of factors such as age, physical ability and access to knowledge, the conceit of flagellant rituals and Damian-inspired discipline is that they are, in some senses, self-willed.

The wilful acceptance of pain was a crucial element, too, in saintly self-fashioning. It is in this context that martyrdom appears to share qualities with certain masochistic scenarios: a central mechanism of masochism is the 'contract', which challenges the barriers customarily erected between victimhood and empowerment. Representations of battered saints also possessed particular pedagogic functions, by inscribing doctrine, mnemonically, in the minds of devotees. But this ideological indoctrination is occasionally produced on the back of representations that have the potential to be symbolically over-determined, and even, I venture, queer.

MASOCHISM AND MARTYRS

An analysis of fifteenth-century French saints' plays – dramas depicting the exemplary lives and deaths of holy men and women – reveals two dominant understandings of pain. On a superficial level, saints' plays are dualistic: they aim at denigrating the sensations of the flesh in order to affirm the power of the spirit. Alluding repeatedly to the topos of *contemptus mundi*, martyrs conceive their bodies as prison-houses from which they desire to escape. For example, in the *Mystère de Saint Laurent*, when Lawrence undergoes torture on the grill, he declares: 'Place my soul in your domain and lessen the harsh pain by which my body is totally blackened.'[29] Statements such as these denigrate carnality and affirm the power of the spirit. Likewise, in the *Mystère de Saint Sébastien*, the martyr declares: 'You can torture and torment the body as much as you like but you will not touch the soul.'[30]

But looking beyond the surface of the plays' dualistic pretensions, one is able to perceive a more complex conception of pain in dramas such as

these: the emergence of a stance geared toward the attainment of pleasure. First, they convey the *positive*, purgatorial aspect to pain. Corporeal sentience is not despised in itself; on the contrary, the martyr constitutes it as the most productive route to the divine. Lawrence states: 'If we bear pain and suffering in this physical life, our soul will be more lovely because of this before God, our redeemer', and later proclaims: 'these coals refresh me . . . and, roasted that I am, I give thanks, because he has sustained me in my sufferings'; Sebastian declares: 'Your great torments give me much pleasure and substantial happiness when I contemplate and think well on the great joys of paradise.'[31] Second, they bear witness to the manifest reality of divine presence in the world. In the realm of the martyr, suffering – whether 'mental' or 'physical' – is transformed from being a mark of passive, powerless victimization to becoming a central signifier of God's present existence.[32] The saint's body – transformed through torture into a palpable sign of God's presence in the world – continues to signify after death through relics. Like the corpse of the executed criminal, the sainted body is divided, distributed and divested of coherent anatomic meaning. But whereas the criminal corpse signals the unfathomable breach between the strength of the individual transgressor and the invincible force of the law, the holy relic testifies to the continued presence of strength in the saint: the marriage of pain with power.

In the *Mystère de Saint Sébastien*, the martyr's physical appearance also plays an important role. Sebastian is characterized as a man of *grant beauté* or 'great beauty', the epithets *courtoys* and *doulx* being deployed constantly throughout the play in order to convey his (implicitly noble) virtues. Early on, a female character comments on the saint's good looks:

> He's so handsome, so fine, so sweet,
> that one couldn't say better.
> Above all else he loves our lord
> with all his heart and his will
>
> . . .
>
> My faith, my lady, there's nothing
> in which I take such great pleasure,
> nor for which I've such great desire,
> than to call upon his sweet presence.[33]

These sentiments are echoed by Maximian, the pagan tormentor, who during scenes of torture begs Sebastian to take pity on his 'great beauty'.[34] The saint is thus constituted as an object of desire. This also reflects the Christological framework within which passion plays should be understood. The signified of the female character's speech is inherently ambigu-

ous: 'our lord', after all, designates Christ, and it is unclear whose 'sweet presence' she desires; it is almost as though the saint and Christ roll into one. Indeed, the play later makes the parallels with Jesus' passion explicit: stripped naked and scourged, Sebastian interjects by demanding pardon for the 'poor people' who beat him, an obvious analogy to Christ's words of forgiveness in Luke 23:34 ('for they know not what they do').[35] Sebastian's request also mirrors the salvific tone of the play as a whole, embodied in his final intercessory prayer: 'may you remember the inhabitants of this town and protect them from harm, war and plague, and may you grant forgiveness to all those who remember me.'[36] In the company of God, to whom these words are addressed, the saint's broken body becomes both a source of salvation and a touchstone for the sublime.

Saints' lives, as such, set up a tension between two alternative conceptions of pain: on the one hand, the martyrs' body-affirming discourse, which emphasizes corporeality as a route to mystical pleasure and spiritual empowerment, and, on the other, the mind–body dichotomies of dualistic pain concepts. Of course, it might be argued that the martyrs at one level become *immune* to corporeal sensation; that heavenly anaesthesia spills over into the experience of the body, so that the saint feels no pain.[37] For instance, in the *Mystère de Saint Laurent*, God orders the angel Raphael to comfort the martyr, telling him to take linen to wipe his wounds. This is a motif that, by advocating the negation of physical perception, is unquestionably dualistic. Nonetheless, motifs of this sort do not dilute the overall impression that pain is synonymous with power in the context of late medieval devotion: hagiographic drama often leaves us in no doubt that the saint *does* feel his pain bodily. St Sebastian prays: 'Alas! Give me patience in my sufferings please', a request that suggests a desire for impassivity rather than insensibility; pain similarly takes its physical toll on St Lawrence, who exclaims: 'I have neither body nor member nor teeth which aren't broken.'[38]

But whereas in actual torture, according to Elaine Scarry, the prisoner's body is split from the self and made a weapon against him or her, in medieval hagiography the martyr repudiates torture's dualistic disposition by valorizing bodily suffering as a source of agency and power.[39] The pained body becomes a weapon to be directed *against* the pagan regime. In this way, the martyr assumes the subversive potentiality of the masochist: he inhabits a world where pain results in 'pleasure' and torment in 'joy'.[40] Pain, experienced as delight by the saints, is not a symbol of the fleshliness that they wish to disavow so much as a symbol of their willingness to embrace the flesh as a source of power and subjectivity. Sebastian boasts: 'My joys and all my delights are to endure pain and suffering for the love of my creator.'[41] Nor does pain generate fear: Sebastian

declares earlier that he is not afraid of any pagan 'threats'.[42] This seems to confirm recent arguments that sadism, contrary to popular belief, is incompatible with masochism: the martyr, far from inflating the sadistic tyrant's ego, causes its undoing. Gilles Deleuze, a French philosopher who has written eloquently on this topic, asserts: 'The concurrence of sadism and masochism is fundamentally one of analogy only; their processes and their formations are entirely different'; Anita Phillips, following Deleuze, calls the phrase sado-masochism a 'misnomer': 'There is sadism, there is masochism, and the two don't get on well together.'[43] This helps to explain why, when he is subjected miraculously to punishments himself, the emperor in the Sebastian play announces: 'All you devils, come here! Consume my body and my soul'.[44] Unlike the saint, the emperor's sufferings do not produce experiences of joy or transcendence but ones of corporeal annihilation.

Also, contrary to the common supposition that masochists are pathological freaks who simply find pleasure *in* pain, in the Deleuzian reading it is rather the case that they expect pain as the condition that will bring about future pleasure.[45] This explains the special significance of suspense in certain modes of masochism: the masochist is prevented from attaining end-pleasure until he has experienced punishment, humiliation and pain, which are in opposition to the pleasure principle.[46] Describing the psychic workings of suspense in hagiographic texts, in the context of an account of what he terms 'moral masochism', the psychoanalyst Theodor Reik notes that the bliss of paradise is preceded by a litany of torments, culminating in the ultimate agony of death experienced as a triumph; it could be said that *all* Christians adopt an attitude of moral masochism to the extent that they live in perpetual suspense of the Second Coming.[47] Saints' lives likewise incorporate motifs of temporal suspension in order to produce desire and longing in the minds of their readers and viewers, for a deferred, yet persistently sought-after pleasure. Hence, in the *Mystère de Saint Laurent* and the *Mystère de Saint Sébastien*, the martyrs' final deaths are continually deferred. Not only are their sufferings quantitatively graduated and divided into numerous 'second deaths', but the saints are frequently described as literally 'suspended' in their threshold states, that is to say they are tied up, held down and placed in pillories and gibbets; as seen previously, St Barbara was herself represented undergoing such tribulations. Moreover, when Lawrence prays that he be allowed to experience the climax of his desires, imploring 'Receive my spirit without waiting', a voice from heaven replies that he has not yet suffered all that is necessary.[48] The implication is that to immerse oneself in pain now is the path to future pleasure.

Visual images of martyrdom similarly suggest the profound importance of depicting the saint's motionless body in order to evoke feelings of

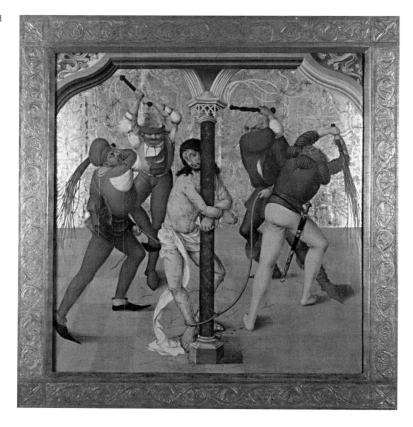

suspense and narrative tension. One of the twelve central panels in a
German *Passion* altar from the workshop of Rueland Frueauf the Elder, of
circa 1500 (illus. 85), depicts a striking beating scene in which Christ's tor-
mentors circle him in a sort of relentless, dance-like movement, their arms
raised and ready to strike. (The symmetrical composition further empha-
sizes the rhythmic structure of the image.) Christ, in contrast, is bound to
a pillar, the epitome of stillness and passivity. A rare representation of the
Death of St Sebastian, attributed to the late fifteenth-century painter Josse
Lieferinxe, employs a comparable arrangement (illus. 86). Paintings such as
these echo the beating scenes in passion plays, which are similarly infused
with a repetitive, game-like structure. Certain texts describe how the torture
is literally counted out onto Christ's body, which becomes a sort of 'toy' for
the tormentors, who, like schoolchildren or gamblers, keep a tally of the
'score'.[49] An exceptionally elaborate report of beating also appears in the
Mystère de Saint Laurent, where one of the tormentors declares:

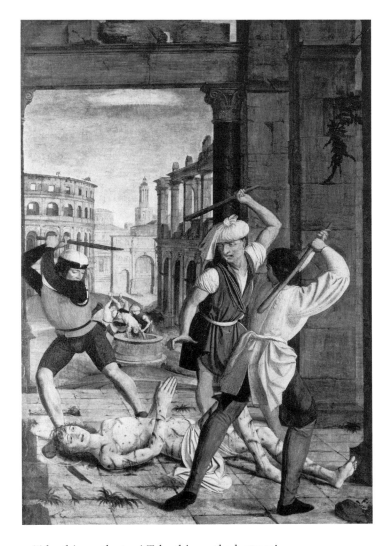

86 Josse Lieferinxe,
*Death of St
Sebastian*, *c.* 1497,
oil on panel.
Philadelphia
Museum of Art.

Take this on the top! Take this on the bottom!
Take this on the body! Take this on the arms!
Take this on the buttocks! Take this on his head!
Take this! And this! May God suffer because of this!
. . .
Let's begin everything again with more vigour.
Take this blow on the breast![50]

Scenes of this sort bear comparison with medieval pedagogy, which as we have seen frequently harnessed violence in the service of memory: representations of Christ's flagellation beat an unforgettable message into the minds of their audiences.[51] But, as well as facilitating the memorization of Christian lessons, beating scenes in passion iconography also engage with the viewer on a deeper level. In the Frueauf *Flagellation* scene, it should be noted, Christ's look seems to meet our own, incorporating *us* into the scene. Gerard David's *Christ Nailed to the Cross* (illus. 87), painted in Bruges after 1484, provides another striking instance of the motif, this time in the context of the crucifixion.[52] As discussed in chapter Two, the representation of a protagonist looking out from the painting toward the viewer gives rise to a suspension of time, since as soon as we, the beholders, are required to participate in the visual narrative, the illusion that Christ's passion was a historical event located at a particular chronological juncture is shattered. We too become implicated in the scene, laying the image open to the possibilities of victim identification and (imaginary) corporeal sensation. Motifs of this sort contribute to the process by which sensations transfer, imaginatively, from one body to another: from the body of Christ to the body of the saint to the bodies of devotees. The medieval principle of *imitatio Christi* encapsulates the fantasy that pain is transferable and that it can be shared – that worshippers are able to fuse mentally and even physically with Christ's body. Of course, the lesson of Scarry's account of torture is that pain is not so easily sharable: resisting verbalization, it enacts a fundamental splitting off of self from other. But the cultural fiction established by medieval hagiographic drama makes it clear that suffering, visualized and performed, is a precursor to extreme

87 Gerard David, *Christ Nailed to the Cross*, after 1484, oil on oak. National Gallery, London.

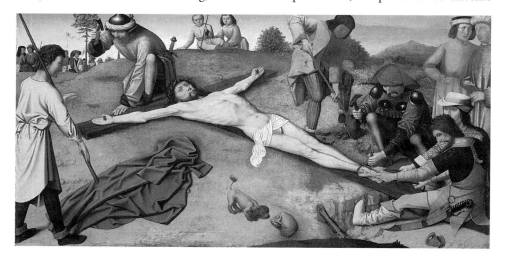

joy. Medieval beholders were being asked to view pain not simply as a destructive force but also as phenomenon that produces bliss.

Dramatic suspense provided a means for artists to communicate this ambiguous pleasure–pain nexus to medieval viewers. Whereas Gerard David's *Judgement of Cambyses* (explored in chapter Two) represents an expression on the face of the condemned that is consistent with the torments being inflicted on his body (illus. 33), martyrdom and passion iconography often depicts the saint's face as unmoved (illus. 61, 73 and 74) or looking up to heaven (illus. 72), and as such conveys a 'lack of fit' between the tortures being carried out and the psychological consequences of those tortures. Other techniques used by artists to evoke suspense involve representing an interval in time just *before* the torments occur – which allows the viewer to meditate indefinitely on the sensations that might result – or alternatively drawing attention to the long-drawnout nature of the martyr's sufferings. Like the Frueauf *Flagellation* panel, Dirk Bouts's and Hugo van der Goes's *Martyrdom of St Hippolytus* (illus. 88), painted in Bruges after 1468 and perhaps the inspiration for the composition of David's *Christ Nailed to the Cross*, adopts a contrast between stillness and motion to evoke dramatic suspense.[53] The saint's legs and arms are splayed in straight lines, his body perfectly still, whereas the tormentors' horses raise their limbs menacingly. But significantly, whereas in the Frueauf scene Christ's body has already been disfigured with cuts and blemishes, the *Hippolytus* panel freezes the narrative to a moment just before any

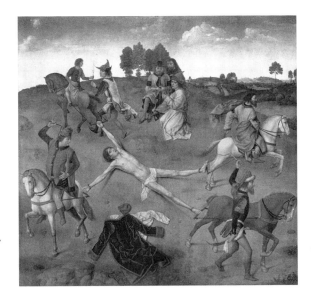

88 'Martyrdom of St Hippolytus', central panel of Dirk Bouts and Hugo van der Goes, *St Hippolytus* altarpiece, after 1468, oil on wood. Groeningemuseum, Bruges.

bloodshed occurs, heightening its masochistic structure.[54] The saint's taut, muscular, about-to-be-ripped-apart body encapsulates the narrative tension – an important feature, too, in visual depictions of the grilling of St Lawrence (which never, to my knowledge, show any signs of burning or bloodshed). In the panel by Michael Pächer (illus. 90), Lawrence lies tensed across the gridiron, his erect nipples bearing witness to the strain of his upper body. The epitome of such representations is the fifteenth-century altarpiece depicting the disembowelling of St Erasmus, by the Netherlandish artist Dirk Bouts (illus. 89). Temporality is crucial to the functioning of the image: one is drawn to imagine the slow, excruciating turn of the spindle, extracting the saint's intestines from his body. Erasmus's insides emerge like a long, flat tape, twisted in a spiral at several places along their length as if to emphasize the agony of the procedure; the saint's skin, stretched taut across his ribcage, further accentuates the narrative tension.

As well as dramatic suspense, another related feature of the masochistic attitude is exhibitionism. Acts of looking and of being seen are important

89'Martyrdom of St Erasmus', central panel from Dirk Bouts, *St Erasmus* altarpiece, before 1466, oil on wood. St Pieterskerk, Leuven.

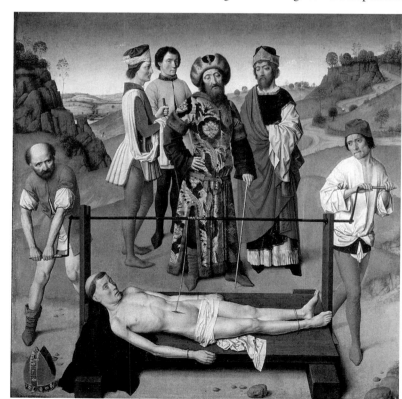

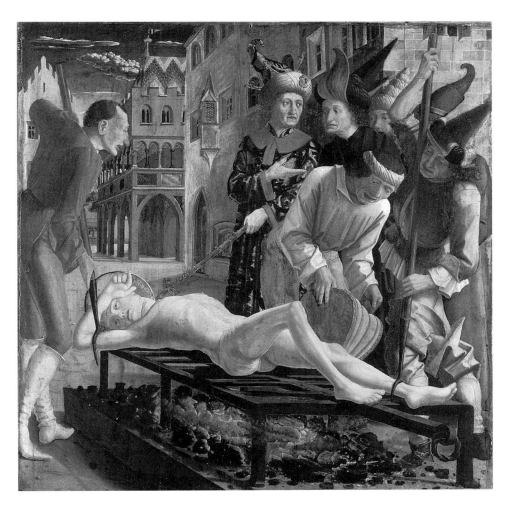

components in medieval penitential rituals, as demonstrated in this account, by the fourteenth-century German mystic Henry Suso, of an act of extreme self-mutilation:

> At dusk he shut himself in his cell and undressed himself to his hair undergarment, took out his scourge with the sharp thorns, and beat himself on body, arms and legs, so that the blood ran down, as it does when one is bled by the physician. He struck himself so hard that the scourge broke into three pieces. As he stood there, and saw himself bleeding – it was a most doleful sight – almost like the beloved Christ,

90 'Martyrdom of St Lawrence', panel from Michael Pächer, *St Lawrence* altarpiece, 1460s, oil on wood. Alte Pinakothek, Munich.

when He was savagely scourged, heartfelt tears flowed from pity of himself. He knelt down, naked and bleeding as he was, in the icy air, and prayed to God to efface his sins before His gentle face.[55]

The lines of sight in this passage are multiple: the penitent watches himself at the same time that we, the readers, look at him, but he also imagines the gaze of God ('His gentle face') authorizing his radical acts of penance. Likewise, scenes of beating in martyrdom and passion iconography place emphasis on vision, and more particularly on the 'Otherness' of the gaze. Christian martyrs attach great importance to the presence of the witness (the term martyr, etymologically speaking, connotes precisely this aspect of having, and bearing, witness).[56] The scene in the *Mystère de Saint Sébastien* discussed earlier, where a female bystander praises the appearance of the saint, embodies the role of witness and in turn provides an exemplary model for the audience of the play. The point of martyrdom depiction is that the viewers themselves become witnesses to the 'realness' of sacred suffering.[57] Fifteenth-century Calvary depictions emphasize this aspect of spectatorship, by depicting large audiences at the foot of the cross (illus. 91). In martyrdom depiction, where onlookers are not commonly depicted within the pictorial frame (that is to say, besides the tormentors and interrogators), spectatorship is nonetheless implied by the stance of the saint in question, placed on display as an object of desire. Images depicting the martyrdom of St Sebastian are especially striking in this respect (illus. 92), transforming the saint explicitly into exhibited, eroticized flesh.[58]

In the previous chapter, I employed the term 'gaze' as it has been taken up by feminist film theory, to refer to the voyeuristic, fetishistic structures of martyrdom iconography. But the gaze is not simply on the side of the viewing subject; psychoanalytic critics also place emphasis on the extent to which the desiring subject wishes to be the object of the Other's gaze.[59] When the subject looks at an object, the object is always already gazing back at the subject, but never from a place in which the subject sees it. This disjunction between the subject and the gaze may help us to understand the desire of medieval Christian devotees for fusion with the martyred body-in-pain. Those who approach the image from the point of view of religious devotion desire recognition in the field of the Other; they wish to place themselves in a situation where they become objects of the gaze. This might, of course, entail identification with the torturers, but the alignment with the 'eye / I' of the pagan tormentor is figured as a minority position in mainstream religious discourse. Identifying both with the sympathetic bystander and the saint, on the other hand, it is possible to see how medieval devotees might have constructed a role for

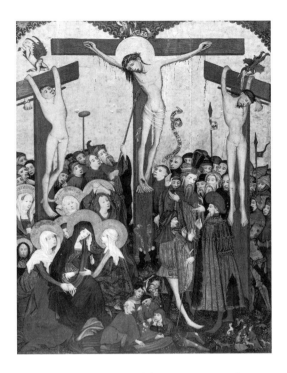

91 Master of the Göttingener Barfüsseraltar, 'Calvary', central panel of the *Göttingen Barfüsseraltar, c.* 1424, tempera, gold ground on oak panel. Niedersächsisches Landesmuseum, Hannover.

themselves in the masochistic structure embraced by martyrs. On the one hand, beholders might be sustained by the (fantasized) recognition of God through identification with the saint; on the other hand, they might inhabit the role of hagiographic witness, both contributing to the recognition of the saint and *receiving*, as a result, self-recognition through the fantasy of saintly intercession. In each instance, the viewer's own subjectivity is potentially guaranteed by their becoming, imaginatively, an object of the Other's gaze. In contrast, the torturer cannot bear the thought of being the object of the gaze, since this reflects his (pagan) world's unmaking. When, in the *Mystère de Saint Laurent*, the martyr hears a voice from heaven (the recognition of the Other), Decius, the Roman prefect, is terrified. Lawrence declares 'It is the voice of God, my sweet master, who speaks in me', to which Decius responds: 'I feel in me such great pain that my strength and my reason diminish.'[60] Unlike Decius, the saint positively wallows in the Other's gaze: the stage directions make it clear that Lawrence is 'laughing to himself' as he speaks.[61]

These examples suggest that if the saint were to draw up a 'contract' in the course of being martyred, it would not be with the torturer as such, but with God: God is the figure who ultimately assumes the 'active' role in

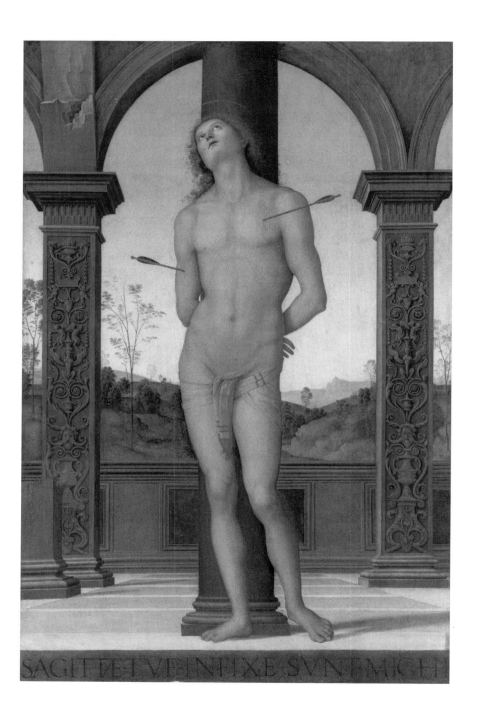

SAGITTET VE INFIXE SVNT MICHI

the martyrdom scene. Saints' plays do not, of course, represent the draw- 92 Pietro Perugino,
St Sebastian, *c.* 1495,
oil on wood. Musée
du Louvre, Paris.
ing up of formal contractual bargains between protagonists, akin to the
written documents envisaged by Deleuze and Phillips in their accounts of
masochism.[62] One cannot expect modern theories of masochism to cor-
respond exactly to medieval ways of representing the world. But it is pos-
sible to draw analogies with certain masochistic structures. One of the
issues raised by the drawing up of a masochistic contract concerns the
wilful acceptance of pain. Clearly this was also a crucial element in saintly
self-fashioning, as it was in the disciplines of flagellants and monks:
saints' plays emphasize the martyr's role in putting himself forward as vic-
tim. In the *Mystère de Saint Laurent*, when the tormentors catalogue the
instruments of torture in their arsenal – 'Nails of iron and good pincers
and teeth to tear the entrails, bellows to light the fire and huge sticks to
beat with, other torments of every kind' – the martyr replies that such
things have been desired all his life: 'I've desired pain and martyrdom to
please Jesus, our lord: These are the meats you are asking for.'[63]
Undergoing torture, he remains defiant: 'I'm making a sacrifice through
devotion [to God] with my blood in this torment and martyrdom. I've
had all that I want.'[64] Like the flagellants, in this way, the martyr's plight is
bound up with the ethics of sacrifice. The saint is required to sacrifice the
self willingly, to desire painful death, in order to be incorporated into the
heavenly community.

This brings me to the final feature that distinguishes sadism from
masochism: masochism's investment in fantasy. According to the
Deleuzian definition, masochism is an 'art form', reliant upon the aestheti-
cization of pain and the drama of suffering; sadism, in contrast, is based
on the expression of pure negation through quantitative repetition.[65]
Likewise, depictions of martyrdom produce a series of masquerades that
create the appearance of the martyr's passive submission, suspending the
fact that, in the context of hagiographic fantasy, they have access to divine
agency and power; the tormentors are depicted attempting to negate their
object actively, by getting on with the job in hand. Martyrdom represen-
tation retains the satisfaction of heavenly bliss as a deferred possibility. It
functions as a space of fantasy that enables the beholder to enjoy the
pleasures of recognition, self-affirmation and belief that experiences of
pain offer, while not threatening the beholder's body in actuality. (In this
respect, there are again elements in hagiographic depiction that align it
with violent pornography.) This element of suspense is what, for Deleuze,
places the spectator on the side of the victim: the transfer of sensation vir-
tually, from one body (the painted saint) to another (the viewing subject),
is fuelled by imagery of immobility, waiting and delay. At the same time,
it is worth stressing the *imaginary* dimensions of this process: viewers of

martyrdom representation require the saint's suffering, but they don't actually suffer as such. While the martyrs and Christ are represented confronting pain and death head-on – they 'traverse' the fantasy and actually become suffering bodies – medieval devotees who responded to martyrdom iconography were not, for the most part, hurling themselves into the abyss of the real and actually becoming martyrs themselves. Images of this sort evoke pleasure – enjoyment within limits – rather than what might be termed, in psychoanalytic parlance, *jouissance* – that which goes 'beyond the pleasure principle'.[66]

In this respect, the enjoyment of rituals of flagellation potentially differs, qualitatively, from the enjoyment of hagiographic violence. If beaten bodies elicit responses on a continuum between pleasure and *jouissance*, then self-flagellation surely comes nearer to the *jouissance* end of the scale, to the extent that it initiates an overpowering, self-shattering kind of ecstasy. The loss of self conjured up by hagiographic fantasy is somewhat guarded in comparison. The insistence on the saint's – and Christ's – consent is a vital component of religious drama, partly because it gives the viewer a licence to take pleasure *in* violence, as well as identifying, imaginatively, with the position of the violated saint. Thus, what appears from one perspective to be masochism may on a different level have fuelled sadistic inclinations in the minds of audiences, modes of aggression that contradict martyrdom's dogmatic premise. Medieval Christianity explicitly promoted a moral alignment *with* masochism: the look of the pagan tormentor was configured as the minority position (the 'perversion'), while sacred masochism was conceived as the norm. But the stake of audiences in seeing the masochistic scenario played out on stage – the underlying impulse – may also be connected to a desire for violence *against* the sacred Other (at least at some level). The alignment of viewers with the exemplary victim-hero in martyrdom iconography seems to have provided an excuse – or disguise – for modes of scapegoating that produce a range of underlying victims and social outcasts. But, as well as violating the identities of those included in these categories (foreigners, religious outsiders and lower classes, for example), projecting hagiographic violence onto the 'others' who superficially carried it out may even have constructed a convenient ideological cover – a camouflage – behind which medieval Christians were able to enact fantasies of aggression against God himself. Rainer Warning, at least, has argued as much in his analysis of late medieval passion plays: he implies that the horrifying and excessive cruelties in late medieval passion plays bear witness to an 'epochal longing for scapegoats', and that the scapegoat selected consciously by Jews in these plays (Christ) is at the same time the 'imaginary' scapegoat of the Christian community.[67]

My point, then, is that violence in hagiography works on a number of different levels. The pleasure involved in identifying, through hagiographic fantasy, with the consenting victim may be partly related to the pleasure of projecting cruelty onto the tormentors; in turn, and paradoxically, this may also have provided a cloak beneath which ritual violence could be unleashed on that sacred victim (albeit in underhand and unacknow-ledged ways). In this sense, sadism should certainly not be ruled out as an implicit feature of martyrdom depiction. But a focus on masochism helps us to comprehend the outward message that these representations are designed to convey, a message promoting the relationship between pain, pain's capacity to be reconfigured in sacred ritual, and power. Narrative sequences of torture, such as the *St Barbara* altarpiece discussed previously, portray violence as ineffective, by imagining the martyr's body seemingly restored in the gaps between one scene and the next. This is a technique that aids the construction of the martyr as an ideological support for the inviolable 'body' of the Church. But individual torture scenes also place emphasis on the meaningful aspects of saintly suffering. Masochism, embedded in motifs of fantasy, suspense and exhibitionism, recodes the body-in-pain as a site of agency and sexual liberation; martyrdom, through an analogous trio of techniques, fashions the sublime body of the saint. Unlike the dualism of a mind-over-matter approach to pain, late medieval Christianity devised a theory of pain that located physical sen-sation and mental faculty in the same entity and gave positive meaning to positions of objectification. In the world of the martyr, *to be penetrated is not to abdicate power*.

QUEER TRANSITIONS

In conclusion, I'd like to consider in more depth the gendered rami-fications of those scenes. Whereas masochism is commonly imagined as a relinquishing of power, the examples of martyrdom representation discussed in the previous section suggest that we ought to interrogate more closely the structural similarities between masochism and certain genres of medieval representation. When the term 'masochism' is carefully employed as an interpretative category, it helps to illuminate the structures of fantasy, suspense and looking that informed certain genres of medieval repres-entation. But the framework of masochism may also enable a more sophisticated critical purchase on the sexual politics of martyrdom repres-entation. One of the challenges that Deleuze offers to previous, psycho-analytically inspired theories of masochism concerns the gender dimensions of the scenario. Whereas Freud believed that masochistic beating fantasies

were a way for men to deal with repressed homosexual desire for the father – in the essay 'A Child Is Being Beaten', he associates the boy's 'passive' attitude to being beaten with a 'feminine attitude towards his father' – Deleuze argues that masochism actually involves a complete *repudiation* of paternal power, a rejection of virility itself.[68] The casualty is no longer Freud's 'feminized' infant but Deleuze's humiliated father; meanwhile the masochist is reborn a new and 'sexless' man. 'Masochistic fantasy', writes Deleuze, 'is less an instance of "a child is being beaten" than of *a father being beaten . . .* it is the master who undergoes the tortures.'[69]

It is important to emphasize that the beating scene in late medieval textual and dramatic representation is not necessarily as subversive as a Deleuzian reading might suggest. Citing examples of pedagogic violence, for instance, Jody Enders has warned that the memories of young boys are tormented as a means of perpetuating male privilege: 'They are', she writes, 'the future teachers, future punishers, future inflicters of beatings upon future generations of boys who seek to enter the community into which the master had already been initiated.'[70] In support of her argument, Enders cites a famous passage in Guibert of Nogent's autobiographical *Monodiae*, which reminisces fondly on the vicious beatings inflicted by his tutor in childhood:

> However oppressive he was, my master made it clear to me in all kinds of ways that he loved me no less than he loved himself . . . As for me, though I was somewhat clumsy and shy for my age, I had such a liking for him – striped as my poor little skin might have been by his many whiplashes – that I obeyed him, not out of fear (as would generally be the case in relationships like these) but out of some curious feeling of love, which overwhelmed my whole being and made me forget all his harshness.[71]

The pain of beating is thus reconfigured by the adult monk as 'love'; moreover, when his mother 'saw how cruelly [he] had been treated at such a tender age',[72] Guibert represents her as a hindrance to his education, describing how, despite her concerns, he insisted on continuing his lessons.[73] Enders, in turn, suggests that the mother incarnates those undesirable feminine traits that the schoolmaster attempts to expunge: 'Re-envisioned as feminine', she writes, '[the young boy's] softness can then be beaten out at the same time that a more condoned view of masculinity is beaten in.'[74]

Clearly masochism, in this example, becomes compatible with – and even a prerequisite for – exceptional virility; and it would be wrong under such circumstances to characterize it as inherently transgressive.[75] Nonetheless, there is room for a degree of optimism. For although Enders

footnotes her observations on Guibert with the statement that a 'queer reading of *saevus amor* lies beyond the scope of this book',[76] unwittingly, in writing of the 'sublimated sexual love between student and teacher', she makes just that reading. The spectre of male–male love rears its potentially subversive head, and, within the context of reparative reading practices, makes for a vision of masculinity that deviates – at least in *some* respects – from hegemonic heterosexual norms. Similarly, it is worth emphasizing that, when martyrs are beaten and tormented, their earthly gender roles are partially reconfigured. In written saints' lives, there are several examples of male martyrs being compared explicitly to cooked meat. In the *Mystère de Saint Laurent*, for instance, the saint's famous gibe to Decius to 'turn me over and eat' draws attention to the culinary dimensions of being roasted on a grill.[77] Motifs such as this connect the saint with Christ's eucharistic body, as seen in iconography depicting Lawrence as a sacrificial offering: an early sixteenth-century altarpiece from Alsace shows one of the executioners drinking on the job, while the saint is cooked before an altar-like table laid out with bread and drink (illus. 93). But the reconfiguration of the saint's body as meat also aligns him with modes of fleshly passivity and – through acts of beating – with the punished child; this produces a subject position at odds with his previous status as wielder of earthly power and responsibility (Lawrence was a church deacon, and Sebastian a military commander, before their subjection to torture). As we saw in chapter Four, female saints' lives also produce their own disruptive effects in the context of torture. While male martyrs, in the course of being tortured, might be divested of certain signifiers of earthly masculinity, the battles that female virgin martyrs undergo to protect their chastity potentially associate them with privileges that, in late medieval culture, were normally gendered male: speaking eloquently, for instance, or thumping demonic entities with hammers.

Queer, too, are those images of Christ and the saints that signal their transition to positions of gender ambiguity in their subjection to bodily torment. Male saints are visually de-phallicized by being decapitated, disembowelled and flayed (illus. 69); female saints such as Barbara and Agatha are purportedly 'de-sexed' by having their breasts removed (illus. 73 and 61). Martyrs such as Sebastian are subjected to a proliferation of phallic instruments (in Sebastian's case, arrows), in order to symbolize their figurative transformation from wielders of earthly power to tortured purveyors of divine presence (illus. 92). In each case, the tormentors adopt exaggerated signifiers of male power – phallic weapons, prurient looks and insulting jeers – while the martyrs embrace phallic absence wholeheartedly through their subjection to torture.[78] Certain artworks depicting Christ's passion also reproduce a similar pattern. I drew atten-

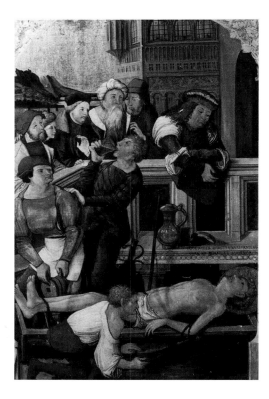

93 'Martyrdom of St Lawrence',
panel from anonymous altarpiece
of *St Catherine and St Lawrence*,
early 16th century, oil on wood,
Alsatian. Musée d'Unterlinden,
Colmar.

tion, earlier, to the ritual structure of martyrdom and its investment in
positions of liminality; the framework of the 'rite of passage' may also
inform images of the dead or tortured Christ, which occasionally make
typological connections to his circumcision.[79] For instance, in a panel
from an Austrian passion sequence by Marx Reichlich depicting Christ's
flagellation (illus. 75), blood seems to drip from wounds in the victim's
belly down his legs, giving the effect of a bloody, 'menstruating' groin. The
drops of blood are echoed by the red string ties on the breeches of the tor-
turer in the left foreground, accentuating the parallel to be drawn between
the torturer's veiled groin and Christ's bloodied, exposed lower body. The
tormentors with their bulging codpieces and phallic signifiers (weapons
and whips) perform an extravagant masquerade of masculinity, while
Christ, naked and genitally ambiguous, adopts his gender-liminal status
as a mark of moral superiority.

Reichlich's painting represents flagellation as a painful ordeal, certainly,
but it also shows how acts of torture might temporarily disrupt the
identities of sacred subjects, producing a confusion of categories such as

gender. Important among the constellation of bodily rituals that nineteenth-century sexologists and psychoanalysts designated 'masochistic' is the fantasy of being beaten. The masochistic climax, in these situations, might be reached when the punishments being inflicted on the surface of the skin are pushed to the point where the skin itself becomes broken. Returning to one of the issues raised in chapter Two, then, it is possible that the drama of being spanked or whipped encodes a fantasy of being flayed until one is completely skinned.[80] If, as I suggested in relation to the Cambyses legend, the tearing away of skin removes the parchment on which meaning can be etched, representations of sacred beating – and indeed of any torture that threatens to disrupt the containing surface of the skin (Sebastian's penetration with arrows, for example) – welcome this loss of self as a point of departure for a spiritual rebirth. Such attitudes were, of course, entirely orthodox. Thomas à Kempis (d. 1471), author of one of the most influential guides to devotion produced in the late Middle Ages, describes how Christ desires his devotees to be wholly divested of self: 'otherwise, unless you are wholly stripped of self-will, how can you be Mine, or I yours?'[81] But these temporary abolitions of identity produce, as a corollary, a field of representation that is queerly disjunctive. Martyrs, suspended in a state of living death, refuse their previous social identities; this is the prelude to their reintegration into a new symbolic order. The rituals of transition used to advance this process give rise to a cluster of images in which men are represented stripped and whipped, their bodies objectified and even, as Sebastian's iconography bears witness, erotically charged (see illus. 92).[82]

Pain, freely embraced by the masochist, generates pleasure and orgasmic release; martyrs welcome suffering as a means of escaping earthly sin and recovering eternal life. The crucial difference between martyrs and masochists is that saints adopt transcendence, rather than eroticism, as a way of handling suffering. At the same time, if we explain away these understandings of pain as the product of a failed or archaic culture (the Middle Ages) or of sexual pathology (notions of masochism as negative or dualistic), we risk ignoring the potential 'vibrations' between medieval and modern in certain encounters with pain. 'Masochism', writes Phillips, 'shares with religious discourses the ability to make use of suffering, to describe or redescribe it as a valuable aspect of life . . . It has to be followed by an upbeat ending.'[83] It is this positive effect that the ex-nun Karen Armstrong notices in her reminiscences on self-discipline in a convent; although she begins by imagining acts of self-mortification as excessively 'medieval', she ends with the insight that pain can produce bodily as well as spiritual rapture. Presumably, those individuals who participate in the *picaos* rituals in modern Spain do so because, like the ordeal of the

martyr, self-inflicted pain provides a means of expiating guilt and moving closer to sublimity. Of course, as Phillips is quick to emphasize, the difference between the masochist and the Christian devotee is that the masochist 'gets his or her thrills in a carnal, profane way ... The encounter ends not with apotheosis, but orgasm.'[84] But it is important to imagine ways in which martyrdom, too, created outlets for earthly release – to consider how the masochistic scenario embraced by medieval martyrs might have provided a framework for structuring people's worldly experiences and desires. My point is not that we discard completely theological readings emphasizing the spiritual and the sublime, but that, within the sphere of medieval devotion, religious sublimation and carnal desire can become powerfully intertwined. The worldly and the transcendent are not always at odds with each other, in other words, but may well *produce* one another – an issue that the final chapter explores in more depth.

CHAPTER 6

Hanging with Christ

I saw, standing in front of the altar . . . an image of the Lord Saviour. As I was in deep contemplation, I recognized the crucified Lord himself crucified in that very place and I beheld him, living, in my mind's eye . . . I took hold of he whom my soul loves, I held him, I embraced him, I kissed him lingeringly. I sensed how gratefully he accepted this gesture of love, when between kissing he himself opened his mouth, in order that I kiss more deeply.[1]

What did it mean for Rupert of Deutz, a twelfth-century monk, to envision himself embracing the crucifix and indulging in a bout of passionate French kissing? To many of today's readers the above passage is striking, some might say shocking. It evokes desires ardently directed toward an image of a barely clothed male deity, in language that appears to resonate sexually, even though the desired object is ostensibly a tormented body-in-pain. How are we to account for the unabashed frankness with which the spectre of male–male love rears its head in an orthodox Christian text? And how should we comprehend the connection between the violent vision that provoked such meditations – the image of the crucified Christ – and the amorous exchange that occurs in the monk's imagination?

It is worth bearing in mind that Deutz's vision – suggestive though it is – repeats a familiar trope in monastic literature.[2] Pinocchio-like tales of crucifixes shuddering to life in order to address or even embrace their beholders frequently formed the basis for a quasi-conversion narrative in which the young initiate discovers that he has been called to a deeper understanding of Christ's mysteries, giving vent, even in the most traditional contexts, to images of men kissing and hugging fast. Whereas Francis of Assisi was simply said to have seen Christ speak 'from the wood of the crucifix',[3] Herbert of Torres, recounting the miracles of Bernard of Clairvaux (d. 1153), describes a 'certain monk' known to him who once found Bernard praying alone in church, worshipping a crucifix and kissing it warmly. Furthermore, Torres explains, the Lord on the cross appeared to 'embrace' the abbot and 'draw tight to him'.[4] A manuscript illumination illustrating an edition of the *Manuel des Péchés* (illus. 94) figures the convention quite literally as two men locked together in an intimate embrace, suggesting the extent to which such imagery was deemed perfectly acceptable in sacred contexts.[5] But for all the conventionality of their immediate context, is it possible that such metaphors might also have been read, in the Middle Ages as today, in queer, counter-

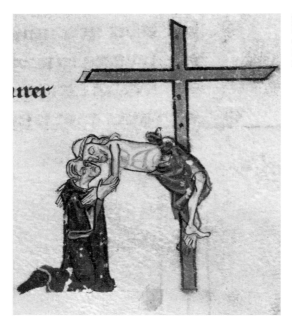

94 'Crucifix embraces a layman', miniature in *Manuel des Péchés*, 14th century, French. Princeton University Library.

hegemonic ways? Should we dare to pose the question 'what if?', and in its answering raise the spectre of queerness in relation to sacred symbolism?

The chief problem is that a culture of hesitancy – even chastisement – militates against comprehending Christian imagery through an overtly queer optic, particularly when the contexts are pre-modern.[6] Part of this has to do with larger anxieties about how to deal with the category of the erotic in medieval religion. Modern scholars, like some medieval theologians, are divided on the issue of whether the enraptured devotions of mystics, nuns and monks were 'really' sexual or 'really' religious.[7] Nancy Partner, posing the question 'Did mystics have sex?', discovers a medieval mysticism fundamentally grounded in sexual drives and sublimations. Scholarly acknowledgement of these libidinal dimensions of mystical experience will, Partner believes, 'restore to the life stories we write of and for [medieval people] the depth, complexity, and fellowship with ourselves they deserve'.[8] Caroline Walker Bynum, conversely, urges a more guarded approach, advancing the view that medieval sexuality may be markedly different from its modern counterpart. In her response to Leo Steinberg's controversial *The Sexuality of Christ in Renaissance Art and in Modern Oblivion*, Bynum reflects on Steinberg's thesis that we should look at the spaces in Renaissance religious painting where we are not supposed

to look – to the Christ-child's groin, to his deliberate acts of self-exposure (the *ostentatio genitalium*), his penis and its fondling by ageing relatives, the homage paid to it by the Magi, the folds of the mature Christ's loincloth insinuating phallic tumescence – and asks:

> Did medieval people immediately think of erections and sexual activity when they saw penises (as modern people apparently do)? . . . It is impossible to prove that medieval people did not assume what we assume when we look at pictures. And we clearly see breasts and penises as erotic. But let me at least suggest that we would do well to be cautious about projecting our ways of seeing onto the artists or the views of the past.[9]

Bynum resorts to evocations of medieval alterity to support this line of thinking. In her view, for example, people did not have a concept of sexual identity or orientation: 'Despite recent writing about "gay people" in the Middle Ages', she remarks, with reference to the work of the historian John Boswell, 'it is questionable whether anyone had such a concept'.[10] Thus, what seems at first sight to be a call for general historicist caution regarding medieval sexuality also becomes an argument for rejecting modern sexual labels as the interpretative key for medieval images and texts.[11]

If Partner puts her faith in Freudian psychology as a way of uncovering the 'truth' of medieval mystical writing (that it is about sex), Bynum's preferred interpretative paradigm is theology. As I suggest later, this aligns her closely in some respects with the Steinberg she aims to critique. But it also leads her to promote what she categorizes as a very medieval way of relating to the world, a nostalgic deference to notions of 'dignity', 'fertility' and 'unavoidable suffering' over and above the pleasures of the sexual. As she puts it:

> If we want to express the significance of Jesus in both male and female images, if we want to turn from seeing body as sexual to seeing body as generative, if we want to find symbols that give dignity and meaning to the suffering we cannot eliminate and yet fear so acutely, we can find support for doing so in the art and theology of the later Middle Ages.[12]

The present chapter aims to contribute to these debates in two, related ways. First, I'd like to suggest that it might not be necessary to make a stark choice between sexual and theological perspectives – that it is not always a case of simply 'turning' from one to the other. While I agree with

Bynum that modern categories should not be applied uncritically to medieval images and texts, I want to question whether theology offers the only interpretative framework for comprehending medieval devotion and whether we should reify it as such. Second, I wish to explore an issue that Bynum responds to implicitly in her review of Steinberg's book, namely the relationship between gender, sexuality and violence in medieval Christological representation.

THE SONG OF SONGS IN MEDIEVAL DEVOTION

Before turning to some examples of passion meditation, it would be worth exploring the tradition that, in the Middle Ages, provided the point of departure for melding sexuality and spirituality in the context of Christian worship. If, as I argue here, the art and literature of late medieval devotion potentially tips over into queerness, perhaps the queerest cut of all is that the roots of this phenomenon can be discovered in the Bible. The Song of Songs is a text that has been subjected to a plethora of interpretations, in both Jewish and Christian exegetical traditions.[13] Ostensibly a collection of poems exchanged between two protagonists, apparently identified as male and female, at the most basic level the Song seems designed to celebrate an intensely erotic relationship between a man and a woman. It should be noted that attempts to read the text literally, in this fashion, produce a degree of discomfiture: the point at which the 'he' stops and the 'she' begins is not always very easy to discern, and the poems are often baffling in their shifts of register and imagery. Nonetheless, the dominant view is that union of the lovers in the Song conveys, on a literal level, the language of heterosexual sex.[14] This is precisely what medieval commentators found troubling about the text: the carnally minded reader, by mistaking the poems for pious pornography, risks being diverted from his or her spiritual vocation.[15]

That the Song *was* sometimes a source of carnal inspiration in the Middle Ages can be gauged from a passage in Chaucer's *Merchant's Tale*, where the protagonist January attempts to woo his wife May by appropriating lines directly from the biblical text: 'Swiche olde lewed wordes used he', remarks the narrator wryly, as if the lines quoted could only signify as smut.[16] In fact, there was a centuries-old tradition of interpreting the Song along very different lines. Origen of Alexandria (*d.* 253) was one of the earliest Christian commentators to offer a solution to the thorny problem of the Song's erotic potential: he suggested that the poetry's carnality veils a spiritual meaning, or *allegoria*, which readers should aspire to comprehend. Rather than describing a cupidinous fleshly exchange

between a man and a woman, Origen argued, the poems refer allegorically to the mystical marriage between the Church and Christ, or between the soul and the Word of God. Moreover, according to Origen, the process of interpretation (*allegoresis*) depended fundamentally on the sublimation of bodily desire – a requirement that, judging by his alleged self-castration, he personally took very seriously indeed.[17]

Allegory, along the lines Origen proposed, was the basis for subsequent analysis of the Song in the Middle Ages. Medieval commentators, following Origen, identified the two protagonists of the poems as a Bride, or *sponsa* – who was interpreted as, variously, the Church, the Virgin Mary and the individual soul – and a Bridegroom, who was identified with Christ. But from the twelfth century, the allegorical interpretation underwent something of a transformation, influenced especially by the sermons on the Song written by Bernard of Clairvaux. Bernard's concern, above all, was to demonstrate how allegorical meanings of the Song could, in a sense, be re-literalized. The bodily affects generated by the Song's imagery, which Origen had sought to expel completely, were viewed by Bernard as a unique opportunity to draw the Christian devotee closer to God. Thus his aim, in allegorizing the Bride as the individual human soul, was to give prominence to the soul's lower, affective qualities. The rhetoric of carnality enabled Bernard to awaken desire in the minds of his auditors, which could be channelled, with renewed vigour, toward the divine object of desire.[18]

Bernard's aim, then, was to combine the letter of the Song, the *littera*, with its *allegoria*, and in so doing to enjoin on devotees an affective relationship with God. Moreover, because the place of audience identification was defined as the Bride, who represented the human soul, the believer was purportedly 'feminized' in the process. The Latin word *anima*, meaning soul, is grammatically feminine, which partially supports this manoeuvre. The Church, *ecclesia*, and the Virgin Mary, with whom the *sponsa* were often associated, were also archetypally feminine. But it is worth remembering that, for all the apparent 'feminization' of religious language in the writings of Bernard and his contemporaries, the position of the Bride was open to men as well as women.[19] This occasionally gives rise to some extremely disjunctive imagery. Listen, for example, to how Bernard expands on the very first verse of the Song, 'Let him kiss me with the kiss of his mouth', in one of his early sermons:

> While the bride is conversing about the Bridegroom, he, as I have said, suddenly appears, yields to her desire by giving her a kiss . . . The filling up of her breasts is a proof of this. For so great is the potency of that holy kiss, that no sooner has the bride received it than she conceives and her breasts grow rounded with the fruit-

fulness of conception, bearing witness, as it were, with this milky abundance. Men with an urge to frequent prayer will have experience of what I say. Often enough when we approach the altar to pray our hearts are dry and lukewarm. But if we persevere, there comes an unexpected infusion of grace, our breast expands, as it were, and our interior is filled with an overflowing love.[20]

Bernard is promoting, in these words, a deeply personal identification between the *sponsa* and the male Christian devotee. It is 'men' who are singled out in the passage as receiving a divinely inspired breast enlargement, which in turn is modelled on the rounded breasts of the Bride. What are we to make of such imaginings?

There is one thing we can be fairly sure about: Bernard's gender-bending performances were not perceived as being especially transgressive by his contemporaries. Feminine figures were associated, in medieval psychology, with the affective element in all human beings. By encouraging auditors to identify their 'bridal selves' with the Bride of the Song of Songs, even to the point of possessing imaginatively engorged breasts, Bernard hoped to awaken affectivity within his monks as a means of drawing them closer to God. The point, moreover, was to turn monks away from women as exterior objects of desire, toward their own, interior feminine self: the loving, self-sacrificing soul. As such, the promotion of feminine role models in twelfth-century exegeses of the Song did not necessarily reflect the attitudes of male clerics toward their actual female contemporaries.[21] Indeed, it might be explained, in part, as a manifestation of clerical misogyny, a fear that women, playing the part of sexual temptresses, would distract monks in their spiritual endeavours. Bernard's allegorical exposition of the Song of Songs, with all the sexual acrobatics it entailed, derived from his recognition that strengthening his monk's sense of their internal femininity, within their *anima*, would protect them against their own lustful desires for an exterior, feminine object in the context of sexual fantasy.[22]

But did it serve to protect monks from desire for each other, or from the fantasy of sexual union with another man? The loving relationships represented in Song of Songs exegesis are superficially heterosexual, but the process of identification that the allegorical reading sets in motion – the alignment of the Bride with the soul of the individual devotee – makes it hard to contain the poems within a stable heterosexual framework: the male devotee, identifying imaginatively with a feminine figure, is plunged into a tender loving relationship with a lover who by all appearances is male. The resolution – if one is needed – depends on which aspects of the reading process are prioritized. Do we re-literalize the scene, by focusing

on the monk's embodiment as a male (in which case a male–male union seems to take centre stage)? Or do we stay with the figurative, and imagine a process of sexual metamorphosis on the part of the devotee (producing the possibility of a spiritual 'sex-change')? Medieval exegeses of the Song of Songs such as Bernard's provide no easy answers to these questions: the rhetoric is designed to open up a space, temporarily, between letter and allegory, generating the paradox that, as creatures of body and soul, humans might descend corporeally as a precursor to spiritual ascent.

It may be argued that chaste nuns and other female religious who cast themselves in the role of *sponsa Christi*, or Bride of Christ, in their devotional lives had a less immediate 'problem' in expressing desire for God – that their social gender marked them out more straightforwardly for identification with the feminine Bride.[23] This, at least, is the view of one modern nun, who wonders whether the application of the *sponsa Christi* topos to male religious produces a conceptual quandary: 'If we're the brides of Christ, what does that make male religious – homosexual?', she asks, in a remark recorded by the journalist Marcelle Bernstein in her book *Nuns*. (Other sisters interviewed by Bernstein reject the brides of Christ label completely, by virtue of the fact that it assumes that they are 'an appendage to a male'.)[24] As it happens, women's desire for the suffering body of Christ, in particular, has the capacity to produce its own disruptive configurations of gender and sexuality, as examples discussed later clearly demonstrate. For the moment, I'd simply like to draw attention to the imaginary investment of certain pious men in positions that were marked socially, and conceptually, as feminine. Devotional divas these men were not, much as certain modern commentators would like to celebrate the fact. 'Throwing off his religious garb and all his inhibitions with it', quips one biblical scholar, Stephen D. Moore, the monk-allegorist 'paints his nails, decks himself out in flamboyant costumes, and camps it up with abandon'.[25] Bernard and his Cistercian peers do cloak themselves in a sort of linguistic drag: their identification with the female *sponsa-anima* is what allows them to enter into a loving relationship with Christ. But the queer effects of such phenomena should not be confused with actual performances of resistance, opposition or transgression.

At the same time, the figurative femininity of male religious figures may provide an interpretative framework for behaviours that do seem, on occasion, to have provoked social discomfort. A collection of biographical fragments and miracles relating to the Life of the English mystic Richard Rolle (*d.* 1349), prepared posthumously in the hope of his canonization, opens with a description of his schooling, followed by an account of how he first entered into the life of a hermit. After returning from study in Oxford as a young man, we're told, Rolle said one day to his sister: 'My

beloved sister, thou hast two tunics which I greatly covet, one white and the other grey. Therefore I ask thee if thou wilt kindly give them to me, and bring them me to-morrow to the wood near by, together with my father's rain-hood.' Agreeing to her brother's demands 'willingly', the sister brings Rolle her tunics as requested; Rolle makes some adjustments and then, having stripped off, puts on the garments so that 'he might present a certain likeness to a hermit'. The sister herself, when she sees what he's done, is astounded and cries 'My brother is mad! My brother is mad!' Whether he's mad for becoming a hermit or for putting on two of his sister's dresses, the narrator doesn't say. What the text does make clear is that Rolle drives his sister away and flees, 'lest he should be seized by his friends and acquaintances'.[26]

Whatever the truth and accuracy of this anecdote (it was recorded several decades after Rolle's death), it might be possible to relate it, in part, to the hermit's commitment to bridal mysticism as a means of expressing love for Christ. Rolle's own writings suggest that he increasingly entered into a relationship with his soul by putting himself in the role of *sponsa Christi*; in his later writings, he also promotes the Virgin Mary as the supreme model for his relationship with Christ.[27] In his *Commentary* on the first verses of the Song of Songs, for example, he remarks how, as a virgin mother, it is truly appropriate that Mary receive a kiss from Christ, 'for indeed you have merited to suck his mouth and deservedly, because better are your breasts than wine' (the description of the breasts here is a direct quotation from the first verse of the Songs). Not only that, but a little later he himself inhabits the Virgin's position as tender lover, languishing with the love of Christ: 'My whole heart', he announces, 'is turned in the fire of love for the desiring of Jesus and absorbed completely by the sweetness of deity'.[28] Likewise in the *Incendium amoris* (The Fire of Love), Rolle's best-known work, the hermit adopts the paradigm of the Song as a way of expressing the union of the soul with Christ. Quoting the Song's first verse, 'Let him kiss me with the kiss of his mouth', he announces (in Richard Misyn's 'Englishing' of the text, dated 1435):

> Lufe [love] makes me hardy [bold] hym to call that I best lufe, that . . . he me comforthand and filland [comforting and filling] myght kys me with kyssynge of hys mouth . . . I beseke he kys me with swetnes of his lufe refreschynge, with kissynge of his mouth me straytly halsyng [embracing me tightly], that I fayl not . . . [29]

These are lines that would not look out of place alongside the Rupert of Deutz extract quoted above. We could, of course, 'desexualize' Rolle's words, by understanding them as metaphors (or an allegory) of spiritual

union and thereby downplaying their potential as eroticism. We could also easily 'heterosexualize' the scene by reminding ourselves that the soul / bridal 'I' is grammatically and figuratively feminine. But Rolle's cross-dressing for Christ – his imaginary identification with the Virgin Mary and with the Bride of the Songs, to the point of imaginatively kissing Christ on the lips – does not necessarily return him to heterosexuality (at least, not in the modern sense). When the union between Christ and his beloved is imagined as bodily union, in keeping with the framework of affective piety inspired by Bernard, gender binaries start to come unstuck. 'Queerness', Carolyn Dinshaw suggests, 'knocks signifiers loose, ungrounding bodies, making them strange'.[30] Similarly, it is perhaps the work of displacement and disjunction that Rolle embraces in his desire to put on his sister's dresses: the canonization papers represent him as a figure who discards the garments of social masculinity, in order to put on the garb of a crazy-looking, and perhaps differently gendered, hermit.

THE EPISTEMOLOGY OF THE ANCHOR-HOLD

It remains to be seen how the representation of *sponsalia Christi* – marriage of Christ – intersects with depictions of violence in passion devotion, and how this produces its own set of queer, gender-disruptive effects. Cross-dressing for Christ might also take a different guise, after all: medieval devotees could be encouraged to imagine themselves, through a process of *imitatio Christi*, putting on the 'garment' of Christ's cross.

A powerful articulation of this phenomenon occurs in the *Wohunge of ure Lauerd* (The Wooing of Our Lord), an English work composed in the early thirteenth century, probably with an audience of female anchorites in mind.[31] Anchorites were men and women who, to protect their chastity and dedicate themselves completely to Christ, spent their lives enclosed in small cells or 'anchor-holds'. Walled up in this fashion, they were discouraged from fraternizing with the outside world, as much as possible, so as not to be distracted from a life of contemplation and prayer.[32] Anchoritic texts produced in the same period as the *Wohunge* often associate the Bride of Christ metaphor with virgins, and the *Wohunge*-speaker is identified explicitly as a bridal figure: I am, announces the voice to Jesus, 'thi leofmon and spuse' (l. 572; 'your lover and spouse'). The first half of the work contains an impassioned meditation on the virtues of Christ, described in the opening lines as 'mi druth, mi derling, mi drihtin, mi healend, mi huniter, mi haliwei' (ll. 1–3; 'my dear, my darling, my lord, my saviour, my honey-drop, my balm'). Jesus is complimented on his beauty, his riches and possessions, his generosity, his wisdom, his bravery, his nobility and

his gentleness (ll. 32–217). In short, his merits are those of the idealized lover-knight of courtly romance.

But Christ's relationship with the speaking 'I' is also, finally, one of blood: through his incarnation in the flesh, he becomes a 'kinsemon' (l. 230; 'kinsman') of humanity. This presages the dramatic narrative shift in the second half of the *Wohunge*, which focuses on the torments that Christ suffers on the speaker's, and implicitly humanity's, behalf: the mockery and spitting he endures, the shame of being crucified between two thieves, and the beatings to which he is subjected. Finally the scene shifts to Mount Calvary, where, the speaker announces, 'is mi lefmon demd for to deien' (ll. 491–2; 'my lover is condemned to die'). Here the speaker draws attention to the temporal dimensions of the beloved's sufferings: Christ literally 'hangs' from the cross. Not only that, but like a hanged man he is suspended from a gallows, a *warhtreo* or 'criminal-tree': 'A nu raise thai up the rode', the speaker announces, 'setis up the warhtreo' (ll. 503–5; 'Ah! now they raise up the cross, they set up the gallows').

The imagery of Christ as a hanged man can be related to artworks depicting Calvary as a zone of judicial punishment: medieval Crucifixion scenes sometimes constructed explicit analogies with contemporary judicial practice, for instance by depicting one of the two thieves being dragged backwards up a ladder by a rope (illus. 95), in a scene that clearly echoes medieval hanging techniques (illus. 3).[33] As if to emphasize the parallel, the *Wohunge*-speaker's descriptions of Christ's crucifixion repeat the verb 'to hang' several times: 'Lahhen the to hokere ther thu o rode hengest. Thu, mi luueliche lef, ther thu with strahte earmes henges o rode . . . A th[at] luvelike bodi th[at] henges swa rewli swa blodi and swa kalde' (ll. 525–34; 'They laugh you to scorn, where you hang on the cross. You, my lovely love, there with stretched arms you hang on the cross . . . Ah! That lovely body, that hangs so pitifully, so bloody and so cold').[34] Christ's suspension in suffering is what leads, in turn, to the dramatic climax in the passion sequence: the merging of lover and beloved in suffering. Here the speaker – and implicitly the anchorite who identifies with the first-person voice – imagines being crucified with Christ, 'touching' him affectively, literally hanging with him in the confined space of the anchor-hold:

> *Mi bodi henge with thi bodi neiled o rode, spered querfaste with inne fowr wahes. And henge I wile with the and neauer mare of mi rode cume til th[at] I deie. For thenne schal I lepen fra rode in to reste, fra wa to wele and to eche blisse. A Iesu, swa swet hit is with the to henge, forhwen th[at] iseo o the th[at] henges me biside, the muchele swetnesse of the reaues me fele of pine* [ll. 590–602].

My body hangs with your body, nailed on the cross, enclosed within four walls from side to side. And I will hang with you and never-more come from my cross until I die. For then I shall leap from the cross into rest, from grief into joy and eternal bliss. Ah Jesus, so sweet it is to hang with you. For when I look on you who hang beside me, your great sweetness relieves me greatly from pain.

The anchorite is invited to position herself, in these lines, at a sensorial *cross*road – to imagine being crucified with Christ until she dies. The hanging tree becomes a place where pain transmutes, imaginatively, into 'swetnesse'.

In chapter Four I identified the space of sacred suffering as a zone between two deaths: the natural death that allows the saintly figure to escape his or her earthly shackles, and the second, definitive death that

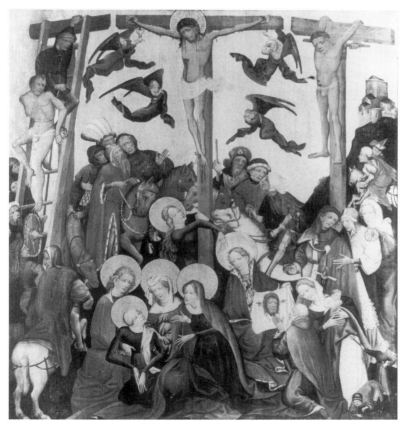

95 Middle Rhenish Master, *Passion* altarpiece, *c.* 1420. Originally St Peterskirche, Frankfurt; now Historisches Museum, Frankfurt am Main.

should, naturally speaking, ensue. The anchorite, like the saint, also ex-
perienced a symbolic 'first death': when the door to the anchor-hold was
first blocked up during the enclosure ceremony, the Office for the Dead
was said, along with prayers for the dying.[35] But, in keeping with the
hagiographic model, the second, absolute death is held at bay in anchoritic
fantasy: the *Wohunge*-speaker looks forward to how, 'yif I the riht luuie,
wilt me crune in heuene with the self to rixlen werld in to werlde' (ll.
632–4; 'if I love you rightly, you will crown me in heaven with yourself, to
rule world without end'). Hanging with Christ imaginatively, then, the
anchorite opens herself up to the possibility of identification with the
sublime.[36]

But was the anchorite also hanging *out*? An epistemology of the closet
is not necessarily the most appropriate interpretative paradigm for
medieval sexualities (at least not if one adheres to a Foucaultian chrono-
logy of pre-modern acts and modern personages).[37] But an epistemology
of the anchor-hold – that space of suspension, in which suffering and sub-
limity coalesce – is a formulation that may have made sense to certain
women and men in the period. Becoming an anchorite, as the *Wohunge of
ure Lauerd* makes clear, demands both physical union with Christ as a
lover and crucifixion with him in the enclosures of the mind. Moreover,
this positioning does not necessarily mark anchorites out for a life of holy
heterosexuality. Inside the four walls of her anchor-hold, the virgin places
herself *out*side the social economy of marital exchange; left out of the
world, she enters into a relationship with God that, by comparison with
earthly categories, seems disjunctive, uncategorizable, queer.

It is not clear, after all, that the object of desire in the *Wohunge* is unam-
biguously male: described as a lover-knight in the first half, Christ is
nonetheless gendered differently in his susceptibility to suffering. The pas-
sage announcing Christ's kinship with humanity through the fact of his
incarnation reads as follows: 'Thu schruddes te with ure flesch, nam of hire
flesch, mon born of wummon, thi flesch nam of hire flesch withuten
meane of wepmon' (ll. 219–23; 'You shroud yourself with our flesh, taken
from her flesh, human born from woman, your flesh taken from her flesh
without intercourse with man'). As Sarah Salih has pointed out, the dis-
tinction between the word 'mon' (translated here as 'human') and the
gendered terms 'wepmon' and 'wummon' in these lines seems deliberately
designed to avoid associating Christ explicitly with maleness.[38] In addition,
the speaker's desire both to *have* and to *be* Christ – to love him as a lover,
while simultaneously becoming Christ-like in suffering – creates a funda-
mental paradox. The *Wohunge*-speaker announces how Christ has 'steked
me i chaumbre' (l. 574; 'locked me in a chamber'), where s/he can 'the swa
sweteli kissen and cluppen, and of thi luue have gastli likinge' (ll. 575–7; 'so

sweetly kiss and hold you, and in your love take spiritual pleasure'), but goes on to develop the spectacular image of communal hanging on the cross, which transforms the encounter in the bridal bedchamber into a penitential workout for the individual soul. Oscillating incessantly between human and Christ-like subject positions, the bride recognizes herself both in her identification with and difference from Christ. The lines dividing *imitatio Christi* from *sponsalia Christi* are consistently collapsed.[39]

The amalgamation of violence and desire in medieval devotional literature thus produces configurations of gender and sexuality that are queerly at odds with earthly categories; it is the threshold spaces of passion devotion that construct the theatrical arena for these odd manipulations. Of course, it is not possible to claim for queerness all devotional encounters embedded in the *sponsa Christi* tradition, at least not without looking first to their particular generic conventions, and to their historical and spatial locations. Nor is it possible to say, definitively, whether such encounters were socially subversive: the link between social disorder, on the one hand, and representations of queerness, on the other, benefits from being analysed in relation to a given time and place, as well as being mapped out across larger temporal expanses.[40] The *Wohunge of ure Lauerd* is just one example of the phenomenon, deployed specifically in the context of thirteenth-century virginity discourse and anchoritic spirituality. If earthly marriage fixes gender difference through the hierarchy of husband over wife, anchoritic deployments of the Bride of Christ motif are not necessarily, as Salih puts it, 'doing the same work'.[41] But we can only speculate as to whether texts such as the *Wohunge* generated disruption in the contexts in which they were originally disseminated.

At the same time, a cursory survey of late medieval English devotional writing does hint at the possibility that other groups of Christian worshippers – lay people, for instance – were encouraged to confront the paradoxes and dissonances of bridal desire for Christ's tormented, wounded body. The fourteenth-century poem *In the Vaile of Restles Mind*, for example, blends together an astonishing mix of gendered imagery, identities and roles.[42] This is a lyric that was heavily influenced by the Song of Songs tradition: the refrain of each stanza, *Quia amore langueo* ('Because I languish for love'), is taken from the Song, where it is addressed to the Bridegroom by the Bride, and several other passages in the poem are also derived directly from the biblical text.[43] Here, though, the *Quia amore langueo* refrain is transferred into the mouth of a wounded lover-knight, who is cast in the Bridegroom role. The poem begins as a discussion between two men: a visionary narrator / reader who is in search of his 'treulofe' (l. 3; 'true love'), and a 'semeli' man who is discovered sitting under a tree, wounded from head to foot and bleeding from

the heart (ll. 9–14). (The latter identifies the former as a 'man' at lines 41 and 50, when he addresses him in conversation.) The wounded figure introduces a third, absent being, 'my systur, mannys soule' (l. 18), thus conjuring up a male homo-social exchange network, in which a woman is circulated as property, symbolically or otherwise, for the purpose of cementing relations between men.[44] But by the end of the poem three have become two, and the partners in the exchange network are gendered differently: the soul, drawn back to love of the suffering Christ by the beauty of his body, is united first as a 'babe' (l. 115) and then as a 'wife' (l. 121) with her former lover (who is a protective mother, as well as a husband and 'semeli' man). In the process, the poetic subject apparently undergoes sexual metamorphosis: by the poem's end, the 'masculine' narrator / reader looking for love has become – or been replaced by – a faithful, loving bride of Christ; the fusion of visionary narrator / reader and bride is signalled by the last two stanzas of the poem, where Christ address 'hir' in the second person.

The gendered transitions in the poem create a backdrop for some quite extraordinary interactions through the medium of Christ's pained body: 'all my membres I haf opynd hyr to', Christ announces, with reference to his spouse, 'my body I made hyr hertys [heart's] baite . . . / In my syde I haf made hir nest, / loke in me how wyde a wound is here!' (ll. 55–8).[45] These lines envisage the wound as a site of tangible ecstasy: Jesus does not want the spouse simply to touch his wound – he wants her to make it her home. The description also marks Christ's wound as an opening with sexual nuances, stemming from its association with the word 'membres', which, in Middle English, often referred to male or female genitalia. (See illus. 28, where the wound sealing the Charter of Christ, containing a bleeding heart within, alludes obliquely to these sexual connotations.)[46] But the Bride and Bridegroom are also imagined later in terms of the relationship between a mother and child, which, juxtaposed with the sexualized imagery a little earlier, produces what might be mistaken for an absurdly incestuous twist: 'wyth my pappe [breast] I shall hyr kepe', Christ announces, 'this hoole in my syde had never ben so depe' (ll. 117, 119).[47] Christ is a wounded body-in-pain, but his 'hoole' also becomes a source of nourishment, a nesting box and even, potentially, a vulva. Christ is not exactly male here, and at the very moment when his gender conversion reaches its dramatic climax – when he becomes a mother nursing his child with his 'pappe' – the reader is aligned, implicitly, with the spousal 'thow' to whom Christ speaks: s/he is referred to as 'myne owne dere wife' (l. 121) and told that, if the reader's soul never leaves him, 'thy mede is markyd, whan thow art mort, in blysse' (ll. 127–8; 'your reward is marked in heaven, when you are dead').[48] Although the text concludes, in this way, with a

scene of conjugal loyalty, the dramatic shifts in subject positions and genders along the way do not necessarily allow the poem to be contained within a securely heterosexual frame. The poem demonstrates how the giving up of self for God demands a complete change of being, a transformation in which gendered certainties become unhinged. The critic Rosemary Woolf judges the poem's juxtaposition of allegorical layers to be 'slightly distasteful', producing 'inconsistencies' and 'strangeness'.[49] Queerness is a label that might be more fruitfully applied.

VISUALIZING PASSIONS

So far, the discussion has been confined to literary deployments of the Song of Songs tradition, deployments that produce conceptual quandaries in the field of gender and sexuality. In this final section, I briefly consider an artwork that visualizes the *sponsa Christi* topos in ways that may be related to the literary examples; it also brings into focus, once again, the suspended moments and threshold spaces of Christological devotion. I then explore, in conclusion, other genres of medieval devotional performance where the suffering / sublimated flesh of Christ becomes a touchstone for potentially troubling modes of amorous exchange.

One of the most widely discussed depictions of bridal devotion to Christ's body occurs in the Rothschild Canticles: a miniature depicting a nun pointing a lance towards the wound in Christ's side (illus. 96). Michael Camille, adopting the paradigm of the hetero-normative 'male gaze' in order to interpret the image, remarks: 'Only by becoming a female body was it possible for God to become the focus of an eroticized gaze . . . The gaze still only goes in one direction, toward the female Christ from the male-female's phallic sphere.'[50] This does not, however, detract from the ways in which Christ's tormented body has the ability to convey other genders and gendered subject positions. Bynum is surely right in her perception that medieval artworks occasionally 'suggest another [female] sex for Christ's body', but certain images may signify in ways that cannot be fully explicated in terms of masculinity or femininity – at least, not to the point where one category cancels out the other.[51] Passion depictions position Christ's body in a zone of between-ness, caught between the 'first' death on the Cross and the death that would, were it to happen, signal complete annihilation. Christ's ambivalent, threshold status endows his body with representational ambiguity; in these moments of flux and instability, his gender refuses to signify monolithically.

Looking at the folios in the Rothschild Canticles again in this light, could we pose an alternative interpretation? The image illustrates Canticles

96 'The *sponsa* penetrates Christ's side', illuminated pages in the Rothschild Canticles, *c.* 1320, Flemish or Rhenish. Yale University, New Haven.

4:9 ('Thou hast wounded my heart, my sister, my spouse'), and, in representing the moment *after* Christ's side has been pierced, the illuminator actually makes the preceding event more immediate, so that the focus is the act of wounding rather than the wound itself.[52] That is to say, it is not an unambiguously 'female' body of Christ on folio 19r that is the focus of the gaze, so much as the penetrating transaction that occurs across the folios between Christ and *sponsa*. Importantly, moreover, Christ appears in the image as the 'agent' in his own passion, holding in one hand the whip of flagellation and in the other hand the nails with which he was fastened to the cross. As such, agency is distributed across both halves of the image, a contradictory and indeterminately gendered performance that renders attempts to conceive it in terms of binaries and 'role reversals' somewhat problematic. Camille argues that 'the woman's masculine role as bearer of the phallus is what makes her vision possible' – a turning-of-the-tables that does, indeed, have potentially subversive implications.[53] But that does not mean to say that Christ himself becomes completely 'feminized' in the process, or that holding a spear remains inherently 'masculine': we should resist reproducing normative gender paradigms in our efforts to describe the image. The probable owner of the manuscript

was a woman, most likely a nun or canoness. But the case for female ownership is not conclusive; nor should we forget that the 'audience' of medieval manuscripts not only extended to their eventual owners but also to the compiler, the scribes and the artists.[54] The Rothschild Canticles image was not necessarily alien to male circuits of devotion and it is possible to see how it might have enabled some male beholders to place themselves in the position of the penetrating *sponsa*, by imaginatively piercing Christ's naked body.[55] Given the sexual indeterminacy of that body, it may even be worth asking whether images of this sort provided opportunities for male devotees to explore metaphors of sexual union with a God imaginatively gendered male.

My point is not to force medieval illuminators, monks, mystics and religious poets to 'come out' gaily from their homo-devotional prayer closets; nor do I want medieval texts and images simply to stand in for my own queer tendencies and desires (though they, and I, may be queerly related in some contingent fashion).[56] What I would like to advocate are interpretative encounters that endeavour to challenge the hetero-normative assumptions of certain modes of historical enquiry. We need Middle Ages, not *the* Middle Ages – Middle Ages receptive as well as resistant to the categories we apply to them, to the disjunctions and dissonances of queerness.[57] Perhaps art historians could themselves learn from such a manoeuvre. Visual images of the tortured body of Christ and the saints, for instance, may produce their own queer possibilities in certain situations. Certainly the medieval ideal was to rise above the corporeal contemplation of images, and, according to writers such as Bernard, images were not the ultimate goal of spiritual meditation.[58] But that does not mean that viewers always, then or now, perceived representations in terms of those ideals. Bernardino of Siena, for instance, expresses the concern that images of Christ's passion are potentially corrupting and warns of the dangers of viewing human flesh in sacred art, even the flesh of Christ himself. As he announces, in his treatise *De inspirationibus*, 'I know a person who, while contemplating the humanity of Christ suspended on the cross [*pendentis in cruce*] (I am ashamed to say and it is terrible even to imagine), sensually and repulsively polluted and defiled himself.'[59] By the sixteenth century comments of this sort had become commonplace in the context of Lutheran religious upheaval. Erotic responses to images of female saints were documented in the writings of German iconoclasts; reformers such as Zwingli likewise reproved the sexual arousal elicited by images of male religious.[60] The Council of Trent in the sixteenth century, indeed, decreed with respect to the veneration of relics and the sacred use of images, that 'all superstition shall be removed, all filthy quest for gain eliminated, and all lasciviousness avoided, so that images shall not be

painted and adorned with a seductive charm'.[61] Sexuality is not simply something that modern beholders 'read into' the texts and images of times past. Regulations such as this bear witness to the zeal with which authorities attempted to read it out.[62]

Tridentine ordinations did not, on the other hand, prohibit the kissing of visual images of Christ's body, despite the fact that manuscript illuminations of the *Crucifixion* literally worn away by years of repeated oral adoration attest to the widespread popularity of the practice (illus. 97).[63] This is not to suggest that the kissing of the *Crucifixion* image by the officiating priest as part of the daily service was in itself especially transgressive or even perceived as such by most participants. Rather, I am proposing that in certain representational contexts – certain manifestations of the *sponsa Christi* topos, for example – we account for a broader range of signifying possibilities than the straightforwardly heterosexual. We need to draw attention to the spaces between letter and allegory (or between the devotional image and its divine referent), rather than assuming

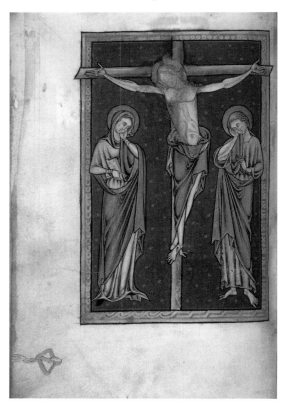

97 'Crucifixion', miniature in a combined Bible and Missal, mid-13th century, English. Henry E. Huntington Library, San Marino, California.

a neat logical progression from one to the other in the minds of medieval beholders.

In order to begin to debate these issues it would be worth looking once again at the images reproduced in Steinberg's book *The Sexuality of Christ*. One of the objections to this study (coming from Bynum, among others) is that its title is misleading since it concerns Christ's 'genitality' rather than his 'sexuality'.[64] I have no argument with Steinberg on that score, since it is evident that the book's subject is 'not the penis but the enigma of its ostension' and that the *ostentatio genitalium* is being read as 'the projection upon Christ of a sexuality which in him – in him as in the First Adam anterior to sin – exists without guilt'.[65] But it is worth pointing out that Steinberg's characterization of Renaissance art as orthodox and accepting of Christian tradition nonetheless closes down the act of looking by rehabilitating it wholly within the sphere of religious orthodoxy. According to Steinberg's interpretation, the presentation of Christ's privy parts signifies *above all else* the humanation of God; it thus represents a quite conventional offshoot from the incarnational aesthetic that was so dominant in the period's sacred representational codes:

> And because Renaissance culture not only advanced an incarnational theology . . . but evolved representational modes adequate to its expression, we may take Renaissance art to be the first and last phase of Christian art that can claim full Christian orthodoxy. Renaissance art – including the broad movement begun *c.* 1260 – harnessed the theological impulse and developed the requisite stylistic means to attest the utter carnality of God's humanation in Christ.[66]

Steinberg thus curtails readings of Renaissance art that see it as representative of anything but 'the theological impulse'. He stands firmly with Bynum on this score: making a case for symbolic polysemy, she nonetheless maintains that medieval devotional symbols were ultimately 'rooted in theology and piety'.[67]

Perhaps the images in Steinberg's corpus that have caused most offence to modern sensibilities are those depicting an ithyphallic Christ (see illus. 98 and 99). This is odd when one considers that the author initially situated the pictures in question within the context of ancient cults of the phallus in Roman and Egyptian mythology, thereby suggesting that the erect phallus's participation in resurrection symbolism for a brief period in the sixteenth century was conceived with 'a Christian will and *de profundis*' as 'the body's best show of power'. In a later revision, indeed, Steinberg rejects the 'resurgent flesh' explanation in favour of another, even more orthodox (Augustinian) line of reasoning: that the erection

98 Ludwig Krug, *Man of Sorrows*, *c.* 1520, engraving (Hollstein 8). British Museum, London.

motif represents Christ's incorrupt nature by implying that he is in command of all his bodily faculties.[68] At the risk of offending Steinberg's critics further, might it not be worth asking whether the images that he himself interpreted in decidedly un-erotic terms did in fact have the potential to signify erotically? There are hints that we might at least keep an eye out for queer diversions from theology in devotional performance (even in as unlikely a place as Christological passion imagery). The example I offer is one that Steinberg himself cites in the revised edition to his book.[69] It appears in a letter of remission for one Guillaume Caranda, a young barber living in 1530 in the French town of Senlis. The letter describes how Caranda, 'on the day of the holy Sacrament of the Altar just past', had acted the part of Jesus in the tomb, 'in record and representation of his holy resurrection'. That evening, Claude Caure, the local toolmaker, approached Caranda in passing, exclaiming:

> 'I see the god on earth. Did you keep your virile and shameful member stiff in playing God?', uttering these dishonest words arrogantly and against the honor of Christianity. To which the supplicant responded that 'his was neither very hard nor heated up, and that he [Caure] was gelded', and after these words he and his company went on their way.[70]

Greeting the barber once again on his return with the same 'dishonest words, insulting to our Lord Jesus Christ and to the holiness of the day', Caure proceeded to start a brawl. Caranda stabbed Caure in self-defence, the latter died, and the former fled in fear. A few weeks later, Guillaume Caranda was granted an official pardon.

Steinberg interprets the episode as proving his point that there was, in this period, a 'ready-made association' between phallus and resurgent flesh.[71] But surely, without wishing to downplay the explanatory force of this example, in the context of the res-erection images Steinberg cites, other interpretations are possible. Caure's observation that Caranda is a 'god on earth' possibly hints at sexual attraction on the toolmaker's part (that is to say, he views him as a sex god). The barber's response, to the effect that he is not similarly disposed, conveys what appears to be a mode of sodomophobic insult. The episode suggests that the stance of the suffering / resurrected Jesus has erotic potential; the ensuing brawl appears to be the result of accusations of perverse desire attendant in the toolmaker's words and the barber's allusions to castration (effeminacy / sodomy) in his reply.[72] Caranda's offence is derived from the fact that his 'virile and shameful member' becomes the object of the 'gelded' toolmaker's imagined gaze, while the resulting stabbing seems to constitute a hyperbolic, paranoid

99 Maerten van Heemskerck, *Man of Sorrows*, 1532, oil on wood. Museum voor Schone Kunsten, Ghent.

response to the situation at hand. That such an affront was caused suggests something more was at stake than Christian orthodoxy. The collision of sacredness, sexuality and violence produces an excess – a leaving of category – that cannot be reined in by theological doctrine alone. Here is an example of the degree to which Christ's suffering body 'makes meaning' for its makers and beholders in ways that clearly implicate cultural anxieties about gender and sexuality as much as theological doctrine.

Certain performances of the passion keep Christ's suffering body, and implicitly the subjectivity of the Christian devotee, in a queerly suspended moment – at least, that is, within the representational field. Loss of self in passion depiction is figured not as *no* self, but as multiply gendered, paradoxically proliferating selves. Christ is a figure to be imitated, but he is also desired – desired in the context of his suffering. This delicate balance between suffering and sublimity is achieved, aesthetically, by constructing sites of identification that arrest time indefinitely (as in the *Wohunge*'s motif of hanging) or that generate dizzying shifts of register and location (as revealed by the complex manipulations of imagery and voice of *In the Vaile of Restles Mind*). But certain visual depictions of Christological suffering also generate comparable identificatory possibilities. Several of the images that Steinberg cites in his book as sporting sacred erections belong to the category of Man of Sorrows – images where, he says, 'phallic erection is unmistakable' (illus. 98 and 99).[73] An act of temporal suspension is what occasions this particular art-form at the outset: the Man of Sorrows, like other devotional images, attempts to isolate the emotional centre of the narrative, the locus of feeling, from the stream of action, and in so doing brings viewers closer – mentally at least – to the sensation. The central figure (Christ) is partially divorced from narrative contexts (suffering / resurrection) and identified as a sublime object.[74] Assistant figures are sometimes included – angels, for instance, or the Virgin and St John the Evangelist, which provides a certain amount of dramatic context for the scene. But these mediating figures also model, for the beholder, the intimate emotional transaction that should ensue.

At the same time, however, the partial suspension of context and historical time opens up images such as the Man of Sorrows to de-historicizing manoeuvres of a different sort, sexual responses that, as Guillaume Caranda's pardon document announces, go 'against the honor of Christianity'. If we wish to entertain the possibility of these temporally extended, contingent, floating spaces, we may need a frame of reference in addition to the theological and the proscribed. The imperative 'always to theologize' generates as a corollary a remainder – a representational excess – that fails to signify stably within its terms. My suggestion, here, is that this residue might sometimes look a little queer.

100 Flyer for the London nightclub 'Heaven', Easter 2001.

Afterword: Heaven Bent

In the Easter of 2001, 'Heaven', a gay nightclub in London, distributed a series of flyers drawing inspiration from Christological themes. One flyer in the series, advertising a special one-off 'Reserection'-themed event, depicts a kitsch, heavily made-up Virgin taking a peek under the loincloth of an otherwise naked man; crowned with thorns, the man's body is spread out lifelessly before her. Another, reproduced here, features a black-and-white photograph of a man in his underpants, stretched out in a cruciform pose (illus. 100). The image is loosely based on Salvador Dalí's painting of 1951, *Christ of St John of the Cross*, where viewers are obliged to look down precariously, with Christ (and implicitly with God in heaven), from the top of an impossibly long cross. But the flyer also forces a fundamental shift of perspective. For a start, the torture instrument of Dalí's painting – the crucifix – has been eradicated. But in addition, the crucified figure in the photograph is now shown looking down toward his groin and his designer underwear, and away from the 'Heaven' logo beneath which he hangs. (In Dalí's painting Christ's head drops further forwards, apparently looking down towards earth.) In this way, an icon of sublimity and suffering gets bent, transformed – refashioned as an overtly erotic object. It also becomes reconfigured as an eye-catching commodity, in a provocative marketing campaign.

The paradigm I've been outlining in this book suggests that medieval cultures also regularly displaced the underlying 'truth' of the spectacularly punished body – that it is a mortal body – to some other place. The penal imaginary acted as a cipher for the production of other values, other truths: the truth of the law, of the body, of the other, of God. In this context, we've seen how the pained body was aestheticized, beautified – transformed into an ideological object. Pushed to its sensorial limits, left suspended in moments of suffering and dying, the other's pain could be appropriated, manipulated, reconfigured. Seized upon in this way, it functioned symbolically, to underpin notions of justice and the law, or to represent the idea and institution of a virtual Christian *corpus*. But if pained

bodies were appropriated, by a process of analogy, to lend an aura of real-ness and truth to certain dominant institutions and ideas, they also held out the possibility of resistant modes of looking: perspectives that went against the grain of dominant visual structures. Penal depictions were designed to connect viewers, imaginatively, with the pains of damnation and the pleasures of transcendence. But they did not, presumably, pre-clude other signifying possibilities. If the representation of executed crim-inals or infernal sinners was designed to convince beholders that they should not, under any circumstance, 'be like that', it could also at the same time focus attention – for some viewers, at least – on the position of the punished outsider as a locus of empathy, attachment, even identification. Moreover, if the image of the suffering saint was designed to turn the attentions of Christian worshippers to God, it likewise potentially ran the risk of bringing them, like the 'Heaven' flyer, right back down to earth.

As modern viewers of these images, we are faced with several interpre-tative possibilities. We can, for example, respond affectively to the depicted body-in-pain, 'touching' that body visually and imaginatively on the basis of our own experiences of mortality, pain and loss. Or we can choose to ignore the violence and suffering inflicted on the punished body, in favour of fantasies that emphasize the potentiality, pleasure and intensity of human experience. Of course, the conclusions to be drawn from such modes of analysis risk being blandly relativistic: we could argue that one subject's pain is another subject's pleasure, one subject's power another's prostration, one subject's pornography another's oppression – and simply leave it there. But there is also a moment when political and ethical con-siderations interrupt the flow of meaning and force viewers to confront their 'interests' in such depictions.

My own interest, in this book, has been to show how the punished body-in-pain of medieval representation did not simply reflect violent realities: rather, these depictions were disseminated because they were motivated by – and constitutive of – certain kinds of pleasure. The overriding aim has been to demonstrate that if representations of torture depict broken bodies and psyches, then they also generate opportunities for constructing selves, institutions and ideas, in the service of a whole spectrum of different agendas and ideological positions. Moreover, if penal spectacle was the symbolic weapon par excellence of sovereign institutions and ideologies, it was not devoid of the capacity to produce meanings outside or in excess of these spaces. To return to one of the poems that provided a focus for chapter Six, the anchoritic subject of the *Wohunge of ure Lauerd* appropriates Christ's spectacularly suffering body as a model and enclosure for her own disciplinary subjection as a virgin – but that produces, as a corollary, a signifying field that is paradoxical, over-determined, queer.

The modern 'Heaven' flyer constructs a different, though perhaps equally disciplinary message: the muscular physique of the photographed figure asks the intended viewers – gay men – to desire a hegemonic masculinity of sorts.[1] But it also constructs an analogy between gay clubbing and crucifixion: the loose s/m connotations of the image seem to imply that the 'Heaven'-going clubber, like the anchorite, is passionately attached, albeit in historically distinctive ways, to the productive possibilities of subjection.[2] The issue raised in this context concerns the particular ethical framework in which that subjection emerges. If the medieval anchorite was committed to an ethics of sacrifice, in which heaven was designated as the ultimate locus for bliss and confirmation of self, the club flyer appears to communicate a different message: if there's a heaven, it says, it's here, and it's happening right now.

Of course, the contrast is not necessarily so stark. It is certainly feasible that individuals who embraced the modes of victim identification described in the second half of this book might have discovered there certain modes of earthly 'release' – liberation from the strictures of marriage and heterosexual economy, for example, or the expression, vicariously, of certain forms of aggression against social outcasts or even – it could be argued – God. And let's not glamorize the process in modernity: who really looks to a club flyer as a critical resource for self-formation? ('Heaven' the club, by the way, is hardly heaven-on-earth.) My point is that the way in which viewers read and respond to these images depends, in part, on whether they are sustaining an unrealizable fantasy of transcendence – the fantasy that heaven exists – or searching for strategies for living *in* the world.[3] My suggestion, with regard to medieval viewers, is that the answer often lay somewhere between these poles, and that we need to open out to the possibility of responses to medieval representation that do not simply mirror (in the flat, platonic sense) the didactic proscriptions of the Christian Church.

The carved crucifix from the Corpus Christi church in Wrocław, discussed in the opening pages of this book, perfectly encapsulates this predicament: the crucified body of Christ simultaneously signifies beyond itself, to divinity and a perpetually deferred afterlife; and it nonetheless remains rooted in corporeality, as an object that has a profound effect on the bodies who view it now (illus. 1 and 66). Lodged between positions of stasis, iconicity and transcendence, and ones of corporeality, ambiguity and flow, the image communicates a sense of suspended animation that places the respondents themselves in a threshold, betwixt-and-between state. Which of the image's meanings prevails depends, finally, on our ethical and political dispositions as viewers.

References

INTRODUCTION: SPECULUM OF THE OTHER MIDDLE AGES

1 V. A. C. Gatrell, *The Hanging Tree: Execution and the English People, 1770–1868* (Oxford, 1996), p. 11, discusses a similar question.
2 Julia Kristeva, *Powers of Horror: An Essay on Abjection* (New York, 1982), pp. 1–31; Judith Butler, *Bodies That Matter: On the Discursive Limits of 'Sex'* (London, 1993), pp. 3 and 243, note 2.
3 For information on the Wrocław crucifix, and others like it, see Anton Legner, *Die Parler und der Schöne Stil, 1350–1400: Europäische Kunst unter den Luxemburgern*, 5 vols (Cologne, 1978–80), vol. II, pp. 496–7.
4 Umberto Eco, *Faith in Fakes: Travels in Hyperreality*, trans. William Waver (London, 1995), p. 69.
5 Johan Huizinga, *The Autumn of the Middle Ages*, trans. Rodney J. Paynton and Ulrich Mammitzsch (Chicago, 1996), pp. 20–23.
6 Lionello Puppi, *Torment in Art: Pain, Violence and Martyrdom* (New York, 1991), p. 14.
7 *Ibid.*, p. 8.
8 Michael Camille, *Mirror in Parchment: The Luttrell Psalter and the Making of Medieval England* (London, 1998); Mitchell Merback, *The Thief, the Cross and the Wheel: Pain and the Spectacle of Punishment in Medieval and Renaissance Europe* (London, 1999). On the constitutive as well as reflective functions of violent imagery in the fifteenth century and beyond, see also Valentin Groebner, *Defaced: The Visual Culture of Violence in the Late Middle Ages*, trans. Pamela Selwyn (New York, 2004), pp. 148–50.
9 Michael Camille, *Gothic Art: Visions and Revelations of the Medieval World* (London, 1996), p. 160.
10 Merback, *The Thief, the Cross and the Wheel*, p. 67.
11 See, for example, Jeffrey Jerome Cohen, *Of Giants: Sex, Monsters, and the Middle Ages* (Minneapolis, MN, 1999).
12 Piero Camporesi, *The Incorruptible Flesh: Bodily Mutation and Mortification in Religion and Folklore*, trans. Tania Croft-Murray (Cambridge, 1988), pp. 86–7.
13 On the Taliban as medieval, see *Financial Times* (24 July 2002), p. 18. The phrase 'We want to lead Afghanistan out of the Middle Ages' is attributed to Younis Qanooni, a Northern Alliance minister, in the *Daily Telegraph* (28 November 2001), p. 16, and *The Guardian* (28 November 2001), p. 4. For an analysis that disputes the location of Islamic fundamentalism in a medieval past, see John Gray, *Al-Qaeda and What It Means to be Modern* (London, 2003).
14 For an argument that desire – and identification – may be at issue in *both* 'alteritist' and 'transhistorical' constructions of the past, see Louise Fradenburg and Carla Freccero,

'Caxton, Foucault, and the Pleasures of History', in *Premodern Sexualities*, ed. Louise Fradenburg and Carla Freccero (London, 1996), p. xix. For an astute analysis of the ethical issues raised by assertions of alterity in medieval studies, see L. O. Aranye Fradenburg, *Sacrifice Your Love: Psychoanalysis, Historicism, Chaucer* (Minneapolis, MN, 2002), pp. 43–78. For discussion of the queer theoretical stake in taking up questions of history and anachronism, see Steven F. Kruger, 'Medieval/Postmodern: HIV/AIDS and the Temporality of Crisis', in *Queering the Middle Ages*, ed. Glenn Burger and Steven F. Kruger (Minneapolis, MN, 2001), pp. 252–83. For an art-historical point of view, see Robert S. Nelson, 'Introduction: Descartes's Law and Other Domestications of the Visual', in *Visuality Before and Beyond the Renaissance: Seeing as Others Saw*, ed. Robert S. Nelson (Cambridge, 2000), pp. 1–21.

15 Fradenburg, *Sacrifice Your Love*, pp. 63–5; Fradenburg and Freccero, 'Pleasures of History', p. xix.

16 Michel Foucault, *Discipline and Punish: The Birth of the Prison*, trans. A. M. Sheridan (London, 1977).

17 Trevor Dean, *Crime in Medieval Europe, 1200–1550* (Harlow, 2001), pp. 118–43.

18 Carolyn Dinshaw, *Getting Medieval: Sexualities and Communities, Pre- and Postmodern* (Durham, NC, 1999), p. 205.

19 Lee Patterson, 'On the Margin: Postmodernism, Ironic History, and Medieval Studies', *Speculum*, LXV (1990), p. 99; Fradenburg and Freccero, 'Pleasures of History', p. xix.

20 Foucault, *Discipline and Punish*, p. 307.

21 The news stories and photographs that circulated in Spring 2004, detailing alleged abuses against prisoners in Guantanamo Bay in Cuba and at the Abu Ghraib jail in Iraq, demonstrate this very clearly. For a discussion of modernity's continuing stake in penal spectacle, which takes issue with Foucault's blunt chronologies, see Page duBois, *Torture and Truth* (New York, 1991), pp. 153–7. See also Edward Peters, *Torture* (Oxford, 1985), pp. 103–87.

22 For comparable arguments, see Jody Enders, *The Medieval Theater of Cruelty: Rhetoric, Memory, Violence* (Ithaca, NY, 1999), p. 24; Groebner, *Defaced*, pp. 17–35.

23 Dean, *Crime in Medieval Europe*, pp. 118–43, provides a useful summary of penal trends across medieval Europe.

24 Philippa Maddern, *Violence and Social Order: East Anglia, 1422–42* (Oxford, 1992), p. 50, table 2.6. Maddern concludes that an average of two felons a year were executed in each East Anglian county, and that 'most East Anglians must have known of hangings as a normal, though infrequent occurrence' (p. 72).

25 Barbara A. Hanawalt, *Crime and Conflict in English Communities, 1300–48* (Cambridge, MA, 1979), pp. 44, 56–7. Maddern makes a similar point in *Violence and Social Order*, pp. 117–30, and suggests that the justices of gaol delivery may have used the remands from one session to the next as a means of imposing short gaol sentences on criminals whose law-breaking activities were felt to merit a penalty somewhere between fines and death. J. B. Post, 'Faces of Crime in Late Medieval England', *History Today*, XXXVIII (1988), pp. 23–4, discusses the frequent mitigation of sentences in English court practice.

26 Jacques Chiffoleau, *Les Justices du pape: délinquance et criminalité dans la région d'Avignon au quatorzième siècle* (Paris, 1984), pp. 211–42. Studies of jurisdictions in Paris convey a similar impression. See Esther Cohen, '"To Die a Criminal for the Public Good": The Execution Ritual in Late Medieval Paris', in *Law, Custom and the Social Fabric in Medieval Europe: Essays in Honor of Bruce Lyon*, ed. Bernard S. Bachrach and David Nicholas (Kalamazoo, MI, 1990), pp. 298–9. See Robert Muchembled, *Le Temps des supplices: de l'obéissance sous les rois absolus, XVe–XVIIIe siècle* (Paris, 1992), pp. 28, 39, 48, 82, on how medieval French justice was generally supported by a system of fines;

Muchembled suggested that it was not until the sixteenth century that the 'real period' of tortured bodies arrived.

27 Kathryn Gravdal, *Ravishing Maidens: Writing Rape in Medieval French Literature and Law* (Philadelphia, 1991), pp. 125–30.

28 Guido Ruggiero, *Violence in Early Renaissance Venice* (New Brunswick, NJ, 1980), p. 44.

29 Cohen, 'To Die a Criminal', p. 298.

30 *Journal d'un Bourgeois de Paris sous Charles VI et Charles VII*, ed. André Mary (Paris, 1929), p. 40; *A Parisian Journal, 1405–1449*, trans. Janet Shirley (Oxford, 1968), p. 51.

31 *Journal d'un Bourgeois de Paris*, p. 47; *Parisian Journal*, pp. 59–60.

32 Bruce Bernard, ed., *Century* (London, 1999); Derrik Mercer, ed., *Chronicle of the 20th Century* (London, 1995). This is not to downplay the reality or extent of the violence and suffering endured by countless millions of people in the twentieth century. Rather, it seems worth investigating the exaggerated interest in images of violence for those living lives that are, relatively speaking, devoid of fear and suffering.

33 Cohen, "To Die a Criminal", p. 300.

34 Judith Perkins, *The Suffering Self: Pain and Narrative Representation in the Early Christian Era* (London, 1995), explores similar issues in relation to the early Christian era.

35 For the notion of 'reparative reading', see Eve Kosofsky Sedgwick, *Touching Feeling: Affect, Pedagogy, Performativity* (Durham, NC, 2003), pp. 125–51. A reparatively positioned reader, writes Sedgwick, 'has room to realize that the future may be different from the present'; that it might be possible to 'entertain such profoundly painful, profoundly relieving, ethically crucial possibilities as that the past, in turn, could have happened differently from the way it actually did' (p. 146).

36 Dinshaw, *Getting Medieval*, p. 21.

37 See Suzannah Biernoff, *Sight and Embodiment in the Middle Ages* (New York, 2002), pp. 17–59, for an extended discussion of sight as a locus of carnality in medieval thought.

38 Roger Bacon, *The Opus Majus of Roger Bacon*, trans. R. B. Burke, 2 vols (New York, 1962), vol. II, pp. 445–6 (5.1.4.2), quoted in Biernoff, *Sight and Embodiment*, p. 96.

39 Bacon, *Opus majus*, vol. II, p. 470 (5.1.7.3), quoted in Biernoff, *Sight and Embodiment*, p. 86.

40 Camille's writings on medieval visual culture have attempted such troubling man-oeuvres, and in the following essay he draws directly on Dinshaw's notion of queer touching: Michael Camille, 'The Pose of the Queer: Dante's Gaze, Brunetto Latini's Body', in *Queering the Middle Ages*, ed. Glenn Burger and Steven F. Kruger (Minneapolis, MN, 2001), pp. 57–86.

41 The rhetoric of this section draws to some extent on Irigaray's discussions of touch and multiplicity in her account of female sexual pleasure. See Luce Irigaray, *This Sex Which Is Not One*, trans. Catherine Porter, with Carolyn Burke (Ithaca, NY, 1985), pp. 23–33.

42 For manuscripts and reproductions, see Adrian and Joyce Lancaster Wilson, *A Medieval Mirror: Speculum humanae salvationis, 1324–1500* (Berkeley, CA, 1984).

43 Nelson, 'Descartes's Law', p. 3; Sarah Salih, 'The Medieval Looks Back', in *Troubled Vision: Gender, Sexuality, and Sight in Medieval Text and Image*, ed. Emma Campbell and Robert Mills (New York, 2004), pp. 223–31.

44 Implicitly, here, I draw on Irigaray's deployment of the speculum as a means of critiquing modes of looking and knowing that evacuate the perceiving subject (who, in her account, is gendered male). See Luce Irigaray, *Speculum of the Other Woman*, trans. Gillian C. Gill (Ithaca, NY, 1985), pp. 205–6. Of course, this isn't to say that articulations of multiplicity are inevitably 'progressive' from an ethical or political point of view. My point is that, rather than simply forming identifications with the past by positing its alterity, we should also approach medieval images and texts using

perspectives and critical languages that their original makers did not approve or articulate explicitly. See Fradenburg, *Sacrifice Your Love*, pp. 75–8, on how we also need to explore how medieval cultures 'might have misunderstood themselves'.

45 Scott Bravmann, *Queer Fictions of the Past: History, Culture and Difference* (Cambridge, 1997), p. 31, theorizes a project of engaging in dialogues between past and present by a process of 'readerly participation' in order to offer some 'possible meanings' of history. For an essay exploring ideas of this sort specifically in relation to medieval historiography, see Daniel Smartt, 'Cruising Twelfth-Century Pilgrims', *Journal of Homosexuality*, XXVII (1994), pp. 35–55. On visual response and historicism more generally, see essays in Nelson, ed., *Visuality Before and Beyond the Renaissance*.

46 On the intellectual promise of antidisciplinarity, see Paul Strohm, 'Coronation as Legible Practice', in Strohm, *Theory and the Premodern Text* (Minneapolis, MN, 2000), p. 34.

ONE BETWIXT HEAVEN AND EARTH

1 Barbara A. Hanawalt, *Crime and Conflict in English Communities, 1300–48* (Cambridge, MA, 1979), pp. 38, 44, analyses fourteenth-century jail delivery records and concludes that, in rural counties, the vast majority of convicted felons were hanged in the traditional manner; only a tiny proportion were dragged and then hanged or, if they were women, burned; records of corporal mutilation are exceptionally rare, and those convicted of minor thefts might be simply released without charge or sentenced to the pillory. See also Philippa Maddern, *Violence and Social Order: East Anglia, 1422–42* (Oxford, 1992), p. 70. On Paris, see Bronisław Geremek, *The Margins of Society in Late Medieval Paris*, trans. Jean Birrell (Cambridge, 1987), p. 53. Jacques Chiffoleau, *Les Justices du pape: délinquance et criminalité dans la région d'Avignon au quatorzième siècle* (Paris, 1984), p. 238, suggests that in Avignon hanging represented around 70 per cent of capital penalties. On Florence, see Samuel Y. Edgerton, *Pictures and Punishment: Art and Criminal Prosecution during the Florentine Renaissance* (Ithaca, NY, 1985), pp. 143–4. Richard van Dülmen, *Theatre of Horror: Crime and Punishment in Early Modern Germany* (Cambridge, 1990), pp. 80–83, 92–7, suggests that early modern Germany presents a similar picture.

2 *Journal d'un Bourgeois de Paris sous Charles VI et Charles VII*, ed. André Mary (Paris, 1929), p. 204; *A Parisian Journal, 1405–1449*, trans. Janet Shirley (Oxford, 1968), pp. 221–2.

3 See, on these points, Marla Carlson, 'Painful Processions in Late-Medieval Paris', *European Medieval Drama*, VI (2003), pp. 65–81.

4 V. A. C. Gatrell, *The Hanging Tree: Execution and the English People, 1770–1868* (Oxford, 1996), p. vii.

5 *Ibid.*, p. 30.

6 *Ibid.*, p. 46.

7 Edgerton, *Pictures and Punishment*, p. 142.

8 Testimony of William de Briouze junior, quoted in Robert Bartlett, *The Hanged Man: A Story of Miracle, Memory and Colonialism in the Middle Ages* (Princeton, NJ, 2004), p. 6. Bartlett's study is a useful resource generally for the study of hanging as a judicial and technological process.

9 The text and translation of the *Ballade des pendus* is taken from François Villon, *Complete Poems*, ed. and trans. Barbara N. Sargent-Baur (Toronto, 1994), pp. 264–7.

10 The best study of Villon to date, to my mind, is Jane H. M. Taylor, *The Poetry of François Villon: Text and Context* (Cambridge, 2001), since it falls into neither of these camps.

11 See, for instance, Aubrey Burl, *Danse Macabre: François Villon, Poetry and Murder in*

Medieval France (Stroud, 2000), pp. 215–18.

12 David A. Fein, *François Villon Revisited* (New York, 1997), p. 133.

13 Burl, *Danse Macabre*, p. 216. See also Edelgard Dubruck, *The Theme of Death in French Poetry of the Middle Ages and Renaissance* (London, 1964), p. 94.

14 See Paul Binski, *Medieval Death: Ritual and Representation* (London, 1996), pp. 134–8, on the legend of the Three Living and the Three Dead. See also Dubruck, *Theme of Death*, pp. 57–62.

15 Elaine Scarry, *The Body in Pain: The Making and Unmaking of the World* (Oxford, 1985).

16 See discussion in Burl, *Danse Macabre*, pp. 215–18.

17 Gatrell, *Hanging Tree*, pp. 175–96, discusses the gallows emblem in post-medieval woodcuts.

18 Immersion in rivers and lakes was a common motif in visionary literature depicting purgatorial suffering between the sixth century and the thirteenth. See Alison Morgan, *Dante and the Medieval Other World* (Cambridge, 1990), pp. 26–33.

19 Fein, *François Villon Revisited*, p. 133, suggests that the words invoke baptism. The word 'Justice' in the second stanza might be similarly understood in both a temporal and spiritual sense.

20 On the attribution of a penal character to Judas's suicide, see Norbert Schnitzler, 'Judas' Death: Some Remarks on the Iconography of Suicide in the Middle Ages', *Medieval History Journal*, III (2000), pp. 103–18.

21 See, for example, the account of the posthumous decapitation of the suicide Jacques de la Riviere in the *Journal d'un Bourgeois de Paris*, pp. 72–3. For a discussion of these practices, see Esther Cohen, *The Crossroads of Justice: Law and Culture in Late Medieval France* (Leiden, 1993), p. 141.

22 Villon, *Complete Poems*, pp. 300–319, ballad x, l. 8, and ballad I, l. 10.

23 Georges Bataille, *The Tears of Eros*, trans. Peter Connor (San Francisco, 1989), pp. 204–7.

24 Cohen, *Crossroads of Justice*, pp. 134–45.

25 A. Sachs, 'Religious Despair in Mediaeval Literature and Art', *Mediaeval Studies*, XXVI (1964), pp. 254–6; Schnitzler, 'Judas' Death', p. 106.

26 Paul Wann (*d.* 1489), quoted in Schnitzler, 'Judas' Death', p. 111.

27 Gatrell, *Hanging Tree*, p. 74.

28 Villon, *Complete Poems*, p. 272; translation in Burl, *Danse Macabre*, p. 215.

29 The point being, I think, that the *pendus* recognize that there *is* potential for mockery in the reactions of the reader / spectator.

30 The classic studies are Gherardo Ortalli, ' . . . *pingatur in Palatio* . . . ': *La pittura infamante nei secoli 13–16* (Rome, 1979), especially pp. 25–91; Edgerton, *Pictures and Punishment*.

31 John Shephard, *The Tarot Trumps Cosmos in Miniature: The Structure and Symbolism of the Twenty-Two Tarot Trump Cards* (Wellingborough, 1985), pp. 19–20, 103–4.

32 The execution of Gorgonius and Dorotheus is also the only instance of saintly hanging in the *Legenda aurea*. See Jacobus de Voragine, *The Golden Legend: Readings on the Saints*, trans. William Granger Ryan, 2 vols (Princeton, NJ, 1993), vol. II, p. 164.

33 Barbara A. Babcock, ed., *The Reversible World: Symbolic Inversion in Art and Society* (Ithaca, NY, 1978), pp. 13–36.

34 On the Brent Knoll bench-end, see Peter Poyntz Wright, *The Rural Benchends of Somerset* (Amersham, 1983), pp. 93–8. For analogues, see Christa Grössinger, *The World Upside-Down: English Misericords* (London, 1997), p. 119, and Malcolm Jones and Charles Tracy, 'A Medieval Choirstall Desk-End at Haddon Hall: The Fox-Bishop and the Geese-Hangmen', *Journal of the British Archaeological Association*, CXLIIII (1991), pp. 107–15. On reversal more generally, see Ruth Mellinkoff, 'Riding Backwards: Theme

of Humiliation and Symbol of Evil', *Viator*, IV (1973), pp. 153–86.

35 General surveys of *uomini famosi* include Theodor E. Mommsen, 'Petrarch and the Decoration of the Sala Virorum Illustrium in Padua', *Art Bulletin*, XXXIV (1952), pp. 95–116; Christiane L. Joost-Gaugier, 'A Rediscovered Series of *Uomini Famosi* from Quattrocento Venice', *Art Bulletin*, LVIII (1976), pp. 184–95.

36 'Lives of Jacopo, Giovanni and Gentile Bellini', in Giorgio Vasari, *Le vite dei piú eccellenti pittori, scultori e architetti*, 4 vols (Milan, 1945), vol. I, pp. 811–12; Giorgio Vasari, *Lives of the Painters, Sculptors and Architects*, trans. Gaston du C. de Vere, 2 vols, (London, 1996), vol. I, p. 495.

37 This isn't a connection remarked upon in any depth either by Ortalli or Edgerton, though the latter does comment briefly on the connection between legal discussions of *fama* in late medieval Italy and a general rise in portraiture at this time. See Edgerton, *Pictures and Punishment*, pp. 62–3.

38 *Journal d'un Bourgeois de Paris*, p. 301; *Parisian Journal*, pp. 323–4.

39 *The Brut; or, The Chronicles of England*, ed. Friedrich W. D. Brie, 2 vols (London, 1908), vol. II, p. 572.

40 Edgerton, *Pictures and Punishment*, p. 92.

41 Edward Halle, *The Union of the Two Noble Families of Lancaster and York: Facsimile of Bodleian Library, Oxford, CC39 Art* (Menston, 1970), fol. xl. See Malcolm Jones, *The Secret Middle Ages* (Stroud, 2002), pp. 81–7, for further examples of defamatory pictures across Europe.

42 For background on metaphors of reversal in England, specifically, see Malcolm Jones, 'Folklore Motifs in Late Medieval Art II: Sexist Satire and Popular Punishments', *Folklore*, CI (1990), pp. 69–87; Mellinkoff, 'Riding Backwards'.

43 Edgerton, *Pictures and Punishment*, p. 73.

44 Otto Hupp, *Scheltbriefe und Schandbilder: ein Rechtsbehelf aus dem 15 un 16 Jahrhundert* (Munich, 1930); Matthias Lentz, 'Defamatory Pictures and Letters in Late Medieval Germany: The Visualization of Disorder and Infamy', *Medieval History Journal*, III (2000), pp. 139–60.

45 Hupp, *Scheltbriefe und Schandbilder*, p. 19.

46 Rudolf Glanz, 'The "Jewish Execution" in Medieval Germany', *Jewish Social Studies*, V (1943), pp. 3–26; Guido Kisch, 'The "Jewish Execution" in Mediaeval Germany', *L'Europa e il diritto romana: Studi in memoria di Paolo Koschaker*, 2 vols (Milan, 1954), vol. II, pp. 65–93; Norbert Schnitzler, 'Anti-Semitism, Image Desecration and the Problem of "Jewish Execution"', in *History and Images: Towards a New Iconology*, ed. Axel Bolvig and Phillip Lindley (Turnhout, 2003), pp. 357–78; Esther Cohen, 'Symbols of Culpability and the Universal Language of Justice: The Ritual of Public Executions in Late Medieval Europe', *History of European Ideas*, XI (1989), pp. 411–12; Cohen, *Crossroads of Justice*, pp. 92–3; Mitchell Merback, *The Thief, the Cross and the Wheel: Pain and the Spectacle of Punishment in Medieval and Renaissance Europe* (London, 1999), pp. 186–95.

47 Cohen, 'Symbols of Culpability', p. 411.

48 Ulrich Tengler, *Der neü Layenspiegel* (Augsburg, 1511), fol. 216.

49 Quoted in Rudolf Glanz, 'Jewish Execution', pp. 6–7. Dülmen, *Theatre of Horror*, p. 97, quotes a similar traditional sentencing formula from Aargau describing conventional hanging. See also Folke Ström, *On the Sacral Origin of the Germanic Death Penalties* (Stockholm, 1942), p. 159.

50 Ström, *On the Sacral Origin*, pp. 115–61, discusses the ancient origins of hanging symbolism.

51 'Das Tagebuch Gattaros', quoted in Glanz, 'Jewish Execution', p. 4.

52 Schnitzler, 'Anti-Semitism', p. 374.

53 Esther Cohen, 'Law, Folklore and Animal Lore', *Past and Present*, CX (1986), pp. 10–12.

54 *Ibid.*, p. 4. For further instances of Jewish animalization, see Cohen, 'Symbols of Culpability', p. 411.

55 *Enderung vnd Schmach der Bildung Mariae von den Juden*, printed by Martin Hupfuff, *c.* 1512–15, described in Eric M. Zafran, 'An Alleged Case of Image Desecration by the Jews and its Representation in Art: The Virgin of Cambron', *Journal of Jewish Art*, II (1975), pp. 62–71. The text and woodcuts are also reproduced from a copy formerly in the Michelstädter Kirchenbibliothek in Adam Klassert, 'Entehrung Maria durch die Juden', *Jahrbuch für Geschichte, Sprache und Literatur Elsass-Lothringens*, XXI (1905). According to Zafran, the same work was apparently subsequently transferred to the Königlichen Bibliothek, Berlin, but is now lost.

56 On the painting in the church near Mons, see Schnitzler, 'Anti-Semitism', pp. 359–64 and figs 1–4.

57 Translation in Schnitzler, 'Anti-Semitism', p. 368, note 22.

58 Merback, *The Thief, the Cross and the Wheel*, pp. 189–95, makes a similar argument, but in relation to depictions of the Impenitent Thief as a broken-backed, upside-down figure in Bavarian and Austrian Calvary iconography.

59 See Isaiah Shachar, *The Judensau: A Medieval Anti-Jewish Motif and its History* (London, 1974), especially. pp. 2, 40–41.

60 *Ibid.*, p. 35.

61 I have come across no references to the 'Jewish execution' being practised in medieval Italy.

62 See Miri Rubin, *Gentile Tales: The Narrative Assault on Late Medieval Jews* (New Haven, CT, 1999), pp. 40–69, 104–31.

63 Merback, *The Thief, the Cross and the Wheel*, p. 195, suggests that images of the inverted Bad Thief in south German Calvary depictions acted as a screen upon which Bavarian and Austrian shrines 'might project some of their pogromist fury'.

64 Edgerton, *Pictures and Punishment*, p. 100; Ortalli, *La pittura infamante*, pp. 90–91.

65 Vasari, *Le vite dei piú eccellenti pittori*, vol. I, p. 757; Vasari, *Lives of the Painters*, vol. I, pp. 453–4.

66 Edgerton, *Pictures and Punishment*, p. 104; Ortalli, *La pittura infamante*, p. 95.

67 Background information on the Pisanello drawings can be found in John T. Paoletti and Gary M. Radke, *Art in Renaissance Italy* (London, 1997), pp. 246–7. Comparable drawings by Pisanello can be found in the Frick Collection, New York, reproduced in Lionello Puppi, *Torment in Art: Pain, Violence and Martyrdom* (New York, 1991), fig. 10.

68 See James Elkins, *The Object Stares Back: On the Nature of Seeing* (New York, 1996), pp. 108–10, on the symbolic content that adheres even to photographs of actual executions.

69 Julia Kristeva, *Powers of Horror: An Essay on Abjection* (New York, 1982), p. 1.

70 David Freedberg, *The Power of Images: Studies in the History and Theory of Response* (Chicago, 1989), pp. 249–57, 271–81. This may also be an element in the northern examples discussed earlier: the 'unpleasant' nature of the pictures displayed in Paris in 1438 in the Bourgeois's *Journal* is attributed to the fact that they were 'very well painted'.

71 Edgerton, *Pictures and Punishment*, p. 124.

72 See Merback, *The Thief, the Cross and the Wheel*, pp. 266–303, on the erosion of the affective, devotional 'medieval paradigm' in sixteenth-century Calvary depictions.

73 Quoted in David Margolick, *Strange Fruit: Billie Holiday, Café Society and an Early Cry for Civil Rights* (Philadelphia, 2000), p. 15.

74 There is no indication that Meeropol knew Villon's poetry directly, but the connections

between 'Strange Fruit' and the *Ballade des pendus* suggest that Meeropol may, indeed, have intended to make allusions to the latter.
75 Margolick, *Strange Fruit*, p. 96.
76 Though, as black journalist Frank Bolden recalls, 'Kids in black colleges were unhappy with the song . . . They thought these kinds of songs made fun of black people' (*ibid.*, p. 94).
77 *Ibid.*, p. 17.
78 *Ibid.*, pp. 34–5.

TWO SKIN SHOW

1 R. W. Macan, ed., *Herodotus: The Fourth, Fifth and Sixth Books*, 2 vols (London, 1973), vol. ii, p. 25.
2 Hans J. van Miegroet, 'Gerard David's *Justice of Cambyses: Exemplum iustitiae* or Political Allegory', *Simiolus*, xviii/3 (1988), pp. 116–33, tries to uncover an original 'source' for David's iconography. Hugo van der Velden, 'Cambyses for Example: The Origins and Function of an *Exemplum iustitiae* in Netherlandish Art of the Fifteenth, Sixteenth and Seventeenth Centuries', *Simiolus*, xxiii /1 (1995), pp. 5–39, considers instead the well-documented medieval literary tradition of *exempla* based on the Cambyses legend.
3 *Gesta Romanorum*, trans. Charles Swan, revised Wynnard Hooper (London, 1905), pp. 62–3. This version of the text was printed in 1473.
4 Van der Velden, 'Cambyses For Example', provides a comprehensive survey of Cambyses iconography. The only image comparable to David's, which represents the flaying in the foreground, is an illumination of 1461 by Loyset Liédet (Brussels, Koninklijke Bibliotheek Albert i, ms 9287–8, fol. 132), reproduced in Hugo van der Velden, 'Cambyses Reconsidered: Gerard David's *Exemplum iustitiae* for Bruges Town Hall', *Simiolus*, xxiii /1 (1995), p. 57, fig. 12. Van der Velden argues that David adopted this image, or an image like it, as the model for his own depiction, and that his inclusion of the arrest panel is explained by a desire to emulate the prestigious justice panels of Bouts and van der Weyden, which likewise distributed four scenes over two panels.
5 See Craig Harbison, *The Art of the Northern Renaissance* (London, 1995), pp. 26–60, for a critique of the notion of Renaissance 'naturalism'.
6 For a general survey of images of justice, see Wolfgang Pleister and Wolfgang Schild, eds, *Recht und Gerechtigkeit im Spiegel der europäischen Kunst* (Cologne, 1988). The earliest records of *exempla iustitiae* appear in Italy, for instance Ambrogio Lorenzetti's *Allegories of Good and Bad Government* (1339) in the Palazzo Pubblico, Siena, and, before that, the now lost paintings by Giotto that adorned the Palazzo del Podestà, Florence. For background on north European justice iconography, see Van der Velden, 'Cambyses For Example', p. 6. James Snyder, *Northern Renaissance Art: Painting, Sculpture, the Graphic Arts from 1350 to 1575* (New York, 1985), p. 190, points out that David's Cambyses commission also included another painting, now lost, depicting the 'judgement and sentencing of Christ'.
7 These paintings were likewise originally accompanied by a smaller commission for *Last Judgement* scenes, also intended to be placed in the council chambers. For analysis, see Otto Pächt, *Early Netherlandish Painting: From Rogier van der Weyden to Gerard David*, trans. David Britt (London, 1997), pp. 139–41.
8 Berne, Historisches Museum, dated 1460–70. The originals were destroyed by fire in 1695. For discussion, see Erwin Panofsky, *Early Netherlandish Painting: Its Origins and*

Character, 2 vols (Cambridge, MA, 1953), vol. I, pp. 264–5.

9 Justice paintings are characterized as examples of 'stern retribution' in Max J. Friedländer, *Early Netherlandish Painting*, vol. VI/2: *Hans Memlinc and Gerard David*, trans. Heinz Norden (Leyden, 1971), p. 77. For a similar comment, see Snyder, *Northern Renaissance Art*, p. 191.

10 Van der Velden, 'Cambyses For Example', p. 11.

11 Miegroet, '*Justice of Cambyses*', pp. 128–33, counts among the portraits Philip the Handsome, Duke of Burgundy, Engelbert of Nassau, Stadtholder-General of the Netherlands, and Gerard David himself. See also Van der Velden, 'Cambyses Reconsidered', p. 52.

12 Miegroet, '*Justice of Cambyses*', pp. 122–33, criticized in Van der Velden, 'Cambyses Reconsidered', and Maryan W. Ainsworth, *Gerard David: Purity of Vision in an Age of Transition* (New York, 1998), p. 62.

13 Miegroet, '*Justice of Cambyses*', thus claims that David's iconographic programme was designed by Burgundian advisers, 'who closely monitored his progress thereafter' (p. 128). He even argues that one of the 'portraits' in the left panel, the figure immediately to the corrupt judge's left, is none other than Philip the Handsome himself (pp. 128–30). See the critique of this position in Velden, 'Cambyses Reconsidered', p. 51.

14 Curiously, the painting is barely mentioned in Huizinga's account of the 'waning' Middle Ages. He merely remarks that the purpose of such paintings was 'to keep before the eyes of the judges a solemn and vibrant reminder of their duty'. See Johan Huizinga, *The Autumn of the Middle Ages*, trans. Rodney J. Paynton and Ulrich Mammitzsch (Chicago, 1996), p. 297.

15 This is one of the shortcomings of van Miegroet's study.

16 Pächt, *Early Netherlandish Painting*, p. 247, for example, confines his analysis to formal considerations ('the perfect isocephaly of the group', the location of the flayed body in an 'oblique spatial recession', etc.) without interrogating more closely what he simply terms the 'revolting business' of Sisamnes' punishment. *Flanders in the Fifteenth Century: Art and Civilisation*, exh. cat., Detroit Institute of Arts (Detroit, MI, 1960), p. 176, declares *Cambyses* to be 'a basic picture for the study of this master', which 'marks the end of the Gothic period of Flemish art'; significantly, only the arrest panel was included in the exhibition. Ainsworth, *Gerard David*, p. 4, purports to take 'a closer look at the work of art itself'; as it happens, these investigations are largely confined to a technical survey of x-rays and infrared reflectographs, a methodology that appears, once again, to direct attention away from the painted surface and its effects on the viewer.

17 Quoted in Francis Haskell, *History and its Images: Art and the Interpretation of the Past* (New Haven, CT, 1993), pp. 459, 461.

18 W. H. James Weale, *Gerard David: Painter and Illuminator* (London, 1895), p. 13. Such reactions continued well into the twentieth century. See Panofksy, *Early Netherlandish Painting*, p. 351, which dubs the painting a 'somewhat pompous' composition, and van Miegroet, '*Justice of Cambyses*', p. 128, which asserts that his hypothesis regarding the Burgundian control over the iconographic programme 'virtually rules out personal interpretation of the iconography on the part of the artist'.

19 Michel Foucault, 'Lives of Infamous Men', in *Essential Works of Foucault 1954–1984*, vol. III, *Power*, ed. James D. Faubion (London, 2000), p. 159.

20 An argument implied by van Miegroet, '*Justice of Cambyses*', p. 125, and firmly refuted by Van der Velden, 'Cambyses Reconsidered', p. 40.

21 W. R. J. Barron, 'The Penalties for Treason in Medieval Life and Literature', *Journal of Medieval History*, VII (1981), pp. 187–202.

22 Barron, 'Penalties for Treason', gives a broad survey of literature depicting flaying, with a list of historical instances. Motifs of flaying in a French religious poem are discussed

in Sarah Kay, 'Flayed Skin as *objet a*: Representation and Materiality in Guillaume de Deguileville's *Pèlerinage de vie humaine*', in *Medieval Fabrications: Dress, Textiles, Clothwork and Other Cultural Imaginings*, ed. E. Jane Burns (New York, 2004), pp. 193–205. The theoretical perspectives that Kay deploys have also shaped my argument here.

23 *The Lay of Havelok the Dane*, ed. Walter W. Skeat, 2nd edition, revised K. Sisam (Oxford, 1915), p. 83, ll. 2476–7.

24 See Didier Anzieu, *The Skin Ego*, trans. Chris Turner (New Haven, CT, 1989), on how the ego itself is modelled on the experience of bodily surface. Anzieu suggests that the Greek myth of the Marsyas, flayed by Apollo, encodes this idea of an imaginary Skin Ego. Gerard David makes reference to the Marsyas legend in the right medallion above the seat in the arrest panel: the motif acts as a harbinger of the fate awaiting Sisamnes.

25 *The Cyrurgie of Guy de Chauliac*, ed. Margaret S. Ogden (Oxford, 1971), p. 32.

26 See, for instance, the Middle English lyric by John of Grimestone, which declares: 'I wolde ben clad in cristis skyn, that ran so longe on blode, and gon t'is herte and taken myn in'. See Carleton Brown, ed., *Religious Lyrics of the Fourteenth Century* (Oxford, 1924), pp. xvi, 88.

27 Mary Carruthers, 'Reading with Attitude, Remembering the Book', in *The Book and the Body*, ed. Dolores Warwick Frese and Katherine O'Brien O'Keeffe (Notre Dame, IN, 1997), pp. 3–4.

28 *Gesta Romanorum*, p. 63.

29 The fifteenth-century 'Long Charter' of Christ is discussed at greater length in Carruthers, 'Reading with Attitude', pp. 4–5; Miri Rubin, 'The Body, Whole and Vulnerable, in Fifteenth-Century England', in *Bodies and Disciplines: Intersections of Literature and History in Fifteenth-Century England*, ed. Barbara A. Hanawalt and David Wallace (Minneapolis, MN, 1996), pp. 21–2.

30 For instance, Geoffroi de Vinsauf's thirteenth-century rhetorical manual *Poetria noua*, which entreats: 'Let her countenance emulate dawn: not red, nor yet white – but at once neither of those colours and both', quoted in A. C. Spearing, *The Medieval Poet as Voyeur: Looking and Listening in Medieval Love-Narratives* (Cambridge, 1993), p. 45.

31 Indeed, in England, leprosy was judged a barrier to inheritance since Norman times, reflecting the identity-less existence that the leper was forced to endure. See R. I. Moore, *The Formation of a Persecuting Society: Power and Deviance in Western Europe, 950–1250* (Oxford, 1987), pp. 58–9.

32 See, for example, Esther Cohen, *The Crossroads of Justice: Law and Culture in Late Medieval France* (Leiden, 1993), pp. 184–5.

33 Julia Kristeva, *Powers of Horror: An Essay on Abjection* (New York, 1982), pp. 4, 2.

34 *Ibid.*, pp. 3–4.

35 Marie-Christine Pouchelle, *The Body and Surgery in the Middle Ages*, trans. Rosemary Morris (Cambridge, 1990), pp. 75–6.

36 E. A. R. Brown, 'Death and the Human Body in the Later Middle Ages: The Legislation of Boniface VIII on the Division of the Corpse', *Viator*, XII (1981), pp. 221–70.

37 Caroline Walker Bynum, *Fragmentation and Redemption: Essays on Gender and the Human Body in Medieval Religion* (New York, 1992), pp. 239–97, provides an illuminating account of the ambivalent medieval responses to bodily division, and its association with personal survival.

38 David Freedberg, *The Power of Images: Studies in the History and Theory of Response* (Chicago, 1989), especially pp. 26–30, 373, 424–5.

39 Pächt, *Early Netherlandish Painting*, p. 247, observes how the flaying is depicted 'with utterly unemotive, conscientious thoroughness, as if the subject were an anatomy lecture'. See also Max J. Friedländer, in Arts Council of Great Britain, *Gerard David and his*

Followers, exh. cat., Wildenstein Gallery (London, 1949), p. 5, and Eberhard Freiherr von Bodenhausen, *Gerard David und Seine Schule* (Munich, 1905), p. 133. For other fifteenth-century illustrations to anatomy manuals, see Jonathan Sawday, *The Body Emblazoned: Dissection and the Human Body in Renaissance Culture* (London, 1995), pp. 39–84.

40 *Lay of Havelok the Dane*, p. 84, ll. 2493–9.

41 See, on this, Michael Camille, 'Mimetic Identification and Passion Devotion in the Later Middle Ages: A Double-Sided Panel by Meister Francke', in *The Broken Body: Passion Devotion in Late Medieval Culture*, ed. A. A. MacDonald, H. N. B. Ridderbos and R. M. Schlusemann (Groningen, 1998), pp. 190, 197.

42 Sawday, *Body Emblazoned*, pp. 42–52.

43 Two dogs are also depicted to the bottom left of the panel depicting Sisamnes' arrest: traditional symbols of fidelity, they may also be linked to Iustitia and the restoration of law and order.

44 Ainsworth, *Gerard David*, pp. 67–72.

45 Miegroet 'Justice of Cambyses', pp. 128–30, even suggests that David himself included a self-portrait in the arrest panel.

46 V.A.C. Gatrell, *The Hanging Tree: Execution and the English People, 1770–1868* (Oxford, 1996), p. 267.

47 On victim identification in modern horror, see Carol J. Clover, *Men, Women and Chainsaws: Gender in the Modern Horror Film* (London, 1992), pp. 61–2, 221.

THREE ELIMINATING SODOM

1 Michael Rocke, *Forbidden Friendships: Homosexuality and Male Culture in Renaissance Florence* (Oxford, 1996), p. 36. Franco Mormando, *The Preacher's Demons: Bernardino of Siena and the Social Underworld of Early Renaissance Italy* (Chicago, 1999), provides a useful account of Bernardino's preaching and its place in fifteenth-century Italian politics and society.

2 Santa Croce, Florence, 7 April 1424, quoted in Michael Rocke, 'Sodomites in Fifteenth-Century Tuscany: The Views of Bernardino of Siena', in *The Pursuit of Sodomy: Male Homosexuality in Renaissance and Enlightenment Europe*, ed. Kent Gerard and Gert Hekma (New York, 1989), p. 7; see also Rocke, *Forbidden Friendships*, p. 44.

3 For the appearance of buggery as a crime in English law, see 25 Henry VIII c.6, quoted in Donald N. Mager, 'John Bale and Early Tudor Sodomy Discourse', in *Queering the Renaissance*, ed. Jonathan Goldberg (Durham, NC, 1994), pp. 142–3. On France, see Trevor Dean, *Crime in Medieval Europe, 1200–1550* (Harlow, 2001), p. 59. Marc Boone, 'State Power and Illicit Sexuality: The Persecution of Sodomy in Late Medieval Bruges', *Journal of Medieval History*, XXII/2 (1996), pp. 135–53, shows how in Bruges, between 1384 and 1515, there were a surprisingly high number of executions for sodomy (90 in total). Michael Goodich, *The Unmentionable Vice: Homosexuality in the Later Medieval Period* (Santa Barbara, CA, 1979), pp. 71–88, provides a general account of sodomy in medieval judicial practice.

4 Helmut Puff, *Sodomy in Reformation Germany and Switzerland, 1400–1600* (Chicago, 2003), pp. 23–5.

5 Rocke, *Forbidden Friendships*, pp. 4, 46–7.

6 Guido Ruggiero, *The Boundaries of Eros: Sex Crime and Sexuality in Renaissance Venice* (Oxford, 1985), pp. 109–45; P. Labalme, 'Sodomy and Venetian Justice in the Renaissance', *Legal History Review*, LII (1984), pp. 217–54.

7 Trevor Dean, 'Criminal Justice in mid-Fifteenth-Century Bologna', in *Crime, Society*

and the Law in Renaissance Italy, ed. Trevor Dean and K. J. P. Lowe (Cambridge, 1994), p. 31. For sodomy prosecutions in other Italian cities such as Lucca, Ferrara, Padua, Modena and Trieste, see Nicholas Davidson, 'Theology, Nature and the Law: Sexual Sin and Sexual Crime in Italy from the Fourteenth to the Seventeenth Century' in *Crime, Society and the Law in Renaissance Italy*, ed. Dean and Lowe, pp. 74–98. Dean, *Crime in Medieval Europe*, pp. 60–61, also mentions a prosecution in Milan, a statute in Bergamo and the institution of Venetian-style penalties for sodomy in Ragusa (modern-day Dubrovnik).

8 Recent discussions of sodomy in Dante include Bruce W. Holsinger, 'Sodomy and Resurrection: The Homoerotic Subject of the *Divine Comedy*', in *Premodern Sexualities*, ed. Louise Fradenburg and Carla Freccero (London, 1996), pp. 243–74, and Joseph Pequigney, 'Sodomy in Dante's *Inferno* and *Purgatorio*', *Representations*, XXXVI (1991), pp. 22–42.

9 See, for example, James Saslow, *Pictures and Passions: A History of Homosexuality in the Visual Arts* (New York, 1999); John Boswell, *Christianity, Social Tolerance and Homosexuality: Gay People in Western Europe from the Beginning of the Christian Era to the Fourteenth Century* (Chicago, 1980); and the essays in the special issue of the *Journal of Homosexuality*, XXVII/1–2 (1994) on 'homosexuality in art'. None makes reference to the depiction of sodomites in hell. The best general account of medieval iconography of hell is Jérôme Baschet, *Représentations de l'enfer: en France et en Italie (XIIe–XVe siècle)* (Rome, 1993). Baschet mentions the depiction of sodomites several times in passing but without concerted analysis: see pp. 304, 361, 364, 371, 395, 502. For an account that focuses specifically on Italian Last Judgements, and that includes discussion of punishments for sodomy, see Iris Grötecke, 'Representing the Last Judgement: Social Hierarchy, Gender and Sin', *Medieval History Journal*, 1/2 (1998), pp. 233–60.

10 The Camposanto frescoes are sometimes attributed to Francesco Traini, but in assigning the *Inferno* painting to Buffalmacco I am following Luciano Bellosi, *Buffalmacco e il Trionfo della Morte* (Turin, 1974). For further discussion of dating and iconography, see Baschet, *Représentations de l'enfer*, pp. 624–7, and Licia Bertolini and Mario Bucci, *Camposanto monumentale di Pisa: affreschi e sinopie* (Pisa, 1960), pp. 57–9. For the engravings, see Carlo Lasinio, *Pitture a fresco del Campo Santo di Pisa* (Florence, 1812) and Giovanni Paolo Lasinio, *Pitture a fresco del Camposanto di Pisa* (Florence, 1832).

11 Malcolm Jones, *The Secret Middle Ages* (Stroud, 2002), p. 87.

12 Text and discussion in Suzanne Lewis, *The Art of Matthew Paris in the 'Chronica Majora'* (Aldershot, 1987), pp. 283–8. This is not to say that there isn't a latent sexual aspect to the Paris miniature: to the far right, tied to a tree by her long hair, Paris depicts one of the virgins who are, as the accompanying text announces, 'raped until they die of exhaustion'; the spit penetrating the man (or boy: the figure, who holds his hands in a gesture of prayer, is rather small) emerges from the Mongol's groin area, which possibly implies a similar sexual subtext. For a scene of 'heterosexual' spit-roasting, in which pairs of men and women are tied together and roasted (but without the spits penetrating their bodies), see Paris, Bibliothèque Nationale, MS fr. 9186, fol. 298v, reproduced in François Avril and Nicole Reynaud, *Les Manuscrits à peintures en France, 1440–1520* (Paris, 1993), p. 47.

13 Detailed discussion and large-scale reproductions in Carlo Volpe, 'La pittura gotica: da Lippo di Dalmasio a Giovanni da Modena', in *La Basilica di San Petronio in Bologna*, 2 vols, ed. Luciano Bellosi *et al.* (Bologna, 1983), I, pp. 224–72, pls 217–22.

14 We lack information on the judicial status of sodomy in San Gimignano, though its proximity to Florence suggests that Bartolo's fresco emerged as a response to Florentine legislation on the matter. For information on prosecutions in Bologna, see

below, note 62. For a general discussion of the Bartolo hell, see Sibilla Symeonides, *Taddeo di Bartolo* (Siena, 1965), pp. 153–8. Baschet, *Représentations de l'enfer*, pp. 636–9, provides transcriptions of many of the fresco's inscriptions.

15 Michel Foucault, *History of Sexuality*, vol. i, *An Introduction*, trans. Robert Hurley (London, 1978), p. 101; Mark D. Jordan, *The Invention of Sodomy in Christian Theology* (Chicago, 1997), pp. 3–9, 163. On sodomy's role in provoking categorical confusion in contemporary settings, see Jonathan Goldberg, *Sodometries: Renaissance Texts, Modern Sexualities* (Stanford, CA, 1992), pp. 9–12.

16 St Thomas Aquinas, *Summa Theologiae*, ed. and trans. Dominican Fathers (London, 1980–), vol. XLIII, pp. 46–7, 248–9, 244–5. For analysis, see Jordan, *Invention of Sodomy*, pp. 136–58.

17 Jordan, *Invention of Sodomy*, pp. 29, 161.

18 Larry Scanlon, 'Unmanned Men and Eunuchs of God: Peter Damian's *Liber Gomorrhianus* and the Sexual Politics of Papal Reform', *New Medieval Literatures*, II (1998), pp. 37–64, problematizes Foucault's account of sodomy as 'utterly confused'.

19 Ruggiero, *Boundaries of Eros*, pp. 120–21; Rocke, *Forbidden Friendships*.

20 Ruggiero, *Boundaries of Eros*, p. 118.

21 Rocke, *Forbidden Friendships*, pp. 93–4.

22 *Ibid.*, p. 11; Jordan, *Invention of Sodomy*, pp. 46, 85, 97; Mormando, *Preacher's Demons*, p. 115.

23 Foucault, *History of Sexuality*, vol. i, p. 43. For critique, see Jordan, *Invention of Sodomy*, pp. 163–4.

24 On the relationship between textual milieus and differing expressions of sexuality, see Sarah Salih, 'Sexual Identities: A Medieval Perspective', in *Sodomy in Early Modern Europe*, ed. Tom Betteridge (Manchester, 2002), pp. 112–30; Puff, *Sodomy*, p. 7.

25 Louise Fradenburg and Carla Freccero, 'Caxton, Foucault, and the Pleasures of History', in *Premodern Sexualities*, ed. Louise Fradenburg and Carla Freccero (London, 1996), p. xx. See also Carolyn Dinshaw, *Getting Medieval: Sexualities and Communities, Pre- and Postmodern* (Durham, NC, 1999), p. 194.

26 The sodomites in Dante's *Purgatorio* are similarly characterized by perceptions of dominant sexual orientation. See Pequigney, 'Sodomy in Dante's *Inferno*'.

27 St Augustine, *City of God*, trans. Henry Bettenson (London, 1984), p. 521.

28 Diane Wolfthal, 'Picturing Same-Sex Desire: The Falconer and his Lover in Images by Petrus Christus and the Housebook Master', in *Troubled Vision: Gender, Sexuality, and Sight in Medieval Text and Image*, ed. Emma Campbell and Robert Mills (New York, 2004), pp. 17–46.

29 Michael Camille, The 'Pose of the Queer: Dante's Gaze, Brunetto Latini's Body', in *Queering the Middle Ages*, ed. Glenn Burger and Steven F Kruger (Minneapolis, MN, 2001) p. 58, fig. 1.

30 For a discussion of the concept of *contrapasso*, see *The Divine Comedy of Dante Alighieri*, vol. i: *Inferno*, ed. and trans. Robert M. Durling (Oxford, 1996), p. 448.

31 Michel Foucault, *Discipline and Punish: The Birth of the Prison*, trans. A. M. Sheridan (London, 1977), p. 113.

32 Rocke, *Forbidden Friendships*, pp. 14, 92–110; Ruggiero, *Boundaries of Eros*, pp. 121–5.

33 To my knowledge, no critical literature refers to this particular inscription. The letterforms that I have been able to make out in the second and third lines are N, C, I, V, L and O.

34 Rocke, *Forbidden Friendships*, pp. 7, 21–4, 46–60; Ruggiero, *Boundaries of Eros*, pp. 110–12; Dean, 'Criminal Justice in Bologna', pp. 27–30.

35 Rocke, *Forbidden Friendships*, p. 24.

36 This purgative dimension also has parallels with medical treatments such as cautery and 'fistula in ano'. See David Williams, 'Radical Therapy in the *Miller's Tale*', *Chaucer*

Review, xv (1981), pp. 227–35, which argues that the red hot 'kultour' used to brand Nicholas's buttocks in Chaucer's *Miller's Tale* draws comparison with such treatments. Elaine Tuttle Hansen, *Chaucer and the Fictions of Gender* (Berkeley, CA, 1992), pp. 229–33, suggests that the latter episode implies sodomy. We should recall that Chaucer himself passed through to Florence in 1372 and may thus have heard tell of the punishment of Giovanni in 1365, or a punishment like it, in the course of his travels. Early modern appropriations of the motif of violent penetration include the description in Holinshed's *Chronicles* of Edward II having a 'hote spitte' thrust into his anus. Dinshaw, *Getting Medieval*, p. 90, cites a late thirteenth-century statute from France asserting that 'he who has been proved a sodomite' should be castrated at the first offence; if he sins a second time, he loses his penis; at the third count, he's burnt.

37 Baschet, *Représentations de l'enfer*, pp. 451–4, discusses the plays briefly, but not specifically in relation to the depiction of sodomites.

38 *Laude drammatiche e rappresentazioni sacre*, 3 vols, ed. Vincenzo de Bartholomaeis (Florence, 1943), vol. I, p. 49, ll. 343–50.

39 *Ibid.*, p. 52, ll. 427–32. See also the variation in *Le sacre rappresentazioni italiane: rauolta di testi dal secolo XII al secolo XVI*, ed. Mario Bonfantini (Rome, 1942), p. 60. It is perhaps significant that *sodomite* here has a feminine ending: the plural of the modern Italian 'sodomita' would be 'sodomiti'.

40 London, British Library, Harley MS 4751, quoted in Isaiah Shachar, *The Judensau: A Medieval Anti-Jewish Motif and its History* (London, 1974), p. 4.

41 For general surveys of pig symbolism, see G. C. Druce, 'The Sow and Pigs: A Study in Metaphor', *Archaeologia Cantiana*, XLVI (1934), pp. 1–7; Claudine Fabre-Vassas, *The Singular Beast: Jews, Christians and the Pig*, trans. Carol Volk (New York, 1997).

42 Aquinas often speaks of sodomy in the same breath as bestiality or cannibalism. For instance, see Aquinas, *Summa Theologiae*, vol. XLIII, p. 47, where, describing sins that go beyond the bounds of human nature, he writes that 'they would appear to come under the heading of intemperance by going to extremes, for instance, taking pleasure in cannibalism or in bestial or homosexual coition'. Joyce E. Salisbury, *The Beast Within: Animals in the Middle Ages* (London, 1994), pp. 90–91, discusses the equation of animality and bestiality with sodomy.

43 Related, as I suggested above in chapter One, to the genre of anti-Semitic representation explored in Shachar, *Judensau*.

44 Otto Hupp, *Scheltbriefe und Schandbilder: ein Rechtsbehelf aus dem 15 un 16 Jahrhundert* (Munich, 1930), p. 8. See Puff, *Sodomy*, pp. 107–23, on defamatory accusations of sodomy in German and Swiss cities in the fifteenth and sixteenth centuries.

45 Mormando, *Preacher's Demons*, p. 119.

46 Caroline Walker Bynum, *The Resurrection of the Body in Western Christianity, 200–1336* (New York, 1995), pp. 117–55.

47 On the iconography of the mouth, see Baschet, *Représentations de l'enfer*, pp. 233–85.

48 *Ibid.*, pp. 220, 509–11.

49 Norbert Elias, *The Civilizing Process: Sociogenetic and Psychogenetic Investigations*, revised edition, trans. Edmund Jephcott (Oxford, 1994), pp. 365–447.

50 For a general account of these mechanisms, see Peter Stallybrass and Allon White, *The Politics and Poetics of Transgression* (Ithaca, NY, 1986), pp. 191–202.

51 Baschet, *Représentations de l'enfer*, pp. 399–404. See Mary Hollingsworth, *Patronage in Renaissance Italy from 1400 to the Early Sixteenth Century* (London, 1994), pp. 33–47, on the moral context that informed mercantile patronage in fifteenth-century Florence.

52 'The will of Bartolomeo Bolognini, 10 February, 1408', in *Miniatori e pittori a Bologna:*

Documenti del secolo XV, ed. Francesco Filippini and Guido Zucchini (Rome, 1968), p. 172.

53 Dante, *Inferno*, ed. Durling, pp. 263–5 (canto 17, ll. 43–78).

54 John T. Paoletti and Gary M. Radke, *Art in Renaissance Italy* (London, 1997), pp. 82–4.

55 Bernardino of Siena, quoted in Rocke, *Forbidden Friendships*, p. 135; Dante, *Inferno*, ed. Durling, p. 235 (canto 15, l. 106).

56 Rocke, *Forbidden Friendships*, pp. 136–47.

57 Mormando, *Preacher's Demons*, pp. 140–45.

58 Rocke, *Forbidden Friendships*, pp. 3, 28–30, 38–9; Mormando, *Preacher's Demons*, pp. 129–34, 152.

59 Rocke, *Forbidden Friendships*, p. 36.

60 Council of Ten, 12 March 1496, in *Leggi e memorie venete sulla prostituzione fino alla caduta della republica* (Venice, 1870–72), p. 81. On the extent to which plague and other natural disasters figured in medieval Italian sodomy rhetoric, see Davidson, 'Theology, nature and the law', pp. 86–7; Rocke, *Forbidden Friendships*, pp. 28–9.

61 For additional background on the links between sodomophobia, plague and campaigns in favour of marriage, see David Herlihy and Christiane Klapisch-Zuber, *Les Toscans et leurs familles: une étude du catasto florentin de 1427* (Paris, 1978), pp. 586–8; Richard C. Trexler, *Public Life in Renaissance Florence* (New York, 1980), pp. 378–81.

62 *Statuti della repubblica fiorentina*, vol. II, *Statuto del podestà dell'anno 1325* (Florence, 1921), pp. 218–19; Dean, *Crime in Medieval Europe*, p. 61; Dean, 'Criminal Justice in Bologna', p. 22. Of the nine men prosecuted for sodomy in fifteenth-century Bologna, five were from outside the city and two were Jews (information provided by Trevor Dean in correspondence). A similar pattern emerges in late medieval Germany and Switzerland, where prosecutions often targeted foreigners, especially Italians. See Puff, *Sodomy*, pp. 109, 118, 127–9.

63 Quoted in Rocke, *Forbidden Friendships*, p. 197. On the link between the political environment of Italian cities and sodomy repression, see Jacques Chiffoleau, 'Dire l'indicible: Remarques sur la catégorie du *nefandum* du XIIe au XVe siècle', *Annales économies Sociétés Civilizations*, XLV (1990), pp. 311–12. Boone, 'State Power', p. 139, associates the repression of sodomy in late medieval Bruges with the fact that, among all the cities in the Burgundian Netherlands, Bruges witnessed the strongest opposition to state making and centralization. References to sodomy also played a crucial role in the construction of a communal body politic in cities in fifteenth- and sixteenth-century Germany and Switzerland, and later in the dissemination of Reform ideology (e.g. in the writings of Martin Luther). See Puff, *Sodomy*, pp. 17–23, 124–66. On the situation in Tudor England, see Goldberg, *Sodometries*, pp. 17, 120, and Mager, 'John Bale', p. 143. For further examples of the political use of sodomy as an instrument of secular power, see Jacques Chiffoleau, *Les Justices du pape: délinquance et criminalité dans la région d'Avignon au quatorzième siècle* (Paris, 1984), pp. 192–4; Labalme, 'Sodomy and Venetian Justice'; Dinshaw, *Getting Medieval*, pp. 56–99.

64 On the notion of the 'constitutive outside', see Judith Butler, *Bodies That Matter: On the Discursive Limits of 'Sex'* (New York, 1993), p. 3.

65 Local Government Act (1988), Section 28, clause 2A (1): 'A local authority shall not – (a) intentionally promote homosexuality or publish material with the intention of promoting homosexuality, (b) promote the teaching in any maintained school of the acceptability of homosexuality as a pretended family relationship'.

66 Lord Waddington, 7 February 2000. Hansard (House of Lords debates), published online at *http://www.parliament.the-stationery-office.co.uk*.

67 Scanlon, 'Unmanned men', pp. 46–7, discusses the letters of Peter Damian to Pope Leo IX, which described sodomy as a form of disease, a cancer that will spread beyond

control. See Simon Watney, *Policing Desire: Pornography, AIDS and the Media* (London, 1987), on the rhetoric of disease used to disparage modern constructions of homosexuality.

68 Steven F. Kruger, 'Medieval/Postmodern: HIV/AIDS and the Temporality of Crisis', in *Queering the Middle Ages*, ed. Glenn Burger and Steven F. Kruger (Minneapolis, MN, 2001), pp. 261, 274–5. Kruger's discussion of 'post-AIDS' declarations focuses especially on writing by Andrew Sullivan on this topic. The British version of the drama *Queer as Folk* features, in the second mini-series, an imaginary nightclub in Manchester called 'Dante's', complete with neon-illuminated flames.

69 'Spit Roast', Sundays at Man Bar, Southwark.

70 See the definitions at *http://www.urbandictionary.com/define.php?term=spit+roast*.

71 *The Riverside Chaucer*, ed. Larry D. Benson (Oxford, 1987), p. 320, l. 999.

FOUR INVINCIBLE VIRGINS

1 Andrea Dworkin, *Pornography: Men Possessing Women* (London, 1981), p. 161.

2 *Ibid.*, p. 164.

3 Two books published in the same year neatly polarize the two sides in the feminist pornography debate: Diana E. H. Russell, ed., *Making Violence Sexy: Feminist Views on Pornography* (Buckingham, 1993) takes the 'anti-pornography' stance, and argues that a meaningful distinction can be maintained between pornography and erotica; Pamela Church Gibson and Roma Gibson, *Dirty Looks: Women, Pornography, Power* (London, 1993) takes an 'anti-censorship' line, arguing that distinctions between erotica and pornography are subjective. For the view that 'pornography is the theory, and rape the practice', see Robin Morgan, 'Theory and Practice: Pornography and Rape', in *Take Back the Night: Women on Pornography*, ed. Laura Lederer (New York, 1980), p. 131.

4 Margaret Miles, *Carnal Knowing: Female Nakedness and Religious Meaning in the Christian West* (Boston, MA, 1989), p. 156; Madeline H. Caviness, *Visualizing Women in the Middle Ages: Sight, Spectacle and Scopic Economy* (Philadelphia, 2001), p. 115.

5 Kathryn Gravdal, *Ravishing Maidens: Writing Rape in Medieval French Literature and Law* (Philadelphia, 1991), pp. 22–4. See also the discussion of voyeurism in Brigitte Cazelles, *The Lady as Saint: A Collection of French Hagiographic Romances of the Thirteenth Century* (Philadelphia, 1991), pp. 47–53.

6 Virgin martyrs turn up explicitly in certain classic feminist discussions of rape, for instance Susan Brownmiller, *Against our Will: Men, Women and Rape* (Harmondsworth, 1975), pp. 329–30. Medieval scholarship dealing with rape in virgin martyr legends has proliferated over the last fifteen years, exhibiting a rich variety of perspectives; the following list is not exhaustive. Simon Gaunt, *Gender and Genre in Medieval French Literature* (Cambridge, 1995), pp. 185–98; Catherine Innes-Parker, 'Sexual Violence and the Female Reader: Symbolic "Rape" in the Saints' Lives of the Katherine Group', *Women's Studies*, XXIV (1995), pp. 205–17; Kathleen Coyne Kelly, *Performing Virginity and Testing Chastity in the Middle Ages* (London, 2000), pp. 40–62; Katherine J. Lewis, '"Lete Me Suffre": Reading the Torture of St Margaret of Antioch in Late Medieval England', in *Medieval Women: Texts and Contexts in Late Medieval Britain: Essays for Felicity Riddy*, ed. Jocelyn Wogan-Browne *et al.* (Turnhout, 2000), pp. 69–82; Sarah Salih, *Versions of Virginity in Late Medieval England* (Cambridge, 2001), pp. 74–98; Corinne Saunders, *Rape and Ravishment in the Literature of Medieval England* (Cambridge, 2001), pp. 120–51; Jocelyn Wogan-Browne, *Saints' Lives and Women's Literary Culture, c. 1150–1300: Virginity and its Authorizations* (Oxford, 2001), pp. 91–122; Diane Wolfthal, *Images of Rape: The 'Heroic'*

Tradition and its Alternatives (Cambridge, 1999), pp. 43–4, 71.

7 Susanne Kappeler, *The Pornography of Representation* (Cambridge, 1986), p. 221.

8 Laura Kipnis, *Bound and Gagged: Pornography and the Politics of Fantasy in America* (New York, 1996), p. 162.

9 Lewis, 'Lete Me Suffre'; Salih, *Versions of Virginity*, pp. 41–106; Karen Winstead, *Virgin Martyrs: Legends of Sainthood in Late Medieval England* (Ithaca, NY, 1997), pp. 34–63; Jocelyn Wogan-Browne 'The Virgin's Tale', in *Feminist Readings in Middle English Literature: The Wife of Bath and All her Sect*, ed. Ruth Evans and Lesley Johnson (London, 1994), pp. 165–94; Wogan-Browne, *Saints' Lives*, pp. 91–122.

10 Lynn Hunt, ed., *The Invention of Pornography: Obscenity and the Origins of Modernity, 1500–1800* (New York, 1993).

11 Studies that take issue with the 'radical' feminist paradigm include Judith Butler, 'The Force of Fantasy: Feminism, Mapplethorpe and Discursive Excess', *differences*, II/2 (1990), pp. 105–25; Carol J. Clover, *Men, Women and Chainsaws: Gender in the Modern Horror Film* (London, 1992); Kipnis, *Bound and Gagged*; Linda Williams, *Hard Core: Power, Pleasure and the 'Frenzy of the Visible'* (Berkeley, CA, 1989).

12 On the idea of pornographic fantasy as a scene that 'suspends action', see Butler, 'Force of Fantasy', p. 113. Evelyn Birge Vitz, 'Rereading Rape in Medieval Literature', *Partisan Review*, LXIII (1996), pp. 280–91, considers medieval literary rape as a space of fantasy in which women, as well as men, may have discovered meaning.

13 Harry F. Williams, 'A Saint Neglected', in *Voices of Conscience: Essays on Medieval and Modern French Literature in Memory of James D. Powell and Rosemary Hodgins*, ed. Raymond J. Cormier (Philadelphia, 1977), pp. 95–103. On dramatic renditions, see Lynette R. Muir, 'The Saint Play in Medieval France', in *The Saint Play in Medieval Europe*, ed. Clifford Davidson (Kalamazoo, MI, 1986), pp. 154–67; L. Petit de Julleville, *Histoire du Théatre en France: Les Mystères*, 2 vols (Paris, 1880), vol. II, pp. 48, 63, 478–86.

14 All quotations from *Vie de Sainte Barbe*, Paris, Bibliothèque Nationale, MS 975, fols 1–25, edition in Harry F. Williams, 'Old French Lives of Saint Barbara', *Proceedings of the American Philosophical Society*, CXIX (1975), pp. 156–85. The manuscript also contains a *Passion Jhesu Crist* and an expense account datable to the second half of the fifteenth century. There is no evidence, of course, that Francke would have been able to read or have access to a French legend – in fact, Francke's iconography appears to follow most closely the Greek of Symeon Metaphrastes. All the same, Francke would probably have used a contemporary vernacular version similar to the one I quote here. To my knowledge, no German lives of St Barbara contemporary with Francke are accessible in printed editions, so I have chosen to read the painting alongside a text that postdates it by several decades. Francke's style suggests the influence of French chivalric-romantic manuscript illumination, making the text an appropriate choice from the point of view of general iconographic patterns. Bella Martens, *Meister Francke* (Hamburg, 1929), p. 44, discusses Francke's textual sources. On the links between Francke's style and French miniature painting, see Riitta Pylkkänen, *Sancta Barbara: The Legend of Saint Barbara*, trans. Päivikki Ojansuu (Helsinki, 1966).

15 'Comme un tres noble et excellent tresor'; *Vie de Sainte Barbe*, p. 170.

16 See Ruth Mellinkoff, *Outcasts: Signs of Otherness in North European Art of the Late Middle Ages*, 2 vols (Berkeley, CA, 1993), vol. I, pp. 25–6, 121, 124, on the clothes and deformed features of executioners in art.

17 The classic formulation of the 'male gaze' as 'voyeuristic-scopophilic' looking is Laura Mulvey, 'Visual Pleasure and Narrative Cinema', *Screen*, XVI/3 (1975), pp. 6–18.

18 'Affin que la couppeure fust plus longuement et plus doloreusement faicte'; *Vie de Sainte Barbe*, p. 174. The sequence in which the torments occur in the painting diverges

from the written narrative, but the motifs are generally comparable.

19 'Barbe, conforte toy car grant joye est faicte au ciel pour toy . . . je suis avec toy et te delivreray de toutes les playes qui te ont esté faictes'; *Vie de Sainte Barbe*, p. 173.

20 For comparisons between the comic-strip excesses of martyrdom imagery and modern animated cartoons, see Duncan Robertson, *The Medieval Saints' Lives: Spiritual Renewal and Old French Literature* (Levington, KY, 1995), pp. 39, 42, 51.

21 Gravdal, *Ravishing Maidens*, p. 24.

22 This view is expressed in Andrea Dworkin and Catherine MacKinnon, 'Questions and Answers', in *Making Violence Sexy*, ed. Russell, p. 83.

23 Tertullian, 'Liber de Virginibus Velandis', in *Patrilogiae Cursus Completus: Series Latina*, 217 vols, ed. Jacques-Paul Migne (Paris, 1844–64), vol. II, col. 892.

24 Judith Perkins, *The Suffering Self: Pain and Narrative Representation in the Early Christian Era* (London, 1995).

25 Gaunt, *Gender and Genre*, pp. 188–9.

26 Kelly, *Performing Virginity*, pp. 43–5; Anke Bernau, 'A Christian *Corpus*: Virginity, Violence, and Knowledge in the Life of St Katherine of Alexandria', in *St Katherine of Alexandria: Texts and Contexts in Western Medieval Europe*, ed. Jacqueline Jenkins and Katherine J. Lewis (Turnhout, 2003), pp. 109–30; Ruth Evans, 'The Jew, the Host and the Virgin Martyr: Fantasies of the Sentient Body', in *Medieval Virginities*, ed. Anke Bernau, Ruth Evans and Sarah Salih (Cardiff, 2003), pp. 167–86.

27 Suzanne Lewis, *The Art of Matthew Paris in the 'Chronica Majora'* (Aldershot, 1987), p. 286.

28 The prose *Vie de Sainte Barbe* makes it clear that Barbara's torments were singularly bloody. Martens, *Meister Francke*, pp. 46–7, considers Francke's omission of bloodshed to be unusual, given the tone of late medieval passion iconography at large.

29 The phrase 'menaced virgin' is Kelly's. See Kelly, *Performing Virginity*, pp. 59–62.

30 Williams, *Hard Core*, p. 42, identifies this association between power, narrative action and event as problematic in Mulvey's account of the cinematic male gaze.

31 Elaine Scarry, *The Body in Pain: The Making and Unmaking of the World* (Oxford, 1985), pp. 125–6.

32 Sarah Kay, *Courtly Contradictions: The Emergence of the Literary Object in the Twelfth Century* (Stanford, CA, 2001), pp. 216–31, discusses the notion of a space between deaths in the course of interrogating the construction of the sublime body of the martyr as an ideological object. See also Kay, 'The Sublime Body of the Martyr: Violence in Early Romance Saints' Lives', in *Violence in Medieval Society*, ed. R. W. Kaeuper (Woodbridge, 2000), pp. 3–20. Kay derives her argument from the Lacanian concept of the second death and the *zone entre-deux-morts*, a 'suffering beyond death that is indefinitely sustained by the impossibility of crossing the limit of the second death'; and from Žižek's appropriation of these principles to produce the notion of a sublime body, 'a body composed of some other substance, one excepted from the vital cycle'. See Jacques Lacan, *Ethics of Psychoanalysis, 1959–1960 (Seminar VII)*, ed. Jacques Alain-Miller, trans. Dennis Porter (London, 1992), pp. 294–5; Slavoj Žižek, *The Plague of Fantasies* (London, 1997), p. 134. L. O. Fradenburg, *Sacrifice Your Love: Psychoanalysis, Historicism, Chaucer* (Minneapolis, MN, 2002), p. 34, discusses the fixing of the body of medieval devotional art 'in suspension' between life and death.

33 Caviness, *Visualizing Women*, p. 86, makes such a pronouncement with respect to virgin martyr depiction.

34 Clover, *Men, Women, and Chainsaws*; Williams, *Hard Core*; Wogan-Browne, 'Virgin's Tale', p. 180.

35 Williams, 'Old French Lives of Saint Barbara', p. 158. See also Christine de Pizan, *The Book of the City of Ladies*, trans. Rosalind Brown-Grant (London, 1999): part 3

contains a list of exemplary female saints, including Barbara, who resist the advances of male tormentors.

36 See, in this connection, the deconstructive strategies of rape prevention proposed in Sharon Marcus, 'Fighting Bodies, Fighting Words: A Theory and Politics of Rape Prevention', in *Feminists Theorize the Political*, ed. Judith Butler and Joan W. Scott (London, 1992), pp. 385–403.

37 Cazelles, *Lady as Saint*, p. 80. On hagiographic speech as the nexus for a body of competing discourses, see Robert Mills, 'Can the Virgin Martyr Speak?', in *Medieval Virginities*, ed. Anke Bernau, Ruth Evans and Sarah Salih (Cardiff, 2003), pp. 187–213, and, from a different perspective, Gail Ashton, *The Generation of Identity in Late Medieval Hagiography: Speaking the Saint* (London, 2000).

38 'en ire et comme mal contante de ce qu'il avoit dit'; *Vie de Sainte Barbe*, p. 171.

39 Scarry, *Body in Pain*, p. 4. Maureen A. Tilley, 'The Ascetic Body and the (Un)making of the World of the Martyr', *Journal of the American Academy of Religion*, LIX (1991), pp. 467–79, applies Scarry's theory of torture to martyrdom legends.

40 'tous ceulx qui adorent les ydoles soient confondues'; *Vie de Sainte Barbe*, p. 175.

41 'Veulx tu congnoistre et savoir ma loy chrestienne? Je adore le vray Dieu'. A laquelle le dit prevost dist: 'Tu es totalement enyvree du venin serpentin et decepcion. Comment! dist il, tu ne te hontoyes point de responde avant que tu soyes interroguee?'; *Vie de Sainte Barbe*, p. 173.

42 The prose *Vie de Sainte Barbe*, after all, makes much of Barbara's *non*-corporeal disposition, repeatedly labelling her 'la prudente vierge', 'l'ingenieuse vierge', 'la discrete vierge', 'la saige vierge', 'la brave espouse'; Dioscurus is characterized, in contrast, as having 'plus cruelle ferocité que beste sauvaige', suggesting that it is he, not she, who becomes the most scandalously fleshly. See also the lengthy passages describing Barbara's disputes 'contre aucuns philozophes', and the description of the episode when messengers sent by Origen find her sleeping in bed not out of 'langueur corporelle' but as a result of meditating on 'l'amour divine'.

43 The iconography is reminiscent of depictions of St Michael trampling the dragon underfoot. See also representations of St Katherine, discussed in Lewis, 'Lete Me Suffre', p. 61. Katherine was sometimes represented with short hair, further underscoring her 'manly' role as scholar, teacher, leader, soldier and preacher: see Karen A. Winstead, 'St Katherine's Hair', in *St Katherine of Alexandria: Texts and Contexts in Western Medieval Europe*, ed. Jacqueline Jenkins and Katherine J. Lewis (Turnhout, 2003), pp. 171–99.

44 Lois Drewer, 'Margaret of Antioch the Demon-Slayer, East and West: The Iconography of the Predella of the Boston *Mystic Marriage of St Catherine*', *Gesta*, XXXII (1993), pp. 11–20.

45 *The Life of Christina of Markyate: A Twelfth-Century Recluse*, ed. and trans. C. H. Talbot (Oxford, 1959), pp. 40–45; Jocelyn Wogan-Browne, 'Saints' Lives and the Female Reader', *Forum for Modern Language Studies*, XXVII/4 (1991), pp. 316–17.

46 *Life of Christina of Markyate*, p. 51.

47 *Ibid.*, p. 43.

48 Christine de Pizan, *Book of the City of Ladies*, pp. 147–98, contains a series of examples designed to contradict claims that women 'want to be raped', followed by a compendium of female saints' lives. Jane Tibbetts Schulenburg, 'The Heroics of Virginity: Brides of Christ and Sacrificial Mutilation', in *Women in the Middle Ages and the Renaissance: Literary and Historical Perspectives*, ed. Mary Beth Rose (Syracuse, NY, 1986), pp. 29–72, considers the significance of the virgin martyr tradition in England during the Danish invasions and suggests that it may have encouraged resistance to acts of Viking sexual aggression.

49 The phrase is Bynum's. See Caroline Walker Bynum, *Fragmentation and Redemption: Essays on Gender and the Human Body in Medieval Religion* (New York, 1992), p. 146.

50 Martens, *Meister Francke*, p. 41, discusses other theories of provenance.

51 Caviness, *Visualizing Women*, p. 115, discusses further the arrangement of the painted panels and carved scenes.

52 Neu-Karsthans, 'Gesprechbiechlin neüw Karsthans', quoted in Michael Baxandall, *The Limewood Sculptors of Renaissance Germany* (New Haven, CT, 1980), p. 88.

53 Clover, *Men, Women and Chainsaws*, p. 230, suggests that contemporary horror films are often similarly 'victim identified'.

54 Kipnis, *Bound and Gagged*, p. 175. On the projection of racial difference onto the figure of the pornographer–rapist, see also Dworkin, *Pornography*, pp. 146, 157; on the stigmatization of the rural poor in modern 'Rape Revenge' films, see Clover, *Men, Women and Chainsaws*, pp. 159–64. For further instances of the stigmatization of minorities in the role executioners in medieval art, see Mellinkoff, *Outcasts*, vol. I, pp. 24–7, 39–42, 65–6, 122–32, 163–6, 204.

55 Kipnis, *Bound and Gagged*, pp. 7–8, 140, 156–7, 175.

56 Wogan-Browne, 'Virgin's Tale', pp. 177–8.

57 'corruptum vitiis . . . Sodomitis'; *Hrotsvithae opera*, ed. Karolus Strecker (Leipzig, 1906), p. 60. For an extended analysis of Hrotsvitha's *Pelagius* and other early medieval versions of the legend, see Mark D. Jordan, *The Invention of Sodomy in Christian Theology* (Chicago, 1997), pp. 10–28.

58 See a parallel argument in Wogan-Browne, *Saints' Lives*, pp. 118–22. Wogan-Browne, citing René Girard's distinction between the scapegoat of the text (the hidden structural principle) and a scapegoat in the text (the clearly visible theme), argues that the fact Jews do not figure explicitly as the persecutors of virgins in written saints' lives might be related to their displacement to anti-Semitic ritual murder narratives.

59 Although Kappeler, *Pornography of Representation*, opens with the suggestion that race may provide an important category of analysis, her suggestion that 'there remains but one kind of look: looking *at*. Man gazing at woman, one-way' (p. 81) ultimately downplays the significance of alternative collectives such as race, class and sexuality in favour of sweeping statements on the ubiquity of male power.

60 'aetatis primos flores iuvenilis'; *Hrotsvithae opera*, p. 58.

61 Miri Rubin, *Gentile Tales: The Narrative Assault on Late Medieval Jews* (New Haven, CT, 1999), pp. 7–39.

62 'commença adoncques a pourpenser comment il pourroit absconcer icelle ymage tant clere, tant doulce et plainne de si grant beaulté, affin que nulz homs ne mist son amour en elle'; *Vie de Sainte Barbe*, p. 170.

63 For instances of idolatrous lady-worship in Gothic representation, see Michael Camille, *The Gothic Idol: Ideology and Image-making in Medieval Art* (Cambridge, 1989), pp. 298–337.

64 Schulenburg, 'Heroics of Virginity'; Wogan-Browne, *Saints' Lives*, pp. 118–22.

65 Philippe de Vigneulles, *Chronique de Metz*, quoted in Jody Enders, *Death by Drama and Other Medieval Urban Legends* (Chicago, 2002), p. 206.

66 For an extended discussion of the Lyonard episode, which attends also to the chronicler's own queer desires, see Enders, *Death by Drama*, pp. 30–42. See also Robert L. A. Clark and Claire Sponsler, 'Queer Play: The Cultural Work of Crossdressing in Medieval Drama', *New Literary History*, XXVIII (1997), pp. 319–44.

FIVE OF MARTYRS AND MEN

1 For a more detailed account of the *picaos* of San Vicente de la Sonsierra, see Patrick

Vandermeersch, *La Chair de la passion. Une histoire de foi: la flagellation* (Paris, 2002), pp. 17–21, 142–49.

2 Emile Verhaeren and Darío de Regoyos, *España negra* (Barcelona, 1899), p. 76.

3 Karen Armstrong, *Through the Narrow Gate: A Nun's Story* (London, 1997), pp. 173–4.

4 *Ibid.*, pp. 175, 177.

5 Maureen Flynn, 'The Spectacle of Suffering in Spanish Streets', in *City and Spectacle in Medieval Europe*, ed. Barbara A. Hanawalt and Kathryn L. Regerson (Minneapolis, MN, 1994), pp. 153–68. (Most of Flynn's examples are, it should be stressed, sixteenth century.)

6 Richard von Krafft-Ebing, *Psychopathia Sexualis*, trans. Franklin S. Klaf (1886) (London, 1965). Krafft-Ebing tries to maintain a distinction between beating fantasies that respond to a desire for 'mechanical irritation', and masochism, which he labels a 'perversion' (p. 93). Anita Phillips, *A Defence of Masochism* (London, 1998), provides a survey of popular understandings of masochism as a kind of 'emotional and sexual wastebasket'. The writings of Leopold Sacher-Masoch, from whose name the term 'masochism' was originally coined, contain references to martyrdom. See, for instance, Sacher-Masoch's *Venus in Furs*, included in Gilles Deleuze, *Coldness and Cruelty*, trans. Jean McNeil (New York, 1989), pp. 172–80.

7 For background on the Operation Spanner case, see Phillips, *Defence of Masochism*, pp. 120–22.

8 Caroline Walker Bynum, *Holy Feast and Holy Fast: The Religious Significance of Food to Medieval Women* (Berkeley, CA, 1987), p. 208. See also Caroline Walker Bynum, *Fragmentation and Redemption: Essays on Gender and the Human Body in Medieval Religion* (New York, 1992), p. 74. For a critique of the notion that female masochism is simply self-hatred, see Phillips, *Defence of Masochism*, pp. 47–52, 80–81.

9 Esther Cohen, 'Towards a History of European Physical Sensibility: Pain in the Later Middle Ages', *Science in Context*, VIII (1995), p. 52.

10 *Ibid.*, pp. 52–3; see also Esther Cohen, 'The Animated Pain of the Body', *American History Review*, CV (2000), pp. 48–52. In support of Cohen's arguments on the changing relation between body pain and truth in the Middle Ages, see Talal Asad, 'Notes on Body Pain and Truth in Medieval Christian Ritual', *Economy and Society*, XII (1983), pp. 287–327.

11 See, though, Vandermeersch's reservations about the use of anthropological categories, in *La Chair de la Passion*, pp. 13–16.

12 Arnold van Gennep, *The Rites of Passage*, trans. Monika B. Vizedom and Gabrielle L. Caffee (London, 1960).

13 It is worth noting, in this context, the remarkable similarities between the initiation ceremonies described by anthropologists as being performed at puberty, and virgin martyr rituals (where the female victims are often barely out of puberty). See Alan Morinis 'The Ritual Experience: Pain and the Transformation of Consciousness in Ordeals of Initiation', *Ethos*, XIII (1985), pp. 150–74.

14 Gennep, *Rites of Passage*, pp. 71–4.

15 For Agatha, see Caroline Walker Bynum, *The Resurrection of the Body in Western Christianity, 200–1336* (New York, 1995), pp. 313–14 and pls 34–5. Irene's ministration to Sebastian, though rarely depicted in medieval art, became popular in sixteenth- and seventeenth-century iconography.

16 Gennep, *Rites of Passage*, pp. 113–14.

17 Vandermeersch, *La Chair de la passion*, pp. 18–19.

18 Morinis, 'Ritual Experience', pp. 164–5.

19 Letter 44 in Peter Damian, *Letters 31–60*, trans. Owen J. Blum (Washington, DC, 1990), p. 233.

20 Norman Cohn, *The Pursuit of the Millennium: Revolutionary Millenarians and Mystical*

Anarchists of the Middle Ages (London, 1993), pp. 127–47; Vandermeersch, *La Chair de la passion*, pp. 81–114.

21 Cohn, *Pursuit of the Millennium*, pp. 137–8.

22 Nicholas Orme, *Medieval Children* (New Haven, CT, 2001), pp. 84–5, 154; Shulamith Shahar, *Childhood in the Middle Ages* (London, 1990), pp. 109–11, 173–5. On the relationship between musical pedagogy and violence, see Bruce W. Holsinger, *Music, Body and Desire in Medieval Culture: Hildegard of Bingen to Chaucer* (Stanford, CA, 2001), pp. 259–92.

23 *Dives and Pauper*, vol. I/1, ed. Priscilla Heath Barnum (London, 1976), p. 326, quoting Proverbs 13:24. Further examples of the trope are discussed in Nicholas Orme, *Education and Society in Medieval and Renaissance England* (London, 1989), pp. 246–7.

24 For examples of religious writers voicing opposition, or at least urging caution, in response to educational beatings, see Augustine, *Confessions*, trans. Henry Chadwick (Oxford, 1991), pp. 11–12; G. R. Owst, *Literature and Pulpit in Medieval England* (Oxford, 1961), pp. 462–3, quoting the Dominican preacher John Bromyard; Eadmer, *The Life of St Anselm*, ed. and trans. R. W. Southern (Oxford, 1962), pp. 37–9. On cases involving students taking their teachers to court for heavy-handed use of corporal punishment, see Orme, *Education and Society*, p. 61.

25 'The Schoolboy's Lament', in Oxford, Balliol College, MS 354, fol. 252r, edition in *Chaucer to Spenser: An Anthology*, ed. Derek Pearsall (Oxford, 1999), pp. 398–9. Girls were also beaten but learned in different contexts: they were usually educated at home. Echoing these contexts, fifteenth-century conduct books presented the pain of beating in gendered ways. See Anna Dronzek, 'Gendered Theories of Education in Fifteenth-Century Conduct Books', in *Medieval Conduct*, ed. Kathleen Ashley and Robert A. Clark (Minneapolis, MN, 2001), pp. 135–59.

26 Item 38 in Lincoln College, Oxford, MS Lat. 129 (E), now in the Bodleian Library, quoted in Orme, *Education and Society*, p. 104. See also p. 102, item 27.

27 Jody Enders, *The Medieval Theater of Cruelty: Rhetoric, Memory, Violence* (Ithaca, NY, 1999), pp. 129–40; Mary Carruthers, 'Reading with Attitude, Remembering the Book', in *The Book and the Body*, ed. Dolores Warwick Frese and Katherine O'Brien O'Keeffe (Notre Dame, IN, 1997), pp. 3–4.

28 Letters 45 and 56 in Damian, *Letters 31–60*, pp. 246, 364.

29 'Mon ame metz en ton demaine / Et abrege ma dure peine, / Dequoy mon corps est tout noircy'; *Le Mystère de Saint Laurent: publié d'après la seule édition gothique et accompagné d'une introduction et d'un glossaire*, ed. W. Söderhjelm and A. Wallensköld (Helsinki, 1890), p. 139, ll. 6940–42.

30 'Le corps peulx tu martiriser / tant que vouldras et tourmanter, / mes a l'ame ne toucheras'; *Le Mystère de Saint Sébastien*, ed. Léonard R. Mills (Geneva, 1965), p. 189, ll. 4248–50.

31 'Se nous porton peine et doulour / En ceste vie corporelle / Nostre ame en sera plus belle / Devant Dieu, nostre redempteur . . . ces charbons me rafreschissent . . . Et moy rosty je le mercie / Car a mes maulx m'a soubstenu'; *Laurent*, ll. 5112–15, 6874, 6880–81. 'Tes grans maulx me font grant plesir / et une tresgrant alegrance / quant je bien remire et pance / les grans joyes de paradis'; *Sébastien*, ll. 5771–4.

32 Elaine Scarry, *The Body in Pain: The Making and Unmaking of the World* (Oxford, 1985), pp. 198–220, argues that the Judaeo-Christian tradition consistently casts the body as a material sign of something beyond itself: the 'sensorially conformable realness' of divine presence.

33 'Il est si beau, si bon, si doulx, / c'om ne pouroit dyre mellieur. / Sus tous ayme noustre segnieur / de tout som cueur et som voloir . . . / Ma foy, ma damme, il n'est rien / ou je

pregne si grant pleysir, / ne a quoy j'aye si grant desir, / que de vouer sa doulce presence'; *Sébastien*, ll. 498–501, 508–11.

34 'Prenés pitié de vous, beau sire, / et de voustre grande beaulté'; *Sébastien*, ll. 5703–706.

35 *Sébastien*, l. 4313.

36 'que tu ayes souvenance / des habitans de ceste ville, / et les garde d'empedimie, / de guere et de pestilence, / y a tous ceulx qui aront remambrance / de moy, vullie leur pardonner'; *Sébastien*, ll. 6342–7.

37 See Bynum, *Fragmentation and Redemption*, pp. 231–2.

38 'Helas! donne moy pacïence / en mes afferes si te plet'; *Sébastien*, ll. 6176–7. 'Je n'ay corps ne membre ne dens / Qui ne soit cassé'; *Laurent*, ll. 6046–7.

39 Scarry, *Body in Pain*, pp. 3–19; Maureen A. Tilley, 'The Ascetic Body and the (Un)making of the World of the Martyr', *Journal of the American Academy of Religion*, LIX (1991), p. 467; Cohen, 'Animated Pain of the Body', pp. 62–3.

40 For a general assessment of the differences and similarities between religious devotion and masochism, see Phillips, *Defence of Masochism*, pp. 135–64; on the possibility of distinguishing distinct Jewish and Christian modes of masochism, see Daniel Boyarin, *Unheroic Conduct: The Rise of Heterosexuality and the Invention of the Jewish Man* (Berkeley, CA, 1997), pp. 81–126. In drawing parallels between masochism and Christian martyrdom, I take on board Phillips's argument that masochism is at the opposite extreme to what she terms 'moral martyrdom' – the martyrdom that 'clutches on to suffering, neither fully experiencing its bite nor ever letting it go into pleasure' (p. 158) – but my argument here is that, in the space of medieval representation, martyrs participate in a scenario that is structurally analogous to the masochistic order.

41 'Mes joyes et tous mes delis / sont endurer poyne et douleur / pour l'amour de mon createur'; *Sébastien*, ll. 6156–8.

42 'certes je n'ay pas peur / de tes menasses;' *Sébastien*, ll. 5750–51.

43 Gilles Deleuze, *Masochism*, in *Coldness and Cruelty*, trans. Jean McNeil (New York, 1989), p. 46; Phillips, *Defence of Masochism*, p. 11. With this point, Deleuze presents an incisive critique of Freud's suggestion that masochism 'is nothing more than an extension of sadism turned round upon the subject's own self'. See Sigmund Freud, 'Three Essays on the Theory of Sexuality', in *The Standard Edition of the Complete Psychological Works of Sigmund Freud*, ed. and trans. James Strachey, vol. VII (1905), p. 158.

44 'Tous les dyables, venés avant! / Devourés mon corps et mon ame'; *Sébastien*, ll. 6538–9.

45 Deleuze, *Masochism*, p. 71; Theodor Reik, *Masochism in Modern Man*, trans. Margaret H. Beigel and Gertrud M. Kurth (New York, 1941), p. 67.

46 Reik, *Masochism in Modern Man*, p. 65.

47 *Ibid.*, p. 355; Kaja Silverman, *Male Subjectivity at the Margins* (London, 1992), p. 200.

48 'Reçoy mon esprit sans atendre'; *Laurent*, l. 6049.

49 See the analysis of these scenes in Enders, *Medieval Theater of Cruelty*, pp. 145–8, 174–5; Rainer Warning, *The Ambivalences of Medieval Religious Drama*, trans. Steven Rendall (Stanford, CA, 2001), pp. 187–204.

50 'Tien cy par hault! tien cy par bas! / Tien sur le corps! tien sur les bras! / Tien sur le cul! tien sur la teste! / Tien! tien! Dieu en ait male feste! . . . / Recommençon tous de plus belle. / Tien ce coup cy sur la mamelle!'; *Laurent*, ll. 5577–86.

51 Enders, *Medieval Theater of Cruelty*, p. 150. For a discussion of the musical dimensions to scenes of holy beating, see Holsinger, *Music, Body and Desire*, pp. 197–204.

52 The underdrawing for this painting, reproduced in Maryan W. Ainsworth, *Gerard David: Purity of Vision in an Age of Transition* (New York, 1998), p. 98, fig. 96, shows Christ looking in the opposite direction, *away* from the viewer. This suggests that David made a conscious decision at a later date to modify Christ's gaze with a view to

incorporating the beholder more deeply into the events depicted.

53 Otto Pächt, *Early Netherlandish Painting: From Rogier van der Weyden to Gerard David*, trans. David Britt (London, 1997), p. 245.

54 In the *Mystère de Saint Laurent*, p. 163, the stage directions specify the use of a body-double to depict the martyrdom of Hippolytus. This suggests that the spectators of the drama, unlike the beholders of the painting, would have experienced the scene's dramatic resolution. For background information on the Bruges Hippolytus painting and another like it (the so-called 'Boston Triptych'), see Julius S. Held, 'Observations on the Boston Triptych of Saint Hippolytus', in *Album amicorum J. G. van Gelder*, ed. J. Buryn et al. (The Hague, 1973), pp. 177–85. Held argues that the face of the patron Hippolyte de Berthoz in the panel by Van der Goes resembles that of the martyred saint on the Boston altar, thus conveying a particular interest in 'victim identification'.

55 Henry Suso, *The Life of the Servant*, trans. James M. Clark (Cambridge, 1952), p. 49.

56 'Martyr' derives from the Greek word μαρτυς, meaning witness; according to the *Oxford English Dictionary*, a 'martyr complex' is 'an exaggerated desire to sacrifice oneself for others and to have the sacrifice recognised'. See Amelia Jones, 'Dis/playing the Phallus: Male Artists Perform their Masculinities', *Art History*, XVII (1994), p. 575, on the place of the witness in male masochistic display.

57 On the role of the witness in hagiography, see Emma Campbell, 'Sacrificial Spectacle and Interpassive Vision in the Anglo-Norman Life of Saint Faith', in *Troubled Vision: Gender, Sexuality and Sight in Medieval Text and Image*, ed. Emma Campbell and Robert Mills (New York, 2004), pp. 97–115.

58 Nigel Spivey, *Enduring Creation: Art, Pain and Fortitude* (London, 2001), pp. 90–92, discusses Sebastian's erotic allure in Italian Renaissance painting.

59 Jacques Lacan, *The Four Fundamental Concepts of Psycho-Analysis (Seminar XI)*, ed. Jacques-Alain Miller, trans. Alan Sheridan (London, 1998), pp. 67–78. For an excellent discussion of the Lacanian gaze and its problematic status within feminist film theory, see Joan Copjec, *Read my Desire: Lacan against the Historicists* (Cambridge, MA, 1994), pp. 15–38.

60 'C'est la voix de Dieu, mon doulx maistre, / Qui parle en moy'; *Laurent*, ll. 5867–8. 'Je sens en moy si grant douleur / Que ma force et mon sens adire'; *Laurent*, ll. 5881–2.

61 *Laurent*, l. 6083.

62 Deleuze, *Masochism*, pp. 75–7; Phillips, *Defence of Masochism*, pp. 24–6.

63 'Cloups de fer et bonnes tenailles / Et crocs pour tirer les entrailles, / Souffletz pour le feu allumer / Et gros bastons pour assommer, / Aultres tourmens de mainte sorte ... J'ay desiré peine et martire / Pour plaire a Jesus, nostre sire: / Ce sont viandes que demandes'; *Laurent*, ll. 5431–5, 5453–5.

64 'luy fay par devotion / De mon sang immolation / En ce tourment et ce martire. / J'ay eu tout ce que je desire'; *Laurent*, ll. 5777–80.

65 Deleuze, *Masochism*, pp. 35, 70, 109.

66 See Slavoj Žižek, *The Plague of Fantasies* (London, 1997), p. 32, for the concept of 'traversing the fantasy'; Jacques Lacan, *The Ethics of Psychoanalysis, 1959–1960 (Seminar VII)*, trans. Dennis Porter (London, 1992), pp. 179–204, develops the distinction between pleasure and *jouissance*. Further discussion in Robert Mills, 'A Man is Being Beaten', *New Medieval Literatures*, v (2002), pp. 135–6.

67 Warning, *Ambivalences of Medieval Religious Drama*, pp. 233, 259.

68 Sigmund Freud, '"A Child Is Being Beaten": A Contribution to the Study of the Origin of Sexual Perversions', in *Standard Edition*, vol. XVII (1919), pp. 198–9; Deleuze, *Masochism*, pp. 57–68; Silverman, *Male Subjectivity*, p. 211.

69 Deleuze, *Masochism*, p. 99, explored in more depth in Mills, 'A Man is Being Beaten',

pp. 141–2.

70 Enders, *Medieval Theater of Cruelty*, pp. 144–5.

71 *A Monk's Confession: The Memoirs of Guibert of Nogent*, trans. Paul J. Archambault (Philadelphia, 1996), p. 19.

72 *Ibid.*, p. 20.

73 Though it should be noted – as Enders does not – that Guibert ultimately suggests that the mother's worries were conceived by her as a 'test' to confirm her son's willingness to be educated.

74 Enders, *Medieval Theater of Cruelty*, p. 142.

75 Silverman, *Male Subjectivity*, pp. 322–8; Phillips, *Defence of Masochism*, p. 30; Christopher Newfield, 'The Politics of Male Suffering: Masochism and Hegemony in the American Renaissance', *differences*, 1/3 (1989), pp. 55–87; Jones, 'Dis/playing the Phallus', p. 567; Linda Williams, *Hard Core: Power, Pleasure and the 'Frenzy of the Visible'* (Berkeley, CA, 1989), p. 213. Judging by Guibert's misogyny (*A Monk's Confession*, p. 36), the virilizing effects of his education seem obvious. Evidence for the sexualization of pedagogic beatings in the early modern period, and the assumed link between the education and 'manning' of the boy, see Alan Stewart, 'Boys' Buttocks Revisited: James VI and the Myth of the Sovereign Schoolmaster', in *Sodomy in Early Modern Europe*, ed. Tom Betteridge (Manchester, 2002), pp. 131–47.

76 Enders, *Medieval Theater of Cruelty*, p. 141, note 172.

77 *Laurent*, ll. 6885–90.

78 On Agatha's pseudo-castration, see Martha Easton, 'Saint Agatha and the Sanctification of Sexual Violence', *Studies in Iconography*, XVI (1994), p. 102. For an analysis of the 'castrating' possibilities of medieval martyrdom iconography, see Robert Mills, '"Whatever You Do is a Delight to Me!": Masculinity, Masochism, and Queer Play in Representations of Male Martyrdom', *Exemplaria*, XIII/1 (2001), pp. 15–18.

79 On typological links between the circumcision and the passion, see Leo Steinberg, *The Sexuality of Christ in Renaissance Art and Modern Oblivion*, 2nd edn (Chicago, 1995), pp. 56–64.

80 Didier Anzieu, *Skin Ego*, trans. Chris Turner (New Haven, CT, 1989), pp. 41–4, suggests that the original masochistic fantasy consists in the attainment of autonomy through the rending of the 'common skin' shared by mother and child.

81 Thomas à Kempis, *The Imitation of Christ*, trans. Leo Sherley-Price (London, 1952), p. 143.

82 For evidence that male martyrs signified sometimes erotically in medieval and early modern art, see Mills, 'Whatever You Do is a Delight to Me!', pp. 25–33.

83 Phillips, *Defence of Masochism*, p. 146.

84 *Ibid.*, p. 148.

SIX HANGING WITH CHRIST

1 Rupert of Deutz, *De gloria et honore filii hominis super Mattheum*, book 12, ed. H. Haacke, Corpus Christianorum Continuatio Medievalis, XXIX (Turnhout, 1979), pp. 382–3. Rupert was born *c.* 1075 in or near Liège and died in 1129; the passage in question was written *c.* 1125–7, but recalls a vision the author had as a young man in his twenties. The episode is discussed in John H. van Engen, *Rupert of Deutz* (Berkeley, CA, 1983), pp. 50–52.

2 Engen, *Rupert of Deutz*, p. 50.

3 Michael Camille, *The Gothic Idol: Ideology and Image-making in Medieval Art* (Cambridge, 1989), p. 214.

4 Herbert of Torres, *De Miraculis*, ii.19, in *Patrilogiae Cursus Completus: Series Latina*, 217 vols, ed. Jacques-Paul Migne (Paris, 1844–64), vol. CLXXXV, col. 1328. The topos was not confined to male religious: *The Book of Margery Kempe* (*c.* 1436–8) describes how Margery 'desiryd many times that the crucifix shuld losyn his handys fro the crosse and halsyn [embrace] hir in tokyn of lofe'; *The Book of Margery Kempe*, ed. Barry Windeatt (Harlow, 2000), p. 66 (chapter 4).

5 David Freedberg, *The Power of Images: Studies in the History and Theory of Response* (Chicago, 1989), pp. 287–306.

6 For studies engaging with contemporary queer Christological response, see Stephen D. Moore, *God's Beauty Parlor, and Other Queer Spaces in and Around the Bible* (Stanford, CA, 2001); Robert Hawley Gorsline, 'Facing the Body on the Cross: A Gay Man's Reflections on Passion and Crucifixion', in *Men's Bodies, Men's Gods: Male Identities in a (post-) Christian Culture*, ed. Björn Krondorfer (New York, 1996), pp. 125–45. Historical accounts include Richard C. Trexler, 'Gendering Jesus Crucified', in *Iconography at the Crossroads*, ed. Brendan Cassidy (Princeton, NJ, 1993), pp. 107–20, which suggests that Christ's nude body sometimes aroused (homo)erotic responses in pre-modern contexts, and Richard Rambuss, *Closet Devotions* (Durham, NC, 1998), which considers seventeenth-century devotional literature.

7 For an astute analyis of these interpretive problems, see Sarah Salih, 'When Is a Bosom Not a Bosom? Problems with "Erotic Mysticism"', in *Medieval Virginities*, ed. Anke Bernau, Ruth Evans and Sarah Salih (Cardiff, 2003), pp. 14–32.

8 Nancy F. Partner, 'Did Mystics Have Sex?', in *Desire and Discipline: Sex and Sexuality in the Premodern West*, ed. Jacqueline Murray and Konrad Eisenblicher (Toronto, 1996), p. 308.

9 Caroline Walker Bynum, 'The Body of Christ in the Later Middle Ages: A Reply to Leo Steinberg', in *Fragmentation and Redemption: Essays on Gender and the Human Body in Medieval Religion* (New York, 1992), p. 85, reviewing Leo Steinberg, *The Sexuality of Christ in Renaissance Art and Modern Oblivion*, 2nd edn (Chicago, 1995). Bynum echoes here the sentiments of Jean Leclercq, *Monks and Love in Twelfth-Century France: Psycho-Historical Essays* (Oxford, 1979), p. 100, which counsels that, in such matters as monastic commentaries on the Song of Songs, 'we must be careful not to project on to a less erotically preoccupied society the artificially stimulated and commercially exploited eroticism of our own sex-ridden age'.

10 Bynum, 'Body of Christ', pp. 85–6.

11 For more detailed discussion of these aspects of Bynum's work, see Karma Lochrie, 'Mystical Acts, Queer Tendencies', in *Constructing Medieval Sexuality*, ed. Karma Lochrie, Peggy McCracken and James A. Schultz (Minneapolis, MN, 1997), pp. 180–200; Rambuss, *Closet Devotions*, pp. 42–9; Robert Mills, 'Ecce Homo', in *Gender and Holiness: Men, Women and Saints in Medieval Europe*, ed. Samantha J. E. Riches and Sarah Salih (London, 2002), pp. 152–73.

12 Bynum, 'Body of Christ', p. 117.

13 Studies of the Song of Songs tradition in medieval culture include Ann W. Astell, *The Song of Songs in the Middle Ages* (Ithaca, NY, 1990); E. Ann Matter, *The Voice of my Beloved: The Song of Songs in Western Medieval Christianity* (Philadelphia, 1990). Moore, *God's Beauty Parlor*, pp. 21–89, produces queer readings. Sarah Salih, 'Queering *Sponsalia Christi*: Virginity, Gender, and Desire in the Early Middle English Anchoritic Texts', *New Medieval Literatures*, V (2002), pp. 155–75, argues a case for viewing marriage to Christ as 'not conducive to heterosexual stability', specifically in relation to thirteenth-century expressions of the topos in virginity literature. For seventeenth-century deployments, see Tom Webster, '"Kiss me with the Kisses of his Mouth": Gender Inversion and Canticles in Godly Spirituality', in *Sodomy in Early Modern*

Europe, ed. Tom Betteridge (Manchester, 2002), pp. 148–63.

14 When I have presented extracts from the Song to students, in classes on queer criticism, those unfamiliar with the biblical context have sometimes read the passages as referring to sexual acts between two men or, occasionally, between two women. Nonetheless, many modern commentators still assume that heterosexuality provides the best interpretive paradigm for reading the text. See, for instance, Denys Turner, *Eros and Allegory: Medieval Exegesis of the Song of Songs* (Kalamazoo, MI, 1995), p. 26, which announces that the text conveys 'the tones distinctively of *eros*, the language of hetero-sexual love'. Lochrie, 'Mystical Acts, Queer Tendencies', pp. 181–2, cogently critiques the 'presumptive heterosexuality' of much mystical scholarship, but goes on to overlook the Song of Songs tradition in her investigations of mystical queerness (thus implicitly, like Turner, claiming the Song for heterosexuality).

15 See, for instance, Denys the Carthusian (*d.* 1471), who emphasizes that the Song is only suitable reading matter for people 'who are reformed, purified of sensual desire, so that they will not, with minds attentive to the descriptions of sensual things, imagine those things of the flesh, but quickly be raised to the things of the mind and spirit'; Denys the Carthusian, 'A Devotional Continuous Commentary on the Song of Songs', in Turner, *Eros and Allegory*, p. 420.

16 Larry D. Benson, ed., *The Riverside Chaucer* (Oxford, 1987), p. 165, ll. 2149.

17 Astell, *Song of Songs*, pp. 1–8. The account of Origen's alleged self-castration appears in Eusebius, *Ecclesiastical History*, 2 vols, trans. Kirsopp Lake and J.E.L. Oulton (Cambridge, 1973–84), vol. II, p. 29.

18 Astell, *Song of Songs*, pp. 89–104.

19 See *ibid.*, pp. 9–15, 111–18, on the appropriation of feminine *figurae* by medieval exegetes of the Song. For a more general discussion of the 'feminization' of religious language after the twelfth century, see Caroline Walker Bynum, *Jesus as Mother: Studies in the Spirituality of the High Middle Ages* (Berkeley, CA, 1982), pp. 135–46.

20 Sermon 9.7, in Bernard of Clairvaux, *On the Song of Songs* I, trans. Kilian Walsh, The Works of Bernard of Clairvaux, II (Kalamazoo, MI, 1971), p. 58.

21 Bynum, *Jesus as Mother*, pp. 143–6.

22 Astell, *Song of Songs*, pp. 95, 98; Moore, *God's Beauty Parlor*, pp. 48–9, 54.

23 The idea that union with a male God presented male religious with a 'problem' is ventured in Bynum, *Jesus as Mother*, pp. 161–2, though Bynum does not acknowledge explicitly what the problem is: the 'solutions' she proposes are identification with the Bride or recasting God as a female parent. For critique, see Lochrie, 'Mystical Acts, Queer Tendencies', pp. 187–8; Mills, 'Ecce Homo', pp. 154–8.

24 Marcelle Bernstein, *Nuns* (London, 1976), p. 121.

25 Moore, *God's Beauty Parlor*, p. 28.

26 This anecdote appears among the *Legenda* included in the Office for Rolle's canonization, prepared in 1381. See Richard Rolle, *The Fire of Love; or, Melody of Love and the Mending of Life or Rule of Living*, ed. and trans. Frances M. M. Comper (London, 1914), p. xlvi.

27 Astell, *Song of Songs*, pp. 105–18.

28 Richard Rolle, *Biblical Commentaries*, ed. and trans. Robert Boenig (Salzburg, 1984), pp. 96, 100.

29 Richard Rolle, *The Fire of Love*, trans. R. Misyn (1435), ed. Ralph Harvey (London, 1896), p. 58.

30 Carolyn Dinshaw, *Getting Medieval: Sexualities and Communities, Pre- and Postmodern* (Durham, NC, 1999), p. 151.

31 Quotations by line number from *Þe Wohunge of ure Lauerd*, ed. W. Meredith Thompson (London, 1958); translation mine. A complete translation appears in *Anchoritic*

Spirituality, ed. Anne Savage and Nicholas Watson (New York, 1991), pp. 247–57. Salih, 'Queering *Sponsalia Christi*', convincingly argues that this and other anchoritic texts produce a version of the Bride of Christ topos that 'is not necessarily heterosexualizing' (p. 162). Susannah Mary Chewning, 'The Paradox of Virginity within the Anchoritic Tradition: The Masculine Gaze and the Feminine Body in the *Wohunge* Group', in *Constructions of Widowhood and Virginity in the Middle Ages*, ed. Cindy L. Carlson and Angela Jane Weisl (New York, 1999), pp. 113–34, focuses on gender transitions speakers and readers undergo in the text, but without letting go of potentially problematic formulations such as 'authentic feminine voice' and 'masculine gaze'.

32 For background on anchoritism and enclosure, see Christopher Cannon, 'Enclosure', in *The Cambridge Companion to Medieval Women's Writing*, ed. Carolyn Dinshaw and David Wallace (Cambridge, 2003), pp. 109–23.

33 Mitchell Merback, *The Thief, the Cross and the Wheel: Pain and the Spectacle of Punishment in Medieval and Renaissance Europe* (London, 1999), pp. 28–9.

34 See also ll. 384–6.

35 Cannon, 'Enclosure', pp. 109, 114.

36 L. O. Aranye Fradenburg, *Sacrifice your Love: Psychoanalysis, Historicism, Chaucer* (Minneapolis, MN, 2002), p. 34, discusses Christ's body as a body fixed in suspension between life and death.

37 See Eve Kosofsky Sedgwick, *Epistemology of the Closet* (London, 1990). On the inappropriateness of the closet as a metaphor for describing premodern sexualities, see Allen J. Frantzen, *Before the Closet: Same-Sex Love from 'Beowulf' to 'Angels in America'* (Chicago, 1998), pp. 3–5, 13.

38 Salih, 'Queering *Sponsalia Christi*', p. 170.

39 *Ibid.*, p. 168.

40 For a discussion of possible relations between queerness and social disorder in the *Book of Margery Kempe*, see Dinshaw, *Getting Medieval*, pp. 143–65.

41 Salih, 'Queering *Sponsalia Christi*', p. 175.

42 Versions of *In the Vaile of Restles Mind*, sometimes referred to by critics as *Quia Amore Langeo*, survive in two early fifteenth-century manuscripts: London, Lambeth Palace Library, MS 853, and Cambridge, Cambridge University Library, Hh.4.12. The poem was probably composed originally in the fourteenth century. Both texts are printed side by side in *Political, Religious and Love Poems*, ed. Frederick J. Furnivall (Oxford, 1965), pp. 180–89. My quotations here are based on the Cambridge text, cited by line number. For a critical edition, with introduction, bibliography and annotation, see the TEAMS version edited by Susanna Greer Fein and accessible online at *http://www.lib.rochester.edu/camelot/teams/valleint.htm*

43 Canticles 2:5: 'Stay me up with flowers, compass me about with apples: because I languish with love'. See also Canticles 5:1, which is the source for ll. 81–4.

44 On the theory of erotic triangles and male homo-social desire, see Eve Kosofsky Sedgwick, *Between Men: English Literature and Male Homosocial Desire* (New York, 1985), pp. 21–7.

45 The Lambeth reading is 'how weet a wounde is heere' (l. 58), which designates the wound as a site of purification and cleansing but also potentially enhances the eroticism. The imagery echoes the language of the Song, for instance Canticles 5:4, 'My beloved put his hand through the key hole, and my bowels were moved at his touch'. It also implicitly conjures up a homology between wound (*vulnus*) and vagina (*vulva*), reminiscent of certain late medieval devotional treatises. For an argument that we need to entertain an 'open mesh of possibilities' in relation to the sacred wound, see Lochrie, 'Mystical Acts, Queer Tendencies', pp. 189–95; for visual images, see Flora

Lewis, 'The Wound in Christ's Side and the Instruments of the Passion: Gendered Experience and Response', in *Women and the Book: Assessing the Visual Evidence*, ed. Lesley Smith and Jane H. M. Taylor (London, 1997), pp. 204–29.

46 The version in the Lambeth manuscript replaces 'membres' with 'humours', which arguably lessens the image's erotic potential.

47 The image of Jesus as a nurturing mother was quite common in late medieval piety, and took a number of forms. Julian of Norwich's *The Revelations of Divine Love*, for example, famously draws parallels between the sufferings of the Crucifixion and the pains of labour. But Julian does not juxtapose erotic language with the image of the mother-Jesus. For general discussion, see Bynum, *Jesus as Mother*, pp. 129–35. The image of the wound as breast may also be inspired by language in the Song of Songs, for instance Canticles 1:3, 'we will be glad and rejoice in thee, remembering thy breasts more than wine'.

48 For a more detailed discussion of the poem's gender transitions, see Thomas Hill, 'Androgyny and Conversion in the Middle English Lyric, "In the Vaile of Restles Mynd"', *ELH*, LIII (1986), pp. 459–70. Hill concludes that the poem and its sources 'seem surprisingly modern' in their awareness of God's resistance to sexual category (p. 465). On the imposition of a 'feminized' perspective on the reader of religious love lyrics more generally, see Astell, *Song of Songs*, pp. 136–58; a discussion of *In the Vaile of Restles Mind* appears at pp. 143–54.

49 Rosemary Woolf, *The English Lyric in the Middle Ages* (Oxford, 1968), pp. 189–90.

50 Michael Camille, *The Medieval Art of Love: Objects and Subjects of Desire* (London, 1998), pp. 38–9.

51 Bynum, 'Body of Christ', p. 82.

52 Jeffrey F. Hamburger, *The Rothschild Canticles: Art and Mysticism in Flanders and the Rhineland circa 1300* (New Haven, CT, 1990), p. 72.

53 Camille, *Medieval Art of Love*, p. 39; Hamburger, too, posits the existence of a gendered 'role reversal', 'the Sponsa penetrating Christ with her phallic spear'; Hamburger, *Rothschild Canticles*, p. 76.

54 Hamburger, *Rothschild Canticles*, pp. 155–9, and p. 296, note 1.

55 Lewis, 'Wound in Christ's Side', p. 215. For a more conventional account of the iconography of the *sponsa*, see Susan L. Smith, 'The Bride Stripped Bare: A Rare Type of the Disrobing of Christ', *Gesta*, XXXIV (1995), p. 139.

56 Rambuss, *Closet Devotions*, p. 135, uses the phrase 'prayer closet' to describe the closeted expression of Christian devotions in early modern literature, a 'space where the sacred may touch the transgressive, even the profane'.

57 Rambuss, *Closet Devotions*, p. 57.

58 Hamburger, *Rothschild Canticles*, pp. 2–4.

59 *De inspirationibus*, sermon III, in *S. Bernardini Senensi Opera Omnia . . . Studio et Cura pp. Collegii S. Bonaventurae*, 9 vols (Florence, 1950–65), vol. VI, p. 259. The gender of this person (*persona* in the Latin) is ambiguous. Given Bernardino's virulent sodomophobia in his other sermons (as discussed in chapter Three), it seems likely that he is referring to a male here.

60 'Here stands a Magdalen painted as so whorish that even the priests have all said again and again: How could a man take mass devoutly here? . . . There stands a Sebastian, a Maurice and the gentle John the Evangelist, so cavalier, soldier-like and pimp-ish that the women have had to make confession about them'; Neu-Karsthans, 'Gesprechbiechlin neüw Karsthans', quoted in Michael Baxandall, *The Limewood Sculptors of Renaissance Germany* (New Haven, CT, 1980), p. 89. See also the opinion of Jacob Wimpfeling who declared, in the early sixteenth century: 'In order to stimulate feelings, it is not necessary that hanging on the Cross, Christ naked all over without a covering expose

the most abtruse and secret parts of his body for human eyes to see', quoted in Trexler, 'Gendering Jesus Crucified', p. 113.

61 *Canons and Decrees of the Council of Trent*, trans. H. J. Schroeder (Rockford, IL, 1978), pp. 216–17.

62 Rambuss, *Closet Devotions*, p. 97.

63 *Canons of Council of Trent*, p. 216; Michael Camille, 'Obscenity under Erasure: Censorship in Medieval Illuminated Manuscripts', in *Obscenity: Social Control and Artistic Creation in the European Middle* Ages, ed. Jan M. Ziolkowski (Leiden, 1998), p. 141.

64 Bynum, 'Body of Christ', p. 85; Caroline Walker Bynum, *Holy Feast and Holy Fast: The Religious Significance of Food to Medieval Women* (Berkeley, CA, 1987), p. 307, note 3. For the objections of other scholars, see the summary in Steinberg, *Sexuality of Christ*, pp. 326–9.

65 Steinberg, *Sexuality of Christ*, pp. 327, 365.

66 *Ibid.*, pp. 70–71.

67 Bynum, 'Body of Christ', p. 116.

68 Steinberg, *Sexuality of Christ*, pp. 89, 323.

69 *Ibid.*, p. 317. For an interpretation of this episode that assumes, like me, that theatrical representations of Christ's suffering body could be erotically charged, see Garrett P. J. Epp, 'Ecce Homo', in *Queering the Middle Ages*, ed. Glenn Burger and Steven F. Kruger (Minneapolis, MN, 2001), pp. 238–40.

70 Full French text, with English translation, in Natalie Zemon Davis, *Fiction in the Archives: Pardon Tales and their Tellers in Sixteenth-Century France* (Cambridge, 1987), pp. 30–31, 124–6.

71 Steinberg, *Sexuality of Christ*, p. 317.

72 Epp, 'Ecce Homo', p. 240. Also, discussing the late fifteenth-century English moral drama *Mankind*, Epp demonstrates that by this period 'effeminacy' and 'sodomy' had become virtually interchangeable terms; Garrett P. J. Epp, 'The Vicious Guise: Effeminacy, Sodomy and *Mankind*', in *Becoming Male in the Middle Ages*, ed. Jeffrey Jerome Cohen and Bonnie Wheeler (New York, 1997), pp. 303–20. In the present context, Caranda's announcement that Caure was a geld might likewise have functioned as a form of sodomophobic insult.

73 Steinberg, *Sexuality of Christ*, p. 83. On pp. 314–15, Steinberg spells out precisely why Maerten van Heemskerck's *Man of Sorrows* depicts Christ with an erection beneath the loincloth. He also points out that the panel was altered at some point before 1800 to camouflage the erection effect.

74 See Sixten Ringbom, *Icon to Narrative: The Rise of the Dramatic Close-up in Fifteenth-Century Devotional Painting* (Beukenlaun, 1983), pp. 107–70, which develops the notion of the 'dramatic close-up' to describe these phenomena.

AFTERWORD: HEAVEN BENT

1 On the connections between the disciplines of modern masculinity and Christian discipline under, among other things, the sign of crucifixion, see Stephen D. Moore, *God's Gym: Divine Male Bodies of the Bible* (New York, 1996).

2 For the idea of subject formation as a 'passionate attachment' to subjection, see Judith Butler, *The Psychic Life of Power: Theories in Subjection* (Stanford, CA, 1997).

3 Anita Phillips, *A Defence of Masochism* (London, 1998), pp. 140–41, discusses the difference between monastic asceticism and sexual masochism along these lines. See also, from a more rigorously psychoanalytic perspective, Louise O. Fradenburg, 'We Are Not Alone: Psychoanalytic Medievalism', *New Medieval Literatures*, II (1998), pp. 264–8.

Select Bibliography

Ainsworth, Maryan W., *Gerard David: Purity of Vision in an Age of Transition* (New York, 1998)

Anzieu, Didier, *The Skin Ego*, trans. Chris Turner (New Haven, CT, 1989)

Asad, Talal, 'Notes on Body Pain and Truth in Medieval Christian Ritual', *Economy and Society*, XII/3 (1983), pp. 287–327

Astell, Ann W., *The Song of Songs in the Middle Ages* (Ithaca, NY, 1990)

Barron, W.R.J., 'The Penalties for Treason in Medieval Life and Literature', *Journal of Medieval History*, VII (1981), pp. 187–202

Baschet, Jérôme, *Les Représentations de l'enfer en France et en Italie (XIIe–XVe siècle)* (Rome, 1993)

Bernau, Anke, 'A Christian *Corpus*: Virginity, Violence and Knowledge in the Life of St Katherine of Alexandria', in *St Katherine of Alexandria: Texts and Contexts in Western Medieval Europe*, ed. Jacqueline Jenkins and Katherine J. Lewis (Turnhout, 2003), pp. 109–30

Betteridge, Tom, ed., *Sodomy in Early Modern Europe* (Manchester, 2002)

Biernoff, Suzannah, *Sight and Embodiment in the Middle Ages* (New York, 2002)

Bravmann, Scott, *Queer Fictions of the Past: History, Culture and Difference* (Cambridge, 1997)

Brown, E.A.R., 'Death and the Human Body in the Later Middle Ages: The Legislation of Boniface VIII on the Division of the Corpse', *Viator*, XII (1981), pp. 221–70

Burger, Glenn, and Steven F. Kruger, eds, *Queering the Middle Ages* (Minneapolis, MN, 2001)

Burl, Aubrey, *Danse Macabre: François Villon, Poetry and Murder in Medieval France* (Stroud, 2000)

Butler, Judith, 'The Force of Fantasy: Feminism, Mapplethorpe, and Discursive Excess', *differences*, II/2 (1990), pp. 105–25

—, *Bodies That Matter: On the Discursive Limits of 'Sex'* (London, 1993)

Bynum, Caroline Walker, *Jesus as Mother: Studies in the Spirituality of the High Middle Ages* (Berkeley, CA, 1982)

—, *Holy Feast and Holy Fast: The Religious Significance of Food to Medieval Women* (Berkeley, CA, 1987)

—, *Fragmentation and Redemption: Essays on Gender and the Human Body in Medieval Religion* (New York, 1992)

Camille, Michael, *The Gothic Idol: Ideology and Image-making in Medieval Art* (Cambridge, 1989)

—, 'Mimetic Identification and Passion Devotion in the Later Middle Ages: A Double-sided

Panel by Meister Francke', in *The Broken Body: Passion Devotion in Late-Medieval Culture*, ed. A. A. MacDonald, H.N.B. Ridderbos and R. M. Schlusemann (Groningen, 1998), pp. 183–210

—, *The Medieval Art of Love: Objects and Subjects of Desire* (London, 1998)

Carruthers, Mary, 'Reading with Attitude, Remembering the Book', in *The Book and the Body*, ed. Dolores Warwick Frese and Katherine O'Brien O'Keeffe (Notre Dame, IN, 1997), pp. 1–33

Caviness, Madeline H., *Visualizing Women in the Middle Ages: Sight, Spectacle and Scopic Economy* (Philadelphia, 2001)

Chiffoleau, Jacques, *Les Justices du pape: délinquance et criminalité dans la région d'Avignon au quatorzième siècle* (Paris, 1984)

Clover, Carol J., *Men, Women and Chainsaws: Gender in the Modern Horror Film* (London, 1992)

Cohen, Esther, 'Symbols of Culpability and the Universal Language of Justice: The Ritual of Public Executions in Late Medieval Europe', *History of European Ideas*, XI (1989), pp. 407–16

—, '"To Die a Criminal for the Public Good": The Execution Ritual in Late Medieval Paris', in *Law, Custom, and the Social Fabric in Medieval Europe: Essays in Honor of Bruce Lyon*, ed. Bernard S. Bachrach and David Nicholas, Studies in Medieval Culture, XXVIII (Kalamazoo, MI, 1990), pp. 285–304

—, *The Crossroads of Justice: Law and Culture in Late Medieval France* (Leiden, 1993)

—, 'Towards a History of European Physical Sensibility: Pain in the Later Middle Ages', *Science in Context*, VIII (1995), pp. 47–74

—, 'The Animated Pain of the Body', *American Historical Review*, CV (2000), pp. 36–68

Cohn, Norman, *The Pursuit of the Millennium: Revolutionary Millenarians and Mystical Anarchists of the Middle Ages* (London, 1993)

Dean, Trevor, *Crime in Medieval Europe, 1200–1550* (Harlow, 2001)

Deleuze, Gilles, 'Masochism', in his *Coldness and Cruelty*, trans. Jean McNeil (New York, 1989)

Dinshaw, Carolyn, *Getting Medieval: Sexualities and Communities, Pre- and Postmodern* (Durham, NC, 1999)

duBois, Page, *Torture and Truth* (New York, 1991)

Dworkin, Andrea, *Pornography: Men Possessing Women* (London, 1981)

Easton, Martha, 'Saint Agatha and the Sanctification of Sexual Violence', *Studies in Iconography*, XVI (1994), pp. 83–119

Edgerton, Samuel Y., *Pictures and Punishment: Art and Criminal Prosecution during the Florentine Renaissance* (Ithaca, NY, 1985)

Enders, Jody, *The Medieval Theater of Cruelty: Rhetoric, Memory, Violence* (Ithaca, NY, 1999)

—, *Death by Drama and Other Medieval Urban Legends* (Chicago, 2002)

Epp, Gareth P. J., 'Ecce Homo', in *Queering the Middle Ages*, ed. Glenn Burger and Steven F. Kruger (Minneapolis, MN, 2001), pp. 236–51

Fein, David. A., *François Villon Revisited* (New York, 1997)

Foucault, Michel, *Discipline and Punish: The Birth of the Prison*, trans. A. M. Sheridan (London, 1977)

—, *The History of Sexuality*, vol. I: *An Introduction*, trans. Robert Hurley (London, 1978)

Fradenburg, L. O. Aranye, *Sacrifice your Love: Psychoanalysis, Historicism, Chaucer* (Minneapolis, MN, 2002)

Fradenburg, Louise O., and Carla Freccero, eds, *Premodern Sexualities* (London, 1996)

Freedberg, David, *The Power of Images: Studies in the History and Theory of Response* (Chicago, 1989)

Freud, Sigmund, '"A Child Is Being Beaten": A Contribution to the Study of the Origin of

Sexual Perversions', in *The Standard Edition of the Complete Psychological Works of Sigmund Freud*, ed. and trans. James Strachey (London, 1953–74), vol. XVII, pp. 179–204

Gatrell, V.A.C., *The Hanging Tree: Execution and the English People 1770–1868* (Oxford, 1996)

Gennep, Arnold van, *The Rites of Passage*, trans. Monika B. Vizedom and Gabrielle L. Caffee (London, 1960)

Gibson, Pamela Church, and Roma Gibson, eds, *Dirty Looks: Women, Pornography, Power* (London, 1993)

Glanz, Rudolf, 'The "Jewish Execution" in Medieval Germany', *Jewish Social Studies*, V (1943), pp. 3–26

Goldberg, Jonathan, *Sodometries: Renaissance Texts, Modern Sexualities* (Stanford, CA, 1992)

Gravdal, Kathryn, *Ravishing Maidens: Writing Rape in Medieval French Literature and Law* (Philadelphia, 1991)

Groebner, Valentin, *Defaced: The Visual Culture of Violence in the Late Middle Ages*, trans. Pamela Selwyn (New York, 2004)

Hamburger, Jeffrey F., *The Rothschild Canticles: Art and Mysticism in Flanders and the Rhineland circa 1300* (New Haven, CT, 1990)

Hanawalt, Barbara A., *Crime and Conflict in English Communities, 1300–48* (Cambridge, MA, 1979)

Harbison, Craig, 'The Sexuality of Christ in the Early Sixteenth Century in Germany', in *A Tribute to Robert A. Koch: Studies in the Northern Renaissance* (Princeton, NJ, 1994), pp. 69–81

—, *The Art of the Northern Renaissance* (London, 1995)

Hill, Thomas, 'Androgyny and Conversion in the Middle English Lyric, "In the Vaile of Restles Mynd"', *ELH*, LIII (1986), pp. 459–70

Holsinger, Bruce W., *Music, Body and Desire in Medieval Culture: Hildegard of Bingen to Chaucer* (Stanford, CA, 2001)

Huizinga, Johann, *The Autumn of the Middle Ages*, trans. Rodney J. Payton and Ulrich Mammitzsch (Chicago, 1996)

Hupp, Otto, *Scheltbriefe und Schandbilder: ein Rechtsbehelf aus dem 15 und 16 Jahrhundert* (Munich, 1930)

Irigaray, Luce, *Speculum of the Other Woman*, trans. Gillian C. Gill (Ithaca, NY, 1985)

Jones, Amelia, 'Dis / playing the Phallus: Male Artists Perform their Masculinities', *Art History*, XVII (1994), pp. 546–84

Jones, Malcolm, *The Secret Middle Ages* (Stroud, 2002)

Jordan, Mark D., *The Invention of Sodomy in Christian Theology* (Chicago, 1997)

Kay, Sarah, *Courtly Contradictions: The Emergence of the Literary Object in the Twelfth Century* (Stanford, CA, 2001)

—, 'Flayed Skin as *objet a*: Representation and Materiality in Guillaume de Deguileville's *Pèlerinage de vie humaine*', in *Medieval Fabrications: Dress, Textiles, Clothwork and Other Cultural Imaginings*, ed. E. Jane Burns (New York, 2004), pp. 193–205

Kelly, Kathleen Coyne, *Performing Virginity and Testing Chastity in the Middle Ages* (London, 2000)

Kipnis, Laura, *Bound and Gagged: Pornography and the Politics of Fantasy in America* (New York, 1996)

Kristeva, Julia, *Powers of Horror: An Essay on Abjection*, trans. Leon S. Roudiez (New York, 1982)

Lacan, Jacques, *The Ethics of Psychoanalysis, 1959–1960 (Seminar VII)*, trans. Dennis Porter (London, 1992)

—, *The Four Fundamental Concepts of Psycho-Analysis (Seminar XI)*, trans. Alan Sheridan (London, 1998)

Lewis, Flora, 'The Wound in Christ's Side and the Instruments of the Passion: Gendered Experience and Response', in *Women and the Book: Assessing the Visual Evidence*, ed. Lesley Smith and Jane H. M. Taylor (London, 1997), pp. 204–29

Lewis, Katherine J., '"Lete Me Suffre": Reading the Torture of St Margaret of Antioch in Late Medieval England', in *Medieval Women: Texts and Contexts in Late Medieval Britain: Essays for Felicity Riddy*, ed. Jocelyn Wogan-Browne *et al.* (Turnhout, 2000), pp. 69–82

Lochrie, Karma, 'Mystical Acts, Queer Tendencies', in *Constructing Medieval Sexuality*, ed. Karma Lochrie, Peggy McCracken and James A. Schulz (Minneapolis, MN, 1997), pp. 180–200

Maddern, Philippa C., *Violence and Social Order: East Anglia, 1422–42* (Oxford, 1992)

Marcus, Sharon, 'Fighting Bodies, Fighting Words: A Theory and Politics of Rape Prevention', in *Feminists Theorize the Political*, ed. Judith Butler and Joan W. Scott (London, 1992), pp. 385–403

Margolick, David, *Strange Fruit: Billie Holiday, Café Society and an Early Cry for Civil Rights* (Philadelphia, 2000)

Mellinkoff, Ruth, *Outcasts: Signs of Otherness in Northern European Art of the Late Middle Ages*, 2 vols (Berkeley, CA, 1993)

Merback, Mitchell, *The Thief, the Cross and the Wheel: Pain and the Spectacle of Punishment in Medieval and Renaissance Europe* (London, 1999)

Miegroet, Hans J. van, 'Gerard David's *Justice of Cambyses*: *Exemplum iustitiae* or Political Allegory?', *Simiolus*, XVIII/3 (1988), pp. 116–33

Miles, Margaret, *Carnal Knowing: Female Nakedness and Religious Meaning in the Christian West* (Boston, MA, 1989)

Mills, Robert, '"Whatever You Do Is a Delight to Me!": Masculinity, Masochism and Queer Play in Representations of Male Martyrdom', *Exemplaria*, XIII/1 (2001), pp. 1–37

—, 'A Man Is Being Beaten', *New Medieval Literatures*, V (2002), pp. 115–53

—, 'Ecce Homo', in *Gender and Holiness: Men, Women and Saints in Medieval Europe*, ed. Samantha J. E. Riches and Sarah Salih (London, 2002), pp. 152–73

—, 'Can the Virgin Martyr Speak?', in *Medieval Virginities*, ed. Anke Bernau, Ruth Evans and Sarah Salih (Cardiff, 2003), pp. 187–213

Moore, R. I., *The Formation of a Persecuting Society: Power and Deviance in Western Europe, 950–1250* (Oxford, 1987)

Moore, Stephen D., *God's Beauty Parlor, and Other Queer Spaces in and Around the Bible* (Stanford, CA, 2001)

Morinis, Alan, 'The Ritual Experience: Pain and the Transformation of Consciousness in Ordeals of Initiation', *Ethos*, XIII (1985), pp. 150–74

Mormando, Franco, *The Preacher's Demons: Bernardino of Siena and the Social Underworld of Early Renaissance Italy* (Chicago, 1999)

Nelson, Robert S., ed., *Visuality Before and Beyond the Renaissance: Seeing as Others Saw* (Cambridge, 2000)

Orme, Nicholas, *Education and Society in Medieval and Renaissance England* (London, 1989)

Ortalli, Gherardo, ' . . . *pingatur in Palatio* . . . ': *La pittura infamante nei secoli 13–16* (Rome, 1979)

Partner, Nancy F., 'Did Mystics Have Sex?', in *Desire and Discipline: Sex and Sexuality in the Premodern West*, ed. Jacqueline Murray and Konrad Eisenblicher (Toronto, 1996), pp. 296–311

Perkins, Judith, *The Suffering Self: Pain and Narrative Representation in the Early Christian Era* (London, 1995)

Peters, Edward, *Torture* (Oxford, 1985)

Phillips, Anita, *A Defence of Masochism* (London, 1998)

Puff, Helmut, *Sodomy in Reformation Germany and Switzerland, 1400–1600* (Chicago, 2003)

Rambuss, Richard, *Closet Devotions* (Durham, NC, 1998)

Reik, Theodor, *Masochism in Modern Man*, trans. Margaret H. Beigel and Gertrud M. Kurth (New York, 1941)

Rocke, Michael, *Forbidden Friendships: Homosexuality and Male Culture in Renaissance Florence* (Oxford, 1996)

Rubin, Miri, *Gentile Tales: The Narrative Assault on Late Medieval Jews* (New Haven, CT, 1999)

Ruggiero, Guido, *The Boundaries of Eros: Sex Crime and Sexuality in Renaissance Venice* (Oxford, 1985)

Salih, Sarah, *Versions of Virginity in Late Medieval England* (Cambridge, 2001)

—, 'Queering *Sponsalia Christi*: Virginity, Gender and Desire in the Early Middle English Anchoritic Texts', *New Medieval Literatures*, V (2002), pp. 155–75

—, 'When Is a Bosom Not a Bosom? Problems with "Erotic Mysticism"', in *Medieval Virginities*, ed. Anke Bernau, Ruth Evans and Sarah Salih (Cardiff, 2003), pp. 14–32

Scarry, Elaine, *The Body in Pain: The Making and Unmaking of the World* (Oxford, 1985)

Schnitzler, Norbert, 'Judas' Death: Some Remarks on the Iconography of Suicide in the Middle Ages', *Medieval History Journal*, III (2000), pp. 103–18

—, 'Anti-Semitism, Image Desecration and the Problem of "Jewish Execution"', in *History and Images: Towards a New Iconology*, ed. Axel Bolvig and Phillip Lindley (Turnhout, 2003), pp. 357–78

Sedgwick, Eve Kosofsky, *Epistemology of the Closet* (London, 1990)

—, *Touching Feeling: Affect, Pedagogy, Performativity* (Durham, NC, 2003)

Shachar, Isaiah, *The Judensau: A Medieval Anti-Jewish Motif and its History* (London, 1974)

Silverman, Kaja, *Male Subjectivity at the Margins* (London, 1992)

Steinberg, Leo, *The Sexuality of Christ in Renaissance Art and Modern Oblivion*, 2nd edn (Chicago, 1995)

Tilley, Maureen A., 'The Ascetic Body and the (Un)making of the World of the Martyr', *Journal of the American Academy of Religion*, LIX (1991), pp. 467–79

Trexler, Richard C., 'Gendering Jesus Crucified', in *Iconography at the Crossroads: Papers from the Colloquium Sponsored by the Index of Christian Art, Princeton University, 23–24 March 1990*, ed. Brendan Cassidy (Princeton, NJ, 1993), pp. 107–20

Vandermeersch, Patrick, *La Chair de la passion. Une histoire de foi: la flagellation* (Paris, 2002)

Velden, Hugo van der, 'Cambyses for Example: The Origins and Function of an *Exemplum iustitiae* in Netherlandish Art of the Fifteenth, Sixteenth and Seventeenth Centuries', *Simiolus*, XXIII/1 (1995), pp. 5–39

—, 'Cambyses Reconsidered: Gerard David's *Exemplum iustitiae* for Bruges Town Hall', *Simiolus*, XXIII/1 (1995), pp. 40–62

Warning, Rainer, *The Ambivalences of Medieval Religious Drama*, trans. Steven Rendall (Stanford, CA, 2001)

Williams, Linda, *Hard Core: Power, Pleasure and the 'Frenzy of the Visible'* (Berkeley, CA, 1989)

Wogan-Browne, Jocelyn, 'Saints' Lives and the Female Reader', *Forum for Modern Language Studies*, XXVII (1991), pp. 314–32

—, 'The Virgin's Tale', in *Feminist Readings in Middle English Literature: The Wife of Bath and All her Sect*, ed. Ruth Evans and Lesley Johnson (London, 1994), pp. 165–94

—, *Saints' Lives and Women's Literary Culture, 1150–1300: Virginity and its Authorizations* (Oxford, 2001)

Zafran, Eric M., 'An Alleged Case of Image Desecration by the Jews and its Representation in Art: The Virgin of Cambron', *Journal of Jewish Art*, II (1975), pp. 62–71

Žižek, Slavoj, *The Plague of Fantasies* (London, 1997)

Acknowledgements

This book has been greatly enriched by the contributions of friends and colleagues. Versions of the manuscript have been energetically dissected by Emma Campbell, Steven Connor, Sarah Kay, Alex Pilcher, Miri Rubin and anonymous referees. Emma, especially, has gone beyond the call of duty in her attentive readings of the text; she has also become a valued friend. Sarah Salih, another friend whose influence on these pages is everywhere, also read through and responded insightfully to certain chapters. Many of the ideas in the book date to my years as a doctoral student at Cambridge, and I'm especially grateful to Paul Binski for inspiring me to write this in the first place and for allowing me not to let academic disciplines get in the way of what I wanted to do. My colleagues at King's College London, notably Simon Gaunt, John Howard, Clare Lees, Sonia Massai, Devyani Sharma, Ishtla Singh, Kimberly Springer, Marion Turner and Mark Turner, have been sources of immense encouragement and support, particularly in the later phases of the project. Simon should be singled out for persuading me to develop my critical and theoretical horizons, and for offering friendship at every stage along the way; Mark has not only read through portions of a manuscript on medieval things (not his field), but he has also helped to make work and life fun these last few years.

For variously commenting on drafts of chapters, articles and conference papers, checking translations, providing references and ideas, sharing unpublished work, helping with picture research, or providing intellectual stimulation, I'd also like to thank the following: Bettina Bildhauer, Alex Campbell, Trevor Dean, Cary Howie, Katherine Lewis, Sam Riches, Katrin Wilhelm, Jocelyn Wogan-Browne and Diane Wolfthal. Although I never knew him well, the late Michael Camille deserves special mention: his writings on medieval visual culture were a major factor in convincing me that it was possible to write differently, imaginatively and queerly about the past, and his untimely death in 2002 was a deep loss to the discipline. My parents and wider family have been cheerily supportive of the project through thick and thin. In addition, I wish to express heartfelt gratitude to my partner, Neil Young, who has suffered the project from its inception, seen it grow and mature, and advised me how to make it a book that he might actually read. Without his love and support, the task of writing, working and living would have been very, very much harder.

Papers based on material in the book were presented at the College Art Association of America Annual Conference, the International Medieval Congress on Medieval Studies at Kalamazoo, the Leeds International Medieval Congress, and the universities of Bristol, Cambridge, London, Southampton, Wales in Aberystwyth and York. I'm profoundly grateful to my audiences on each of those occasions for their feedback, criticism and ideas. I'd also like to thank all those individuals who organized these events for their generous invitations to speak. For travel grants that enabled me to present work at conferences and view the paintings discussed in the book first-hand, I wish to acknowledge the Humanities Research Board of the

British Academy, the Master and Fellows of Pembroke College, Cambridge, the Kettle's Yard Travel Fund, Cambridge, and the English Department, King's College London. I also owe sincere thanks to my department, and especially to the British Academy, for assistance with the prohibitive costs associated with reproducing visual materials. Finally I must thank Michael Leaman and the staff at Reaktion Books for their help in bringing the project to fruition.

Throughout the book, all translations from French, German, Italian, Spanish and Latin, unless otherwise attributed, are my own. In the interests of accessibility, obsolete letters in Middle English have been replaced by their modern equivalents: *thorn* and *eth* are represented as *th*, and *yogh* as *gh* or *y* as appropriate; the letters *i/j* and *u/v* are normalized in accordance with modern usage; ampersands appear as *and*. Biblical quotations are from the Douay-Rheims edition. A few of the formulations in the Introduction appeared previously in '"For They Know Not What They Do": Violence in Medieval Passion Iconography', in *Fifteenth-Century Studies*, xxvii, Special Issue: *Violence in Fifteenth-Century Text and Image*, ed. Edelgard E. DuBruck and Yael Even (Rochester, NY, 2002), pp. 200–16. Several phrases and some of the argument in chapter Five appeared, in a substantially different form, in 'A Man Is Being Beaten', *New Medieval Literatures*, v (Oxford, 2002), pp. 115–53. A few paragraphs from chapter Six are taken from 'Ecce Homo', in *Gender and Holiness: Men, Women and Saints in Late Medieval Europe*, ed. Samantha J. E. Riches and Sarah Salih (London, 2002), pp. 152–73. My thanks go to the editors and publishers of these articles for their permission to allow me to make use of this material again.

Photographic Acknowledgements

The author and publishers wish to express their thanks to the below sources of illustrative material and/or permission to reproduce it.

Alinari Archives, Florence: 42, 47, 48, 52; Alinari Archives/Bridgeman: 21, 44, 45; Alte Pinakothek, Munich: 75, 90; Archivio Fotografico, Bologna: 49, 70; photo Artothek: 69; Bayerisches Hauptstaatsarchiv, Munich: 17 (Nachlass Lieb 8); Bayerische Staatsbibliothek, Munich: 8 (cod. lat. 935, fol. 57v); Bibliothèque Nationale de France, Paris: 5 (Réserve des livres rares, Rés. Ye. 245, fol. g2v), 6 (Réserve des livres rares, Rés. Ye. 245, fol. g3), 7 (lat. 9471, fol. 236v), 62 (Bibliothèque de l'Arsenal, Paris MS 650, fol. 146r); Bibliothèque Royale de Belgique Albert I, Brussels: 82 (MS 13076–77, fol. 16v); photo Bildarchiv Foto Marburg: 76; photo © Bildarchiv Preussischer Kulturbesitz, Berlin: 31; photos Blauel/Gnamm – Artothek: 75, 90; Bodleian Library, University of Oxford: 83 (Gough Missals 143); Bridgeman Art Library, London: 40, 72, 89, 90; British Library, London (by permission of the British Library): 2 (Add. MS 16949, fol. 58v), 4 (1605/481), 28 (Add. MS 37049, fol. 23r), 30 (1605/479.(3)), 35 (IB.21041), 36 (C.112.f.10), 37 (Harley MS 4425, fol. 59r), 51 (Add. MS 29433, fol. 89r), 63 (Egerton MS 877, fol. 8r), 81 (10161.f.23); British Museum, London (© Copyright The Trustees of the British Museum): 23 (no. 1895.9.15.441), 98 (no. B.VII.537.4); photo Conway Library, Courtauld Institute of Art, London: 84; Corpus Christi College, Cambridge (by permission of the Master and Fellows of Corpus Christi College, Cambridge): 46 (Parker Library, MS 16, fol. 166r); photo © Jay Eff: 100 (Heaven logo reproduced by permission); Finsiel/Alinari Archives: 14, 22; Groeningemuseum, Bruges (photos Stad Brugge): 24, 25, 32, 33, 34, 38, 39, 67, 68, 88; photos Heinz Hebeisen–Iberimage.com: 79, 80; Hessisches Hauptstaatsarchiv, Wiesbaden: 15 (Abt. 170, Nr. 1026); Historisches Museum, Frankfurt-am-Main (photos Ursula Seitz-Gray): 20 (Nr. 45411), 95; Huntington Library, San Marino, CA: 97 (MM 26061, fol. 178v, reproduced by permission of The Huntington Library); Institut für Stadtgeschichte, Frankfurt-am-Main: 16 (Reichssachen II, Nr.3605); photos © IRPA-KIK, Brussels: 26, 27, 41, 88, 99; John Rylands Library, Manchester (MS lat. 24, fol. 151r), reproduced by courtesy of the Director and Librarian, The John Rylands University Library, The University of Manchester: 78; photos Piotr Ligier: 1, 66; Harald Malmgren: 56, 57, 58, 59; Harald Malmgren/C. Grünberg: 65; The Metropolitan Museum of Art, New York: 61 (Robert Lehman Collection, 1975 [1975.1.2488], photograph, all rights reserved, the Metropolitan Museum of Art); Museum of Fine Arts, Boston: 64 (Sarah Wyman Whitman Fund, photograph © Museum of Fine Arts, Boston); photo © National Gallery, London: 87; photo NMR, reproduced by permission of English Heritage/NMR: 13; photos © Parrocchia di Santa Maria Assunta di San Gimignano: 53, 71; Philadelphia Museum of Art: 86 (John G. Johnston Collection, 1917); The Pierpont Morgan Library, New York: 3 (MS M.457, fol. 85v), 9 (MS

Index